DANCE VISION

DANCE
THROUGH
THE EYES
OF TODAY'S
ARTISTS

DANCE VISION

DANCE THROUGH THE EYES OF TODAY'S ARTISTS

JOSHUA TEAL

CERNUNNOS

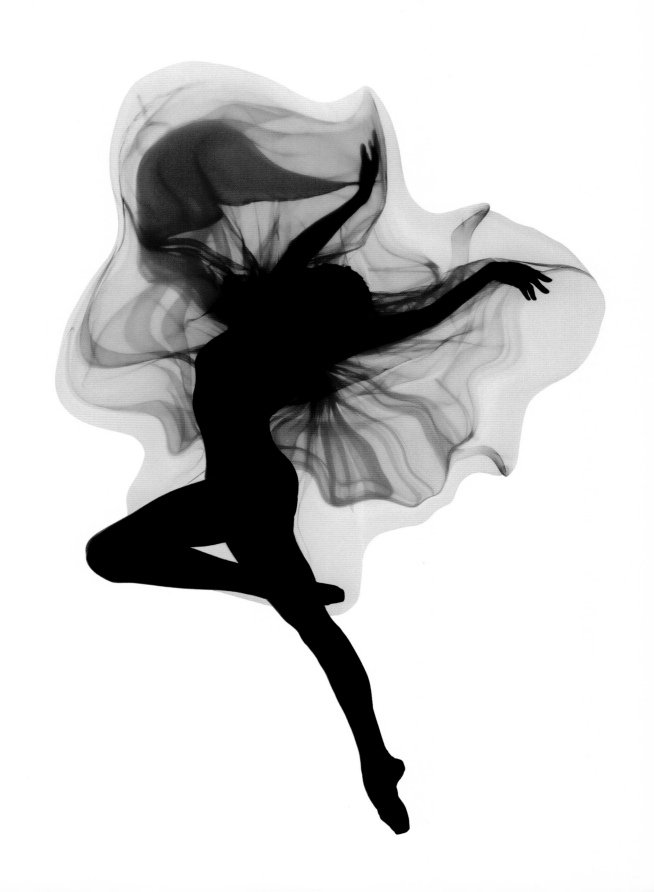

CONTENTS

OPPOSITE PAGE
Baki, *Shadow 1-1(12)*
2019

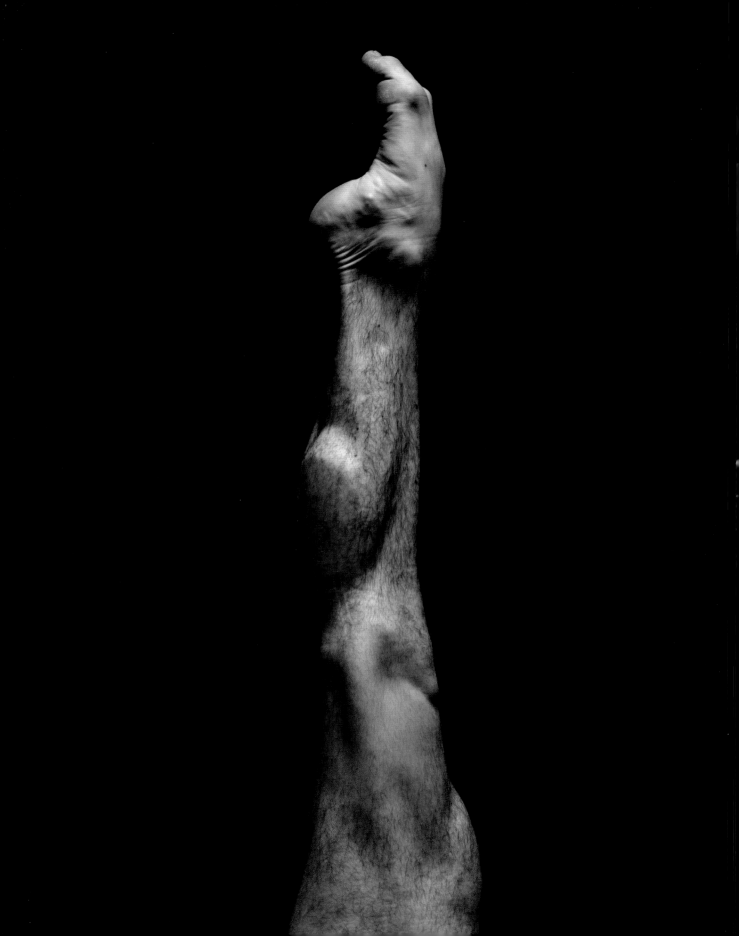

"THE BOY WITH THE BEAUTIFUL FEET"

A Fictive Introduction by Joshua Teal

He is the boy with the beautiful feet. His cold hands grab black tea, burnt toast, cinnamon plum jam. His fingers relax around his cute teacup, which features cubism and cats around brilliant white, tap-shoe black, yellow blaze, and French blue Pantone colors. Against an alexandrite plate. He wraps his breakfast like a Persian red present. He smells the laser lemon roses in the center of his table; he smiles.

He takes the barbary red bus to the Royal Opera House. His new home. "Don't look," he says to the front desk attendant, Peter. "Oh, you are just the sweetest boy in all of London," Peter replies. Peter's counterpart, Alexandria, blushes. She adjusts her peri Cazal frames. "I have this letter for you!" she says. The boy exchanges a gin fizz tin full of chocolate chip cookies for the letter. He says, "I made them." He smiles and carries his tall, meerkat ballet body inside. He signs in.

It's opening night of *The Nutcracker*. He walks to his dressing room and bumps into Jordan, who opens the mahogany door. "Your dream has come true!" Tobin says. The boy collapses into a folding chair. He can't believe his dream is true. His mouth opens wide as he looks at himself in the round mirror. His eyes begin to well with tears of joy. "Tired?" Tobin asks. "Yeah, and excited . . ." he replies.

He tears the envelope and places it inside a cerulean box he keeps on the top shelf of his dressing room. It's full of letters. Tobin leaves so that the boy with the beautiful feet can read the letter from his mentor, Nadine. The fragrance Un Jardin Sur Le Nil still seeps from the paper in his hands.

OPPOSITE PAGE
Paul Marque, *Dancer*

Dear boy with the beautiful feet,

You went to the Big Island! You deserved a holiday. I wish I was there in London to see you debut as the prince, the cavalier. Boy am I proud of you! You heard me when I saw you that day in that San Francisco dance studio, the one with that recessed oval window and the window I'm sure they got from a funhouse. You remember what I said, that you are a brilliant and prolific dancer, now dance like no one watches!
 You are a classical ballet dancer!

Yeah, he thinks. *I am*. He picks up a piece of paper. "Thirty minutes until places. And congratulations," the stage manager says. The boy replies, "Thank you, Thirty-Minutes-Until-Places."
 And he begins to write a response.

Dear Nadine,

I am in awe of the newness. Now that I am away from my mother and father, I can see. Dance and art are a powerful combination.
 I dance like no one is there to watch me. I promise. I have all your letters here. I never told you about my first ballet class. Like a sugar glider released back into his natural habitat. I remember how I would jump and glide across the studio. My body fits ballet. Can you imagine how I looked in my first ballet class?
 I even auditioned for So You Think You Can Dance, *a major dance television show that discovers professional dancers. I waited in line to audition for that show and compete with those people. Because I love dance. I am so inspired by how much freedom there is when I dance. I learned ballet because I saw the sinews of my body change. And that came from my commitment to learn this new language. Until I began to communicate through the movements I made in my first ballet class. I didn't think dance was a language.*

He stops and begins to apply foundation to his skin. He starts to give himself eyebrows. He pulls his white ballet tights snug against his skin. He fastens the cavalier's jacket to his chest. He straps his ballet flats around his beautiful ballet feet.

I will write a book. For you. For everyone. That captures the language of dance and art. I want you to keep it on your coffee table. I want you to have it close to your bedside. It will be this collection of incredible artists and collaborators that showcase dance through the mediums of photography, sculpture, illustration, painting, and design. Each will bring their own unique perspective to dance as an art form. You will see world-class artists.
 Each artist will give more insight into the mystery behind dance, the possibilities within dance, and how artists collaborate with dancers to create expansive structural elements, new worlds on ballet stages, and still moments in time, in motion.

Lee Gumbs discovered photography out of sheer curiosity. He was once a dancer himself, and now he captures those moments to share with viewers. He wants to inspire, evoke, create moments that excite the viewer. And there is Lois Greenfield. She is the mastermind of photography, the legend, the one that so many of these photographers look up to. And Brendan Fernandes. He is an artist whose projects capture humanity and hold up a mirror to reflect society.

And what if we see bliss in these images? It is, we will find it here, and I know this will inspire people to follow the bliss of their lives.

I can hear you right now, Nadine! "Curious boy, slow down!" I can't. I am on fire! That curiosity and self-discovery led me here. It led me to learn so much from you. I am transformed when I dance, and I want readers to have the opportunity to see that transformation. I had to transform my mind. Critics told me I didn't have it, whatever it was, that they couldn't see in me. My curiosity, my love for dance, and my movement. I saw it. I convinced myself, and I convinced them to see me.

I want to give people faith. We find ourselves in connection with others. It wouldn't have happened unless I wasn't seen by my family. I slid into this quiet solitude that created my massive imagination.

Like a top, that whirls and spins. I laugh now when I remember how I would run around in circles in my tiny room. I don't stop anymore. I keep the momentum.

I will create a livelihood as an artist. I lost time with my parents. I lost time with their dreams. I see my dreams alive in dance and literature. I can see myself even on the West Coast in San Francisco, California. My dreams will come true as I write and dance. I will create symbols out of these mediums of expression. I made a commitment to self-discipline. And I learned this new language.

I want readers to see art and dance with fresh, unbiased eyes, and this book, Dance Vision*, gives them a moment to experience dance for themselves.*

I have no hope. I have no fear. I know that through the art and dance held within this book, readers will become transformed; there is no disguise. It will be an opportunity to experience dance, beauty, bliss through the eyes of these artists' imaginations.

The door cracks open.

"It's time," Tobin says. His best friend, with carrot, curly hair. A guide dog's nose enters after him, a guide dog who belongs to Nadine.

The boy stops his hand. He signs, Always, and folds the letter, needles it in an envelope, and pins a stamp on it.

"Places, everyone," the stage manager says.

The boy grabs a handful of mango gummy bears and takes a sip of tangerine sparkling water.

"Thank you, Places," he says.

He turns around, and there is Nadine. He finds her hands. "I smell you," he says, and giggles.

CAPTURED ON CAMERA: PHOTOGRAPHY

NIR ARIELI

Nir Arieli was born in 1986 in Tel Aviv and launched his career as a military photographer for the Israeli magazine *Bamachane*, before receiving a scholarship to pursue a BFA at New York's School of Visual Arts; he graduated with honors in 2012. Arieli's two solo shows, *Inframen* and *Flocks*, were exhibited at Daniel Cooney Fine Art gallery in New York City. Select group shows include the Museum of Greek Folk Art (Athens), the Red House gallery (Tel Aviv), and Klompching gallery (Brooklyn). Arieli's work has appeared in the *New York Times*, the *Huffington Post*, the *Daily Telegraph*, *TimeOut*, and the Israeli newspaper *Haaretz* and he has been a guest speaker at the International Center of Photography, the School of Visual Arts, and the Fashion Institute of Technology's photography programs. Among his commercial clients are Ailey II, Gibney Dance, the Juilliard School, the Ailey School, the Joyce Theater Foundation, Estée Lauder, and BBR Saatchi & Saatchi.

Website: nirarieli.com
Instagram: @nirarieli

OPPOSITE PAGE
Tal ("Tension")
2011

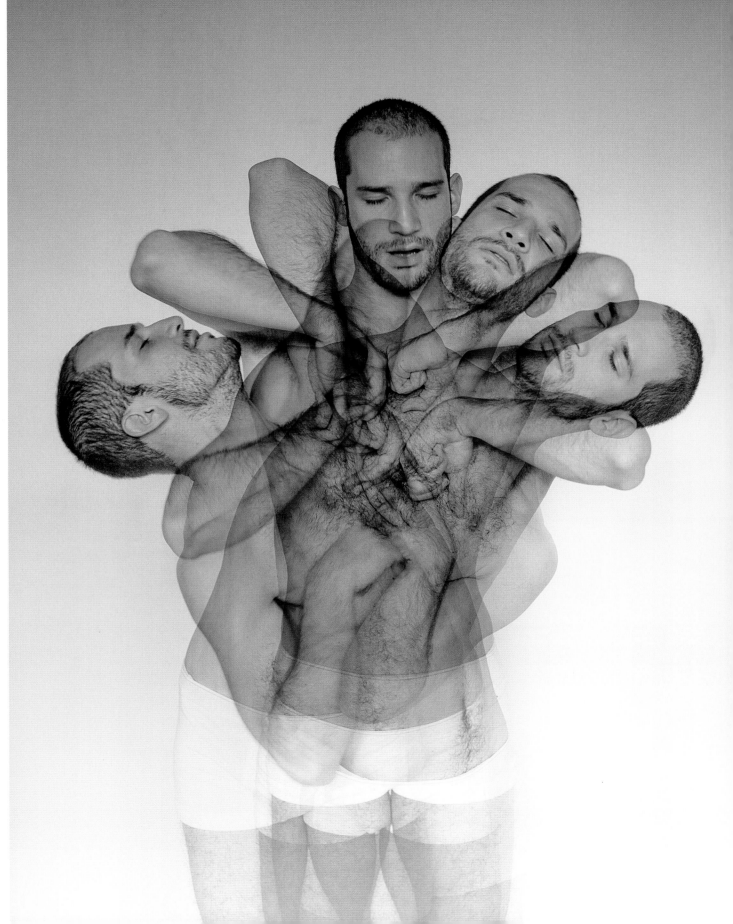

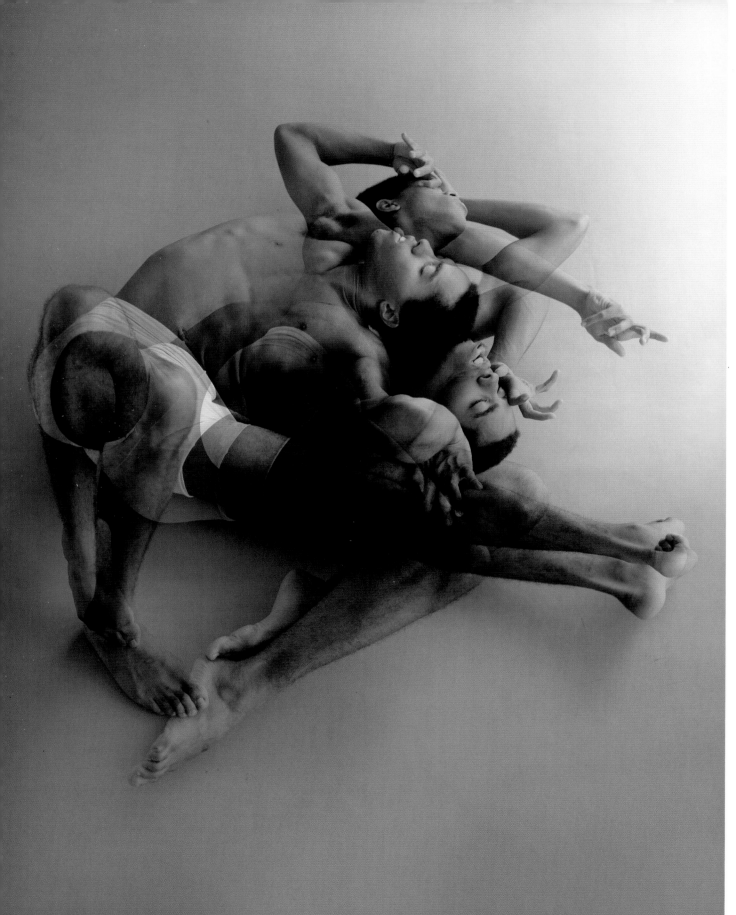

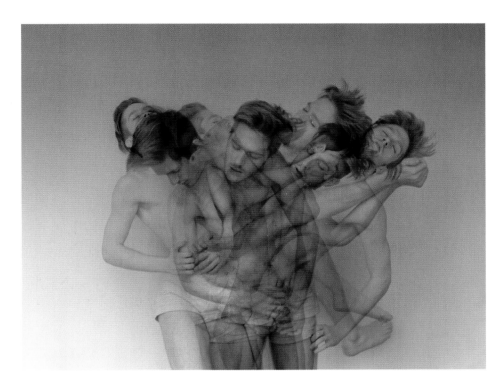

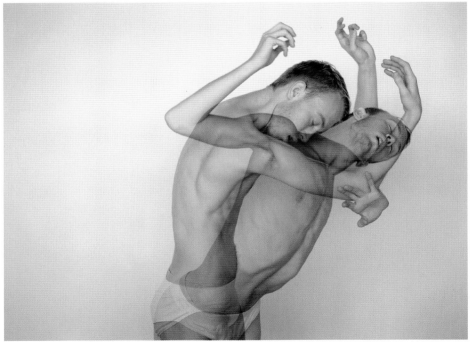

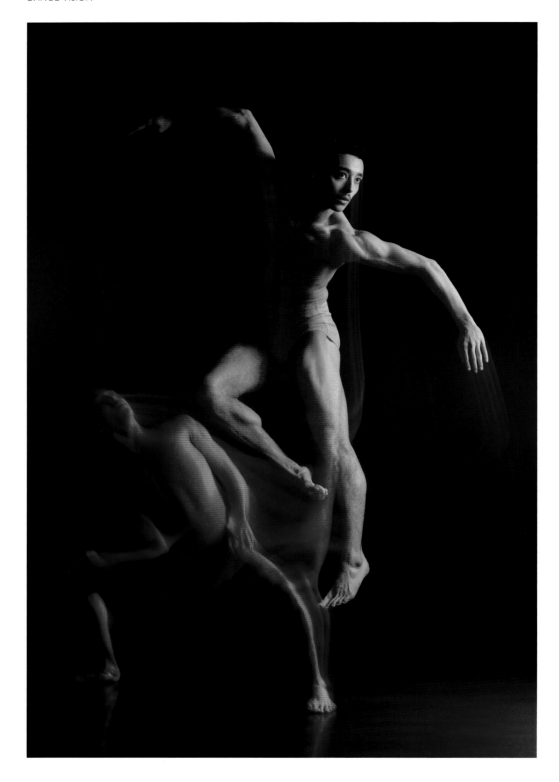

ABOVE
Jacob (for Gibney Company)
2019

OPPOSITE PAGE
Leal (for Gibney Company)
2019

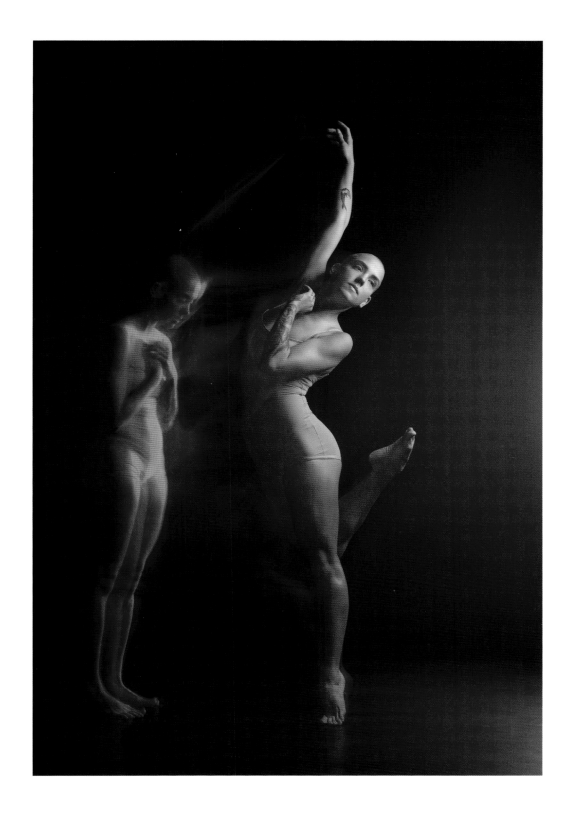

What makes it possible for you to create the art you want to create in your life?

The support from the dancers I invite to collaborate with. They have always been the most generous, risk-taking, and vulnerable. They are the reason this work exists.

What will you leave behind as your legacy?

I hope to leave a significant visual essay that looks at the male dancer, specifically in a variety of photographic approaches and processes.

What attracts you to dancing bodies?

I found dancers interesting before I found dance interesting. I saw people who are emotionally and physically intelligent, dedicated, and passionate, that need to be seen, that performance is a cathartic healing mechanism for them, who sacrifice and injure their bodies and who are often not compensated enough. I wanted to put a spotlight on them because they are exceptional.

When and why did you start incorporating dance into your work, and what do you feel dance brings to it?

My cousin Tal was a dance student at Juilliard when I was a photo student at SVA. His fellow dancers were the first to do volunteer modeling for me. Juilliard's student performances were a great place to be educated about dance and I've continuously worked with the school's students and alumni since. I often meet them later in their career when they are successful independent choreographers or members of some of the greatest dance companies in the world.

Are there any works of art by other artists featuring dance that have inspired you?

Dance is my medium of inspiration and reference. I remember how my body was storming from the inside when I watched Batsheva Dance Company perform "Bill" by choreographer Sharon Eyal. It was in a theater in Tel Aviv and I was hypnotized by the physical aesthetic and the movement language. Although I don't dance at all, I felt like my body was moving from the inside.

What process do you go through to create your work? What inspires you?

My work includes a lot of trial and error. I'm much better at conceptualizing while I'm actually photographing or reviewing the work, and I always draw conclusions for the next set when working on a project.

In my role as a director, I try to borrow tools from the contemporary choreography world, where the dancers are important collaborators that are in charge of translating words, feelings, and abstract instructions into body movements.

I'm inspired by the dancers themselves. I invite dancers that I feel have the ability to perform a wide range of ideas and emotions. I would often describe to them the feeling I'm searching for and let them go into physical improvisation that will lead to the final image. That starts the dialogue, and we exchange notes and thoughts throughout the process.

What might people be surprised to know about you (or your work)?

That I usually have very little idea about what is going to happen in a shoot before I get on set. I don't sketch, and I get excited about the endless possibilities and opportunities that different spaces or people might offer.

The production side of the shoots was always hard for me, so I made minimalism a part of my style of work.

What question do you wish I had asked you?

What value can photography bring to dance?

What is your answer to that question?

In my work, I try to distance as much as I can from what dance appears to look like onstage. I believe it's an injustice to the medium to try and capture what is a series of moments by definition. Photography has to give value when capturing dance/rs, and that's why I photograph outside of the studio or use multi-exposures and long exposures; I try to make an environment that is unique to the photographic medium. I'll never try to imitate or replace the experience of a performance.

OPPOSITE PAGE, TOP
Cedar Lake
2015

OPPOSITE PAGE, BOTTOM
Batsheva
2013

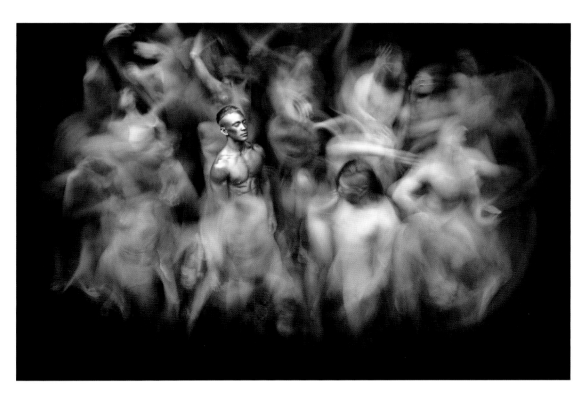

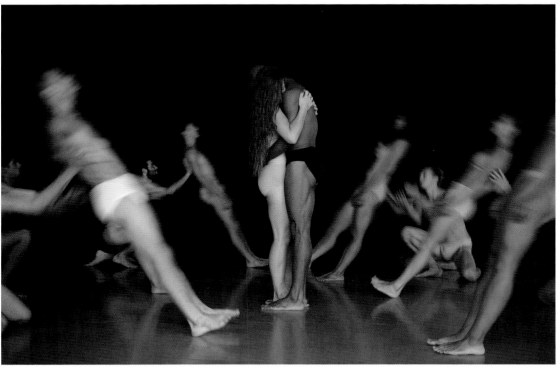

RAVSHANIYA AZOULAY

My name is Ravshaniya. I am a woman. I am thirty-eight. I live in Moscow. Photo levitation is my great love in life.

Website: ravshaniya.com
Instagram: @ravshaniyaofficial
Facebook: Ravshaniya

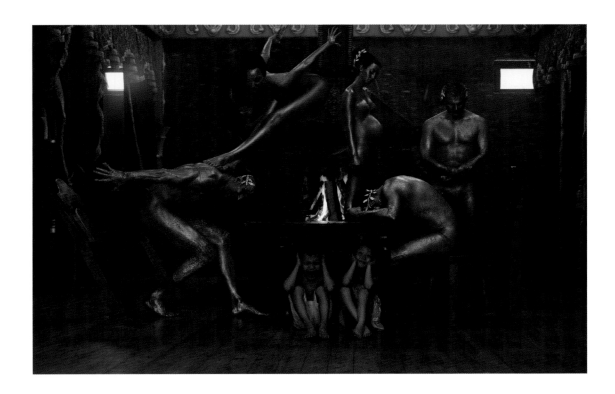

ABOVE
Kookaburra

OPPOSITE PAGE
Water on aquarelle

20

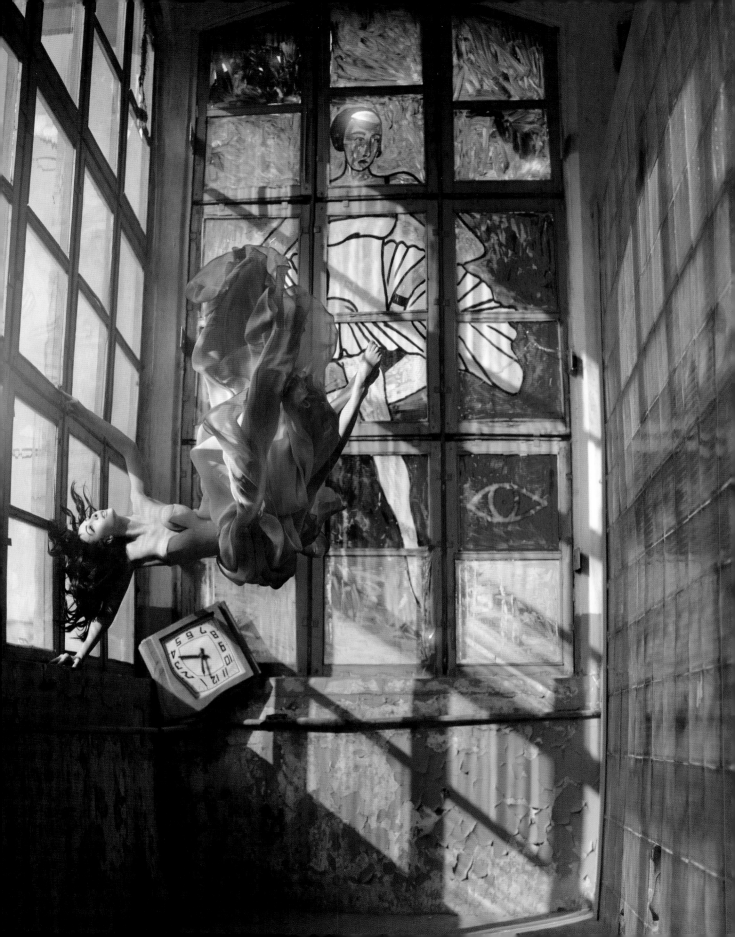

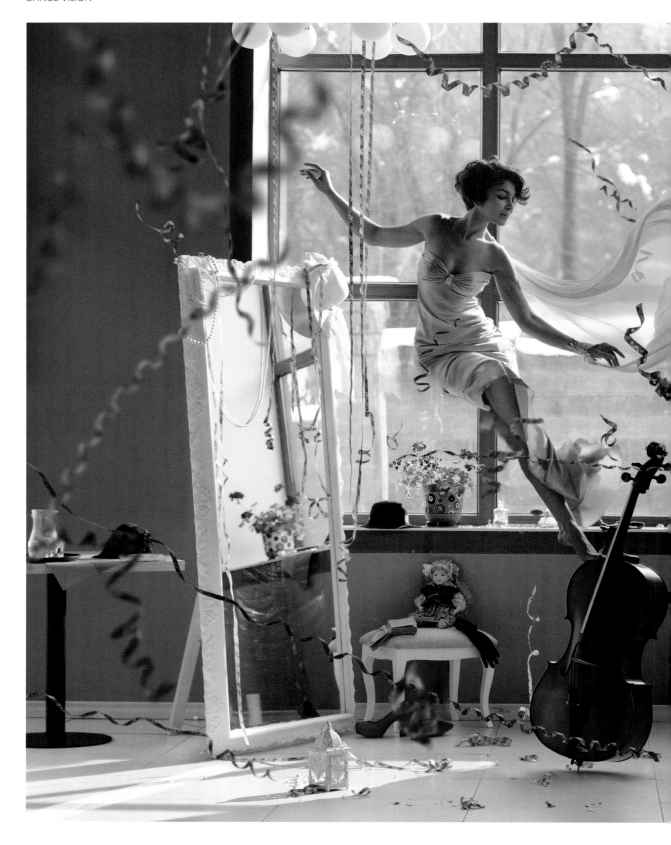

THIS SPREAD
Snowdrop

FOLLOWING SPREAD
12 chairs

What makes it possible for you to create the art you want to create in your life?
As with many people—the desire for self-fulfillment drives you to move forward and come up with new things.

What will you leave behind as your legacy?
If I manage to leave at least one good memory of myself in the memory of one person for a long time, it will already be a great legacy.

What attracts you to dancing bodies?
What attracts me to dancing bodies is movement. And I consider it a great success if I manage to capture it in a photograph.

When and why did you start incorporating dance into your work, and what do you feel dance brings to it?
It seems to me that almost any movement can be seen as a dance movement. And I've been trying to use movement in photography since the very beginning of my work with photo levitation. Without movement there would be no life within the frame.

Are there any works of art by other artists featuring dance that have inspired you?
I don't know where inspiration comes from. It comes suddenly and inexplicably.

What process do you go through to create your work? What inspires you?
To catch inspiration and start working, I just have to start working.

What might people be surprised to know about you (or your work)?
I'm just a human being, like everyone else. A human being is already an amazing creature in itself.

What question do you wish I had asked you?
Your questions were quite profound. I don't think anything needs to be added. Thank you.

THIS SPREAD
Atmosphere

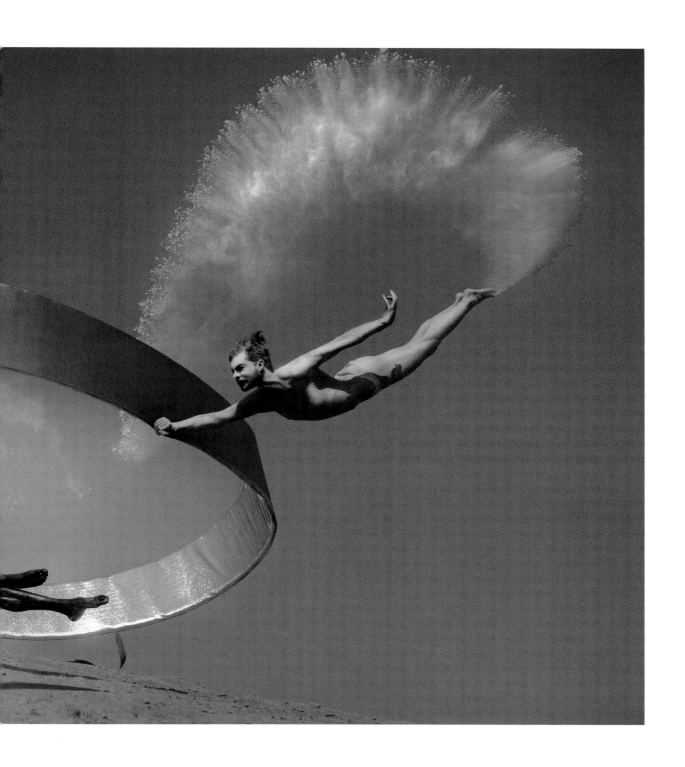

BAKI

Baki is a Korean photographer and visual artist. He danced as a soloist with the Korean National Ballet Company and was awarded numerous international prizes (by, for example, the New York International Ballet Competition). As a natural evolution of his internalization of dance, Baki began to interpret the human body and its gestures as a language capturing emotions and enabling visual communication.

As an artist, Baki sees himself as a mediator connecting corporeal language to a visual image. "For me," he explains, "photography is a connotative message. It is an expression of what I feel as I live my life through a new language."

His exhibitions include diverse artistic mediums that communicate emotive expressions to the viewer. Photographic images optically transcend poise and movement. Installations inviting viewer participation form representational bonds between invoked feelings and experienced imagery. The emotional intimacy of his work is personified in continuous collaborations with his wife, a talented painter, and other close associates.

His photos have been widely published, adorning the book cover of Bernard Weber's *Tree* (Russian edition) as well as the album cover of Lyfe Jennings's *Tree of Life* (Sony Music). His video and performance directing can be seen in the opening title of the Netflix TV series *Sweet Home*, Korea's Ministry of Health and Welfare's public service film for their anti-smoking campaign, and multiple videos of the Korean National Ballet Company's *Beyond the Stage* video series.

Website: a-apollon.com
Instagram: @1984baki

OPPOSITE PAGE	FOLLOWING SPREAD, LEFT	FOLLOWING SPREAD, RIGHT	PAGES 32–33
Shadow 2-0(skin)	**Shadow 2-7(2)**	**Shadow 2-7(1)**	**Shadow 2-1**
2014	2016	2016	2014

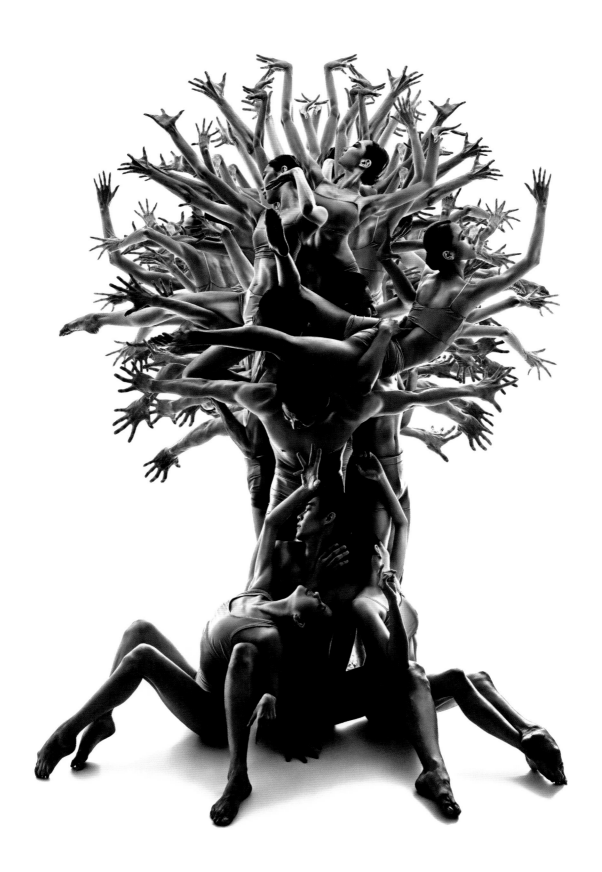

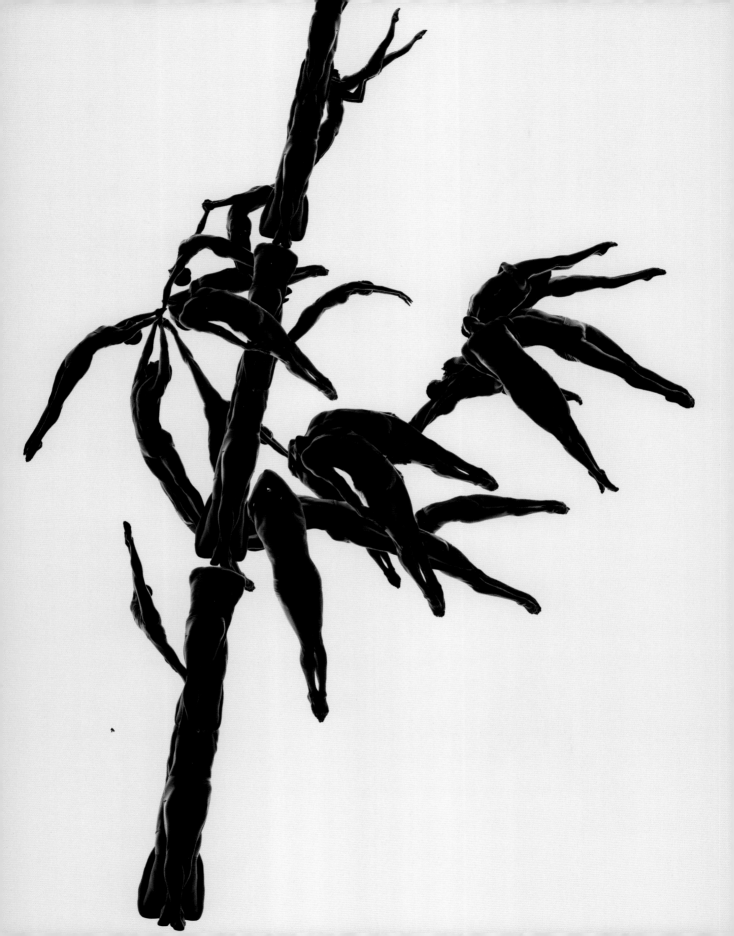

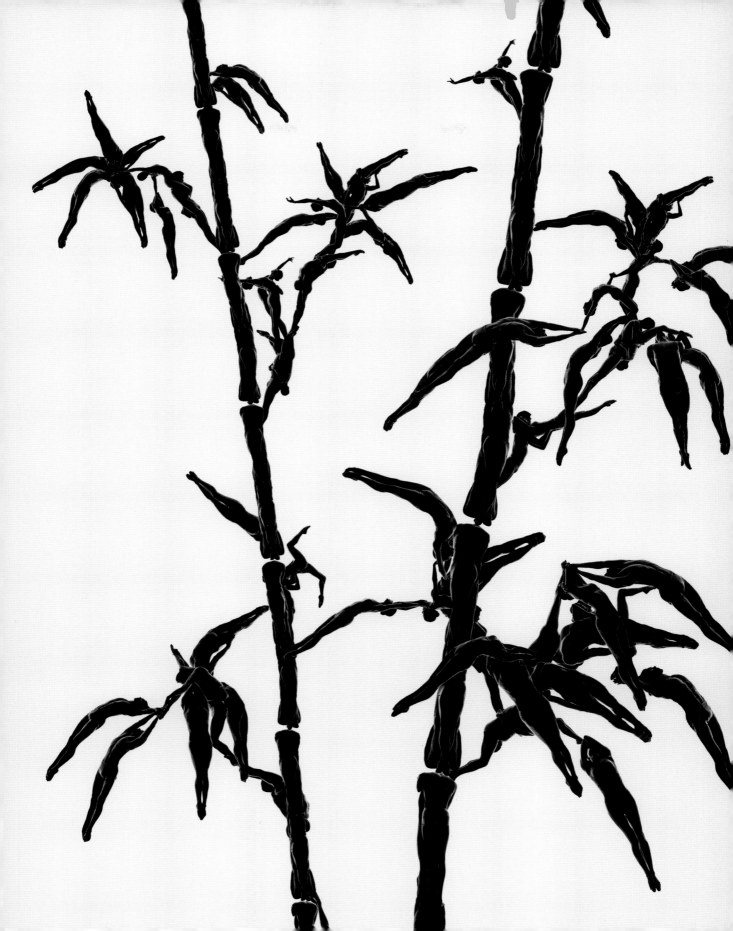

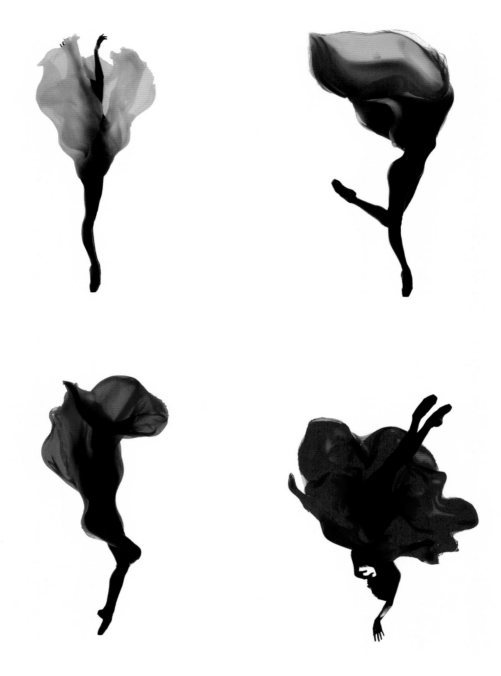

TOP LEFT
Shadow 1-1(9)
2019

TOP RIGHT
Shadow 1-1(11)
2019

BOTTOM LEFT
Shadow 1-1(8)
2019

BOTTOM RIGHT
Shadow 1-1(7)
2019

34

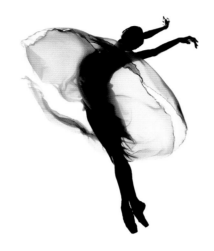

TOP LEFT
Shadow 1–1(01)
2015

TOP RIGHT
Shadow 1–1(06)
2015

BOTTOM LEFT
Shadow 1–1(05)
2015

BOTTOM RIGHT
Shadow 1–1(04)
2015

What makes it possible for you to create the art you want to create in your life?

My emotion is the key to creat[ing] art: My emotion leads me to my own expression, which can tell what I feel in my life. As I live my life, my concern has been changing from my teenage [years] through my twenties and even now ([into] my thirties). I am still me, but my life and concerns have changed so many times as well as my atmosphere.

What will you leave behind as your legacy?

My works. They represent my feelings and life[time].

What attracts you to dancing bodies?

Dance is a language: an abstract one.

It expresses what it is, but a lot of [the] time, it is vague to figure out what it is. However, when those vague expressions are expressed through various forms and energy, the audience receives them in a diversity of interpretations.

Thus, for me, "an expression of a body" means "communication with the viewers" and "a method of abstract conversation."

When and why did you start incorporating dance into your work, and what do you feel dance brings to it?

I used to be a ballerino. My life was closed to dance, and I wanted to make a new artwork through it. If the classical ballet is a work requiring honing the skills, I wanted to make my own story with those skillful bodies.

[My] Shadow series was the first work for it. I didn't give the works direct titles (I just called them all "Shadow") because I wanted to see how the viewers feel about [them]. When I had an exhibition, I put a post mailbox in the gallery and asked people to write a postcard about what they feel towards my works. People shared their own stories about my works.

This is how I communicate with them, and this kind of work is what I want to make the most.

Are there any works of art by other artists featuring dance that have inspired you?

I preferred fashion photographers rather than dance-related photographers. My favorites are Nick Knight and Tim Walker.

What process do you go through to create your work? What inspires you?

Most of my works express what I feel: The feelings coming from my present life and emotions. From there, I make a story and share it with people around me, especially my wife. My wife Gia Lee, also an artist, a painter, helps me most to draw forth the stories of those feelings.

What might people be surprised to know about you (or your work)?

People [are interested in] my past story that once I was a ballerino. It's because I was a prospect soloist at the Korean National Ballet Company and also won several prizes at competitions overseas. People love this story of my past and finally get to understand how and why I make these kinds of artworks.

What question do you wish I had asked you?

Why are you so enthusiastic to work in several different fields, including not only your own exhibitions, but also art directing, including choreography and TV series?

What is your answer to that question?

I want to be famous. I wonder how people [would] think about my works if I became famous, so more people get to know about my works.

OPPOSITE PAGE
Shadow 1-1(02)
2015

JULIEN BENHAMOU

Born in 1979, Julien Benhamou lives and works in Paris. At age twelve, he was offered a fully manual camera that would quickly become an exciting tool for him. He realized that photographing people allowed him to access a special relationship with them.

After his photography studies, he became the assistant to several photographers in the worlds of advertising, fashion, and contemporary art. He focused his personal research on movement and became a dance photographer. He relates his passion with dance to his artwork. Sensuality, nude bodies, movement, and gravity define his style.

He collaborates with the greatest dancers, including performers such as Marie-Agnes Gillot, Marie-Claude Pietragalla, Aurélie Dupont, and with choreographers such as Ohad Naharin, Benjamin Millepied, Carolyn Carlson, William Forsythe, Crystal Pite, Hofesh Schechter, and more.

Website: julienbenhamou.com
Instagram: @julienbenhamouphotographe

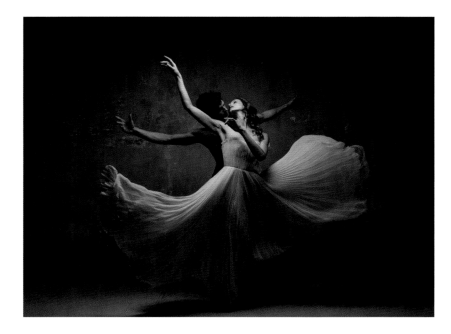

LEFT
Chloé Bernard and
Mickaël Lafon

OPPOSITE PAGE
Marie-Agnès Gillot, dancer
at Etoile à l'Opéra de Paris

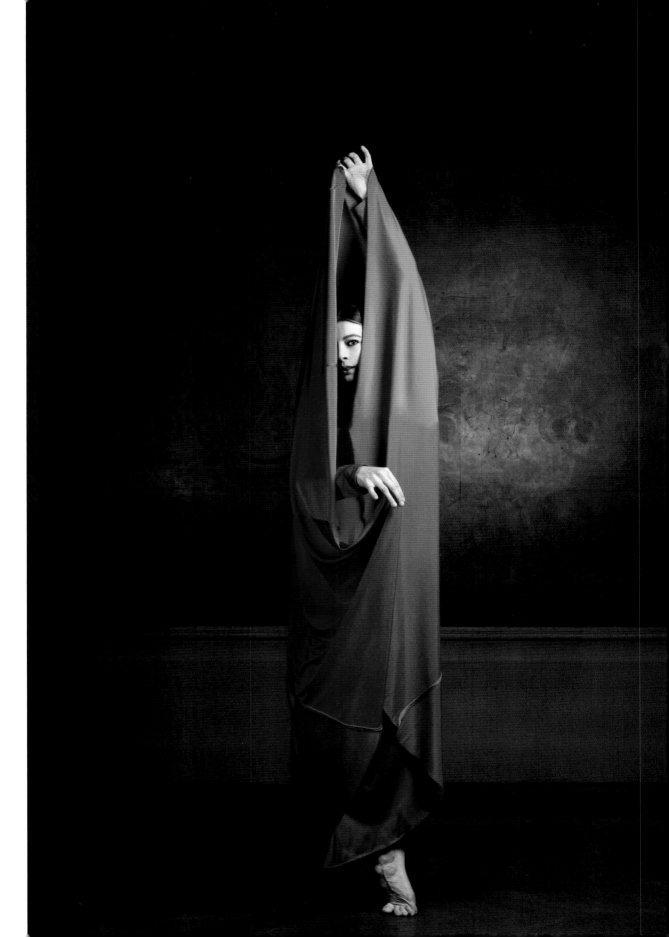

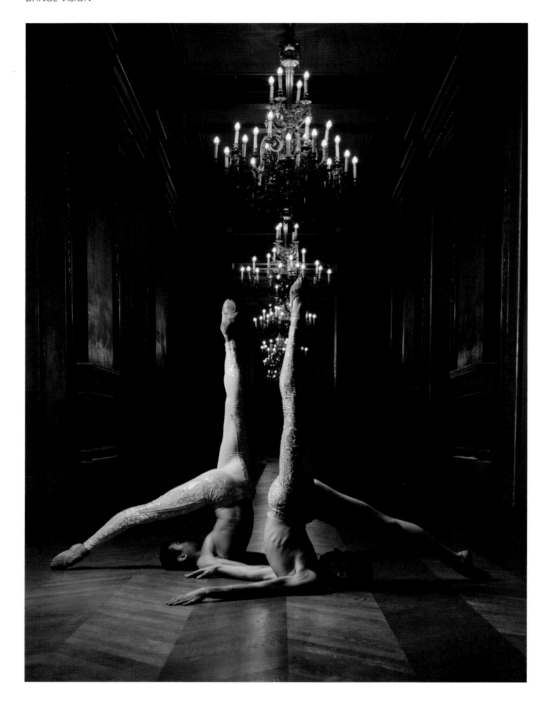

ABOVE
Renaissance
Sébastien Bertaud

OPPOSITE PAGE
Audric Bezard

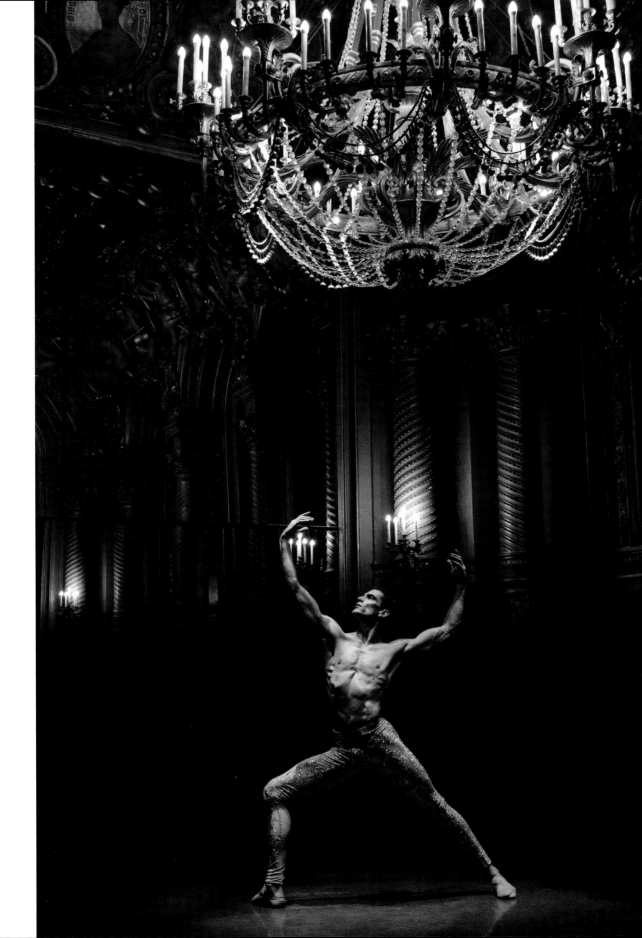

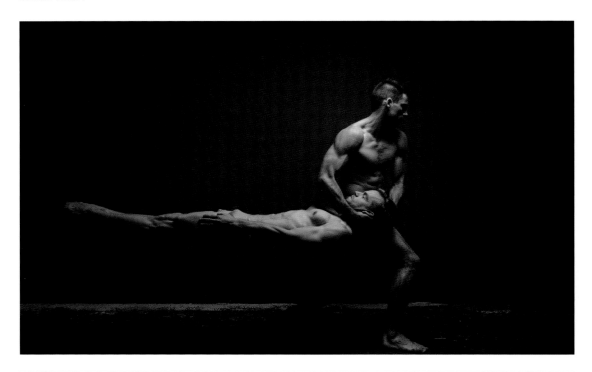

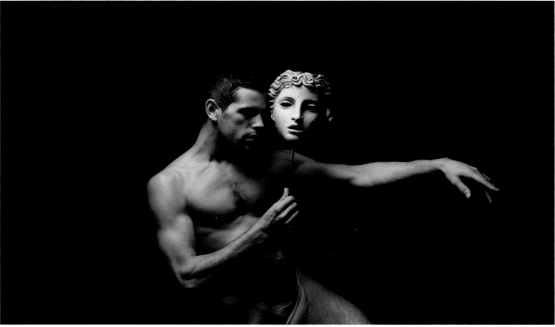

TOP
Julian and Vincent

BOTTOM
Valentin Chargy

OPPOSITE PAGE
Sean Carmon, Alvin Ailey

FOLLOWING SPREAD
**Morgan Lugo
and Juliano Nunes**

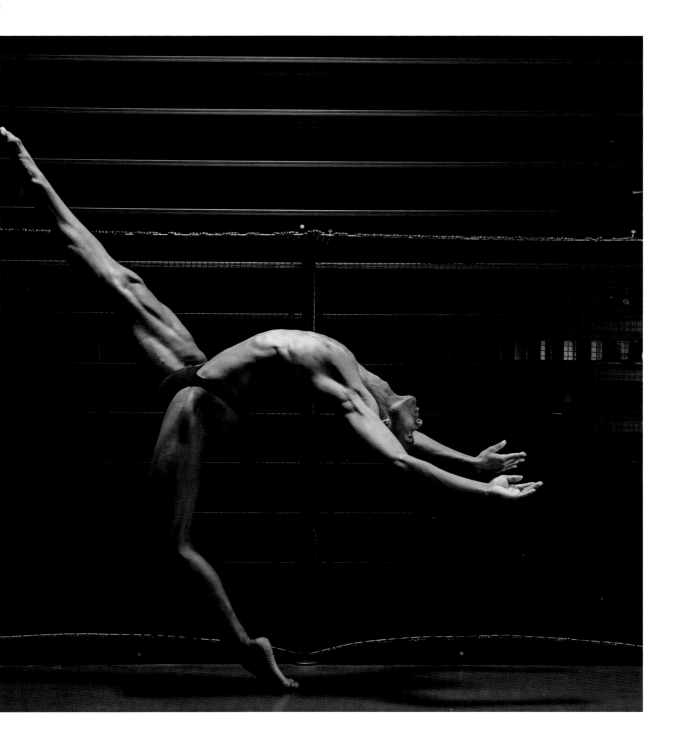

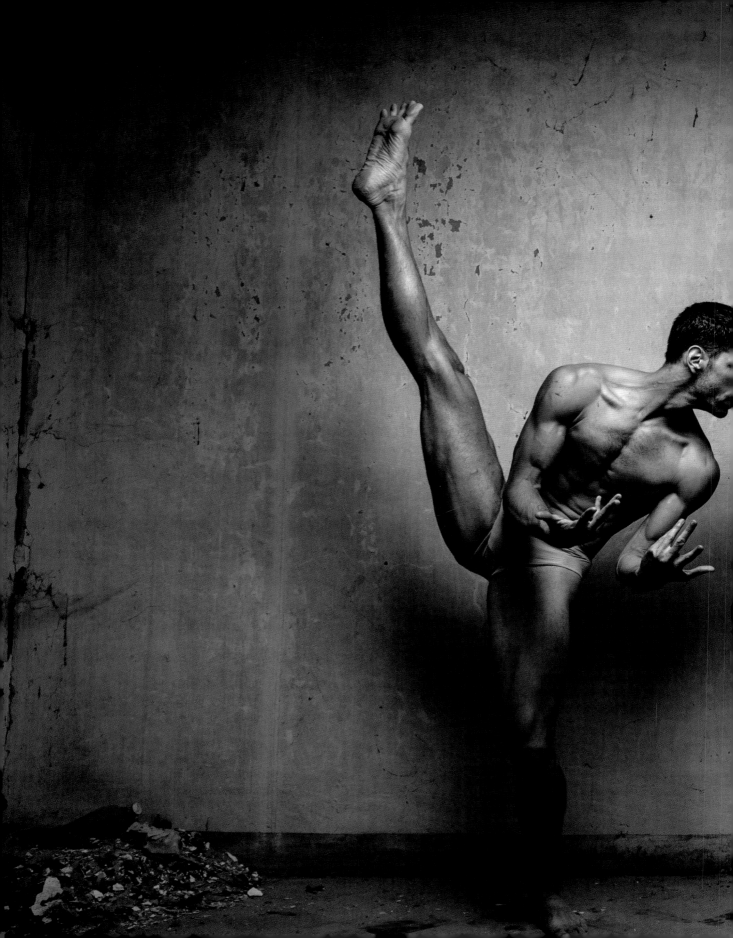

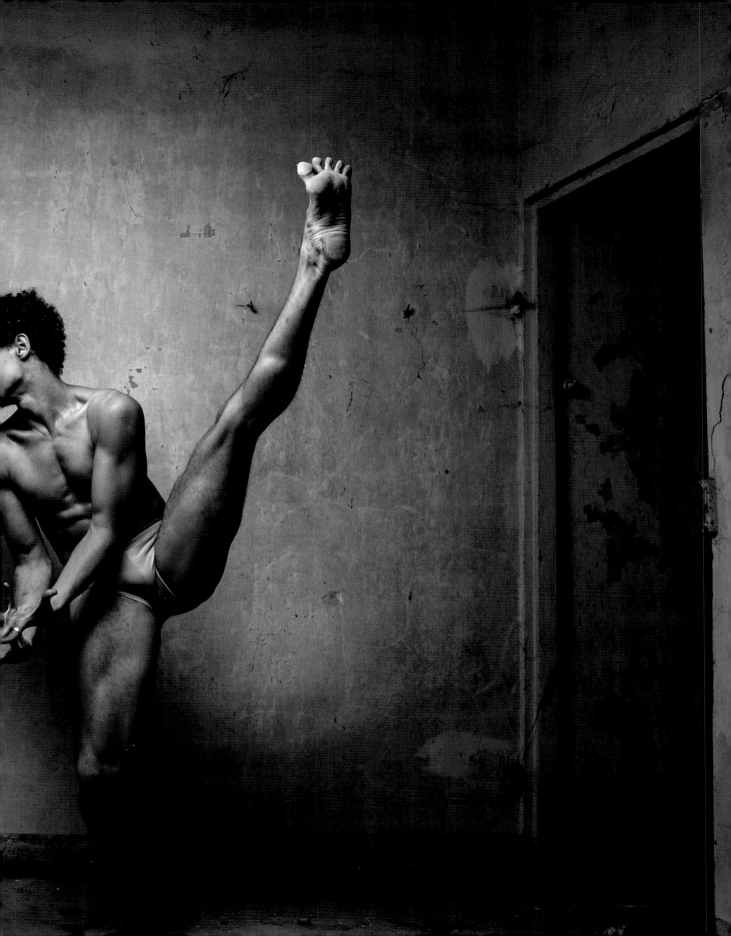

What makes it possible for you to create the art you want to create in your life?
The encounters

What will you leave behind as your legacy?
A little beautiful daughter

What attracts you to dancing bodies?
Their beauty is very moving for me. They remind me of statues I could see in art books when I was a child. They were the first erotic memories I had.

When and why did you start incorporating dance into your work, and what do you feel dance brings to it?
I first was a portraitist, but I was not satisfied as an artist. Collaborating with dancers reunited my two passions: dance and photography.

Are there any works of art by other artists featuring dance that have inspired you?
Herb Ritts and Annie Leibovitz inspired me.

What process do you go through to create your work? What inspires you?
It always starts with the model: I want to photograph someone, and I project my imagination. I'm looking for a concept, a location, a style, etc. Then I inform the model, and I ask him to be creative.

What might people be surprised to know about you (or your work)?
That photos are made in a very spontaneous way.

What question do you wish I had asked you?
Was being a photographer your dream?

What is your answer to that question?
I would answer yes.

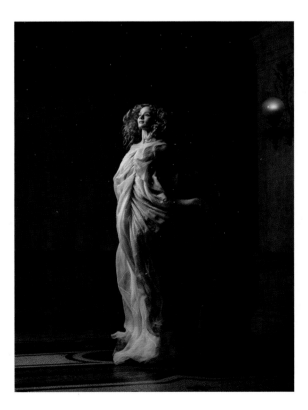

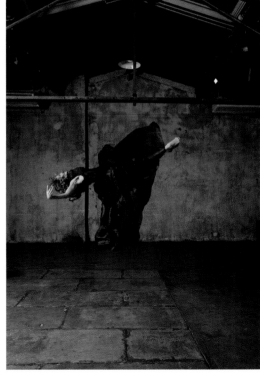

ABOVE

Léonore Baulac, dancer
at Etoile à l'Opéra de Paris

OPPOSITE PAGE

Dylan Jolly

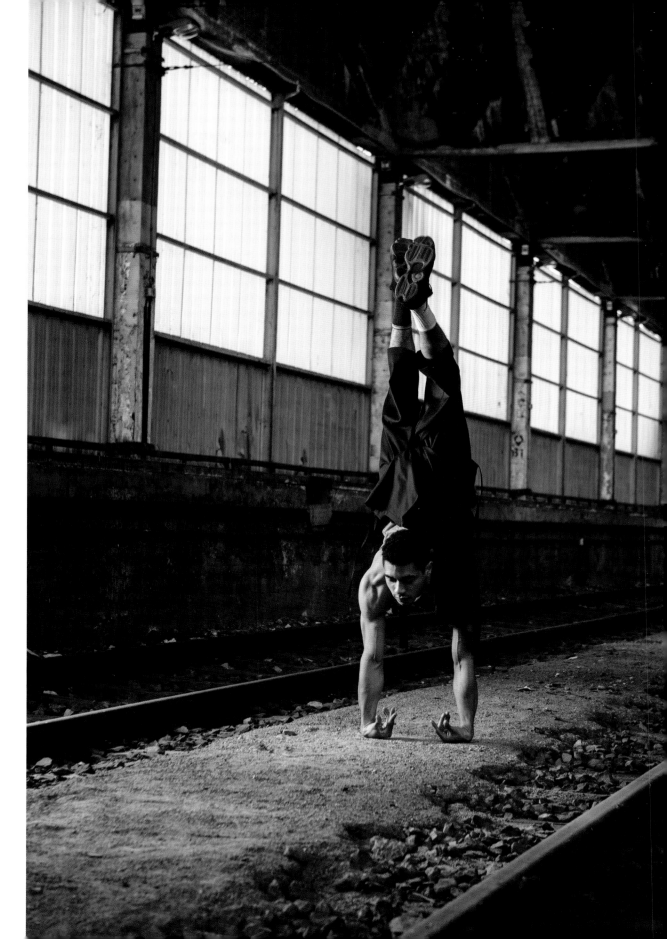

AXEL BRAND

I am a part-time photographer based in southern Germany, focusing on ballet/dance and fine art photography. I started out in travel and landscape photography until I moved into studio photography in early 2017. My style is minimalist, focused on the lines of the dancers, paired with elegance, dynamics, body tension, and relaxation.

In the meantime, I give workshops in different topics of studio photography for participants from all over Europe, mainly in ballet photography, but also in acrobatics, sports, and nude photography. My pictures have won many awards in international photo competitions (e.g., Trierenberg Super Circuit, Monochrome Awards, Spider Awards) and have been published in various international magazines and art exhibitions throughout Europe.

Website: axelbrandphotography.de
Instagram: @axl_brand

OPPOSITE PAGE
Dedication
Model: Katharina Merk

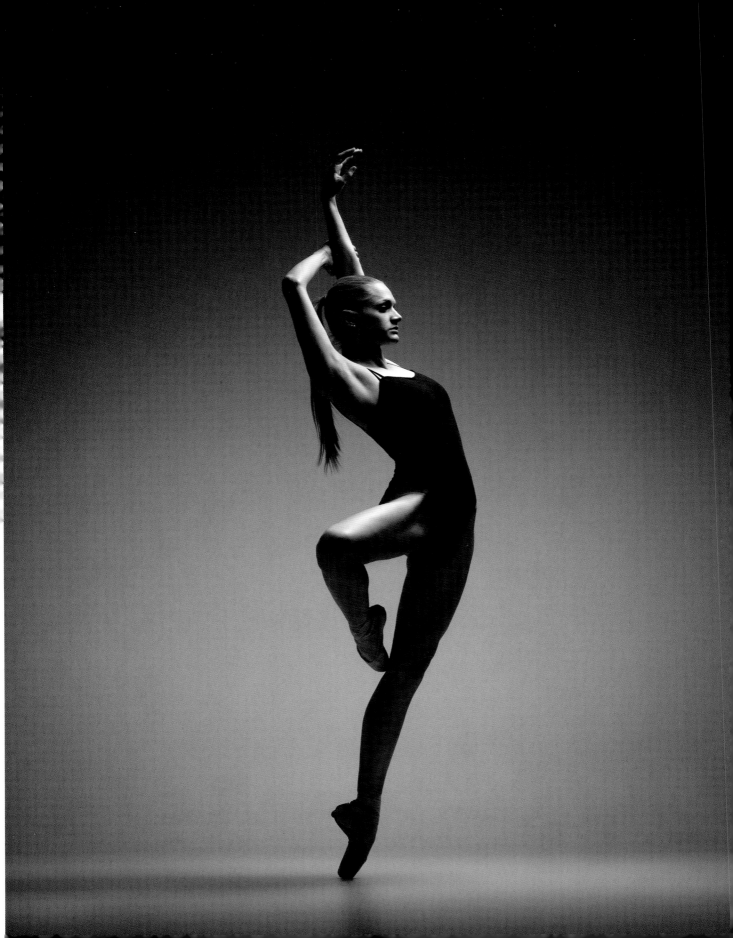

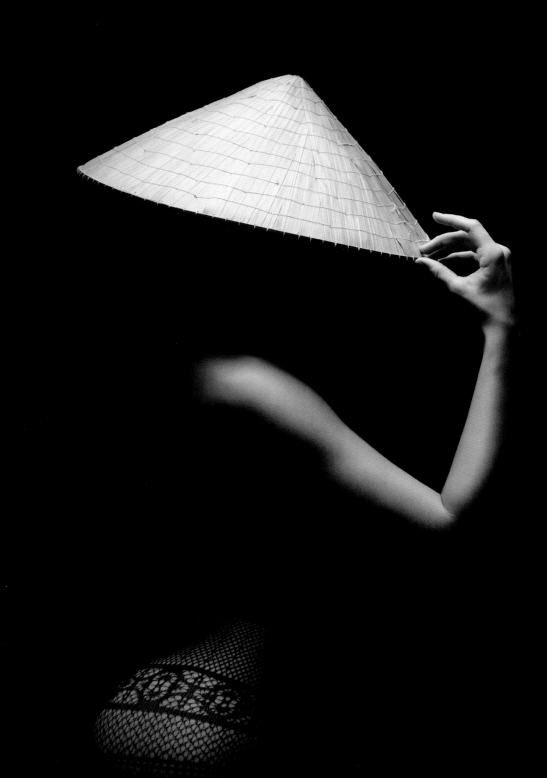

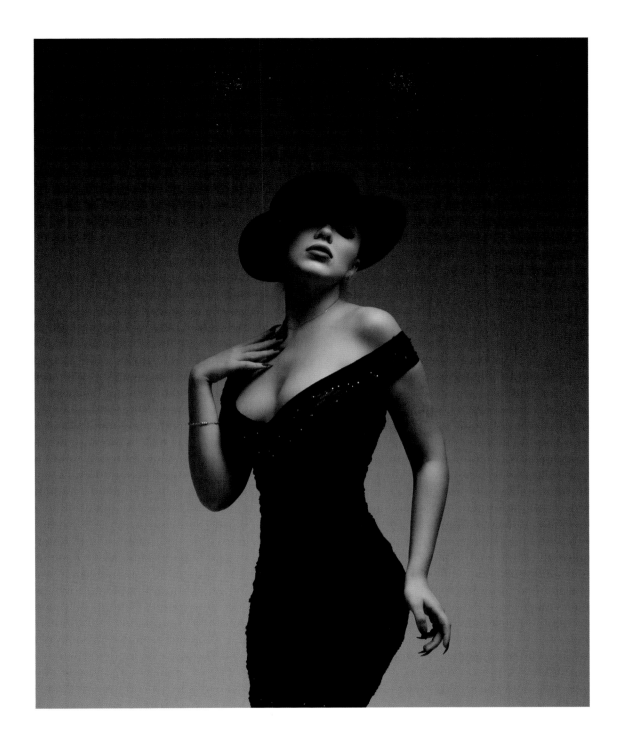

ABOVE
The Woman with the Hat
Model: Olga-Maria Veide

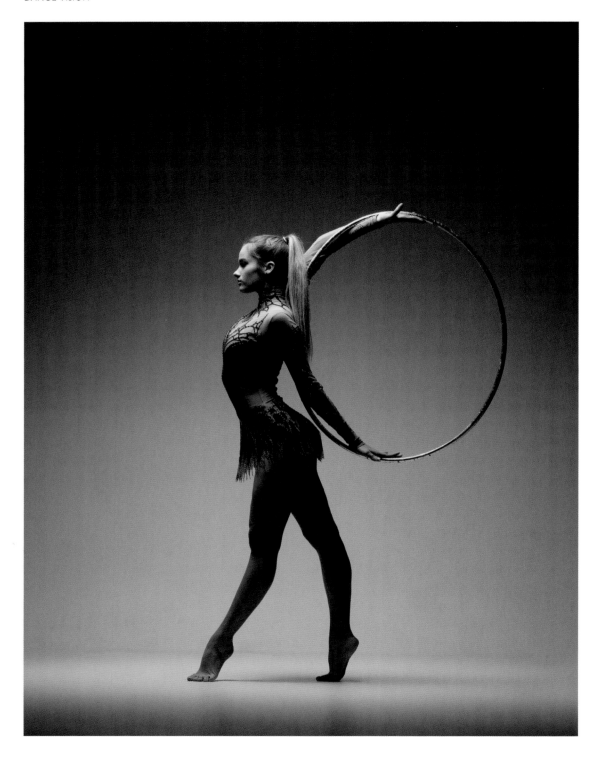

ABOVE
Rhythmic Gymnastics
Model: Stine Ehlert

OPPOSITE PAGE
Hoop
Model: Lexa-Lee

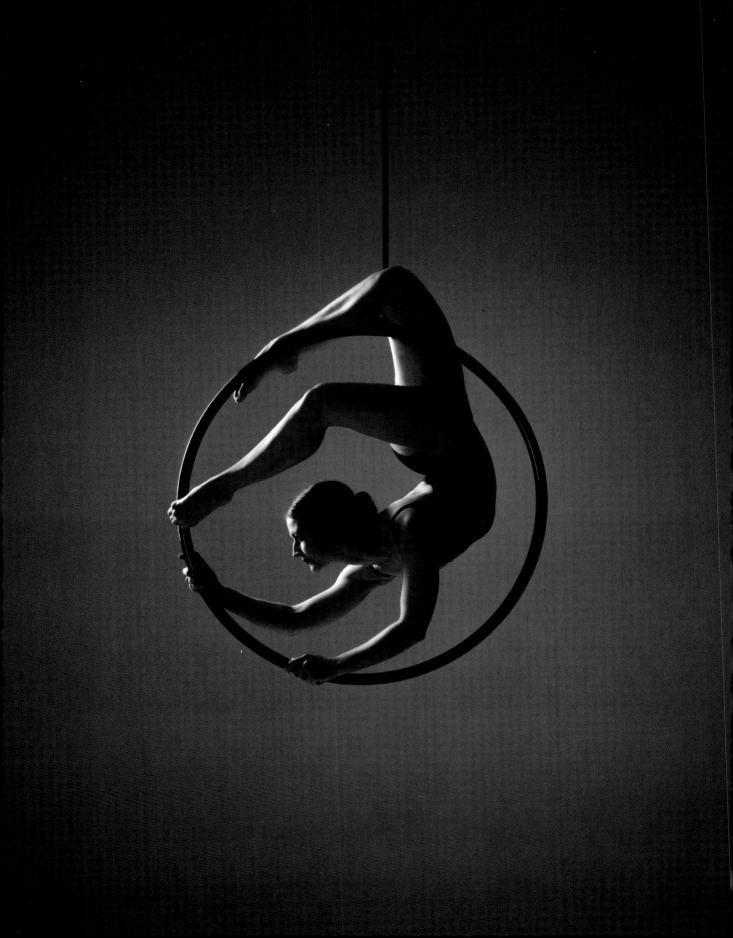

TOP
Triangle
Model: Lexa-Lee

BOTTOM
Graceful
Model: Katharina Merk

OPPOSITE PAGE
Elegance
Model: Jana Prendel

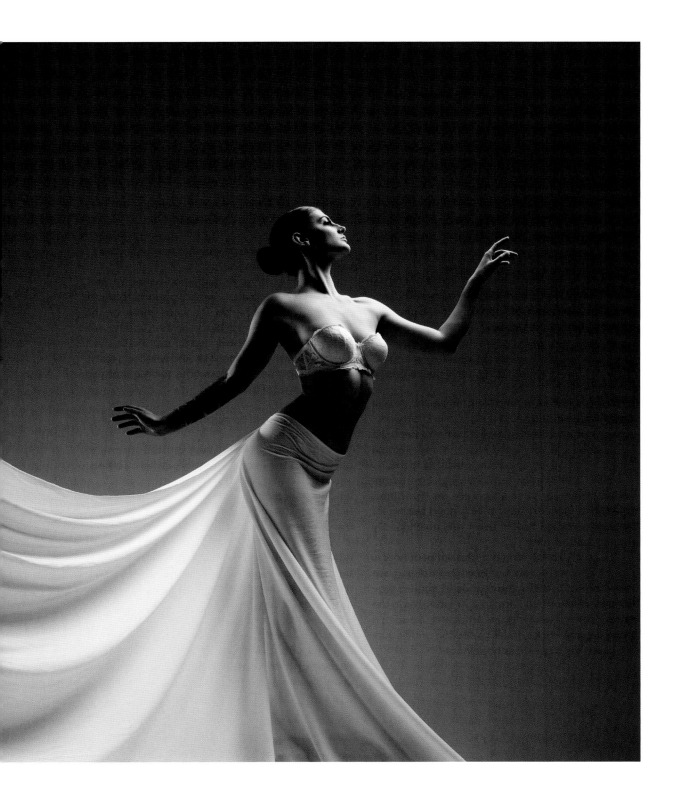

What makes it possible for you to create the art you want to create in your life?

For me, art is a word that I don't think applies to me. I take photos and edit them. The artists are the dancers or, generally speaking, the people in front of my camera. I only capture a moment.

What will you leave behind as your legacy?

I do hope that my legacy will be beautiful images that people will enjoy for a long time. For me, it's not about fame but rather about creating positive feelings in the viewers; when they look at the pictures, they want to look at the pictures again and again.

What attracts you to dancing bodies?

The body control of dancers is excellent, they express themselves very skillfully with body language. In doing so, body tension and expression produce beautiful aesthetics.

When and why did you start incorporating dance into your work, and what do you feel dance brings to it?

I did a shoot with Katharina Merk for the first time in 2018. She is a ballerina, and I had so much fun working with her and creating ballet pictures, because the pictures are very aesthetic and every single picture is something special, captivating to me.

Ballet and dance photography captivates me, as I place a lot of emphasis on light/lines. Professional dancers have a very good feeling for the body and know how to use it very aesthetically and with perfect form.

The path to becoming a professional dancer is a lot of hard work. Years of intensive training are necessary to present the figures in such a way that they are aesthetic and trigger emotions in the viewer. For me, ballet triggers emotions, like such a strong joy when I look at this perfection and beauty that I even cry from sheer happiness.

Are there any works of art by other artists featuring dance that have inspired you?

I like the pictures by Alexander Yakovlev and Carlos Quezada very much. The flour pictures series by Alexander Yakovlev radiates a lot of calm and elegance, but at the same time also a dynamism through the flour dust. Carlos Quezada creates beautiful pictures with his male-dancer project, which also appear very elegant but powerful. Elegance, dynamism, and calmness are also important to me in my pictures, as these attributes contribute a lot to the aesthetics.

What process do you go through to create your work? What inspires you?

I don't consciously go through processes anymore. The idea for the picture simply springs to mind. When I have a rest period, the ideas come. On the other hand, creativity is blocked when you have a lot to do. It's also a trial-and-error process to see if it works the way you want it to. And when you test it, new concepts emerge from time to time that you hadn't thought of before.

What might people be surprised to know about you (or your work)?

That's a good question! Very difficult for me to answer. This is a question best answered by others.

What question do you wish I had asked you?

Hahaha, instead of a question, I would rather use this opportunity for an acknowledgment:

Without my excellent models, most of whom have accompanied me on my photographic journey since the beginning, I (or rather we) would not be where we are at the moment. I know and appreciate it very much. Namely, Katharina Merk, Lexa-Lee, Marietta Fliegerbauer, Jana Prendel, Stine Ehlert, Daria Ivakhnenko. What would I be without you and your great achievements? A thousand thanks for that. I am very proud of you and our shared pictures! A big hug!

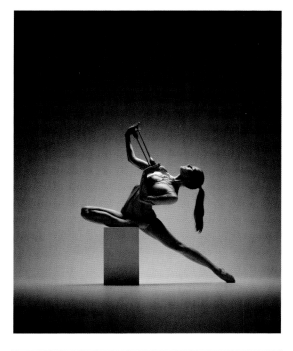

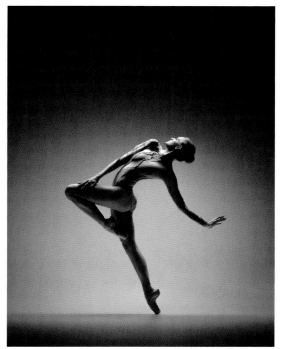

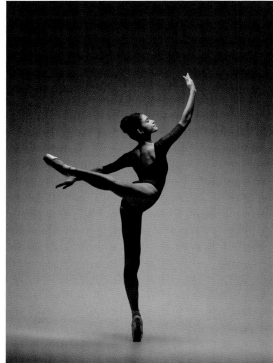

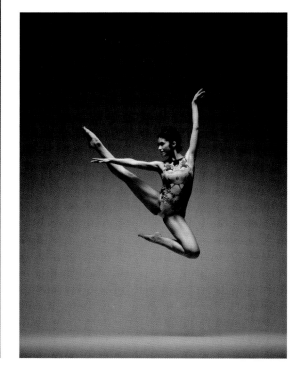

TOP LEFT
Clubs
Model: Daria Ivakhnenko

TOP RIGHT
Sophisticated
Model: Katharina Merk

BOTTOM LEFT
Attitude
Model: Marietta
Fliegerbauer

BOTTOM RIGHT
Jump and Smile
Model: Marietta
Fliegerbauer

BRENDAN FERNANDES

Brendan Fernandes (b. 1979, Nairobi, Kenya) is an internationally recognized Canadian artist working at the intersection of dance and visual arts. Brendan is currently based out of Chicago, and his projects address issues of race, queer culture, migration, protest, and other forms of collective movement. Brendan is always looking to create new spaces and new forms of agency. His projects take on hybrid forms: part ballet, part queer dance hall, part political protest . . . always rooted in collaboration and fostering solidarity.

Brendan is a graduate of the Whitney Independent Study Program (2007) and a recipient of a Robert Rauschenberg Fellowship (2014). In 2010, he was shortlisted for the Sobey Art Award, and is the recipient of a 2017 Canada Council New Chapters grant. His projects have been shown at the 2019 Whitney Biennial (New York); the Solomon R. Guggenheim Museum (New York); the Museum of Modern Art (New York); the Getty Museum (Los Angeles); the National Gallery of Canada (Ottawa); MAC (Montreal), among a great many others. He is currently an assistant professor at Northwestern University in the Department of Art Theory and Practice and is represented by Monique Meloche Gallery in Chicago. Recent and upcoming projects include performances and solo presentations at the Noguchi Museum (New York); Monique Meloche Gallery (Chicago); the Art Gallery of Ontario (Toronto); and the Museo de Arte, São Paulo (Brazil).

Website: brendanfernandes.ca

OPPOSITE PAGE
72 Seasons Brendan Fernandes September 01
Brendan Fernandes, 72 Seasons. Photographer, David C. Sampson. Costumes by Rad Hourani. Images courtesy of the artist and Monique Meloche Chicago, 2021.

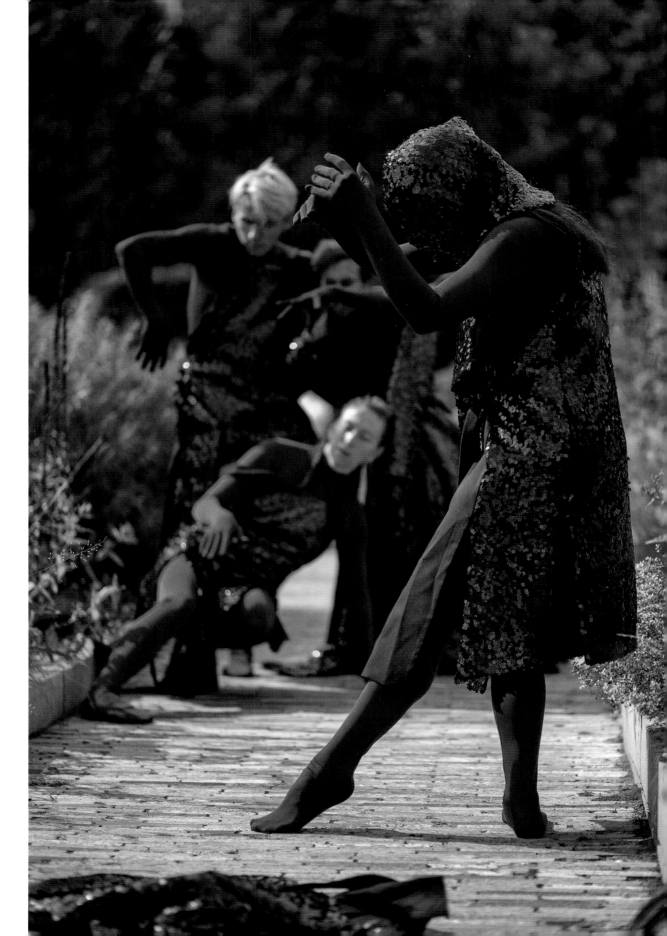

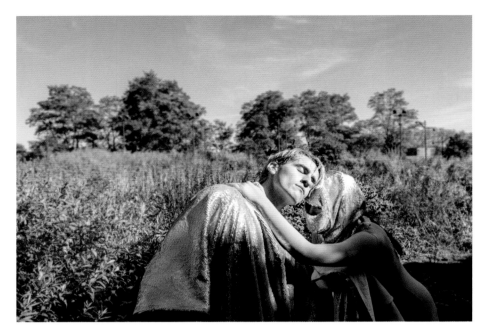

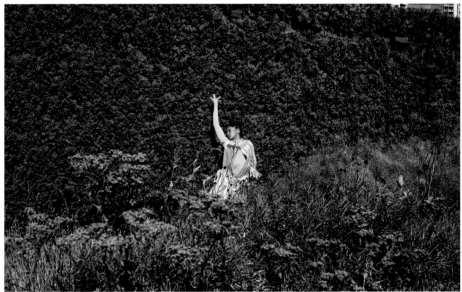

TOP
BF 72 Seasons October 05

BOTTOM
BF 72 Seasons October 02
72 Seasons Brendan Fernandes The Lurie Garden
Chicago, IL, October 23, Courtesy of the artist and
Monique Meloche Gallery, Chicago. Photo by Dabin Ahn.
Costumes by Rad Hourani, 2021.

OPPOSITE PAGE, TOP
Recess Brendan 497

OPPOSITE PAGE, BOTTOM
Recess Brendan 404
Brendan Fernandes, Hit Back, Recess, New York.
Performance / Installation: panels of sprung-flooring,
felt mats, clothes racks and clothes hangers, custom
costuming and choreography for 3 dancers. Performers:
John Alix, Khadija Griffith, and Oisin Monaghan. Uniforms
by the Rational Dress Society. Image courtesy of the artist
and Monique Meloche Gallery, Chicago, 2017.

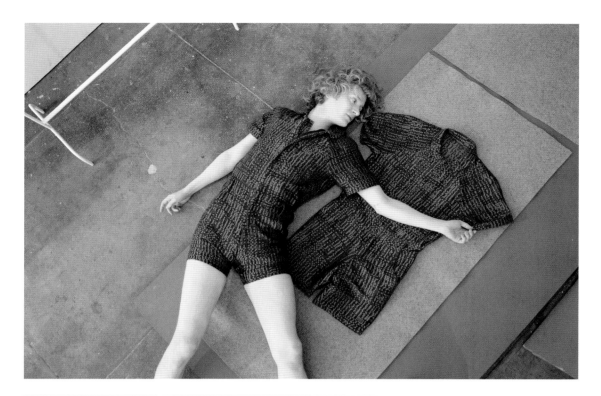

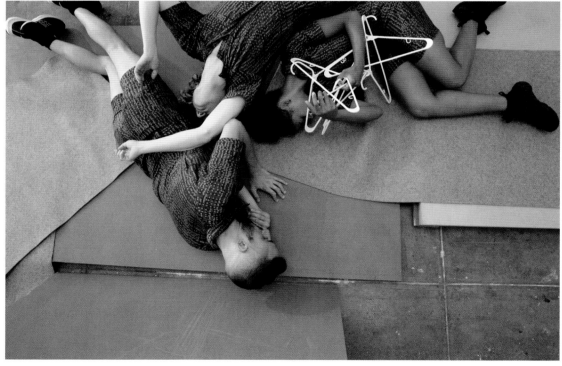

TOP
BF17–As One VIII

BOTTOM
BF17–As One I

OPPOSITE PAGE
BF17–As One II
Brendan Fernandes As One II,
Edition of 3, plus 2 AP Digital
print 34 × 48", 86 × 122 cm.
Courtesy of the artist and
Monique Meloche Gallery,
Chicago, 2017.

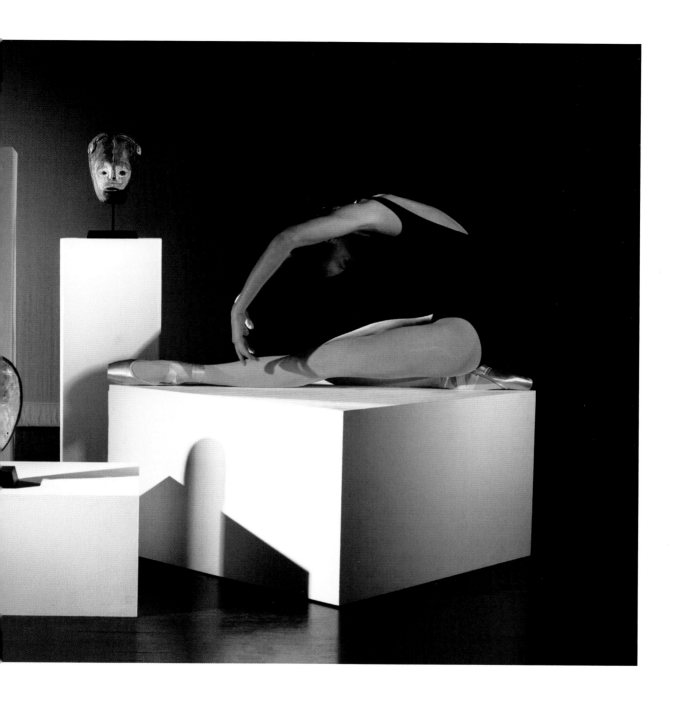

What makes it possible for you to create the art you want to create in your life?
I left dance and I realized dance was still something I wanted in my life. And I moved to New York and I did the Whitney program and then I started to think about dance again, and how I can challenge the preconceived world of ballet. And then I focused on art making.

What will you leave behind as your legacy?
That is a hard question. I do my work because of newness and purpose.

I think that it is important to see a body moving, in unison, together; that is a way of supporting and taking care of each other. You are not touching, you are feeling each other, and there is a certain sense of intimacy and vulnerability to that, especially in the corps de ballet, and I think that is amazing. I am telling myself, *No there are other ways to do it*, I am giving that agency to others and to myself, and that is something that is very important to me.

What attracts you to dancing bodies?
Dance, It's beautiful, effortless, such hard work. I am creating spaces for bodies to move together. I always found beauty in that relationship and community. I always found the subtle acts of fortitude so beautiful and rigorous. I admire the beauty, romanticism, and the rigor of the process of becoming a dancer.

When and why did you start incorporating dance into your work, and what do you feel dance brings to it?
Dance and the collaboration of visual art have always been the same to me. There is a synergy. It brings playfulness, cheekiness, expansion of people's minds to the possibility of seeing dance outside of the space/context of a concert stage.

Are there any works of art by other artists featuring dance that have inspired you?
I am definitely inspired by Simone Forti, *Huddle*, a Fluxus piece, of bodies in a huddle supporting each other, moving over the huddle; it is a beautiful [example] of being so caring and in touch with each other onstage.

I have seen videos and read about it, and I think Yvonne Rainer told me about it, and I always think about it all the time, and I try to share it; it made me feel validated in the way I make my work. Because it is so subtle and powerful. I think when we see dance, there is an expectation that we have to show great acts of fortitude. It makes me think of the spectacle. And Simone's piece is a subtle piece of bodies holding each other, and for me to be powerful, dance does not have to be big turns, jumps. Again, the body being in the space of major endurance, high kicks jumps.

This is a subtle piece of bodies holding each other, wavering, and then in that it becomes these moments of a body moving across a huddle. Based on a set of rules, hold each other, support each other, and then move across the body, a set of directives.

Yoko Ono's work makes me excited. Again, Fluxus, giving instruction. The dance score, how do we learn, archive, [provide] dance instruction? There is possibility. I am curious about the possibility.

What process do you go through to create your work? What inspires you?
I feel I am making a new way of thinking about dance by giving the dancers choices, [encouraging them to] support each other, creating agency. As a dance maker, I am collaborative and we make choices together. I am interested in a process that allows for choice and agency. My dancers always mention that there is "so much allowance" in the work. I am interested in the actual process.

I think for all of us to be more human, finding connections with other people, to show people that we are vulnerable, we need solidarity, holding each other; it is about a human relationship. My work is supporting this idea of let's be supportive of each other.

What might people be surprised to know about you (or your work)?
I think the structure, well, how is this choreographed, a set of rules, I think they want me to have a dance

Noguchi Dance Neige 06
Brendan Fernandes: "Contract and Release." Photo courtesy of the artist and Monique Meloche Gallery, Chicago. Photography: Neige, 2019.

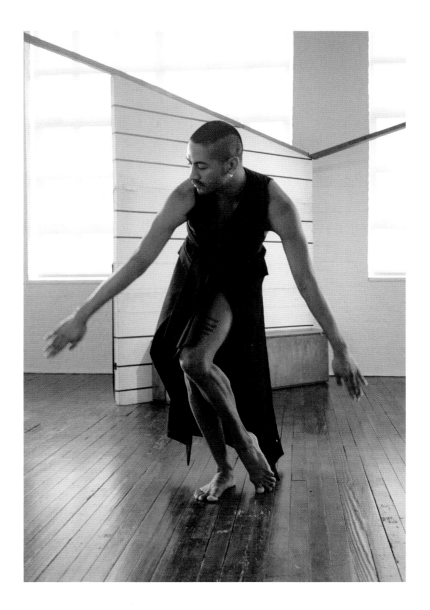

that is rhythmic, musical. How does this happen? I bring my dancers to interviews to give their voices expression and agencies; I want them to have a sense of process, and for them to talk about how they make things as well, and how they are doing in the piece.

In the six-month process of creating my work for the Whitney we checked in throughout the process, and that is unheard of. I asked [the dancers] how do you feel, et cetera. I want to know how they are feeling in the work.

What question do you wish I had asked you?
Well, maybe, what are my new ways of making dance using the camera? Or the telephone, a device that's a part of our life, how I can communicate with you?

What is your answer to that question?
I am thinking about my new ways of making dance using technology. Thinking of dance as a new form with technology.

MATI
GELMAN

Mati Gelman is a self-taught commercial and fine art photographer. Born in Hungary, he grew up in Israel, where he earned a bachelor's in biochemistry and a master's in chemistry before moving to New York City, where he discovered photography. Mati's images explore sexuality, queerness, and human integration with nature, sparking a sense of unease. Originally a chemist manipulating matter and molecules, Mati now manipulates pictures and pixels in exploration of context and meaning.

Website: matigelman.com
Instagram: @matigelman

OPPOSITE PAGE
Legion

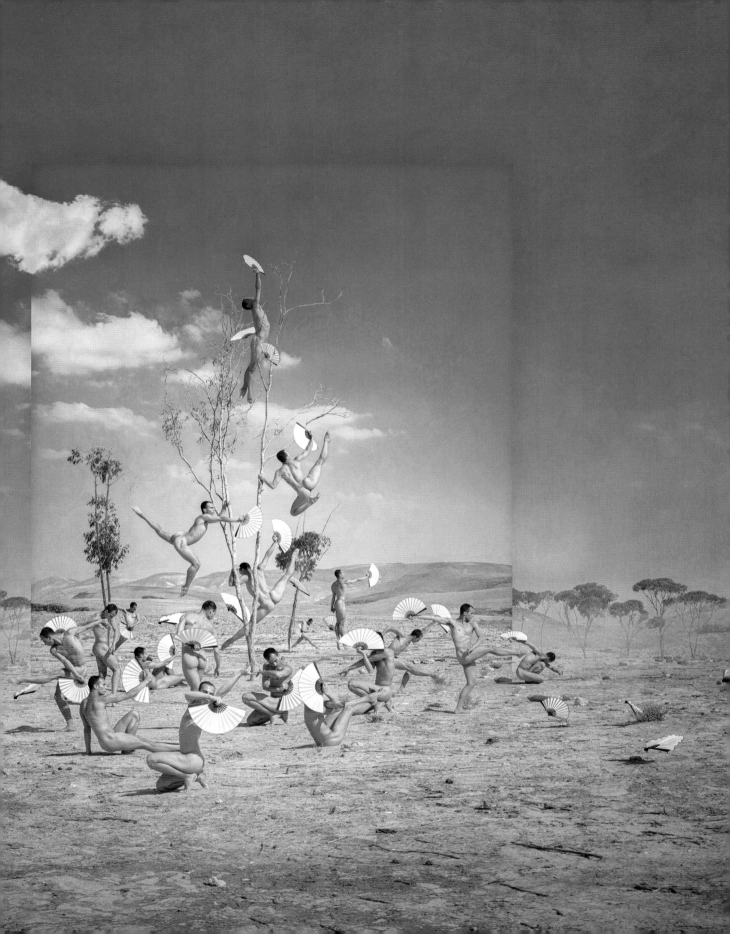

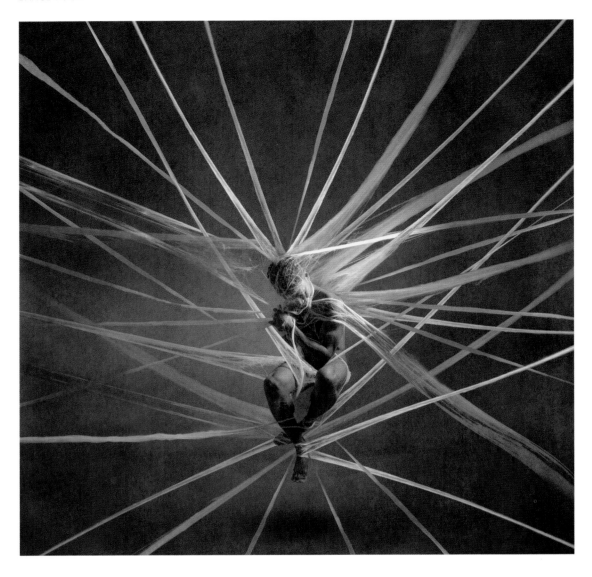

ABOVE
Entangled

OPPOSITE PAGE
Curtain Call

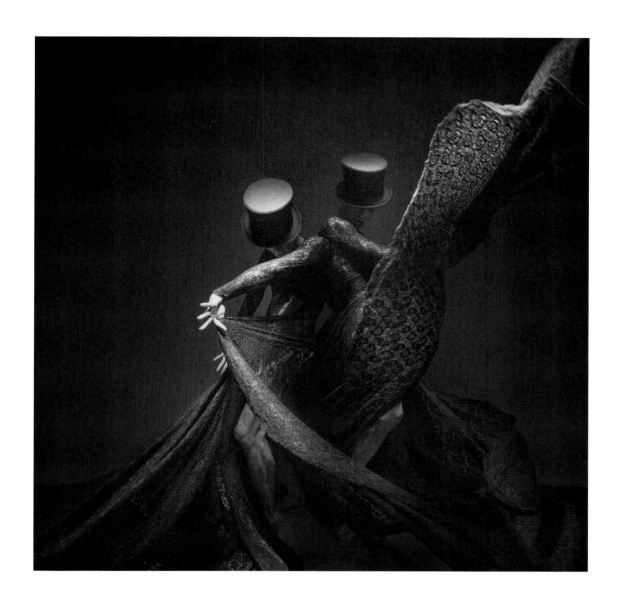

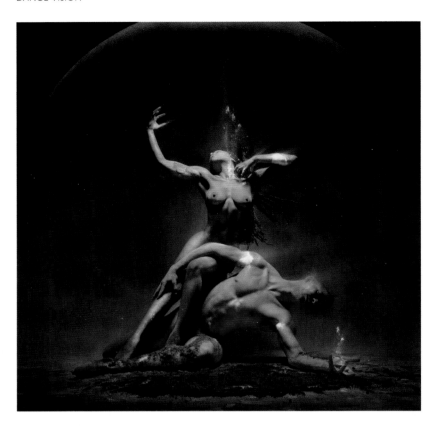

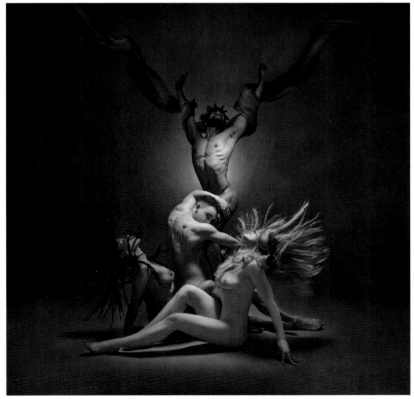

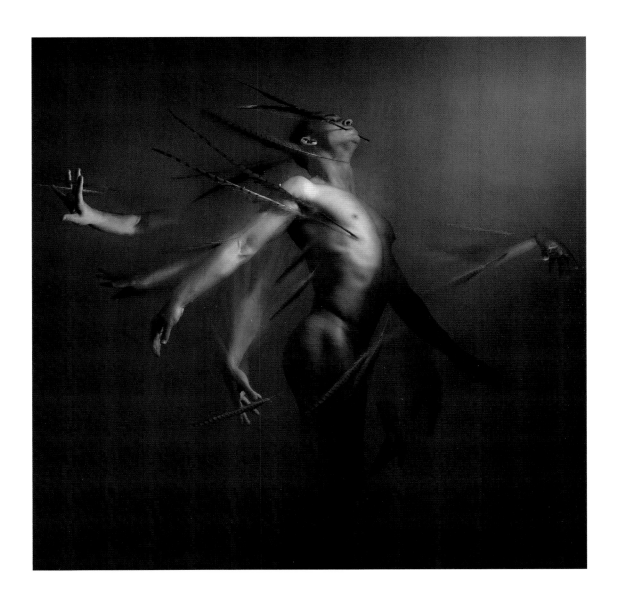

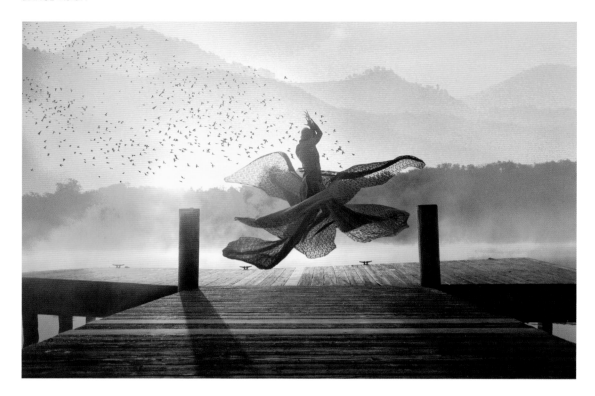

What makes it possible for you to create the art you want to create in your life?

This is a multifaceted question . . . Ultimately, it comes down to support. Once I figured out my finances, physical spaces to create in, and sources of inspiration, it came down to the people in my life who believed in me and supported what I do. Creating art is never a routine, it's an ever-changing, ever-evolving journey. As much as I need to be encouraged, pushed, and motivated, I also need to be discouraged, ignored, and criticized in order to keep creating. Each one of these elements is essential for my process.

What will you leave behind as your legacy?

I want to leave behind a sense of wonder mixed with unease. I want my legacy to be the triggering of disfluency in people's minds in order to snap them out of autopilot. I want them to see ability and possibility.

What attracts you to dancing bodies?

I always wanted to be a dancer. I dabbled in it, but multiple injuries due to my scoliosis and the condition of my spine prevented me from pursuing it further. I found a way to live this dream through the dancers and the bodies I work with. I see myself in them. My condition both helped me to understand my body better and to genuinely appreciate movement, ability, and dexterity.

When and why did you start incorporating dance into your work, and what do you feel dance brings to it?

Ever since I first picked up a camera, I gravitated towards my dancer friends. It was clear to me that they would be my subjects. I still didn't know what I was doing, but I did know who I was photographing. With time, it started becoming clear to me why I was photographing dance—it encapsulated my attraction to the natural world, which I see as fluid and ever changing. I am a chemist by education; it was always important to me to see the mechanisms of nature—how things tick. When we divide the study of nature into physics, chemistry, and biology, it all comes down to forces; there is an action and a reaction. Together, they create a dance, and with multiple forces and elements, complexity rises. The human body is an embodiment of these natural forces, which the mind, in turn, reflects and processes.

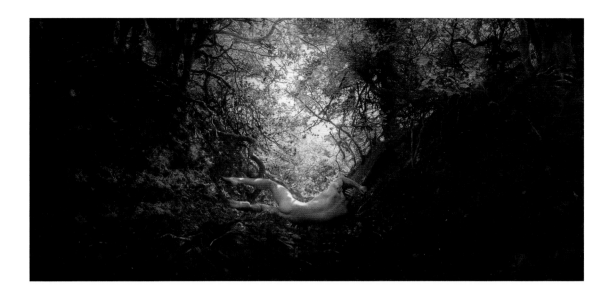

Are there any works of art by other artists featuring dance that have inspired you?

I love Rodney Smith's work. A friend introduced me to his photography awhile back and I absolutely fell in love with his use of the human form. I love when an artist uses dance or dancers in a nontraditional way. I think he did this beautifully and I draw inspiration from that.

What process do you go through to create your work? What inspires you?

So much inspires me. We live in a universe of possibility; inspiration can come from anything. My process generally involves a lot of planning since, most of the time, I am staging my photography. After figuring out the concept, the first decision I make is whether the image I want to create needs to be shot on location or in the studio. I often combine photos shot in multiple locations. The photographs are just the raw materials I use to create my images, so my true process starts on my computer when I start combining them. While I have the general composition drawn out before the photo shoot itself, some decisions I can only make in post-production, which can then, in turn, alter the composition. Sometimes I just work off of a feeling, and then the art almost creates itself.

What might people be surprised to know about you (or your work)?

My work reads rather cerebral. It pushes people to think about what they are seeing, or the story involved behind an image, so I believe some might assume me to be a rather serious person, when in fact, the opposite is true. I laughed at a joke in 2017. It was very funny.

What question do you wish I had asked you?

How does your background in science relate to your art?

What is your answer to that question?

My interest in science comes from the same place as my interest in art—the exploration and discovery of the self. I feel a constant urge to uncover mysteries and to show that all of us are, at our core, fundamentally the same. We all come from the same place and dance to the same rhythm.

In order to uncover a mystery, the mind has to accept it first. By accepting it, a cerebral shift is created, halting traditional thinking. This is the state of mind that can make a discovery; therefore, mysteries are essential to learning and evolving.

LOIS GREENFIELD

Lois Greenfield is from that seminal generation of female photographers of the 1970s who made their mark in the field of photography by creating a radically new vision.

Greenfield has created signature images for most of the contemporary dance companies around the world. Many of these photographs have appeared in her three bestselling books, published by Chronicle Books (US) and Thames & Hudson (UK): *Breaking Bounds*, 1992; *Airborne*, 1998; and *Lois Greenfield: Moving Still*, 2015. This latest book was accompanied by exhibitions in the United States, Russia, China, and Colombia.

Greenfield has created ads and campaigns for many clients, including Disney, Orangina, Proctor & Gamble, Pepsi, AT&T, Sony, Raymond Weil, and Rolex.

Since her first show at New York City's International Center of Photography (ICP) in 1992, her work has been exhibited in many galleries and in over fifty museums, including the Tel Aviv Art Museum, the Venice Biennale, the Musée de l'Elysée, and St. Peterburg's Erarta Museum of Contemporary Art. Greenfield's photographs have been archived in the New York Library for the Performing Arts, Harvard Art Museums, Walker Art Center, Cooper Hewitt (Smithsonian Design Museum), and Bibliothèque National de France, and other prestigious institutions.

From 2003 to 2007, Greenfield collaborated with the Australian Dance Theatre on *HELD*, a dance inspired by her photography. Shooting the live action onstage with the dancers, her images were projected as an integral part of the performance. This award-winning dance was performed around the world, from the Sydney Opera House to Sadler's Wells in London, the Joyce Theater in New York City to Théâtre de la Ville, Paris.

Greenfield was an artist in residence at NYU/Tisch in 2014. In 2015, she was honored with the Dance in Focus award given by the Film Society of Lincoln Center and the Dance Films Association and, in 2016, she received a lifetime achievement award from the McCallum Theatre Institute in recognition of her groundbreaking contributions to the field.

Website: loisgreenfield.com
Instagram: @loisgreenfield
Facebook: Lois Greenfield Photography
Email: greenfieldstudio@loisgreenfield.com

OPPOSITE PAGE
David Parsons, 1983
Photo © Lois Greenfield, 1983

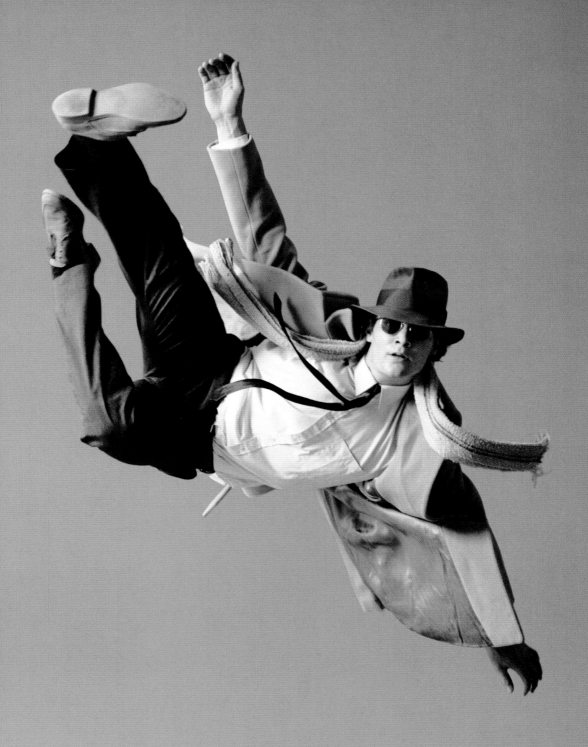

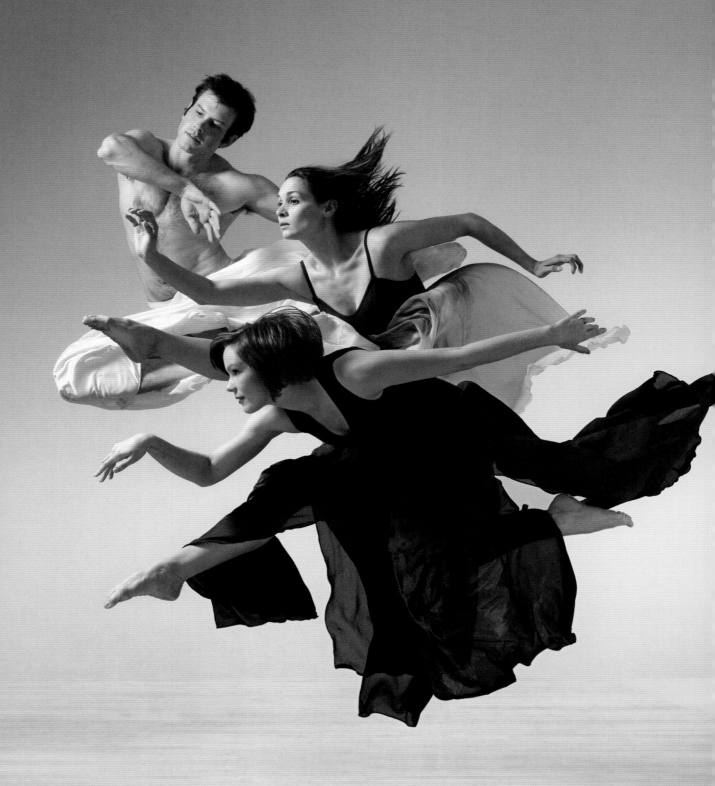

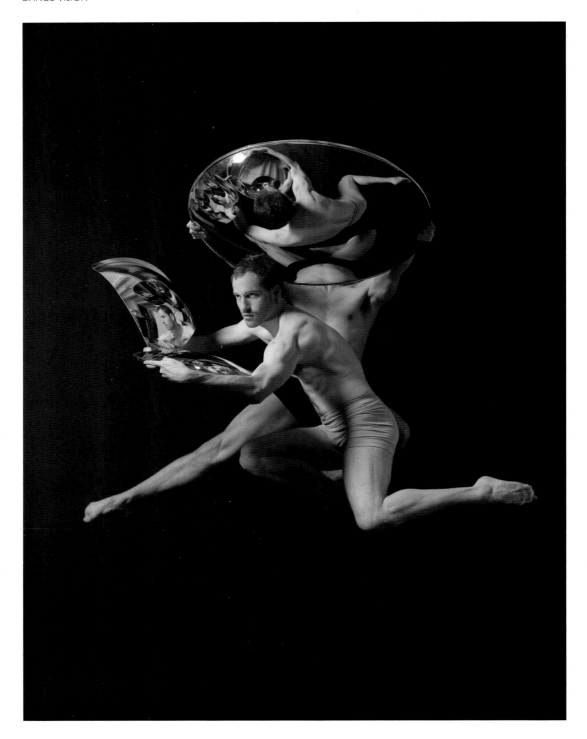

ABOVE
**Paul Zivkovich and
Craig Bary, 2007**
Photo © Lois Greenfield,
2007

OPPOSITE PAGE
Paul Zivkovich, 2014
Photo © Lois Greenfield,
2014

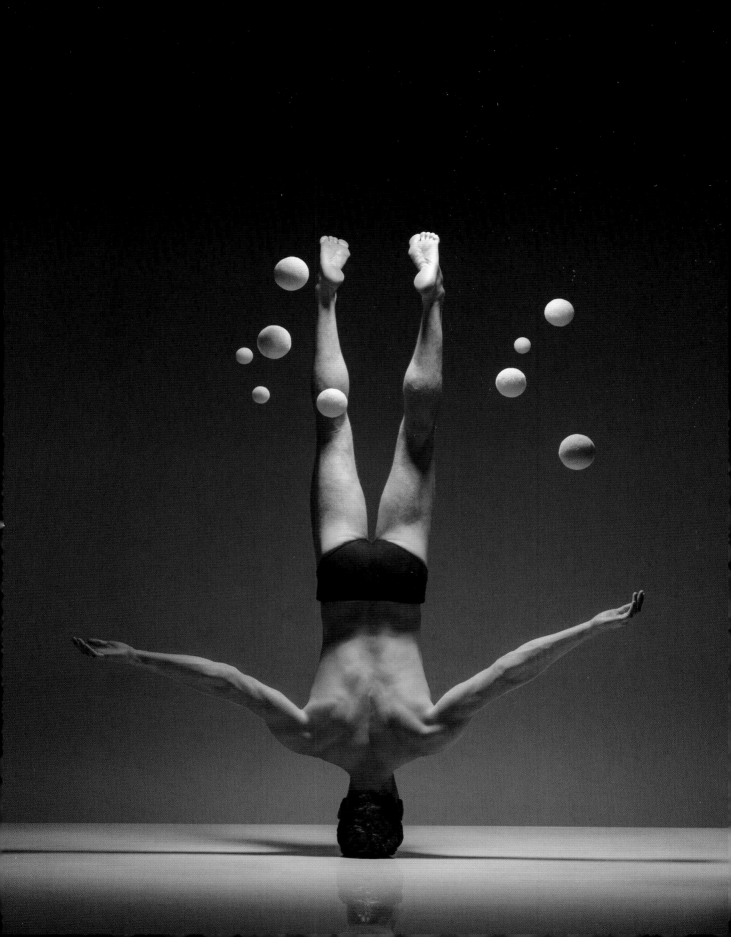

What makes it possible for you to create the art that you want to create in your life?

I started out as a photojournalist in the seventies, but on assignment I stumbled onto dance, shooting for the *Village Voice* from the mid-seventies to the mid-nineties. Working for newspapers and magazines, I developed an unusual method of photographing dancers performing improvised moments in my studio. I shot with a square-format camera, which was a rather counterintuitive way to photograph dancers. The results were startling, with the dancers often flying in and out of the square frame of my Hasselblad camera.

What will you leave behind as your legacy?

My legacy will be determined by the future, but one of the unique aspects to my work is that I ask the dancers to improvise for my camera, as opposed to performing choreographed positions. I am drawn to capturing split-second moments that are beneath the threshold of human perception: In this thin slice of time the dancer is either rising or falling, but always in motion.

Are there any works of art by other artists featuring dance that have inspired you?

When I was starting out, I was influenced by three well-known photographers who encouraged me along my path: Duane Michals, who is not a dance photographer, and Max Waldman and Barbara Morgan, who were. Duane is not interested in taking routine photos. Instead, he creates different series of hypothetical events that would not have existed had he not set them up.

Morgan, famous for her photos of Martha Graham, had an uncanny ability to dissect movement into its emotional anatomy. The dancers and actors in Max Waldman's photos always seemed to be pushing through a dense fog of the grain from his processed film.

What process do you go through to create your work? What inspires you?

I am inspired by photography's ability to stop time and reveal what the naked eye cannot see. I am interested in the spontaneous act of creating images without forethought. Unless I am on assignment for a commercial job or dance company, my approach is always improvisational. I never plan ahead. If I knew what the finished photo would look like, I would not bother to take the picture. My process allows me to go beyond my imagination.

I am also inspired by Baroque imagery, reflections in mirrors, mythology, angels, Bernini sculptures, and more.

What might people be surprised to know about you (or your work)?

I never studied photography. Growing up, I wanted to be an ethnographic filmmaker or a simultaneous translator at the United Nations.

What question do you wish I had asked you?

Have you ever stepped out of your studio to collaborate with other dance and photography-related projects?

What is your answer to that question?

I had two fabulous experiences stepping out of the box.

In the mid-nineties I was invited to do an installation at Le Printemps de Cahors festival. My photos were projected onto a thirty-foot-high water screen in the Lot River in France. Set against the night sky, the images seemed to magically appear then fade away. The propulsion of the water turned my crystal-sharp images back into ephemeral moments, making the live experience seem like a product of the imagination.

From 2003 to 2007 I collaborated with the Australian Dance Theatre on *HELD*, a dance based on my photography. I was onstage shooting the dancers, and my photos were projected instantaneously onstage, becoming part of the performance. We toured the production around the world—from the Sydney Opera House to Sadler's Wells in London, the Joyce Theater in New York City to the Théâtre de la Ville, Paris, and more.

OPPOSITE PAGE, TOP
STREB Extreme Action, 1996
Photo © Lois Greenfield, 1996

OPPOSITE PAGE, BOTTOM
Ashley Roland, 1997
Photo © Lois Greenfield, 1997

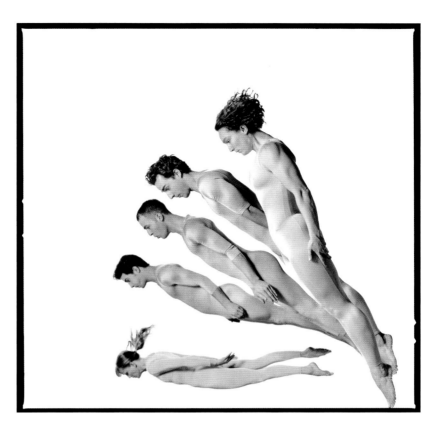

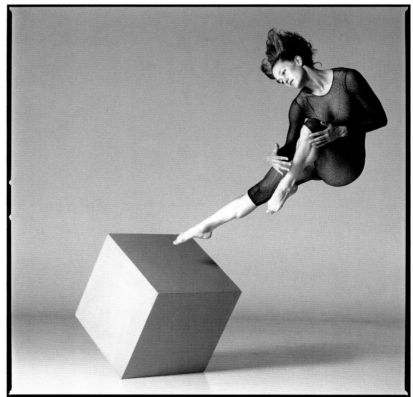

CAMILLA GREENWELL

Camilla Greenwell is a photographer and visual artist who works with numerous dancers and performers to create imagery that stems from an interest in people and the stories they tell, often occupying a space between reality and performance. She made her first short film in 2020, *In Search of Sanctuary*, a collaboration with James Cousins Company that documented four dancers and their experiences in lockdown. Camilla also had two solo exhibitions in 2021. The first, *Movement in Still Form*, was commissioned and produced by Sadler's Wells and is available on their digital stage. The second, *Of Stillness and Sight*, showed at Déda until April 2022.

Website: camillagreenwell.com
Instagram: @camillagreenwellphotography

OPPOSITE PAGE
Folu Odimayo and Will Thompson for Work in Progress by Harry Price
Photographed at Sadler's Wells, 2021

FOLLOWING SPREAD
Rhys Dennis, *In Search of Sanctuary*, collaboration with James Cousins Company
2020

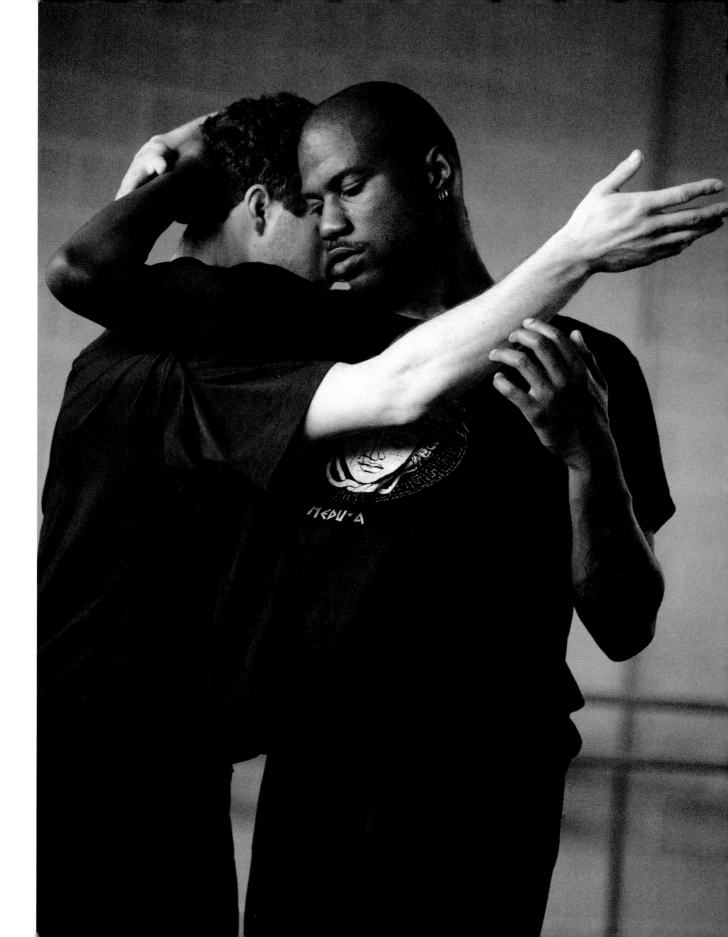

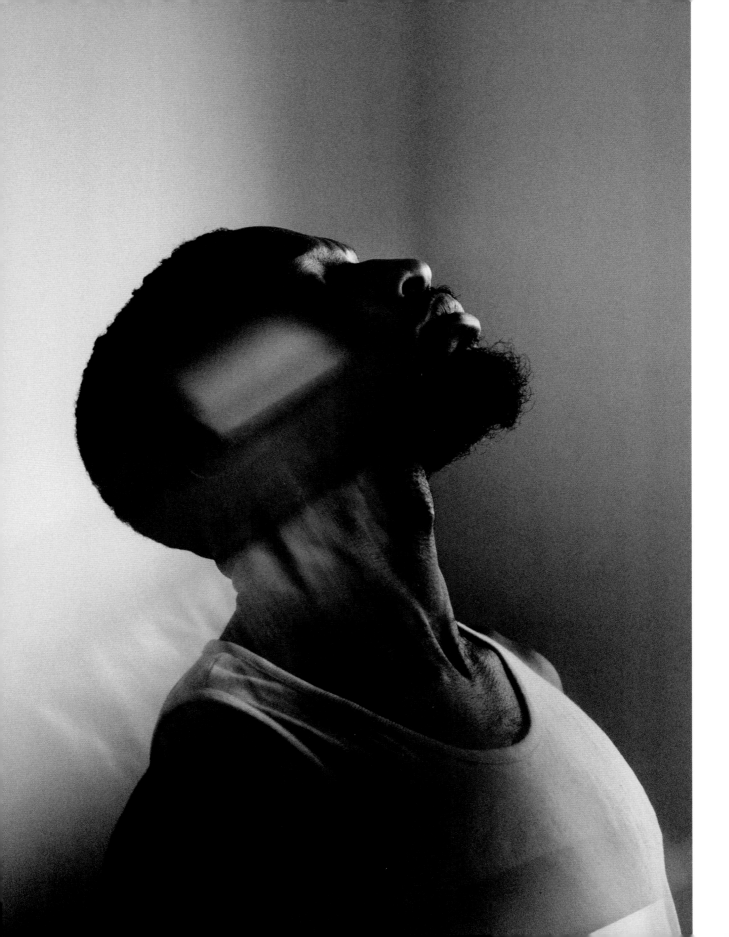

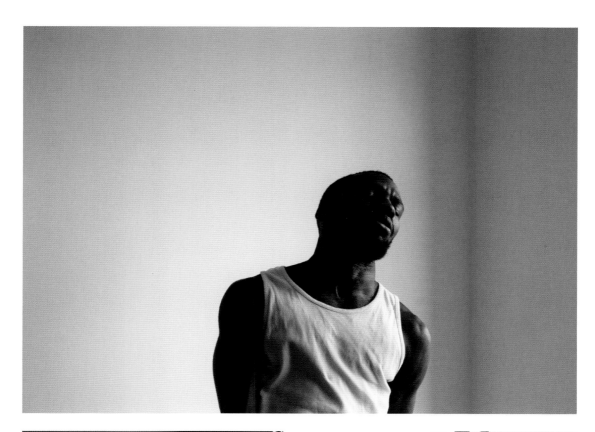

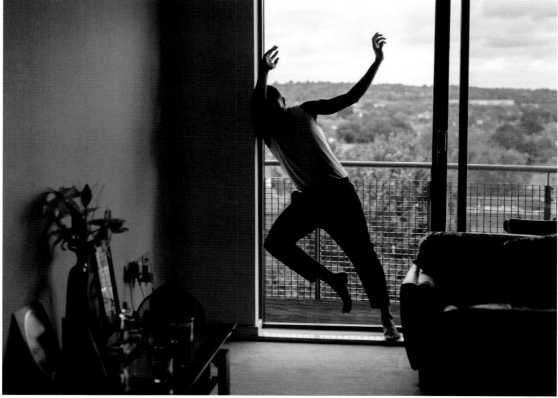

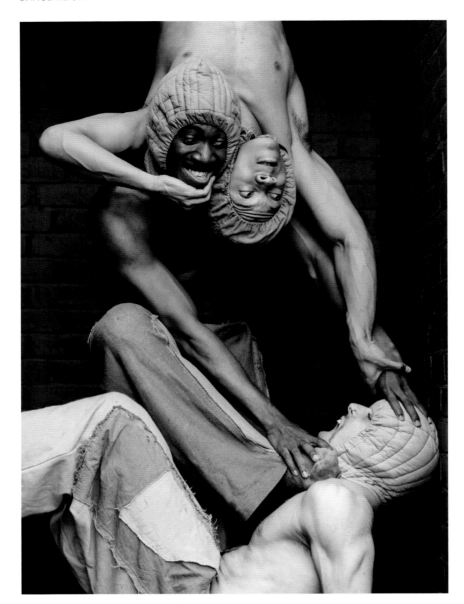

THIS SPREAD

Shangomola Edunjobi, Jordan Douglas, Ezra Owen, for Far From the Norm BLKDOG
2019

FOLLOWING SPREAD

Jemima Brown, *In Search of Sanctuary*, collaboration with James Cousins Company
2020

86

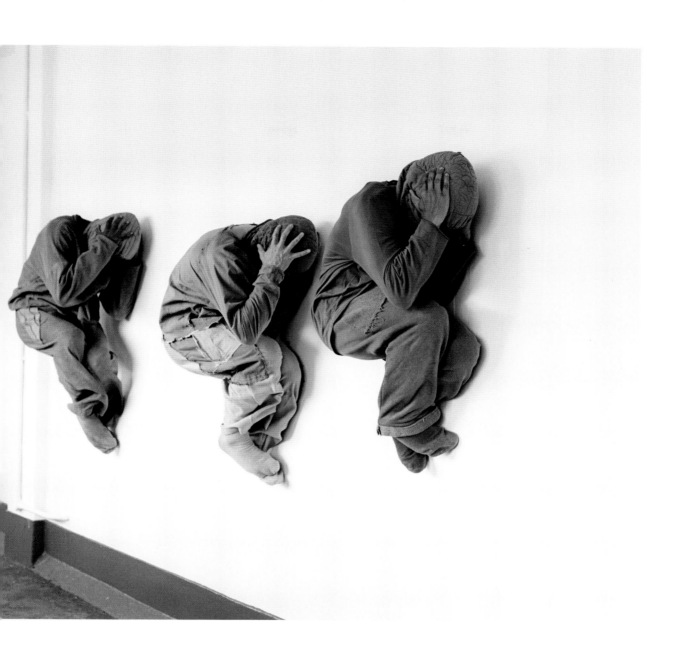

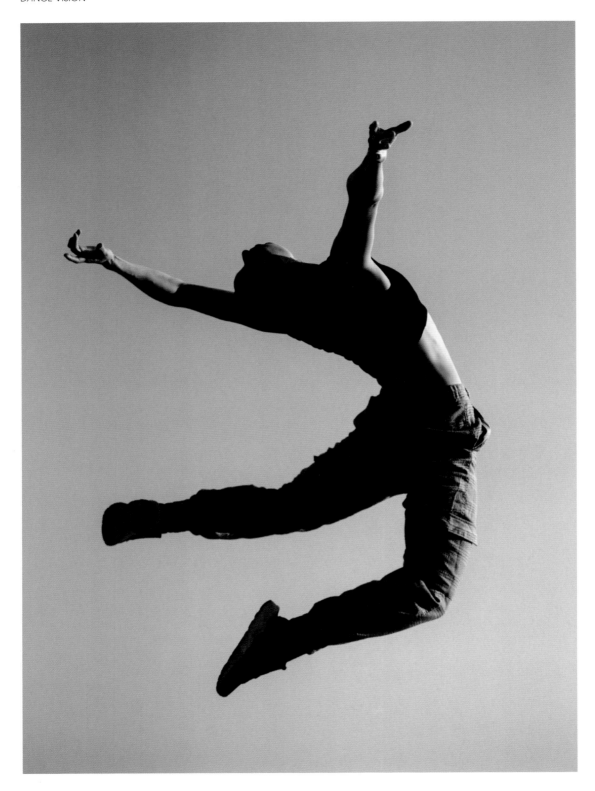

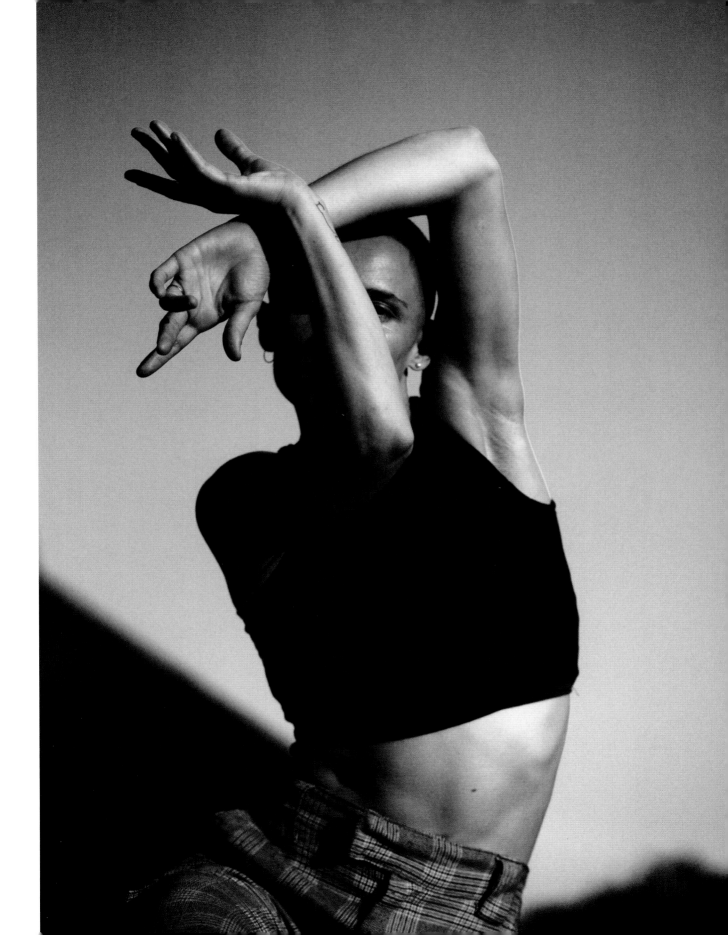

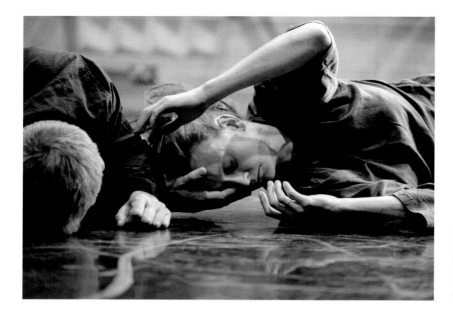

Charlie Morrissey &
Katye Coe for Wild
Card Katye Coe –
Preparation
Photographed at Sadler's
Wells, London, 2015

What makes it possible for you to create the art you want to create in your life?
The willingness of others to observe and encounter what it is I'm creating. And even more so, for them to be a central part of that work. When I studied fine art at university, I found it very difficult to create art by myself. I really struggled to find my voice at that time, and it took meeting various dance artists and working collaboratively that helped me come back to my own practice, years after I thought I had failed at being an artist.

What will you leave behind as your legacy?
Hopefully images that will still move people in years to come. And a record of some of the amazing work and people I have witnessed.

What attracts you to dancing bodies?
I think it's more the people that inhabit those bodies. I mean, obviously dancers' bodies can be exceptionally beautiful, but what draws me to work with them is the way they interact with people and with their environment. It's a very unique way of being. I think dancers are very collaborative by nature, and through that, I've really found my voice in a way I would never have done alone in my studio.

When and why did you start incorporating dance into your work? What do you feel dance brings to it?
I started freelancing as a photographer whilst I was at university; I had done a summer course at an acting school but felt very out of place as a performer. I ended up winning a competition to photograph one of their performances, and it was the first time I realized that there were other things you could do within the theater world that didn't mean you had to be onstage yourself. It was a revelation! I began by shooting theater performances but was asked to take some pictures of a couple of dance shows, too. I felt so out of my depth! My cameras were not great as I couldn't afford a full frame at that time, and I really didn't think I was very good. But people kept asking me back, and slowly working with dancers grew to be my predominant line of work.

During this time, I was still trying to make my own personal work but wasn't getting anywhere with it. It was only until I decided to restart a personal project, but with dance artists, that I suddenly realized there was a completely different way I could be making my own art, just not on my own. A lot of my personal work comes from quite difficult

Deborah Hay, for Nora invites Deborah Hay — Where Home Is
Photographed at Dance4, Nottingham, 2019

moments in my life, so it tended to be quite heavy, which is fine—but by collaborating and being able to bring others into this world I'm creating, it's actually helped the work develop past that sadness and into something more hopeful and playful, I think.

Working with choreographers and dancers to create imagery for their work also really informs my practice; it allows me to hear such varied stories, and being trusted to visualize them is a real privilege.

I do also make work solely about being in the moment with dancers and am really interested in capturing fleeting moments and working intuitively and in an improvisational way. To make pictures of things we don't have words for and feel quite primal, perhaps.

Are there any works of art by other artists featuring dance that have inspired you?

Actually, the work that first inspired me wasn't really to do with dance at all. I loved artists who worked with materials and sculpture, like Louise Bourgeois, as well as photographers like Francesca Woodman. They may not have been depicting dancers, but I was fascinated by their depiction of the female body and often the body's relationship to its environment. I also loved documentary photographers like Diane Arbus, who photographed performers but in a very raw and unflinching light. I think that is why I am so drawn to rehearsal photography—I am really interested in capturing the process behind performance and the human element to it, rather than a polished final piece.

What process do you go through to create your work? What inspires you?

I draw inspiration directly from the people I am working with. I like to work very intuitively, and I tend not to set things up so much as I wait for something to happen of its own accord.

Saying that, if I am working with a company to create specific images, then we often create mood boards together, and I like to know about their influences for the work, and see any documentation of their process before we start to shoot. I will plan the skeleton of the shot—location, lighting, etcetera—but I always like to build in time for spontaneity and play during the process.

What might people be surprised to know about you (or your work)?

A lot of people think I trained as a dancer, but I didn't!

LEE GUMBS

After purchasing his first SLR camera at the age of sixteen, Lee Gumbs was able to learn his way around the many settings on a camera. During his senior year of high school, he was photographer on the yearbook staff, capturing memories that would be with his graduating class for a lifetime. This is where he was first introduced to Photoshop and the editing process of touching up photos. For Lee, a dancer since the age of eight, dance photography is a passion and focus. After graduating, he began touring with a professional dance company and he would use many of his fellow cast members as subjects to photograph around the world. At age twenty-one, he moved to LA where he became a professional photographer. Lee has had the pleasure of photographing some of this industry's most prestigious dancers dancing on hit shows such as *Dancing with the Stars* and *So You Think You Can Dance*, and for artists such as Beyoncé, Lady Gaga, Mariah Carey, Jason Derulo, Chris Brown, Taylor Swift, and more. He has been published in numerous magazines and has photographed campaigns for multiple brands. Lee is very excited to see where his path in photography will take him.

Website: leegumbsphotography.com
Facebook: Lee Gumbs Photography

OPPOSITE PAGE
Aries

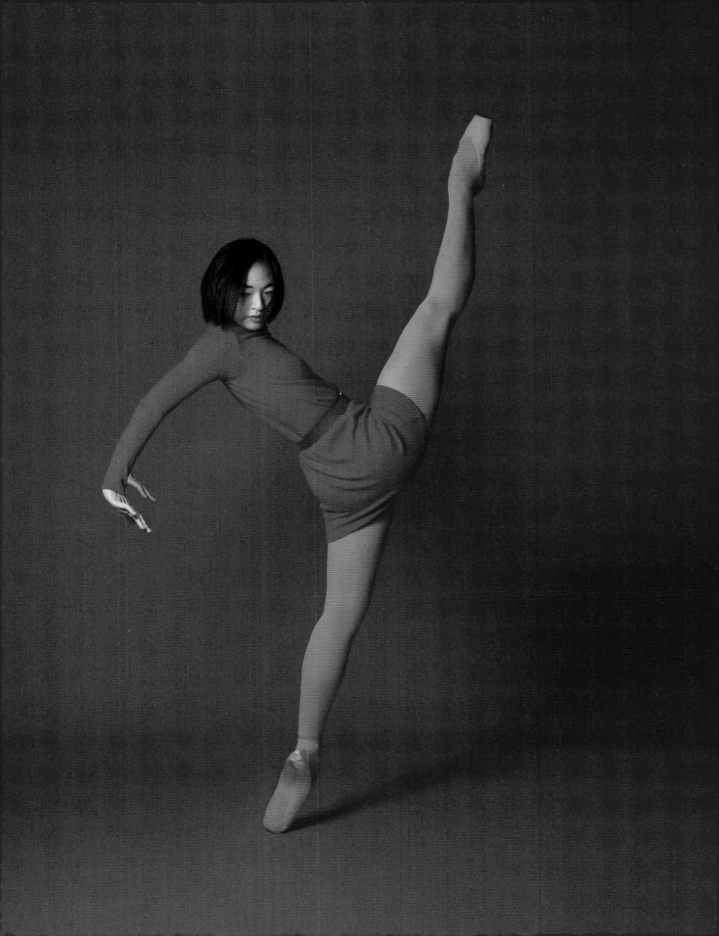

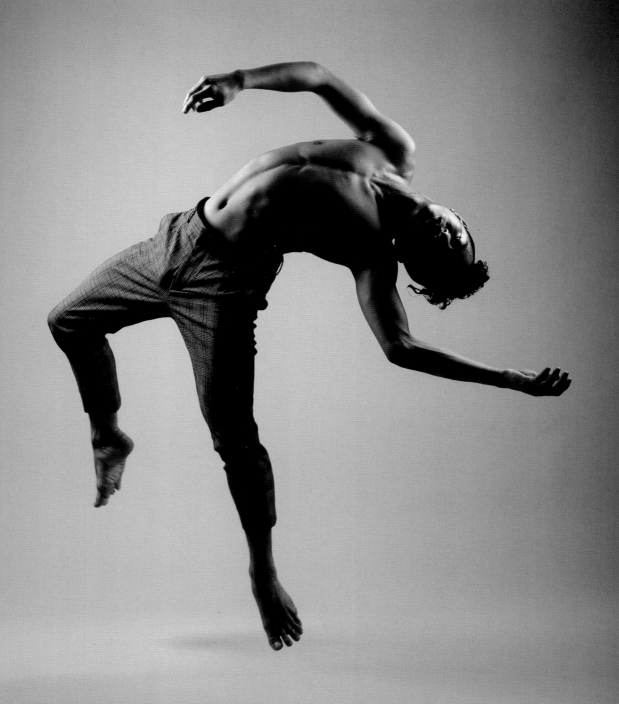

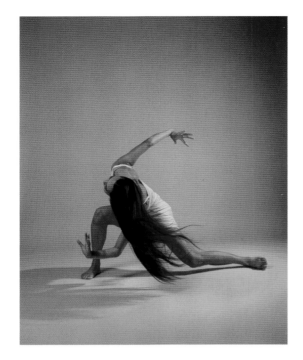

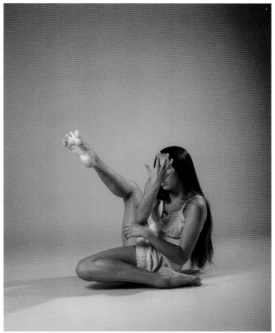

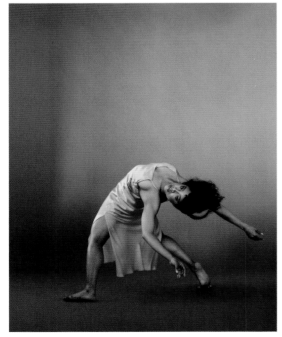

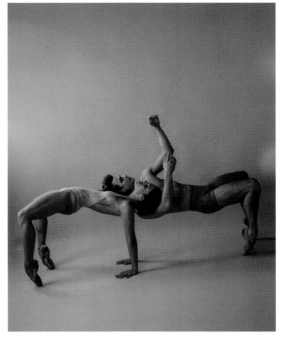

OPPOSITE PAGE
Pisces

TOP LEFT
Scorpio

TOP RIGHT
Sagittarius

BOTTOM LEFT
Libra

BOTTOM RIGHT
Gemini

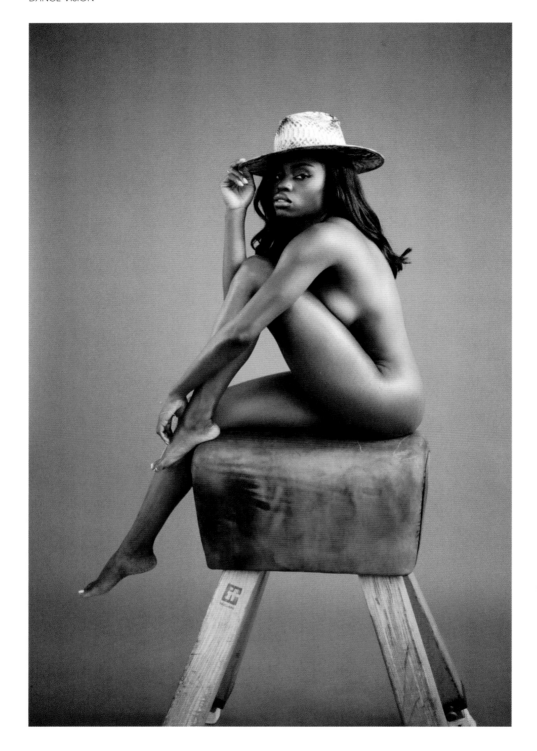

ABOVE
Leo

OPPOSITE PAGE
Aquarius

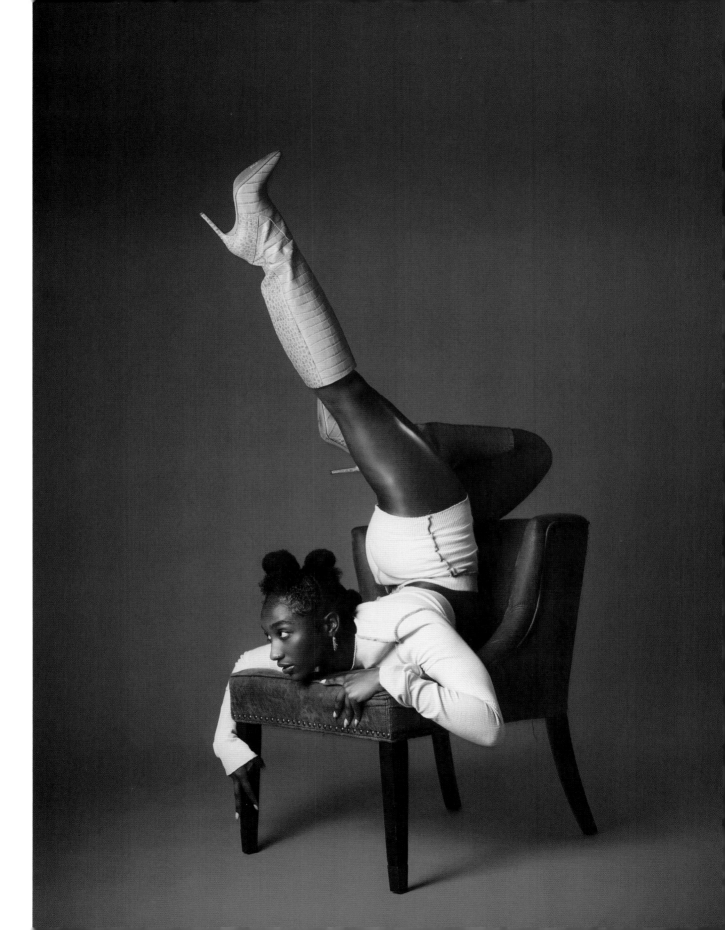

What makes it possible for you to create the art you want to create in your life?
Curiosity has kept me exploring new lighting techniques, shapes for poses, angles, intention for subjects, etc., in my work. Without creative exploration, I would feel stuck and uninspired, which I believe would keep me from producing my art. That being said, curiosity has made it possible for me to stay motivated and inspired to keep creating.

What will you leave behind as your legacy?
I'd want the legacy of my art to be remembered as someone who photographed bodies in positions that hadn't been seen before.

What attracts you to dancing bodies?
Dancers have the ability to bend and shape their bodies in ways that most people without the training can't execute on the same tier of elegance.

When and why did you start incorporating dance into your work, and what do you feel dance brings to it?
I've incorporated movement in my photographs from the very beginning. Being a dancer myself, I couldn't help but naturally gravitate towards capturing the world I had been a part of since the age of eight.

Are there any works of art by other artists featuring dance that have inspired you?
Shortly after I graduated high school, I came across the work of fashion photographer Steven Meisel. Immediately, I was captivated by the way he used movement in a lot of his fashion campaigns that he photographed. I hadn't seen movement represented in that big of a light in fashion before seeing his work. He has inspired me tremendously and is my favorite photographer.

What process do you go through to create your work? What inspires you?
When photographing my subjects, I need the process to be collaborative. I don't know each individual's strengths or unique quirks when it comes to their body and what it's capable of. When someone comes prepared and can explain or show their strengths, I can think of different ways to make the pose I'm capturing more peculiar and interesting.

What might people be surprised to know about you (or your work)?
People are often surprised to learn that I didn't go to school to study photography.

What question do you wish I had asked you?
Do you prefer photographing in color or black and white?

What is your answer to that question?
I have always been a fan of how timeless black and white is. A part of me wishes we were still in the era where only black and white photographs were produced.

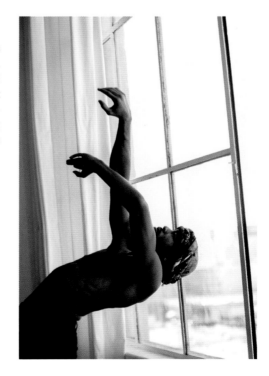

RIGHT
Capricorn

OPPOSITE PAGE
Virgo

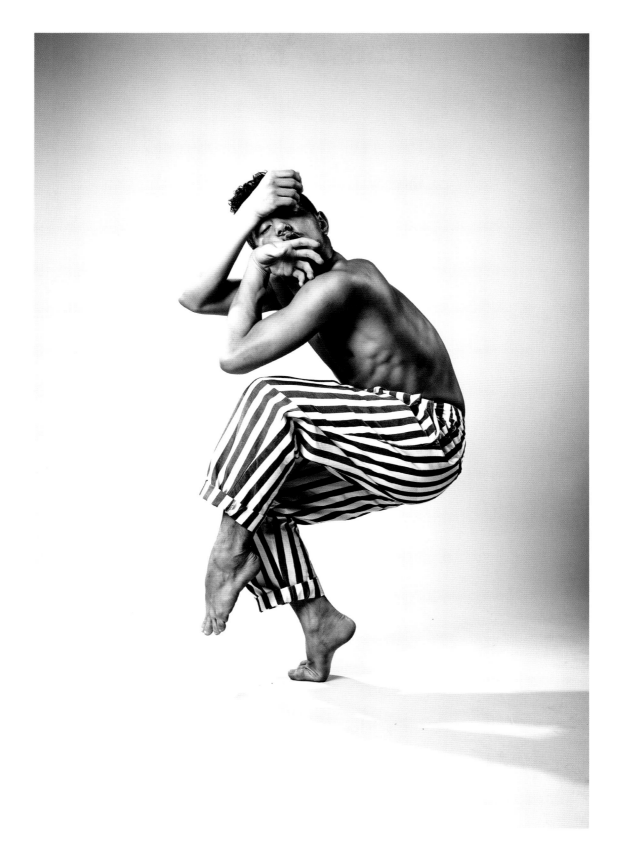

CHRIS HERZFELD

Established in 2003 by Chris Herzfeld, Camlight Productions is a unique photography/cinematography business that provides photography, cinematography, and lighting services.

After winning the inaugural Kodak Nikon Supershot Award in 1984, Herzfeld embarked on a career as a lighting cameraman. He has worked with Channel 10 and 7 in South Australia on a wide range of programs from lifestyle shows to documentaries. He has also worked on a number of commercials, film clips, and news services as both a cameraman and lighting director for many local, interstate, and international production companies.

He works extensively in the arts and in particular throughout the Australian dance industry as a photographer and a cinematographer. Clients have included Australian Dance Theatre, Expressions Dance Company, State Theatre Company of South Australia, Restless Dance, Country Arts SA, and Brink Productions. Camlight Productions also supports many emerging choreographers such as Erin Fowler, Lewis Major, and Riannon McLean.

Herzfeld has won a number of awards for his dance photography in the International Loupe and the AIPP photography awards. He has also won a number of Australian Cinematographer Society awards, including two gold awards in 2005 for the Channel 7 News promo campaign and two gold awards in 2006 for the Australian Dance Theatre television campaign for Devolution.

Herzfeld's images are a fusion of fashion and dance. Drawing on the distinctive range of movement and shapes of dance in combination with the more traditional modeling poses, the image embodies a sense of drama, poise, and style. This unique style creates images that have a sense of narrative within them. Herzfeld likes to leave it to the viewer to use their imagination to create that story. In a world where digital manipulation and compositing are commonplace in photography, Herzfeld's approach is more classical, with an emphasis on lighting, colors, and composition with the look of minimal postproduction processing. His images take on a 3D appearance, so the viewer feels as if they are present in the location watching the action happen before their eyes.

All his dance images are "real in camera"—he doesn't use harnesses, ropes, trampolines, motor winders, or Photoshop cut and pasting to manipulate the dancers in his images. The dancers jump and one image is taken with usually no more than four to six attempts in that moment by the dancer.

Website: camlight.com.au
Email: chris@camlight.com.au

OPPOSITE PAGE
Pascal Marty in Lewis Majors Epilogue

FOLLOWING SPREAD, LEFT, TOP
Erin Fowler

FOLLOWING SPREAD, LEFT, BOTTOM
Jess Minas

FOLLOWING SPREAD, RIGHT, TOP
Catherine Wells

FOLLOWING SPREAD, RIGHT, BOTTOM
Jazz Hriskin

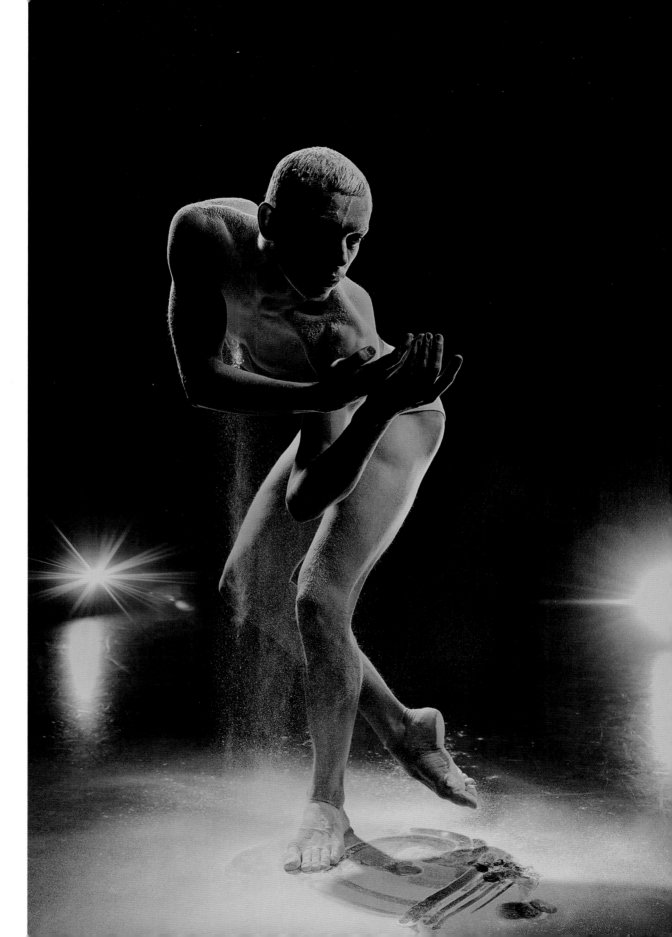

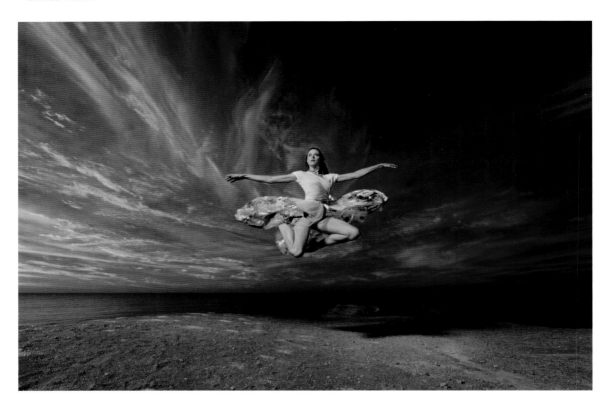

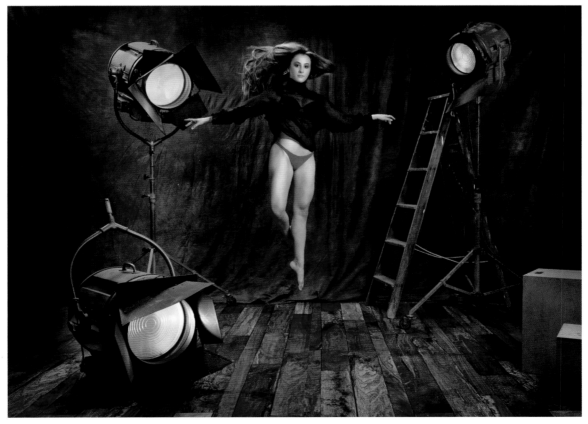

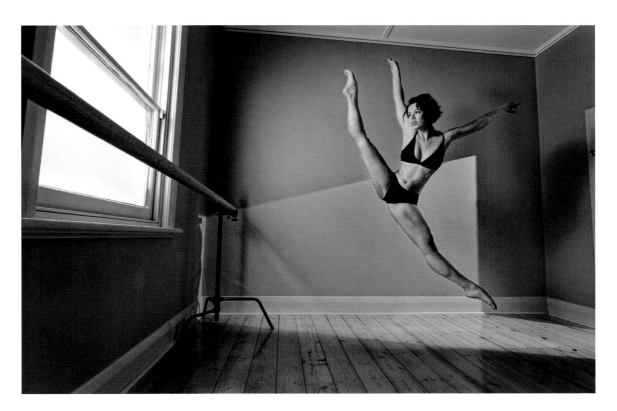

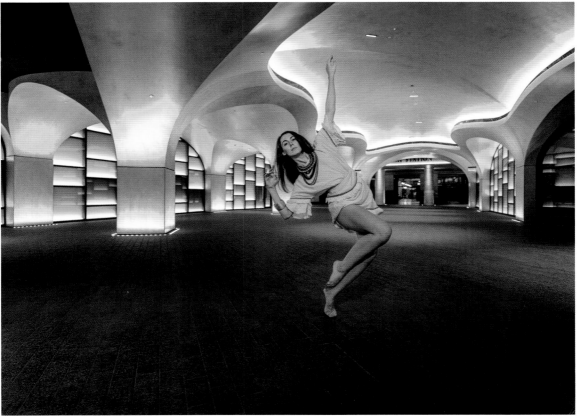

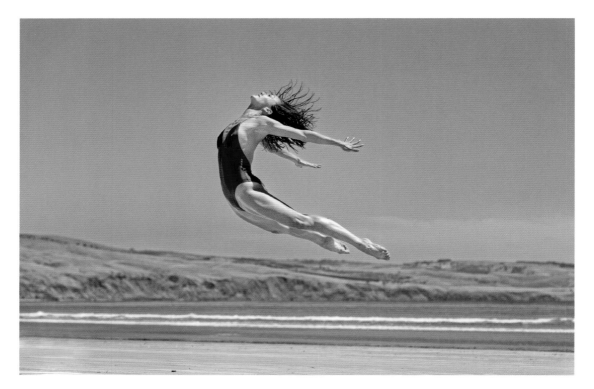

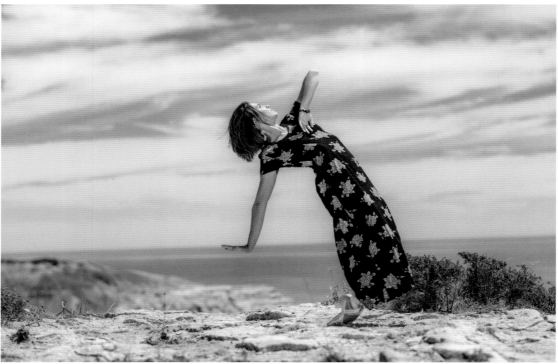

TOP

Janessa Dufty

BOTTOM

Sarah Wilson

OPPOSITE PAGE

Erin Fowler

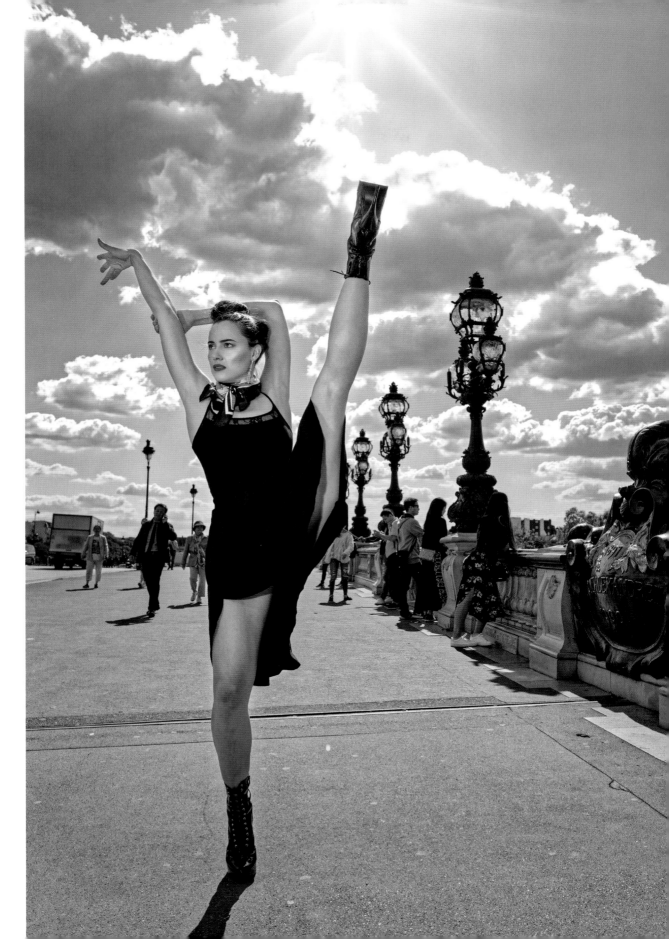

What makes it possible for you to create the art you want to create in your life?

I have been very fortunate to be in the right place at the right time in each stage of my creative journey. When I started out in photography, I was able to pursue the creation of images from activities in my life such as travel and sports. Moving into the realm of dance late in my career was definitely one of those "right place, right time" moments. I was looking for a new outlet when I got the chance to work with Lois Greenfield. Things just took off from there. Now, I am continually looking to work with a willing group of dedicated dancers and choreographers. My hope is that we can create something new, for all of us.

What will you leave behind as your legacy?

There's the obvious—a collection of images of dancers from in a particular moment in time. The other thing I hope I leave behind is a sense of wonder in the creative abilities of humans, as both dancers and photographers, designers, and all of the other wonderful people I work with in a non-AI way.

What attracts you to dancing bodies?

I love the organic fluidity of a dancer's body and how they interpret and respond to the environment they are in. I find this particularly engaging in outdoor settings, both natural and urban.

When and why did you start incorporating dance into your work, and what do you feel dance brings to it?

Following my start of working with Lois [Greenfield] and professional dance companies I started to extend myself by creating personal projects based on my vision. I wanted to take the dancers out of the theater or photo studio and place them in real life situations—usually in a street or a nature setting. I also changed them out of dancewear or costumes into fashion clothes. A cornerstone of my practice is to light the subjects as if they were in a studio no matter where they are. It distinguishes the image from a lucky happy snap.

I love playing with the way a dancer infuses quirkiness into a familiar scene. I wanted to create images that possess a narrative that the viewer can decide upon.

Are there any works of art by other artists featuring dance that have inspired you?

Lois Greenfield's photography. I was lucky enough to have worked with Lois in the early to mid-2000s so watching her create images that capture dancers flying through the air was inspirational.

What process do you go through to create your work? What inspires you?

I'm inspired by broad themes, colors, textures, and forms that may be at odds when placing dancers in them, e.g., dancers on a salt lake or on a cliff top. Once I have found a location that interests me, I start to think about how to light it, what clothes the dancer could wear, and what props to use.

What might people be surprised to know about you (or your work)?

I have never danced—even socially!

What question do you wish I had asked you?

What's your next project?

What is your answer to that question?

A photo-essay collaboration with an aboriginal photographer/artist exploring traditional stories from her culture in a contemporary way using aboriginal and non-aboriginal dancers.

OPPOSITE PAGE, TOP

Dïane Major

OPPOSITE PAGE, BOTTOM

Riannon McLean

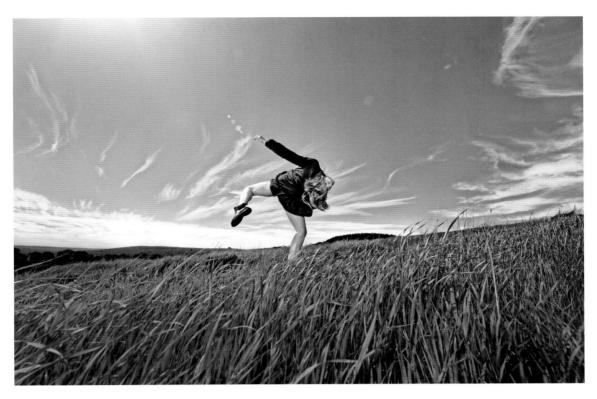

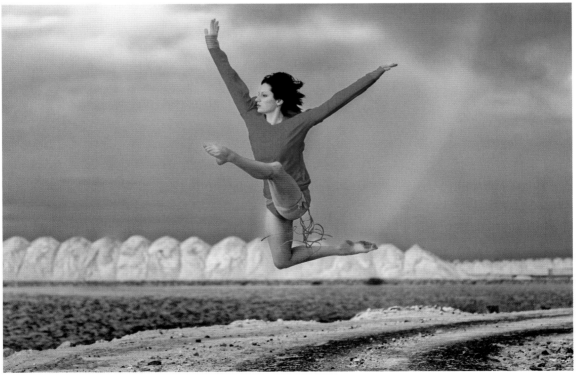

JEAN-YVES LEMOIGNE

Jean-Yves Lemoigne is a French photographer-director based in New York. He is a visual innovator and storyteller interested in bodies in motion through dance and sports. With a background in graphic design and art direction, he brings his own vision to photography through unusual perspectives, elegant lighting, and visual twists. He is also exploring the boundaries beyond photography and film by creating original digital work including 3D scans, computer-generated images, and virtual reality.

Lemoigne shoots stills and moving campaigns for some of the biggest brands in the business including Nike, Puma, Visa, Sony, Barclays Bank, Cartier, and Stella Artois. He is also a contributor to publications such as *GQ, Esquire, Men's Health, Women's Health*, and *Le Monde*.

Website: jeanyveslemoigne.com
Instagram: @jeanyveslemoigne

OPPOSITE PAGE

3D scan exploration with model and dancer Dean Maupin, 2019

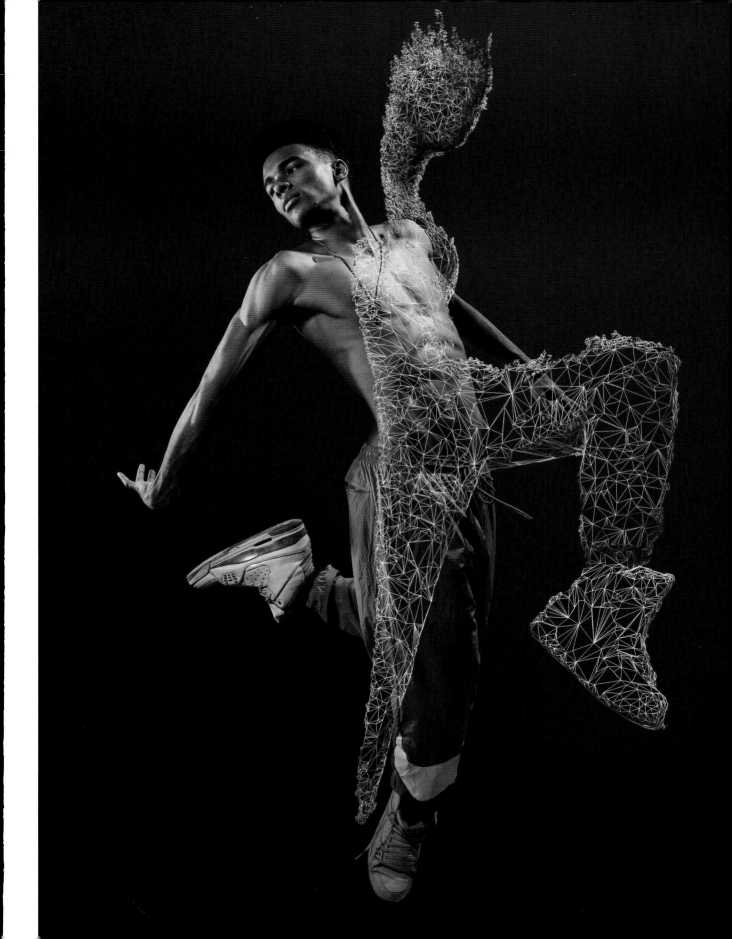

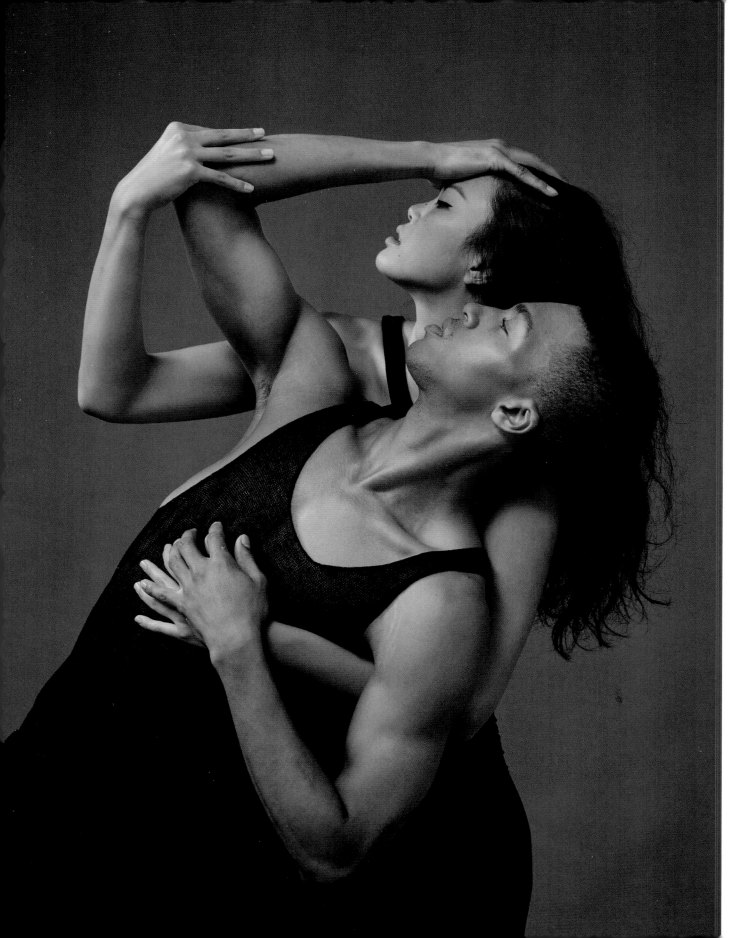

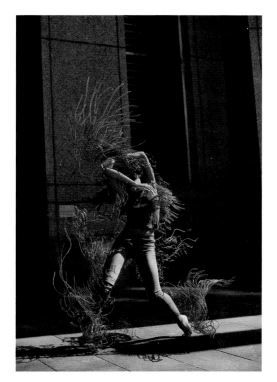

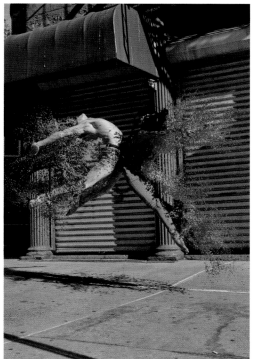

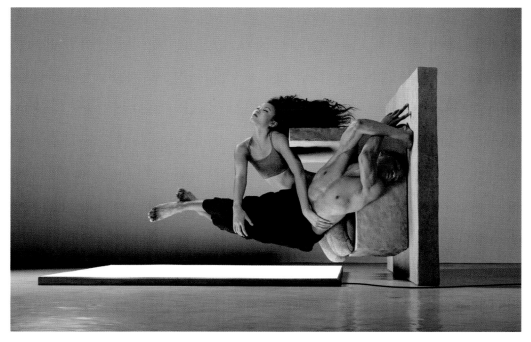

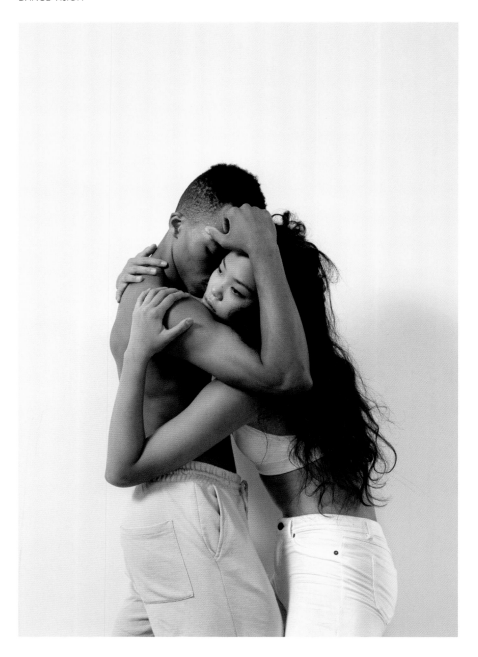

THIS SPREAD

Dancers Umi Akiyoshi and
Sy Lu with choreographer
Loni Landon

FOLLOWING SPREAD

Dancer Emily Paige
Anderson

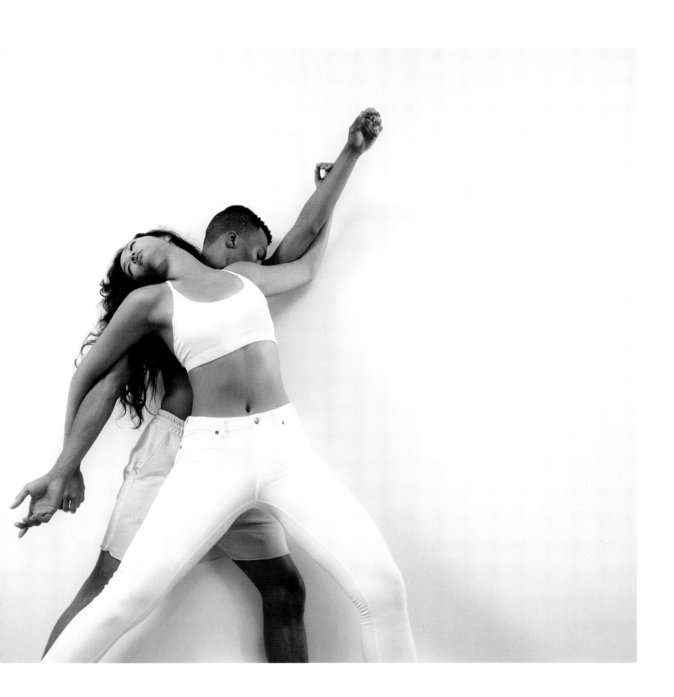

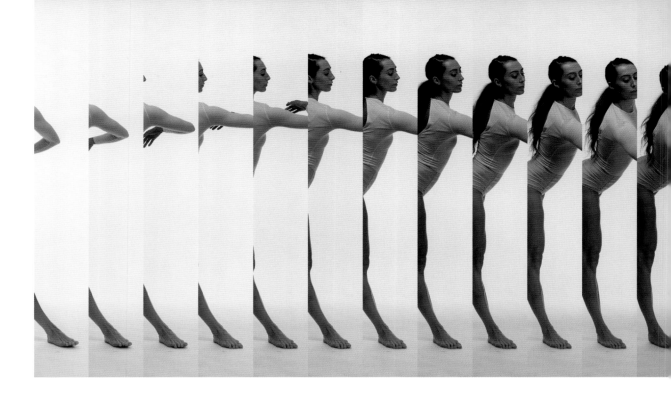

What makes it possible for you to create the art you want to create in your life?
I was a good student. I was heading to science and math when I decided to switch to art studies at eighteen. I did art studies in the north of France and Paris. I then started to work as an art director in advertising. For five years, I have worked on exciting projects. Advertising is interesting because everything goes fast, and you get to collaborate with photographers, illustrators, filmmakers, etc. But at some point, I started to get frustrated with so much time spent in endless meetings. I am a maker. So, I decided to be a photographer. This choice was a key moment for me. Between commissioned projects, I developed personal projects with different kinds of techniques with photography, film, and computer-generated images.

What will you leave behind as your legacy?
We are living in a world where there are way too many images. Every time I take a photo or create an image I wonder, has this image been done before? Do I really need to add one more to this world? But when you create, it comes from your gut, you have to do it. I used to be a magazine lover, for their photos and design. I liked that it was expendable. Now the era of the magazine is over; we are in the digital world, but it is the same, all those images will be forgotten. Instagram might look as outdated as Myspace. . . . I have no illusions my work will be anything but dust, and it is nice like that.

What attracts you to dancing bodies?
I think that the human body is one of the most archetypal subjects in art (along with nature). I feel it is interesting to explore the body and its motion with the modern tools of photography and digital art. Also, the expression of the motion in a still image is quite challenging, and I try to find new ways to visualize it.

When and why did you start incorporating dance into your work, and what do you feel dance brings to it?
I started ten years ago. My photographic work at that time was carefully prepared and staged. You need this approach when you work for advertising. I was tired of that. Starting to collaborate with dancers was for me a way to be out of my comfort zone; I want to be surprised while working, I want to end with something different to what was planned.

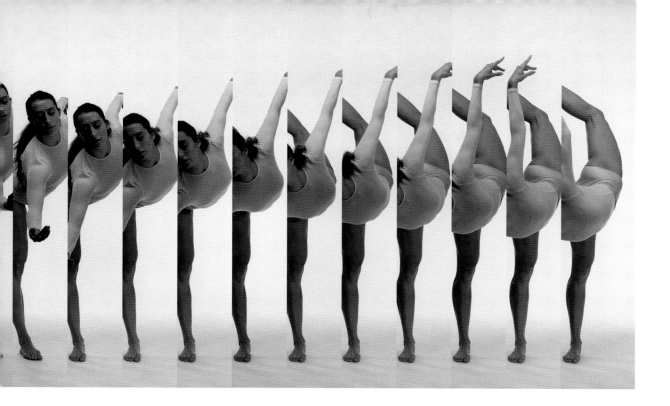

Are there any works of art by other artists featuring dance that have inspired you?
Obviously, I saw many dance and ballet shows. One of my favorite choreographers is Angelin Preljocaj. His work is incredible; every show is so different but very accessible to people who are not too much in the dance world. Dance is the universal language of the body, so you could imagine that everything has been done, but sometimes you discover a new work, and then this vision is completely new and you are amazed. I loved this feeling of discovery.

What process do you go through to create your work? What inspires you?
I will give a classic response; it could be anything. I see a lot of museum and gallery exhibitions, so that is part of it, but I can see a science TV show and discover something that will change the project I am working on.

What might people be surprised to know about you (or your work)?
When I was ten to twelve years old, I wanted be to a comic book artist. I was drawing a lot of super-heroes running, jumping, etc. . . . I think it was the starting point of my love for the body in motion.

When you look at the movements of superheroes, you can see that there is a kind of choreography that is not that far from dance.

What question do you wish I had asked you?
Where do you see yourself in twenty years?

What is your answer to that question?
I think dance has gotten a lot of exposure in the last five years because of video on social media. Dance needs motion to fully express its creativity. Before the internet, the only option was TV. There were only a few films/shows available, and they were mainly very elitist. Now, dance is very popular, which is good. Think TikTok. I think the next phase will be space. Dance is the expression of the body in time and space. So we can imagine that virtual reality will be a very interesting tool for dancers and choreographers. I am starting to work with motion capture and CGI. Can you imagine a ballet in VR where you are in the middle of the dancers?

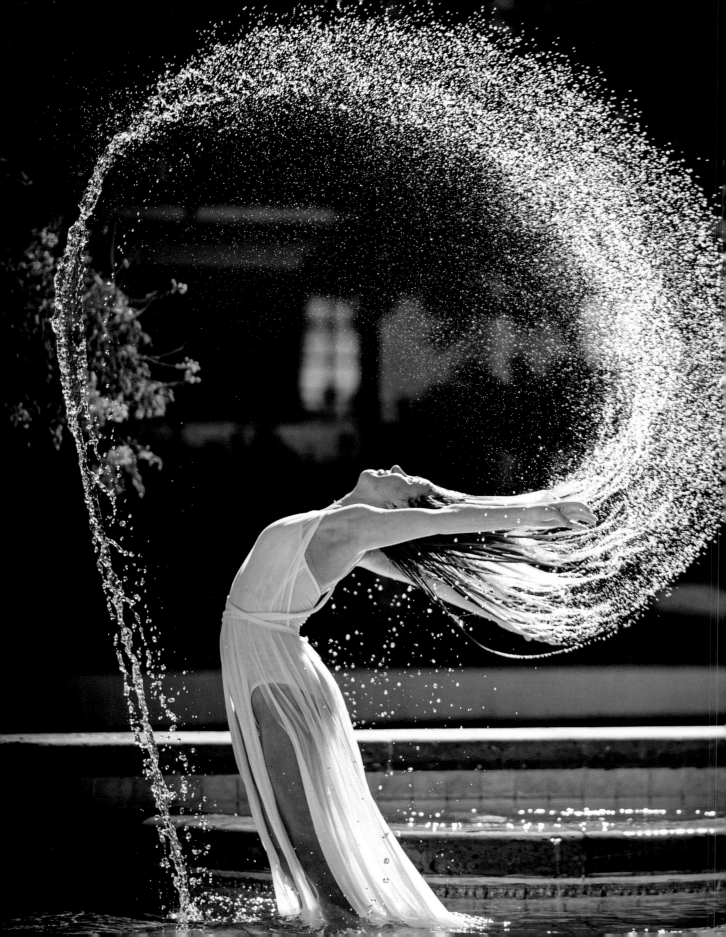

JORDAN MATTER

Jordan Matter (b. 1966), is an American photographer who is especially famous for his captivating dance photography. He is also the author of two *NYT* bestsellers, including *Dancers Among Us: A Celebration of Joy in the Everyday*. A grandson of the renowned photographer, Herbert Matter, Jordan was also inspired by the photojournalist Henri Cartier-Bresson. Matter was not initially intent on pursuing photography as a career; in fact, he was a popular baseball player during his college days and wanted to become an actor. Even though he comes from a family with a rich legacy in photography, his photography career started in a very unorthodox way. He took some headshots of one of his model friends and those pictures went on to become very popular. Soon, he started getting offers from aspiring models who wanted him to photograph them. Several agents also began recommending him to models, thereby helping him embark on a lucrative career as a photographer. Matter has since been profiled by major media outlets like MSNBC, CBS, NBC, and BBC, and has been interviewed by Tyra Banks. In addition, he has appeared on *The Today Show* and has been featured in top magazines. With over 20 million followers on social media, Matter is known for his out-of-the-box approach to photography, a unique talent that sets him apart from other professionals in the same field.

Instagram: @jordanmatter
Youtube: Jordan Matter
Facebook: Jordan Matter Photography

OPPOSITE PAGE
Phoenix, AZ

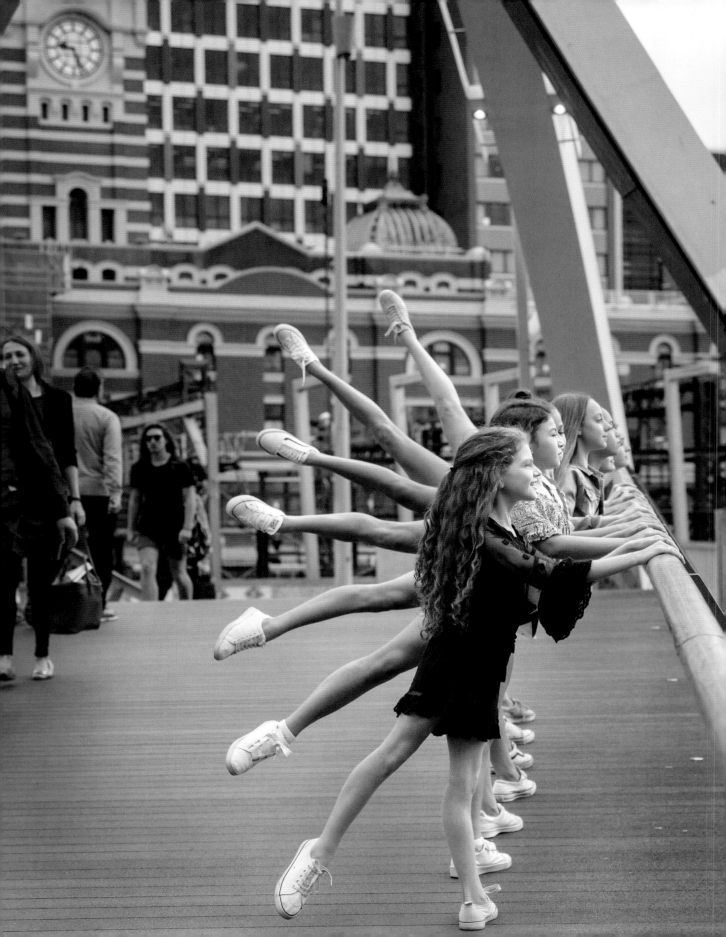

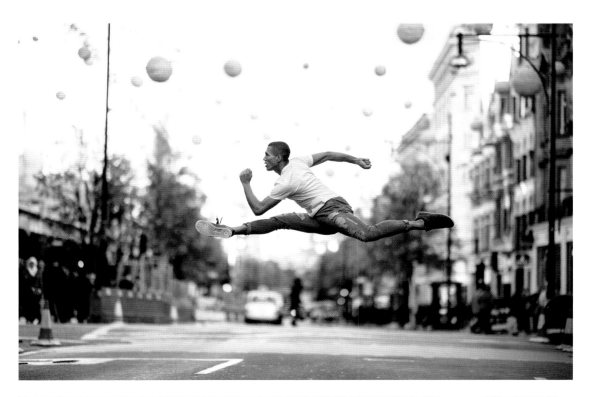

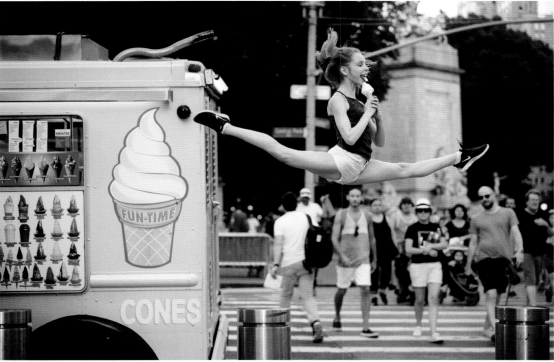

OPPOSITE PAGE

Melbourne, Australia

TOP

London, England

BOTTOM

New York, NY

FOLLOWING SPREAD

Emerald Isle, NC

119

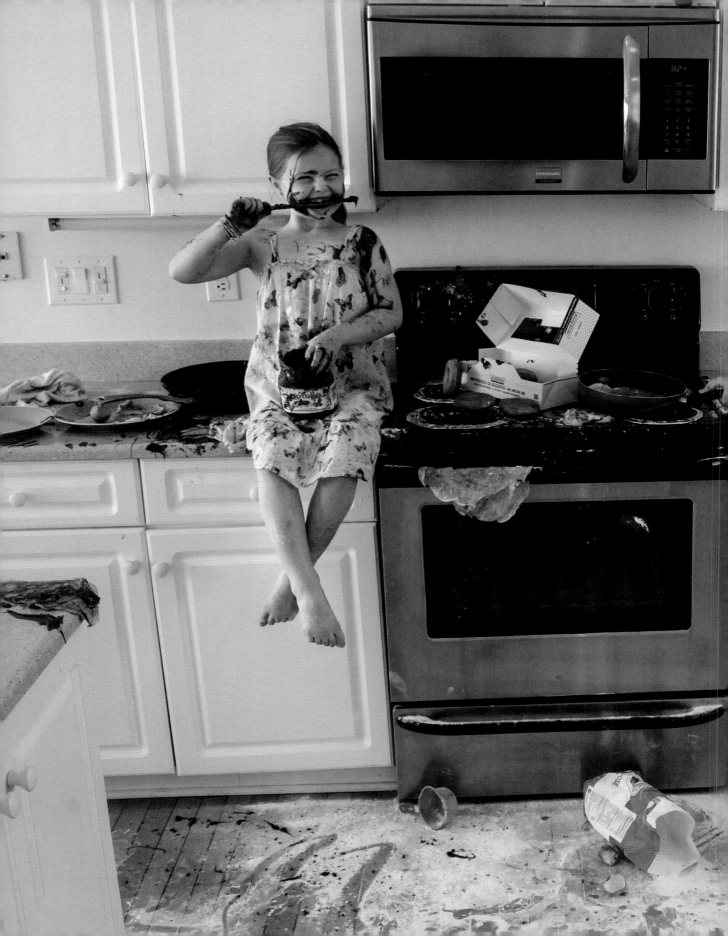

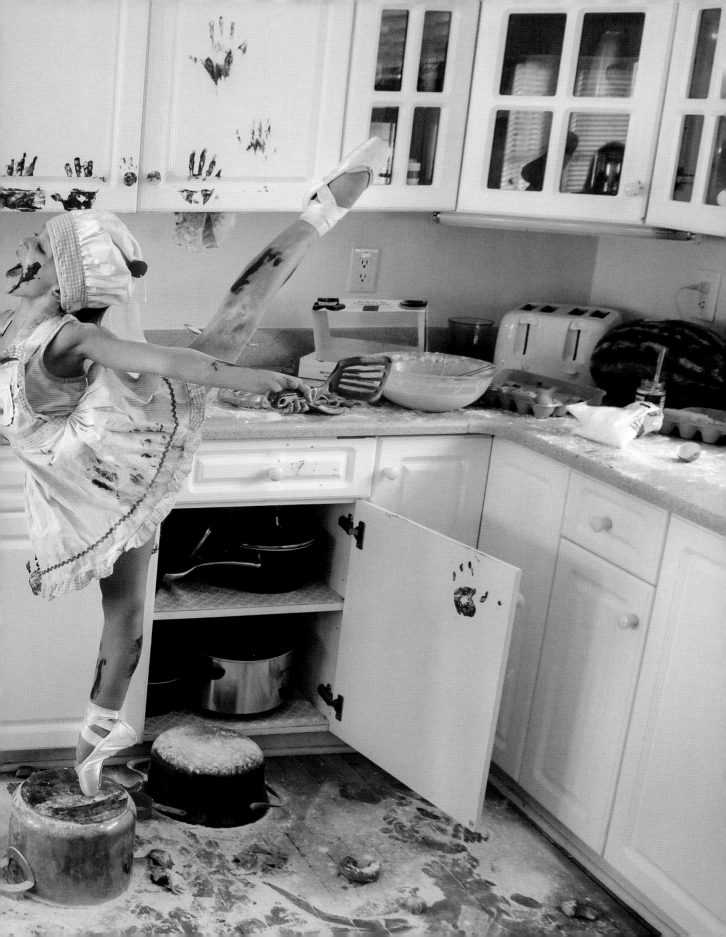

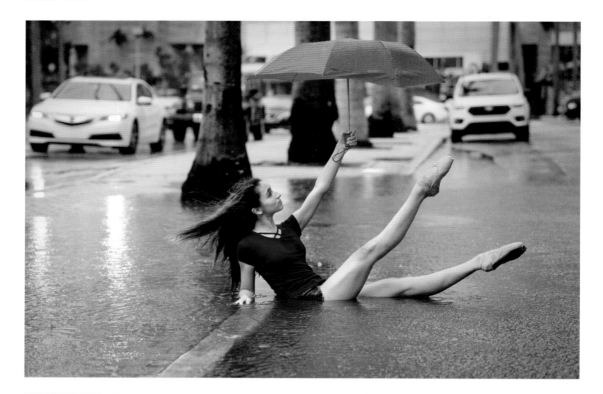

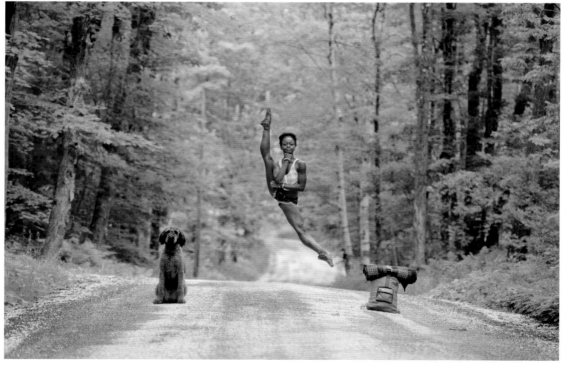

TOP
Miami, FL

BOTTOM
Jacobs Pillow, MA

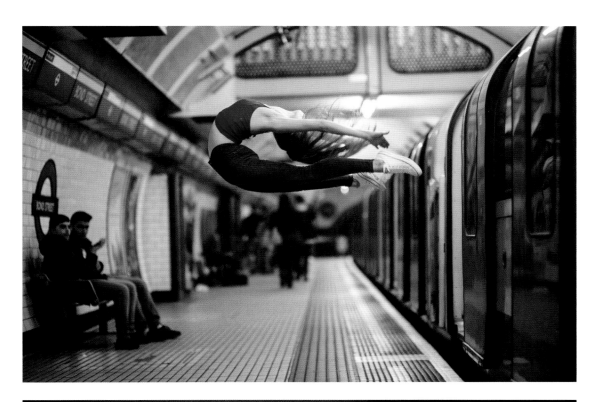

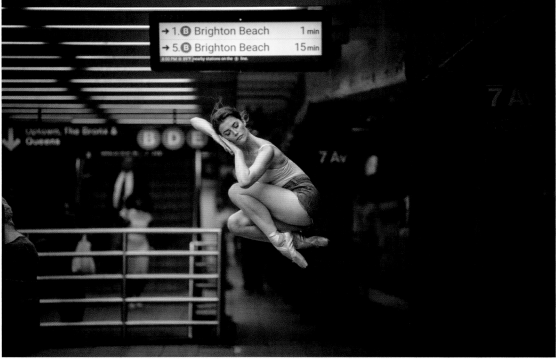

TOP
London, England

BOTTOM
New York, NY

EVA NYS

Twenty-four-year-old Eva Nys has spent nearly a decade refining her craft as a dance photographer. With her knowledge of dance and years working behind a camera, Eva specializes in capturing a dancer's own passion and skill in her photographs. Over the years, she has become most known for her Spooky Season photographs and has inspired many other photographers to connect horror and dance. Eva has traveled all over the globe to work with a variety of dancers, studios, and competitions. Originally an Arizona native, Eva currently resides in New York City where she hopes to continue to evolve her craft.

Website: evanysphotography.com
Instagram @evanysphotography

OPPOSITE PAGE

McKenzie Wilson in
Snoqualmie, Washington

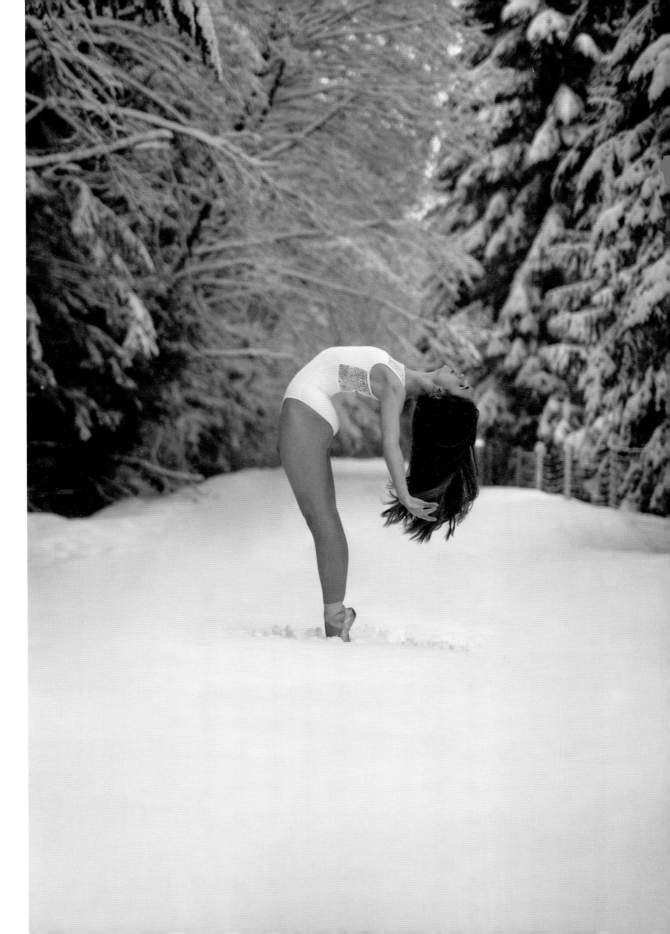

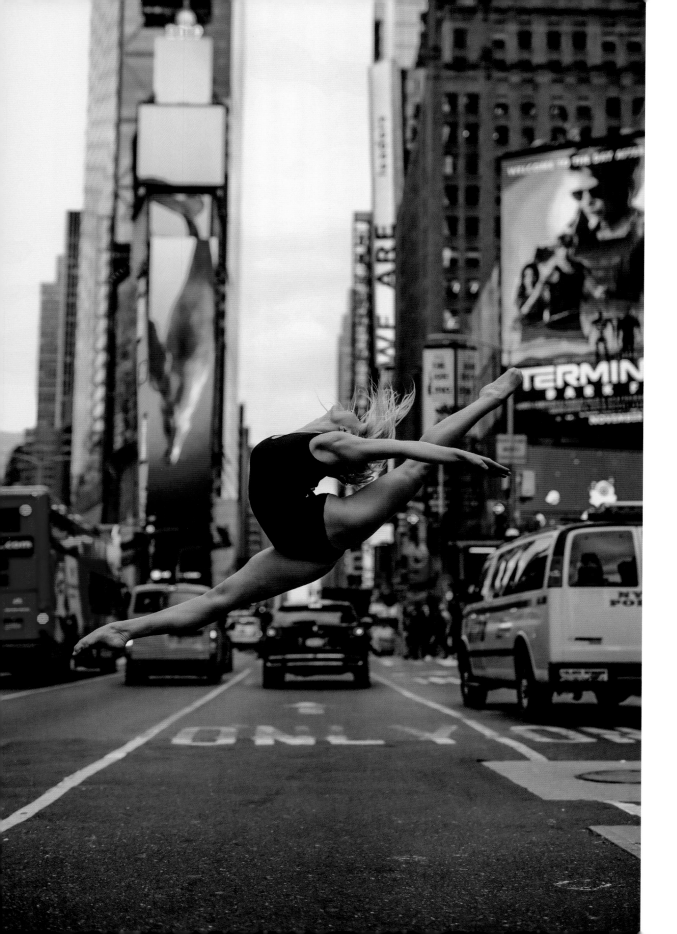

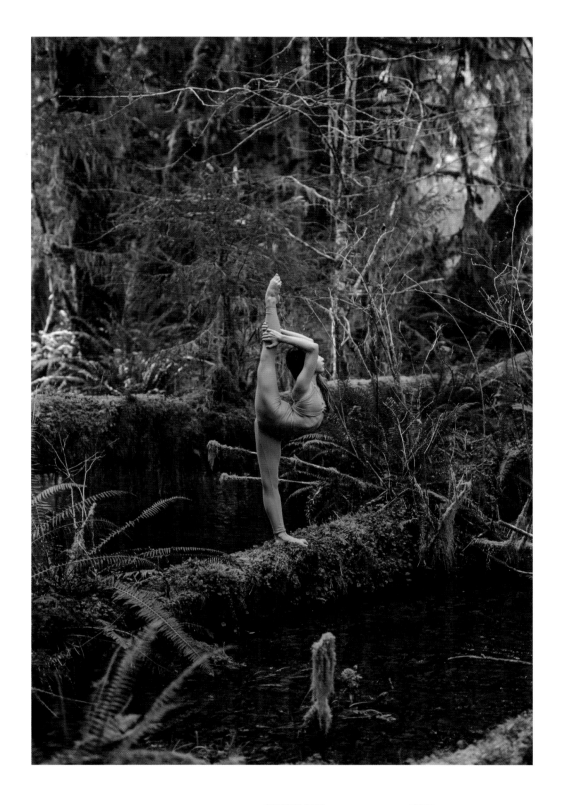

ABOVE

Sydney Tam in Olympic
National Park

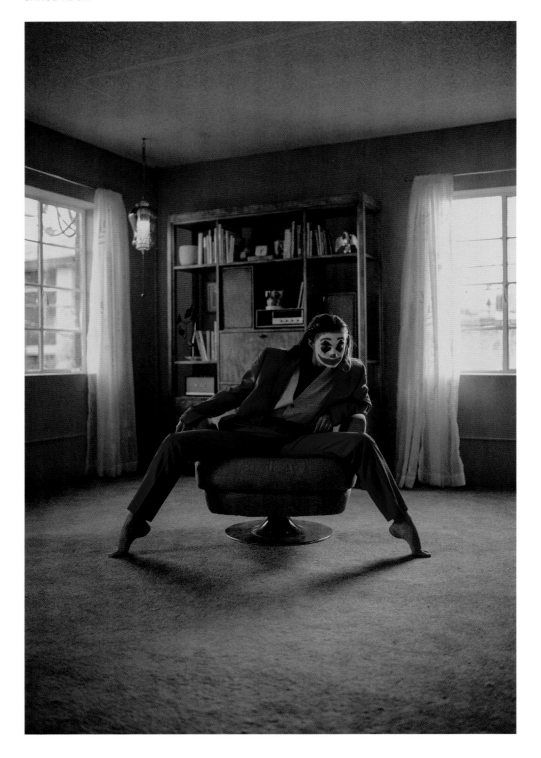

ABOVE

Amber Skaggs as Joker

OPPOSITE PAGE

Emerald Gordon Wulf portraying the story of "Annabelle"

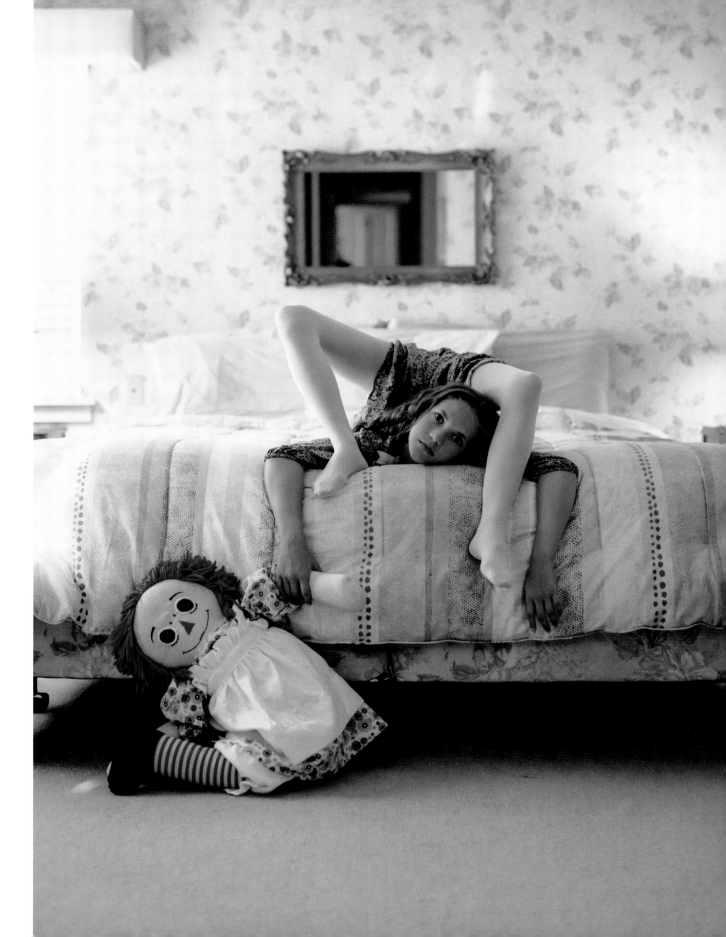

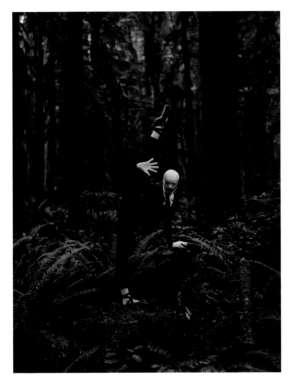

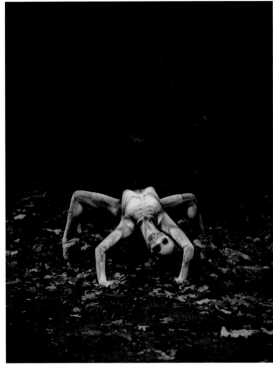

THIS SPREAD
Amber Skaggs

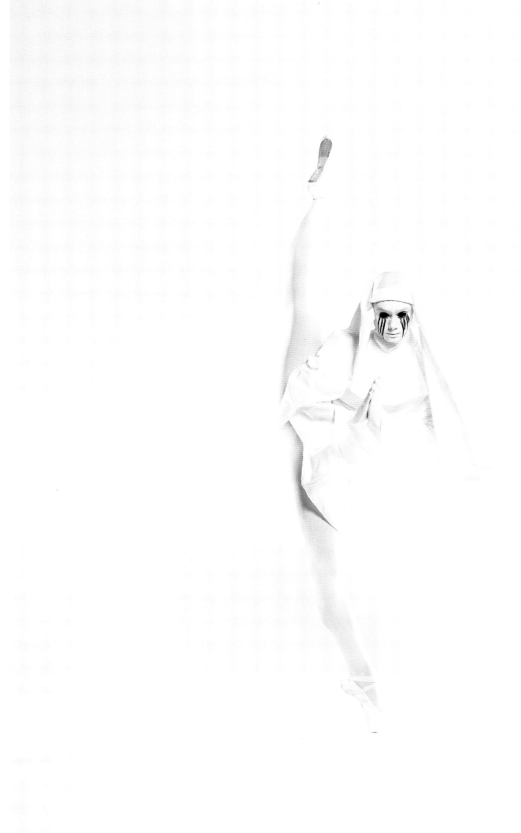

What makes it possible for you to create the art you want to create in your life?
Although it may sound cliché—my family. Every member has played a distinct role in helping me become successful. I had big dreams as a child and was rarely handed what I wanted. My parents made it clear that I could achieve whatever I wanted if I was willing to put in the work and make sacrifices for it. I applied that belief from a young age and continue to follow that to this day.

What will you leave behind as your legacy?
When I started, the only dance photographers I had to look up to were male and it seemed like there wasn't much space for women. I hope by the time I retire from photography, that seemingly nonexistent space has been widened to make room for more diversity. If I can help create that space or even become an inspiration to another aspiring photographer, that would be more than enough for me.

What attracts you to dancing bodies?
My own love and passion for dance has always made me feel most excited and comfortable photographing dancers. I understand the way they move and can capture details to showcase their best technique.

When and why did you start incorporating dance into your work, and what do you feel dance brings to it?
Dance has been a part of my work since Day 2. Day 1 included me realizing that photographing flowers and my dogs wasn't quite my cup of tea.

Are there any works of art by other artists featuring dance that have inspired you?
Throughout my life my parents made sure my brother and I were exposed to as much art as possible. I remember going to museums often as a child, but it was actually Instagram where I found that initial inspiration to do something with dance photography. I stumbled across an account called @ballerinaproject_ in 2013. There was an ethereal quality to their work that I wanted desperately to be able to communicate to an audience of my own.

What process do you go through to create your work? What inspires you?
I often meld my work with whatever other factors in my life inspire me at the time. Sometimes it's fashion, nature, painting, music, travel, or movies. The fun part about inspiration is that it can come from literally anything at any time. You just have to keep your eye out for it.

What might people be surprised to know about you (or your work)?
If I hadn't gone down the path of dance photography, there's a 99 percent chance I would have become a marine biologist. I haven't missed a shark week since I was five years old.

What question do you wish I had asked you?
Was there anyone who helped you in the beginning or made you believe you could be great?

What is your answer to that question?
Renee Clancy, a very well-respected wedding photographer, also happened to be my Spanish teacher when I was fifteen. With a handful of images that I had taken on my new camera, I approached her after class one day and asked if she might be able to look at some of my pictures and help me edit them. She didn't even hesitate to say yes and hours later she was scrolling through my pictures telling me she thinks I have the eye for it. It was truly the first time in my life I knew I could be excellent at something.

OPPOSITE PAGE
Dancer
Whitney Ross portraying
La Llorona

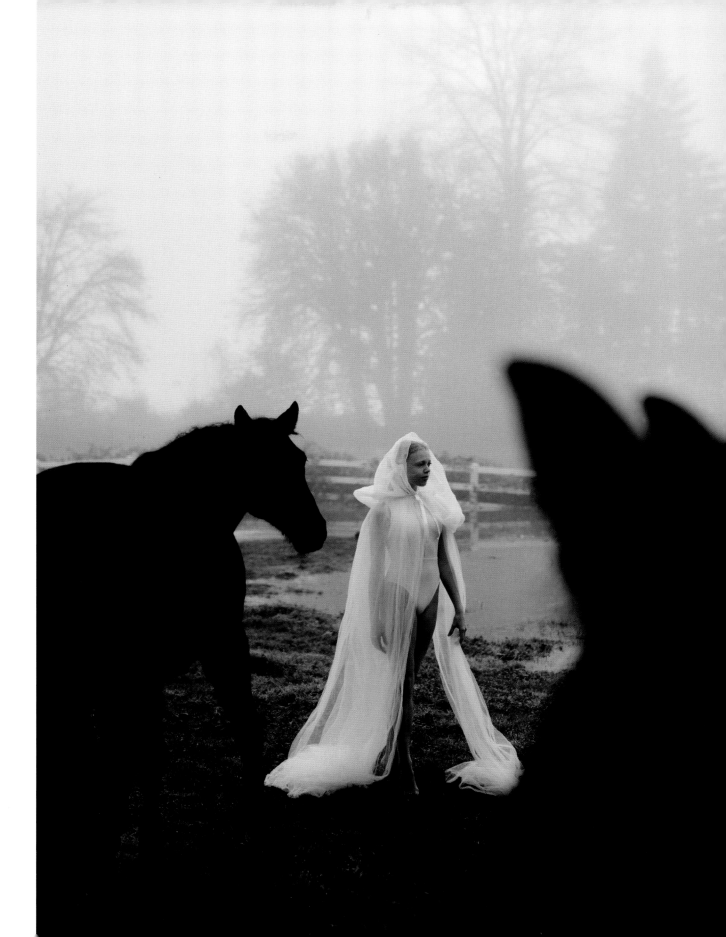

YEVGENIY REPIASHENKO

Yevgeniy Repiashenko was born in Kiev, Ukraine, in 1979. At the age of twenty, while studying at the National Technical University, he started to work with his first SLR camera. He got into portrait and fashion photography, which he explored through glossy magazines and photographers' albums from around the world.

After graduation, Yevgeniy founded his high-end audio salon, as he had a great love for music and technology. His time was divided—during working hours he directed the audio salon, and in the evening he was engaged in photography. For the most part, the work was not commercial, but fine art photography. He independently studied the perception of the light image and did post-processing by himself. Step-by-step he set up his own photo studio and decided to turn his passion into his profession.

His works always reflect poetic beauty, naked grace, and harmony. Through his fascination with classical sculpture and Renaissance painting, Yevgeniy finds a new creativity direction—sculptural photography and the plastic movement. The flawless nudity of ballerinas' and gymnasts' bodies freezes in a fit of dance, leaving the strongest feelings and passion in the frame. At first glance, the subjects do not seem real, but sculpted by the hands of the master. The models say that shooting with Yevgeniy is not easy, but he knows what he wants to achieve; he often serves as a choreographer at his shoots, which helps with his invention of new images. His SPIRIT series is a combination of the texture of classical sculpture with the feeling of modern rhythm and emotions.

Website: repiashenko.com
Instagram: @yevgeniy_repiashenko

OPPOSITE PAGE

No05 SPIRIT Series

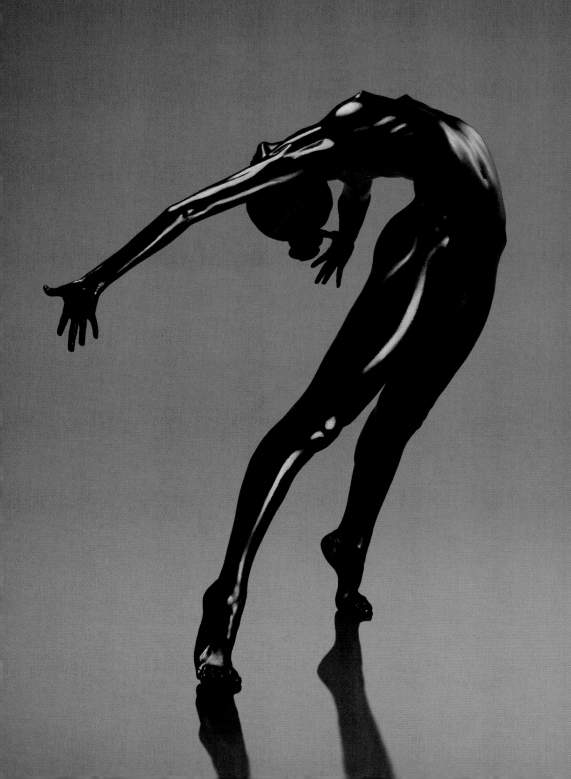

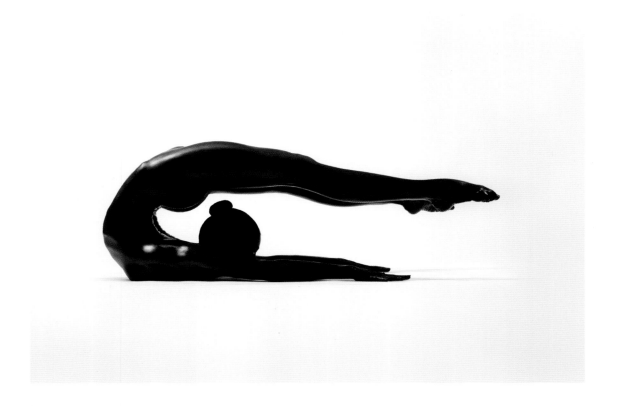

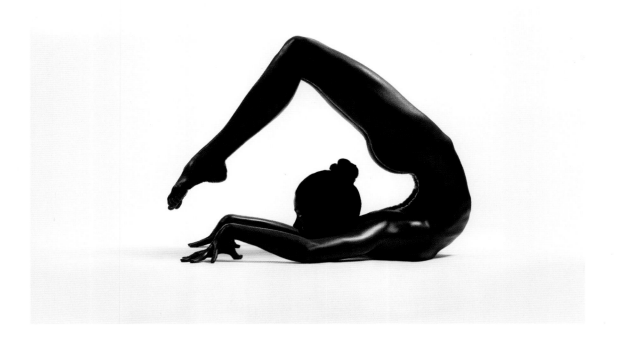

TOP	BOTTOM	OPPOSITE PAGE, TOP	OPPOSITE PAGE, BOTTOM LEFT	OPPOSITE PAGE, BOTTOM RIGHT
No13 SPIRIT Series	No12 SPIRIT Series	No57 SPIRIT Series	No43 SPIRIT Series	No31 SPIRIT Series

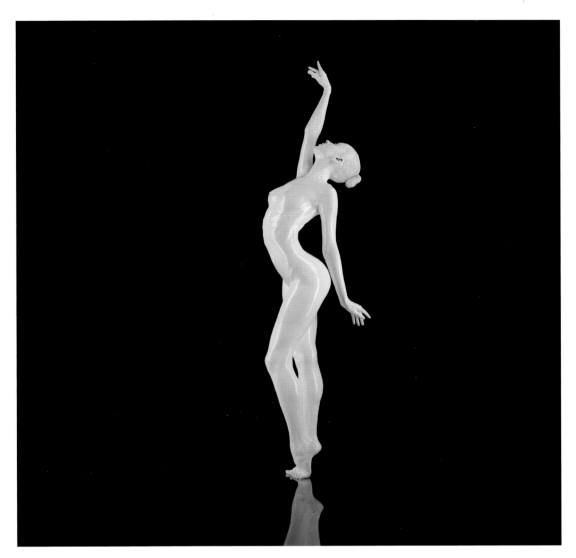

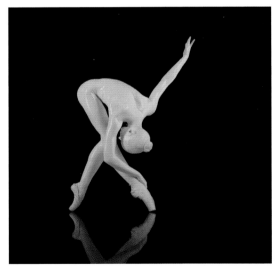

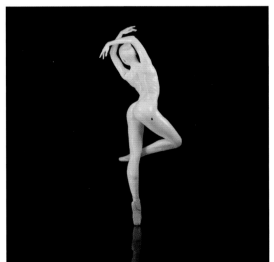

What makes it possible for you to create the art you want to create in your life?

The main driving force is love for beautiful and harmonious lines of the body, its plasticity and dynamics; love for the classical art of sculpture and painting of the Renaissance; and, of course, love for the process of photography.

What will you leave behind as your legacy?

I think that the aesthetics of classical art will never lose their relevance.

What attracts you to dancing bodies?

The most valuable thing in a person's life is communicating with people, experiencing feelings. Dance is a very expressive language of communication; expressive forms and movements are able to convey the strongest emotions and feelings.

When and why did you start incorporating dance into your work, and what do you feel dance brings to it?

There was no starting point. It was some kind of experiment among other shoots. It's just that interest in dancers grew, and the frequency of such shoots, along with me.

Are there any works of art by other artists featuring dance that have inspired you?

When I started working with the dynamics of movements, I did not follow any artists, but with my growing interest in this theme, of course, I looked at shooting practices of these dynamics worldwide. I can single out the work of Vadim Stein as special, not a stereotyped vision of movements and angles.

What process do you go through to create your work? What inspires you?

The choice of movement is made in different ways. Sometimes it comes before the shoot and I tell the model how I want to convey it. Sometimes the model makes free movements according to their feelings and we catch an interesting moment and refine it in detail.

What might people be surprised to know about you (or your work)?

These are not sculptures or 3D graphics in my artwork—these are people who love art.

What question do you wish I had asked you?

Who do you create your art with?

What is your answer to that question?

First of all, these are people who are not indifferent to art, they are ready to work on a shot, and I help bring them to perfection. These are ballerinas, gymnasts, circus artists, dancers, all those to whom I am infinitely grateful for their contributions to my work. The vision is developed, and during shooting, I partly become a choreographer of performances and movements, which are often contrary to the basic principles my models studied.

OPPOSITE PAGE,
TOP
No64 SPIRIT Series

OPPOSITE PAGE,
BOTTOM LEFT
No74 SPIRIT Series

OPPOSITE PAGE,
BOTTOM RIGHT
No25 SPIRIT Series

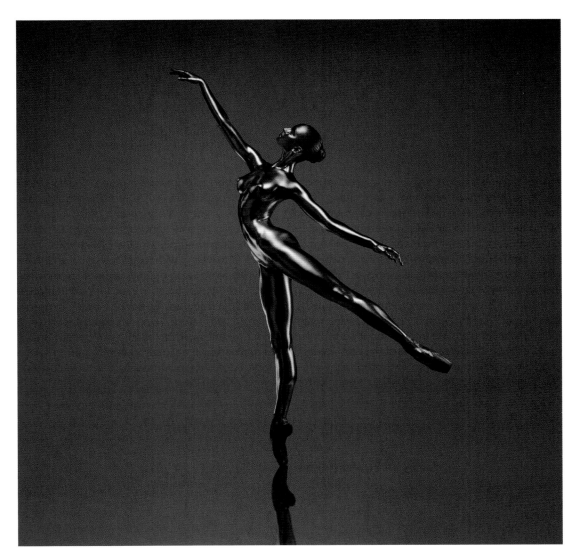

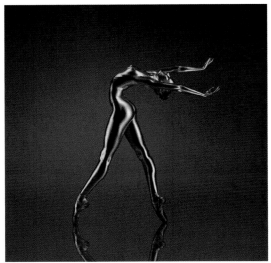

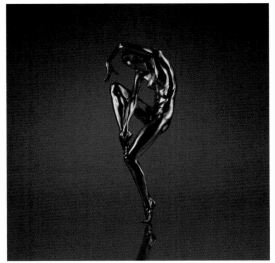

PIPPA SAMAYA

Pippa Samaya is an Antwerp-based photographer/filmmaker with two overlapping specializations of practice: dance/movement, and humanitarian documentaries. Awards include two-time winner of the International 60-Second Dance Film Competition (Denmark/Finland); two-time winner of an Australian Dance Award for Excellence in Dance on Film; a double win at the SALON exhibit at Center for Contemporary Photography (AU); Best Film at FAD Film Festival (US); the Berlin motion picture festival (DE); the International portrait film festival (BUL); Best Music Video at the NIMA awards (AU); finalist in the National Photography Prize (AU); the Ballarat International Foto Biennale; the Association of Photographers (UK) awards; and the IRIS portraiture prize. Samaya has worked extensively with the dance and portrait industries in Australia, New Zealand, and Europe. Her humanitarian documentary work evolved from several years of traveling with NGO OneVoice and visiting a Syrian refugee camp in Greece. Since moving to Berlin in 2019, Pippa has worked for the International Women* Space as its documentary filmmaker, working with refugee and immigrant women. Her most recent work includes a dance film and live performance in collaboration with performer Tara Jade Samaya, presented by the Staatsballett at the Komische Oper.

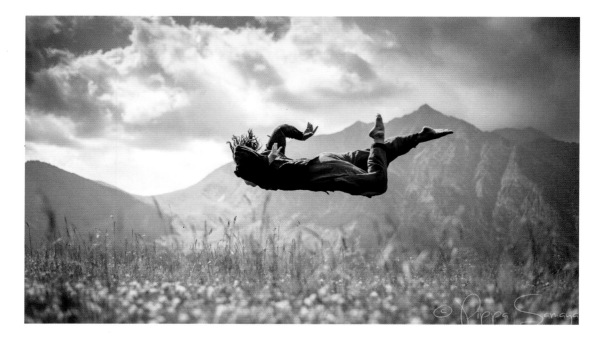

ABOVE
Life of Birds
Featuring Tara Jade
Samaya, Spain

OPPOSITE PAGE
Tree Hugger
Featuring Paul Vickers
and Tara Jade Samaya,
Germany

Website: pippasamaya.com
Instagram: @pippa_samaya

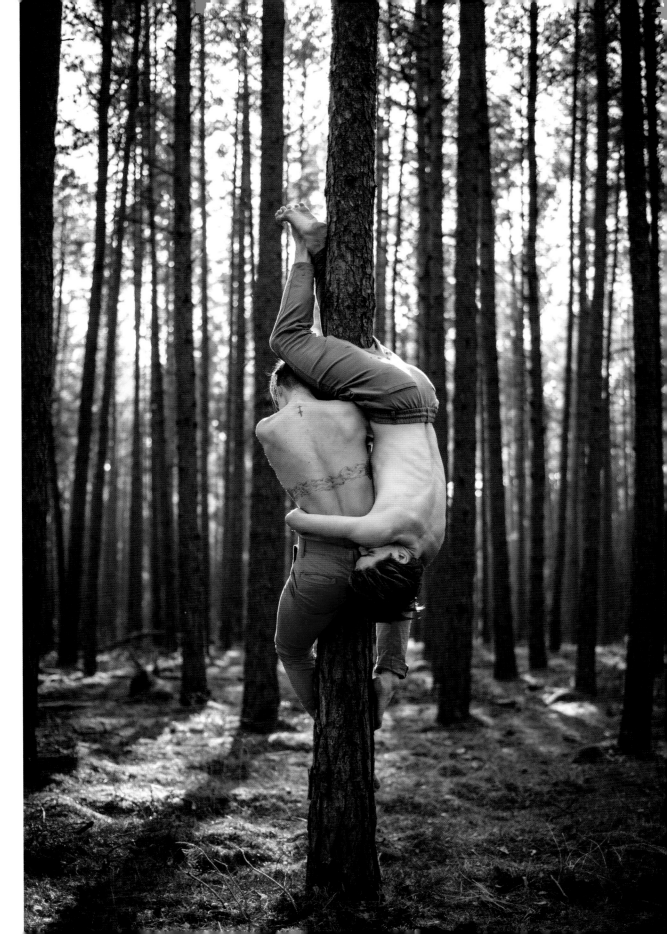

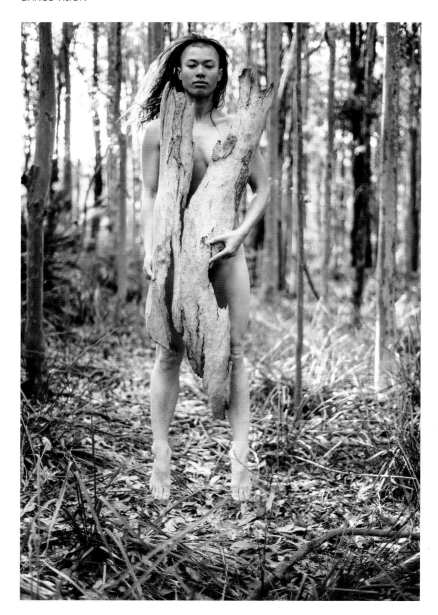

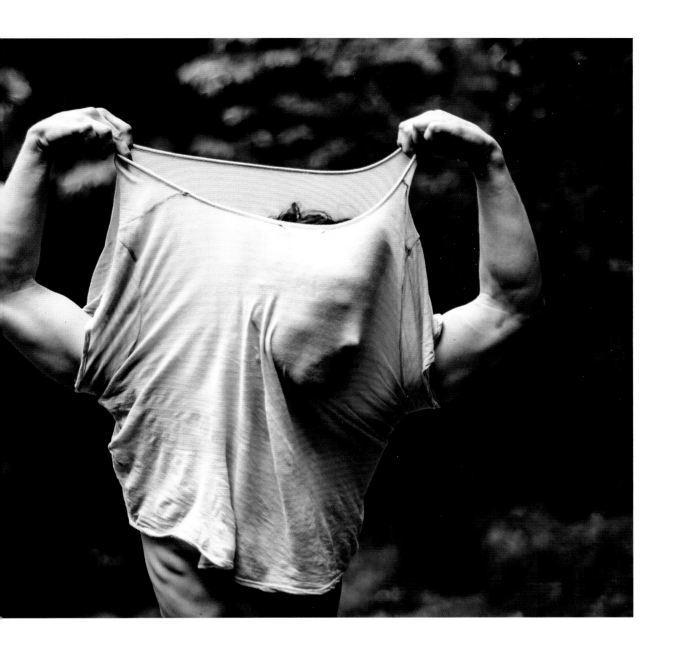

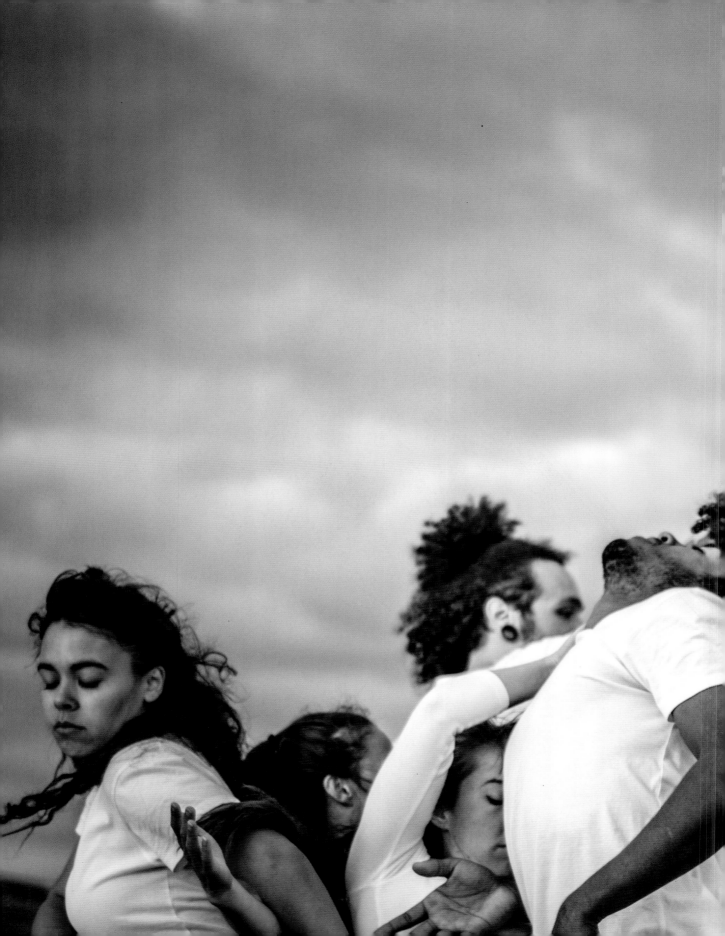

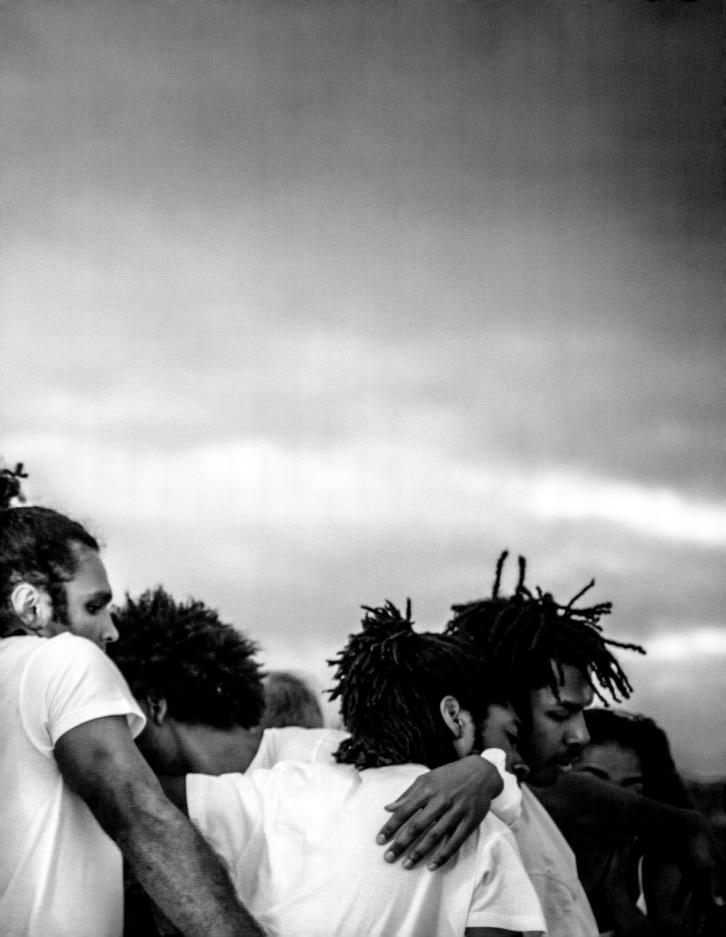

What makes it possible for you to create the art you want to create in your life?

I am very blessed to have been born into a time and place in the world where I have the freedom, as a woman, to follow my dreams and my intuitive creative pathways. Additionally, I had two parents who taught me that if I want to create something in/with this life, the only person who can really make it happen is me, which is an incredibly empowering and motivating thing to understand and work with. I see this privilege as both a gift and a responsibility, to be a voice for those who don't have the opportunities I do and to find a way to speak to the vast spectrum of what it means to be human on this earth.

What will you leave behind as your legacy?

I hope my legacy leaves behind a timeless collection of beautiful, heartfelt moments shared between humans, illustrating the dance of life in all its colors, confronting, inspiring, hopeful, and full of emotive charge. I hope through my images I can inspire people to dance more, live more, love more. and feel more. To not be afraid of the shadows, but to greet them as [an] integral part of ourselves, and empower them to stay curious, even in the darkness, and discover the ability to choose a positive perspective, and ultimately surrender fully to the glorious mystery that this life is.

What attracts you to dancing bodies?

With an insatiable curiosity for the complexities of the human experience, a specialization in dance photography stemmed from the discovery that dancers provided a deeply empathetic physical vessel, which enabled me to communicate through external imagery the internal world of the human psyche. A single moment frozen of a dancer in full embodiment can illustrate such deep insights into what it feels like to be human.

When and why did you start incorporating dance into your work, and what do you feel dance brings to it?

I started working with dancers early on in my career; I believe the first time was in second year of university. Once I discovered dance and dancers, there really was no going back. I think dance adds something truly alive, organic, authentic, and incredibly raw. There is a real vulnerability and at the same time an immense strength, courage, and grace, all of which really amount to all the things I most wish to inspire in others and embed into my work.

Are there any works of art by other artists featuring dance that have inspired you?

Early on I came across the incredible work of Lois Greenfield through her collaboration with a prominent dance company in Australia, Australian Dance Theatre (ADT). Her work continues to blow my mind, and even though we have quite different aesthetics and approaches to dance photography, she was definitely my introduction to what could be possible working with dancers and a great source of inspiration.

What process do you go through to create your work? What inspires you?

I am inspired by all sorts of things. Sometimes it's the urge to be a voice for the forest that's just been logged, sometimes it's fueled by the passion to raise awareness for gender-based violence, sometimes it speaks to the spiritual path of how to learn to let go of control and understand the perfection in our imperfection, and sometimes it's simply fueled by an aspiration to remind us all to

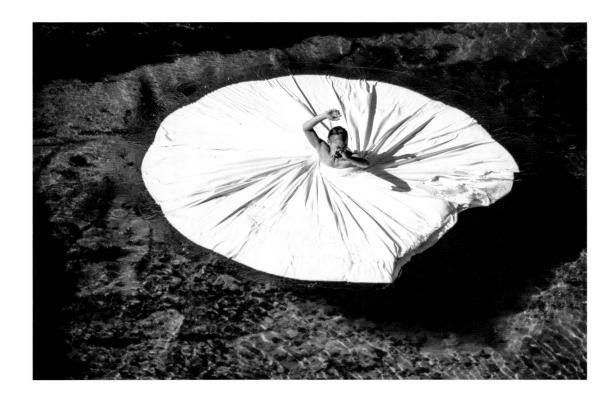

remember to actually have fun, play, and enjoy life! While color, design, and hints of surrealism are pillars in my work, what really fascinates me is finding new ways to create experiences for people, help them strip away their defense layers, let go, connect with the present moment and the world surrounding them, to capture and share something truly raw and human.

What might people be surprised to know about you (or your work)?
What is surprising about my work. Hmmm. Perhaps the degree to which I myself join the dance that I capture, both energetically and physically. I am very intuitive and rely very little on planning, scheduling, or structure. Rather, I prefer to keep things simple and organic as much as the circumstance allows.

What question do you wish I had asked you?
Hmmmm. Perhaps a question that revolves around what dance itself can offer us (beyond incredible imagery!).

What is your answer to that question?
Dance is a vessel of explosive expression. Dance is a primordial energetic release. Dance is a connection to the energy that makes up the essence of every being in this universe. It is about using nothing but the rawest of materials—our own body, our senses, our mind, and our soul—to express our emotions, thoughts, and experiences as a human. It is this natural instinct of the individual which bonds and connects us as a whole. Twisting and twirling in colorful transformations, it travels across all countries and cultures alike. I believe it to be one of the most easily accessible and most powerful tools of healing available to us.

ABOVE
Often
Tara Jade Samaya, Australia

HOWARD SCHATZ

Schatz's fine artwork is represented in galleries in the United States and abroad. He has made extraordinary images for such advertising clients as Ralph Lauren RLX, Escada, Sergio Tacchini, Nike, Reebok, Wolford, Etienne Aigner, Sony, Adidas, Finlandia Vodka, MGM Grand hotel, Virgin Records, and Mercedes-Benz.

Website: howardschatz.com
Instagram: @howardschatz

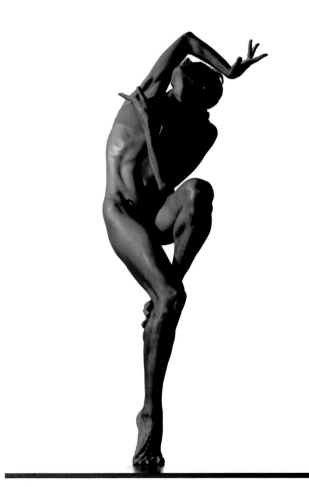

RIGHT
Dance Study 1340
Danica Paulos

OPPOSITE PAGE
Dance Study 1378
Chikako Iwahori

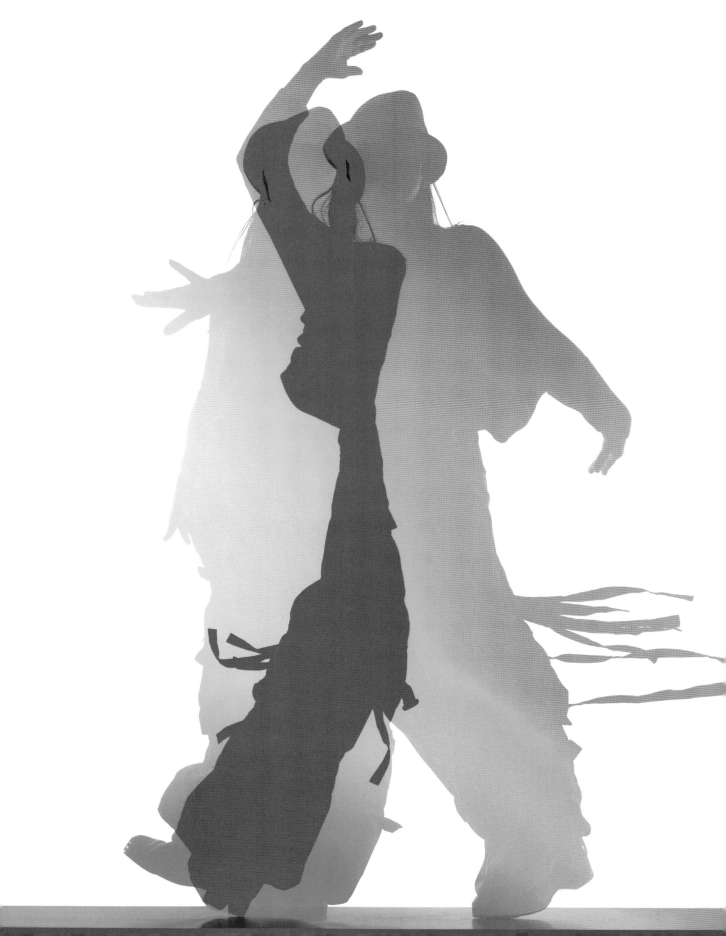

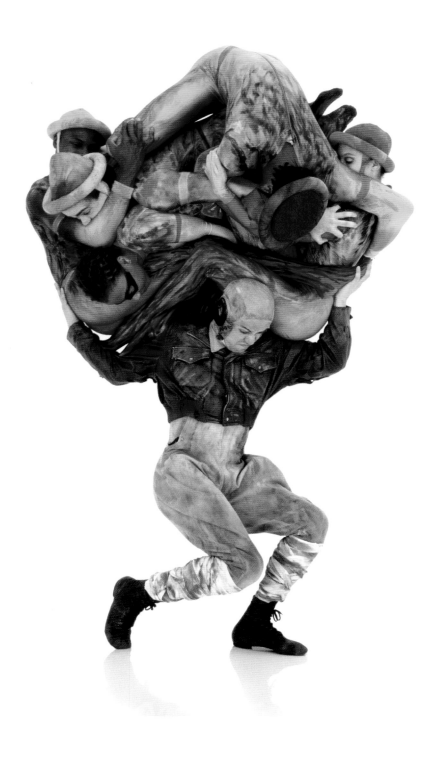

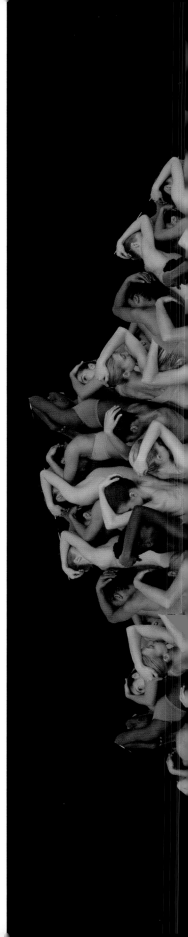

ABOVE
Pilobolus 04

OPPOSITE PAGE
Dancers Flower 004

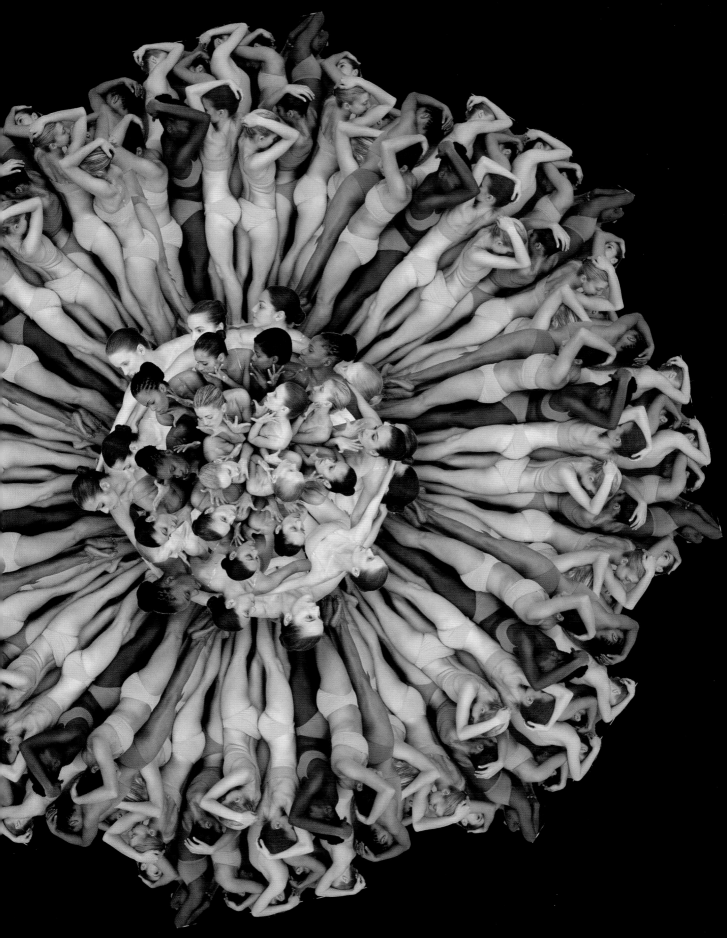

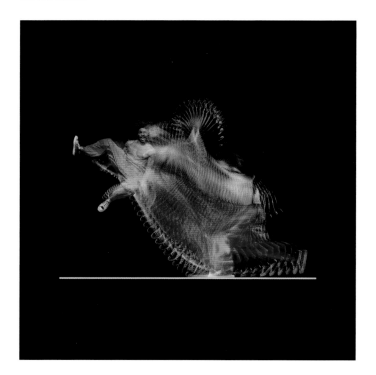

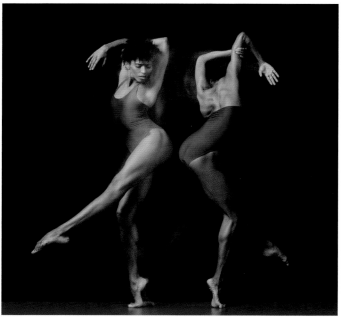

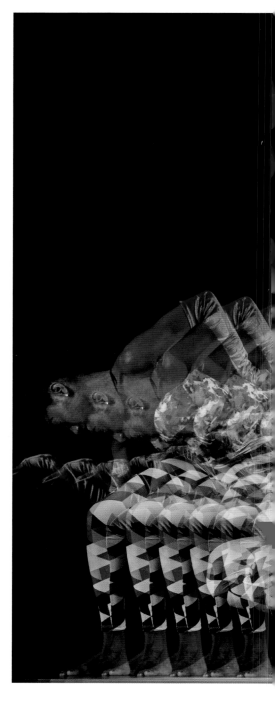

TOP
Motion Study 1188

BOTTOM
Dance Study 1328
Jacqueline Green-Alvin
Ailey American Dance
Theater

OPPOSITE PAGE
Dance Study 1423
Antonia Raye

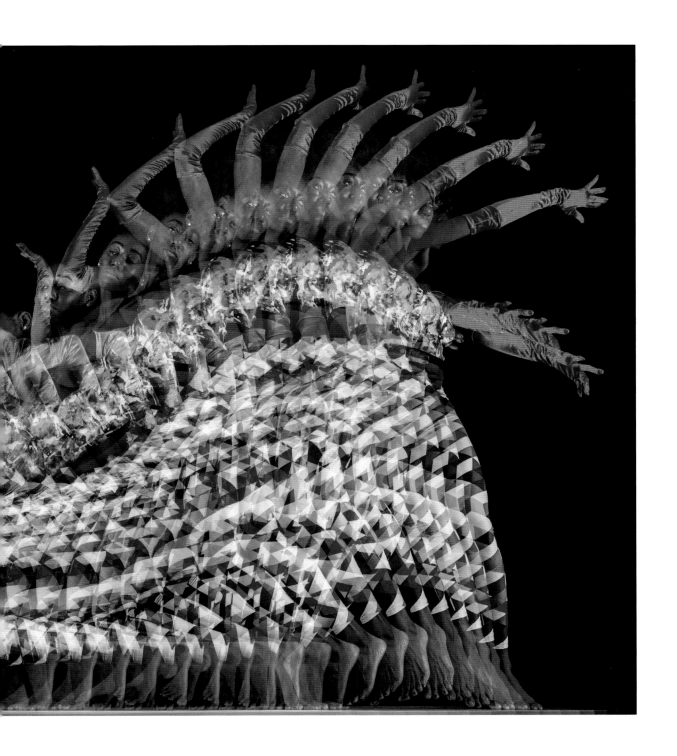

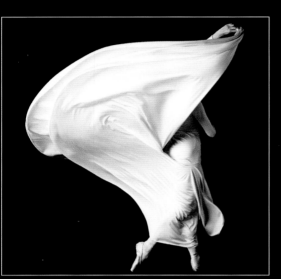
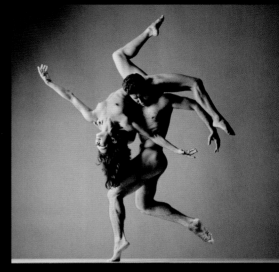
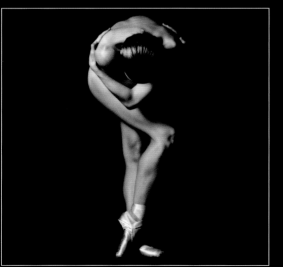
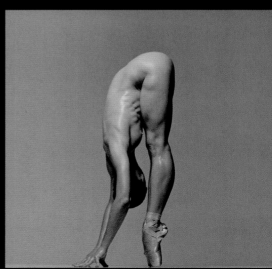

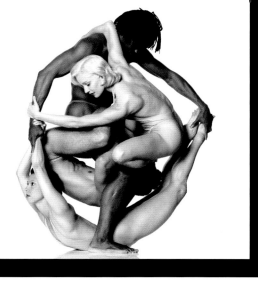
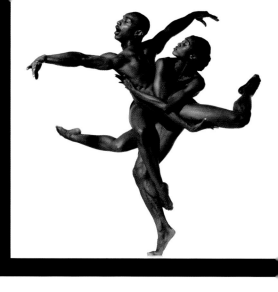
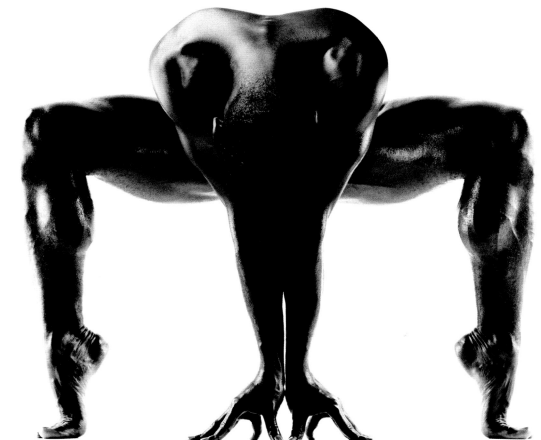

What makes it possible for you to create the art you want to create in your life?

I photograph to surprise and delight myself. It is a treasure hunt, a constant seeking to make imagery that I have never seen before. In art, repetition is abhorrent. My work is informed by the desire to create imagery that is truly new to me and to any human eye.

What will you leave behind as your legacy?

Legacy is not important to me. I want to feel an emotional impact from my work. When this occurs in others, it is a bonus. But it is not my primary concern.

What attracts you to dancing bodies?

I have always been fascinated by human beings: their emotions, intellect, and physical being. Finding new ways to see the body is a special adventure. I have attended dance performances for most of my adult life and continue to find dance fascinating and exciting.

Are there any works of art by other artists featuring dance that have inspired you?

I find the work of other artists compelling and inspiring. It is so interesting to me as to how human beings see things in front of us so differently and interpret originally. I study the work of other

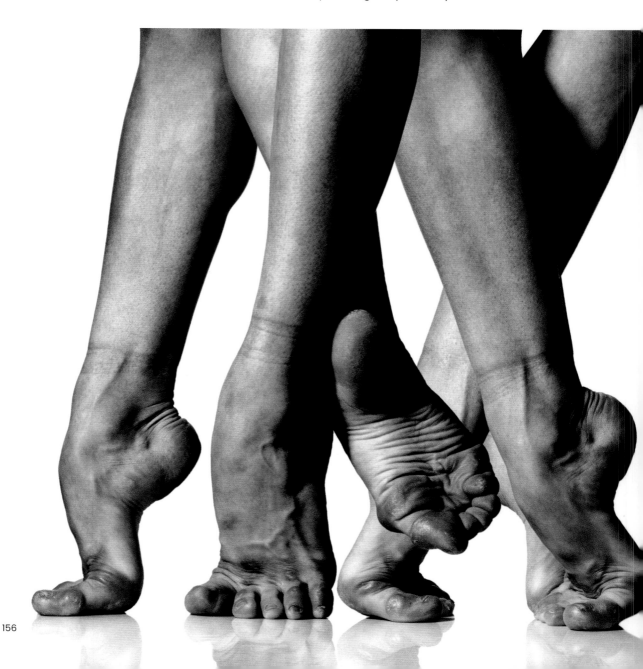

creatives and I carry a notepad and frequently, constantly, jot down ideas. When I see or read something that is a fresh thought or visual idea, I write it down. I also keep a vast image data bank through books and screenshots.

What might people be surprised to know about you (or your work)?
I don't know that there is anything particularly surprising about me other than the fact that I am constantly, unrelentingly, tenaciously, persistent.

What question do you wish I had asked you?
Where do you find joy in your process of making art?

What is your answer to that question?
For me, the joy is in the journey, a journey that is vast and endless.

BOTTOM
Feet
Paloma Herrera ABT

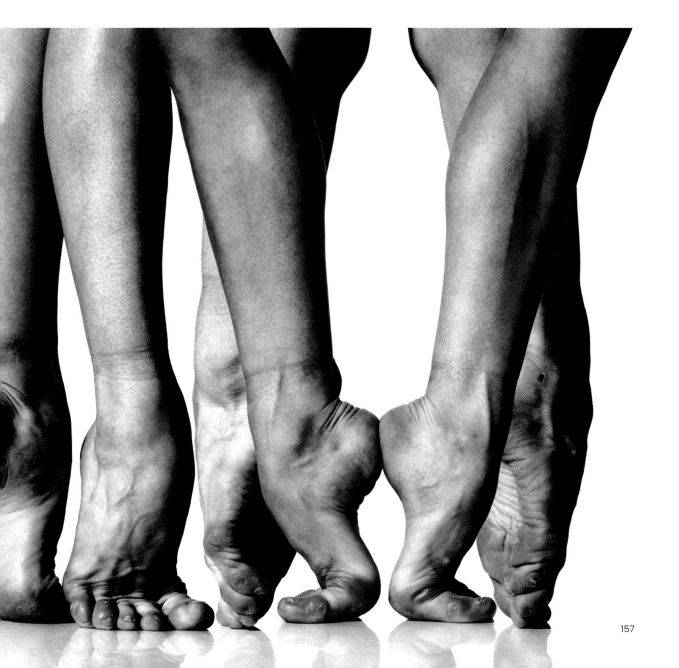

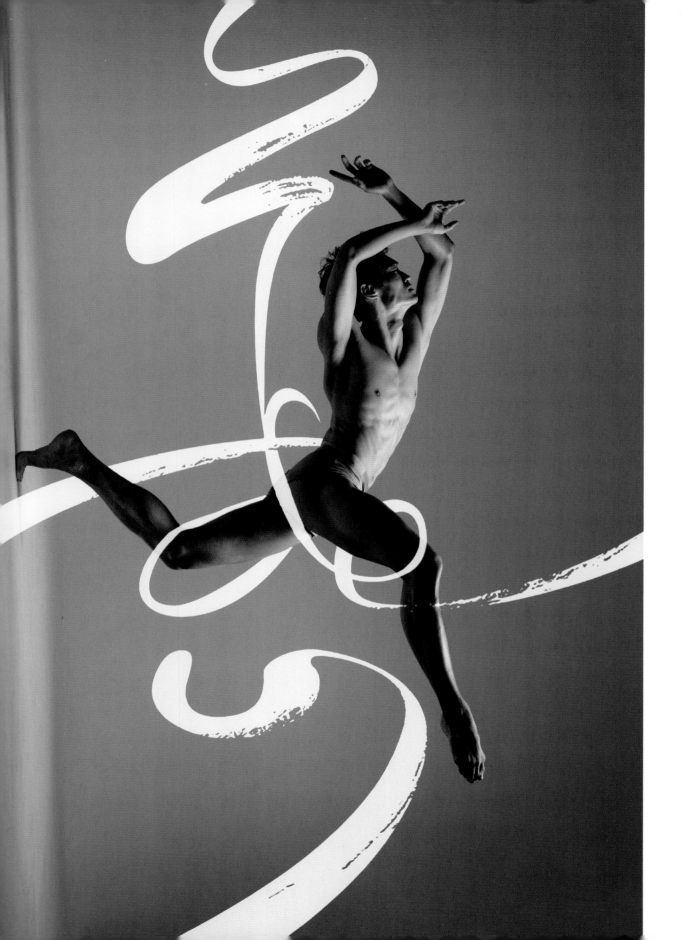

ALICE TIKSTON

Alice Tikston, a photographer from St. Petersburg, is a winner of international competitions and a member of the National Union of Professionals of the photo sector and the Federation of European Photographers. She's been involved with photography since 2014 and works with star dancers of Russian ballet from the main theaters such as the Bolshoi, Mariinsky, Stanislavsky and Nemirovich-Danchenko, and Eifman Ballet.

"My photos tell what I am silent about. They are more about me than about dancers, but without dancers it would be impossible. A photo is the sum of how a photographer looks at a model and how she looks at him."

Website: behance.net/atikston

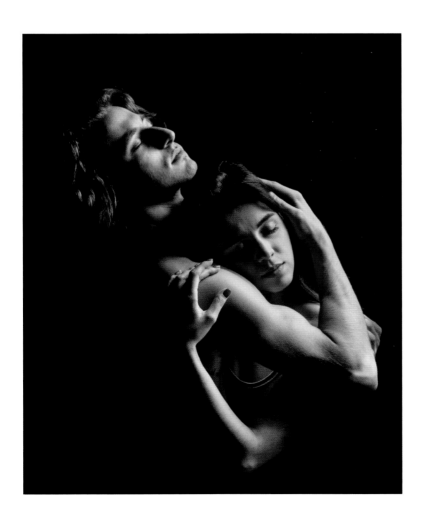

OPPOSITE PAGE
Kimin Kim, principal dancer at Mariinsky Theatre

LEFT
Harmony
Anastasia Limenko, principal dancer at Moscow Stanislavsky Music Theatre & Evgenii Zhukov, leading soloist at Moscow Stanislavsky Music Theatre

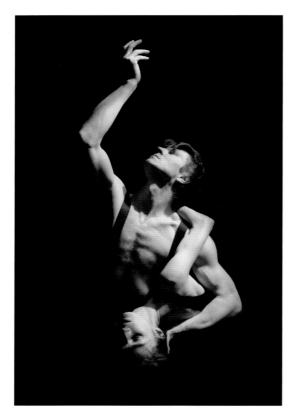
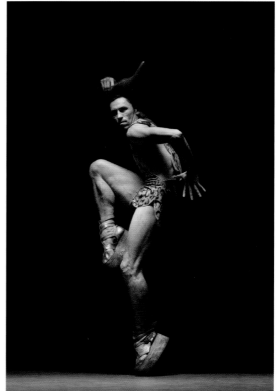
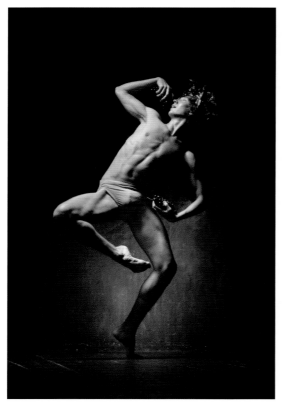
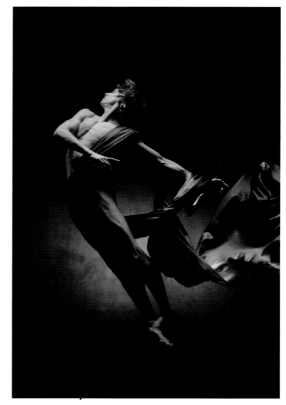

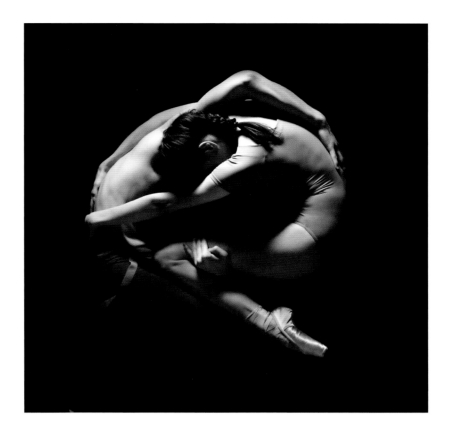

OPPOSITE PAGE, TOP LEFT
Alla Bocharova & Denis Klimuk, principal dancers at Saint-Petersburg State Academic Leonid Yacobson Ballet Theatre

OPPOSITE PAGE, TOP RIGHT
The Faun
Igor Kolb, principal dancer at Mariinsky Theatre

OPPOSITE PAGE, BOTTOM LEFT
Bacchus
Leonid Leontev, soloist at Moscow Stanislavsky Music Theatre

OPPOSITE PAGE, BOTTOM RIGHT
Caesar
Xander Parish, principal dancer at Mariinsky Theatre

THIS PAGE
Svetlana Savelieva, dancer at Mariinsky Theatre & Alexey Shmetoev, dancer at Saint-Petersburg State Academic Leonid Yacobson Ballet Theatre

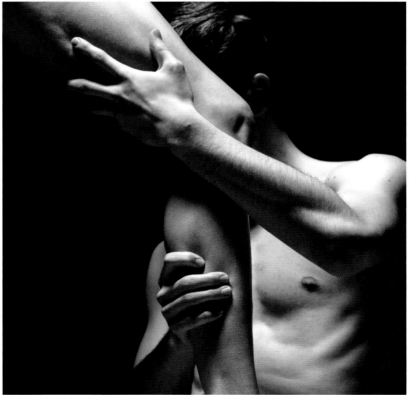

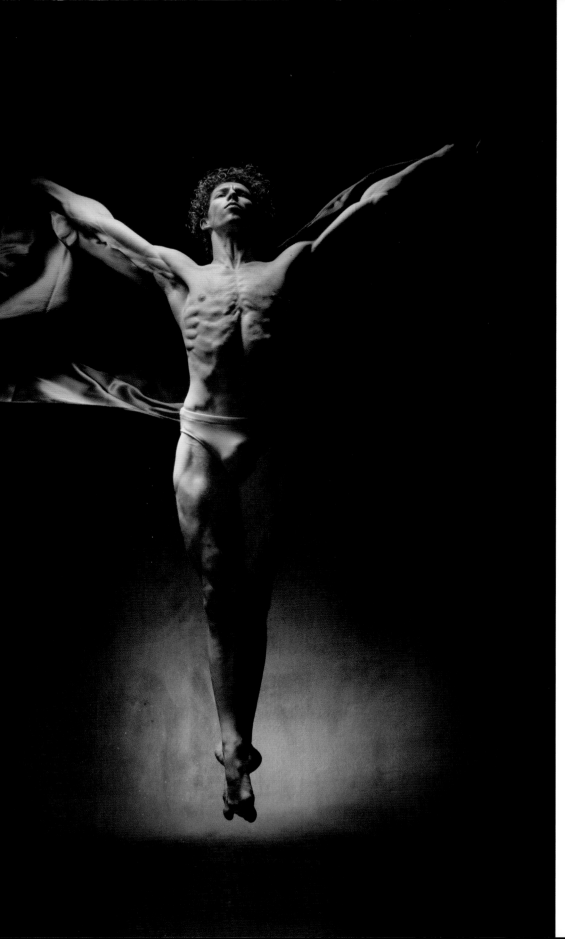

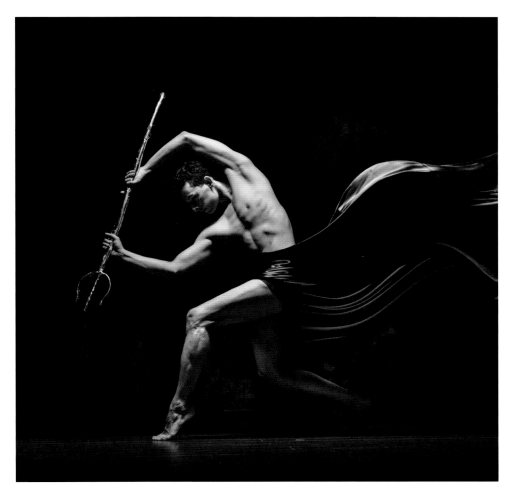

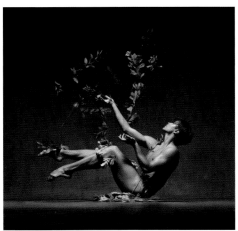

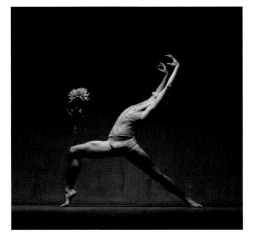

OPPOSITE PAGE
Apollo
Daniel Rubin, leading
soloist at Eifman Ballet

TOP
Neptune
Zachary Rogers,
first soloist with the
Stanislavsky Ballet

BOTTOM LEFT AND RIGHT
God of Love
Artem Ovcharenko,
principal dancer at the
Bolshoi Theatre

What makes it possible for you to create the art you want to create in your life?

There are many obstacles on any creative path, but curiosity, imagination, analysis of my work, perseverance, and support of my family and friends help me.

What will you leave behind as your legacy?

One day, I will be able to answer this question, but it's too early to judge. Now I'm only looking forward. I am interested in going beyond ballet. I want to work with different directions of dance, with athletes, actors, models, and other interesting people. I want to study how people move, how they perceive their body, how they feel it. I want to shoot not only the perfect body of a ballerina but also find beauty in every type of figure in different ages. There is a lot to learn from people and what to tell about them. There is still a lot of work ahead, and in time, we will see where it will lead me and what I will leave behind as my legacy.

What attracts you to dancing bodies?

A model is more than a beautiful body. For me, it is important to combine all elements: the character of the dancer, his body, how he moves, his attitude, my point of view, ideas, feelings, and intuition. If all this works, then I have a chance to shoot the perfect picture. I decide that a photo is successful if it tells the viewer more than I can describe in words.

When and why did you start incorporating dance into your work, and what do you feel dance brings to it?

I don't shoot dance, I shoot dancers and what I think about them. For me, working with them was a most unexpected decision, because I have never been engaged with and was not interested in dance. I tried to shoot the dancer as an experiment, and it was a good coincidence. A year later, I found that I was shooting only ballet. I like finding out how to make my work even better, finding a lot of interesting ways to study and grow. Working with dancers taught me to speak through photography, and it helped me to understand what I want to say and why I shoot. Their artistry and physical abilities give me the opportunity to go beyond the correct classical ballet poses and to tell my own stories.

Are there any works of art by other artists featuring dance that have inspired you?

If I consider the most important moment about dance, then it was meeting with photographer Vadim Stein. He was the only artist whose works were close to me. Due to his support, I believed in myself and realized in which direction to move.

What process do you go through to create your work? What inspires you?

Ballet is an important basis in my work, but I take inspiration from other places. I find ideas by mixing dance with other topics. I am inspired by sculpture, art history, theater, cinema, music, fashion, design, the contrast of modernity and classics. I like to learn new things, listen to lectures, and watch documentaries. I learned to draw, and it was also a very useful experience. I believe that any knowledge will be useful in work and the more of it, the better. I can even be inspired by random found objects, which then will become stuff for shooting.

On shooting, I like to feel myself as a director who creates a story within a single freeze-frame. I make sketches, pay a lot of attention to the preparation, choosing of model, [and]

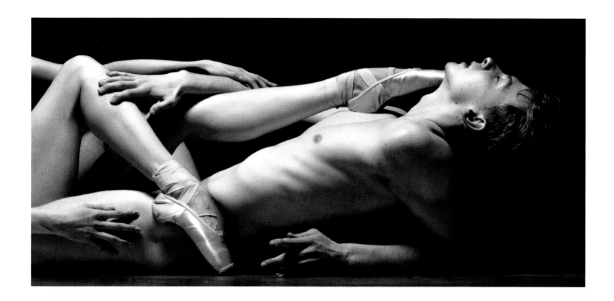

imagine poses and ideas by myself. But the result is strongly influenced by intuition, mood, our relationship with the model during shooting, and her vision of our idea. Photography is limited to one moment, so I use body language and pay a lot of attention to working with poses, details, and their meaning. In my favorite photos, the rotation of the body, the position of the head, and the direction of the brush all are important. They all talk about something. I have no choreographic education, so my method of working with a pose is based on my own observations and conclusions; it is very intuitive and original, and I rely only on my feelings and ideas. Very simple objects like ropes or a branches become props. I see more potential for ideas, interaction, and interpretation in them. And of course, light is important for me. I start working only when I am satisfied with the light. Without good light, there will be no good frame.

What might people be surprised to know about you (or your work)?

I like to experiment and work with my hands. For example, making a filter out of glass and nail polish, smearing the model with colored clay, mixing different techniques, cutting and painting printed photos, scratching the negative and printing from it, scanning objects on a home scanner, and sprinkling salt on photo paper during exposing. I am interested in all options for manual printing. I do what comes to mind and use everything that is at hand. This often gives interesting results and at least pleasure from the process. And I also keep strange items that may one day be useful on the set. I have stuff like medieval dresses, crossbows, whips, small things from a flea market, fragments of broken mirror, and a huge branch that I brought from the forest.

What question do you wish I had asked you?

How was I influenced by working with dancers?

What is your answer to that question?

I became more confident as an author. Working with artists has influenced not only my perception of photography but also my perception of the human body. Over time, I got used to speaking through the model's body. For me, they are like marble for a sculptor.

I have been watching dancers for many years, working closely with them, and at work I often show poses by myself. As a result, I think not only about what I see, but also about what I feel. Finally, I wanted to establish a relationship with my own body. I took up sports and dancing. It would seem a small step, but for me it is important. I stopped being an observer and added a physical experience to the visual one. Working with artists has a much greater impact on me than I could have expected.

ROB WOODCOX

Rob Woodcox is a fine art and fashion photographer who divides his time between Mexico and the United States. Rob's passion for art has developed into a dedication to advocacy; he has produced projects raising consciousness and conversation around the US foster care system and adoption, queer identity, body neutrality, racial equality, and environmental justice. Having been adopted as a child and interacted with the foster care system, Rob creates from a unique perspective, finding hope in human connection and the will to overcome negative constructs within our complex societies.

In 2013, Rob went through his own "coming out" experience, a societal passage only necessary because of the lack of education and acceptance within the greater population. Though a challenging and demanding experience, Rob used this energy to pursue his photographic goals full time and began touring the world teaching workshops and creating sponsored content. Rob has taught thousands of students in six continents, fifteen countries, and thirty-four cities worldwide. He has been featured in various major publications and exhibitions and has produced commercial work for clients like Universal Pictures and Capitol Records. In 2020, Rob released his first photographic art book, *Bodies of Light*.

In October 2021, Rob made his first debut as a film director with the art piece *We Are Molecular*, in partnership with Dr. Barbara Sturm and the Royal Ballet in London. He continues to embark upon new endeavors in both still and moving images.

Website: robwoodcox.com
Instagram: @robwoodcoxphoto

OPPOSITE PAGE
High Noon
California, USA, 2018

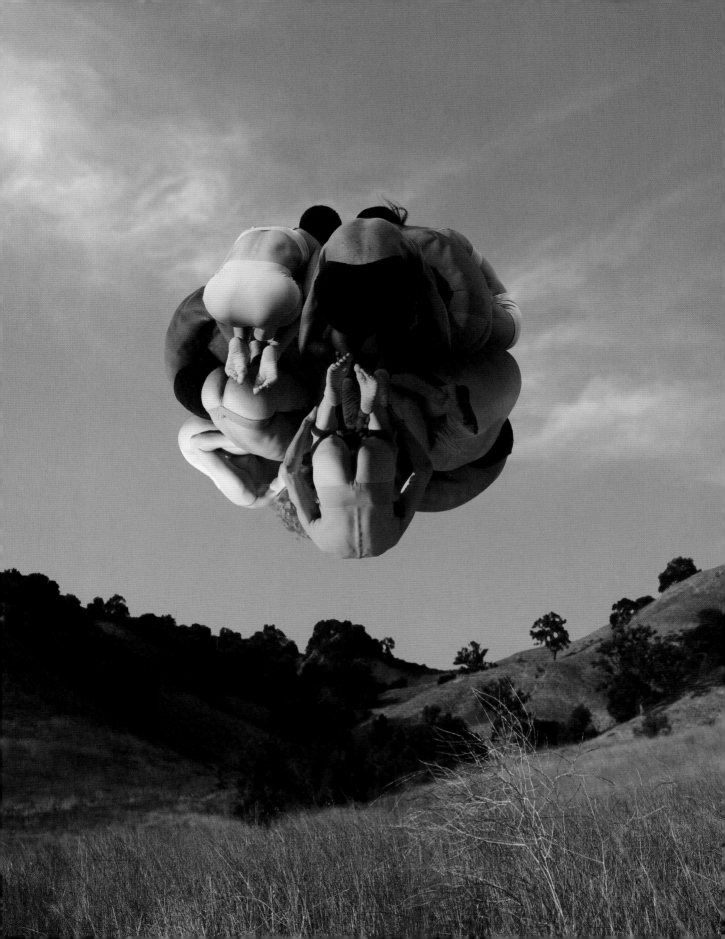

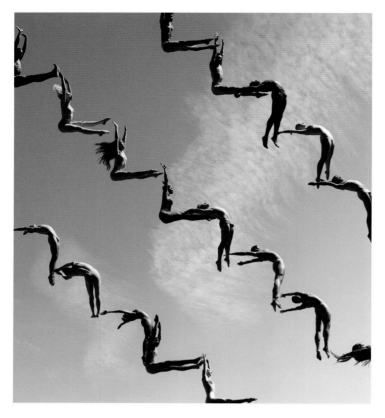

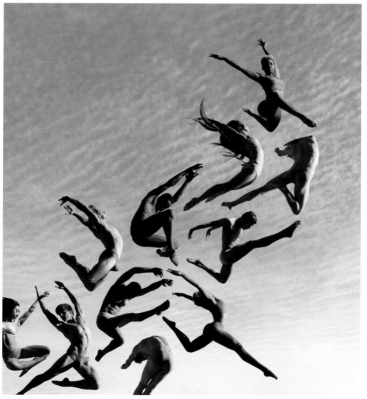

TOP
Sky Climb
California, USA, 2019

BOTTOM
The Wave
California, USA, 2019

OPPOSITE PAGE
Spontaneous Creation
Alaska, USA, 2018

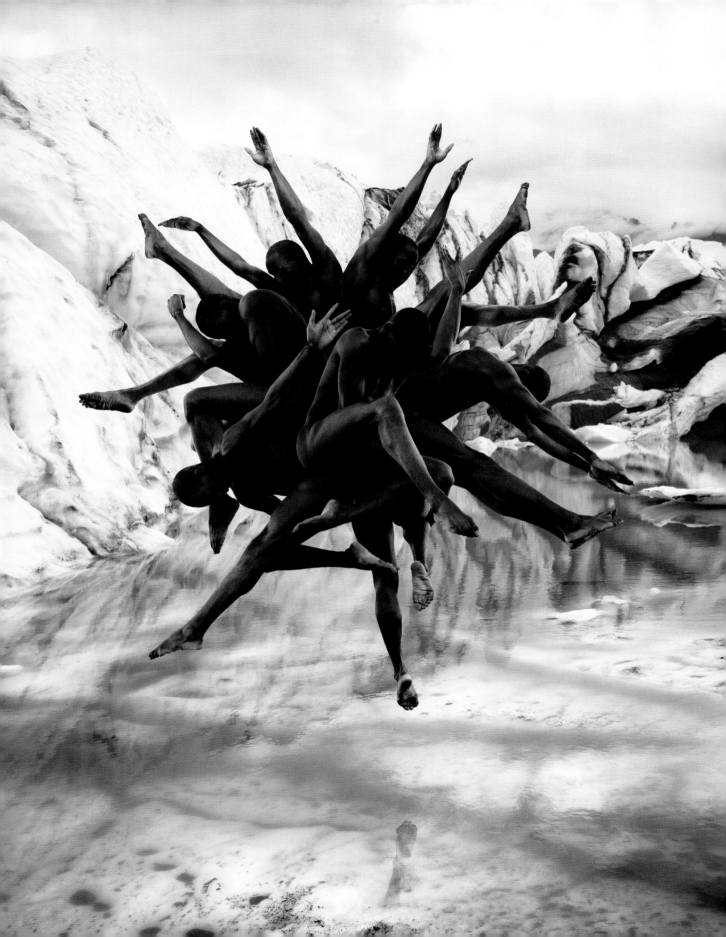

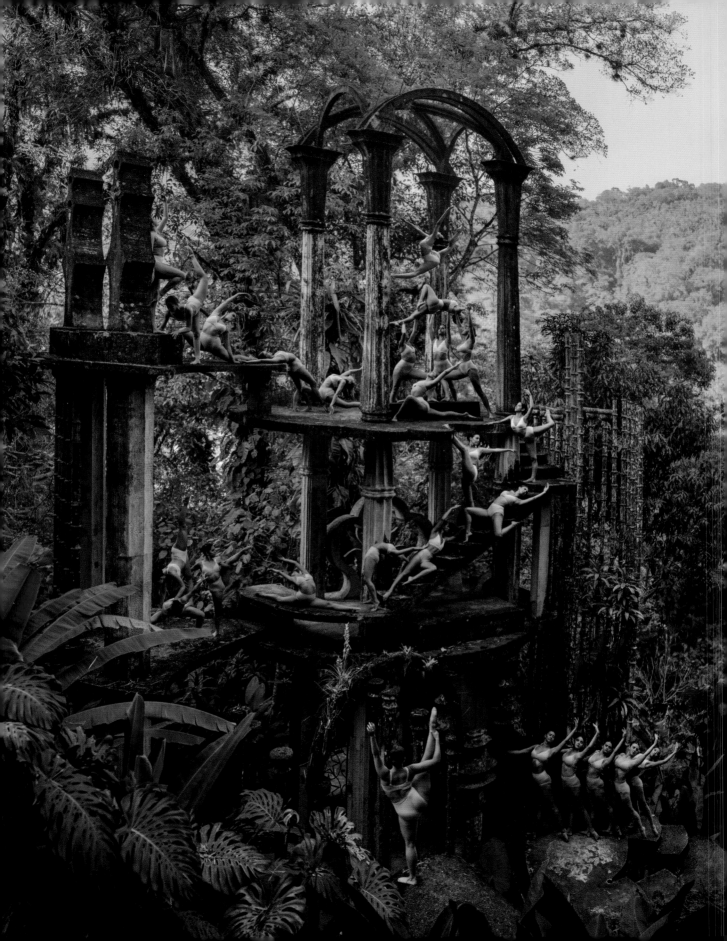

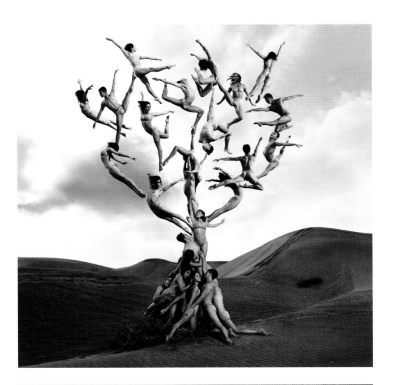

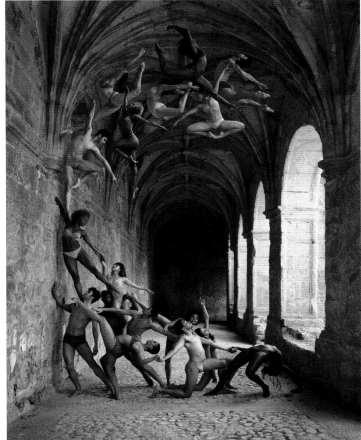

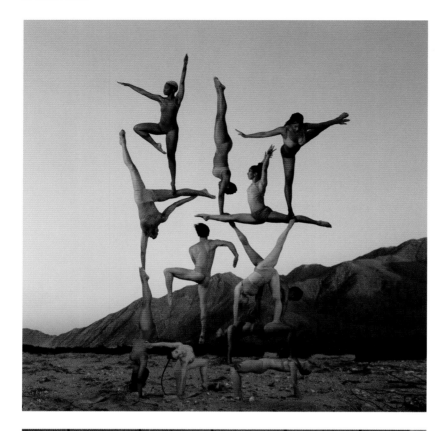

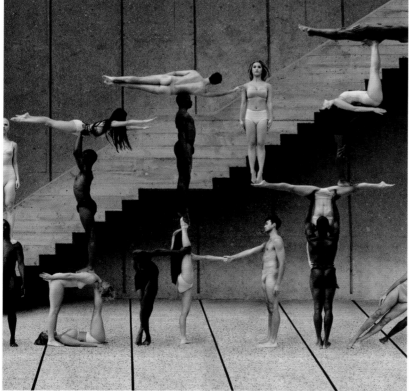

TOP
The Tower
California, USA, 2019

BOTTOM
Human Tetris
California, USA, 2018

FOLLOWING SPREAD
Unity
California, USA, 2018

What makes it possible for you to create the art you want to create in your life?

I would say my survival depended on creating what I longed to create in this life. I think a lot of people can put on a show and do what is expected of them, but it was never that easy for me in this complex society. I always longed for something different, a world where my daydreams were reality and not just a fantasy. I guess I never gave up on my inner child. I let that part of me continue to grow when I was told to "get a real job" or that I'd "never make money" by family, teachers, and other influential people in my life. All of that pressure built up until it was either sink or swim, and so I decided it would be a triathlon. I'd swim, run, climb, and fight until I made it, and that is what I have continued to do. I don't think there could be anything more satisfying than to know you put your all into something and that it made a difference.

What will you leave behind as your legacy?

I would hope it's too early in my life to know what my legacy will be. I always joke with my friends that we're a one hundred club and that we'll all live to be over a hundred. That means I'm not even one third of the way through my life. However, I hope my work will make a great impact on social and environmental education, expanding the boundaries of acceptance for alternative and queer identities, and helping to apply healing to the damaged planet we're living on.

What attracts you to dancing bodies?

People who use their body to move attract me because they spend their lives learning to express in the most unique ways. Their entire being becomes their palette, and I find transmitting stories through this physical intelligence to be the most fluid creative experience. My imagination produces many images of grandeur, often involving human structures and movement; dancers are the perfect pairing for these larger scale productions. It started in my younger years when I was starting to experiment with making people levitate and pose in realistic but unusual ways; I had the privilege to work with a trained dancer and I immediately got the results I had imagined. I haven't looked back since, and have developed various bodies of work in partnership with dancers.

When and why did you start incorporating dance into your work, and what do you feel dance brings to it?

It wasn't until 2017 that I intentionally made a shift to work consistently with dancers. Trump had been elected to office the previous fall and I watched my country fall into chaos as his divisive rhetoric became celebrated from a position of power. Meanwhile, I saw all of my communities rise up and fight back, taking to the streets and organizing counter-movements to harmful policies and laws. This unifying event brought me visualizations I'd never had before of people lifting each other up and growing as a unified entity. The first images from my Bodies of Light dance series were born in May 2017 on a rooftop in New York City. I had verbalized all these thoughts and emotions to my friend who wrote plays and had shows off Broadway; their closest friends were all dancers throughout the city, from the Joffrey and American Ballet to Cirque du Soleil. Within a few days I had a crew of ten dancers at my whim and that series began.

Are there any works of art by other artists featuring dance that have inspired you?

I have always been attracted to dancers and choreographers like Pina Bausch, Damien Jalet, and Parris Goebel. Their highly emotional, bizarre, and human expression connects to me instantly like nothing else I've seen. There are also many painters like René Magritte and Frida Kahlo that inspire me with color, concept, and form. Many of my visuals come directly through meditating on subjects of importance to me. I've spent a lot of time in natural expanses since I was a kid. I have backpacked into remote areas since I was fourteen. I wasn't allowed to watch much television and didn't know a lot about magazines and pop culture when I was growing up, so I invented my own worlds instead. I suppose many of my first profound encounters with dance were as an early adult as my community expanded beyond my hometown. As I discovered the possibilities of human expression and creativity, I would experiment with pushing my own technical and conceptual boundaries. Dance invigorates me and makes me feel the most alive. Seeing a dancer breathe and pulse as they flow effortlessly in tune with their body—it's ecstasy.

What process do you go through to create your work? What inspires you?

Every piece of my work starts with conceptualization. I often sit in bed, on a cliff, next to a tree, and write out the wanderings of my mind. I have massive note archives with concepts I'd like to create some day. It's an important part of my process to create from meaningful thoughts or ideas. Once I've landed on a concept for personal or client purposes, I move into pre-production. This involves location and talent scouting, acquiring a beauty team when necessary, and translating my mental images to a mood board for the team to digest. I'm inspired by emotions, nature, architecture, dance, design, human connection; really anything can spark inspiration if I become enamored with it. When I travel with friends, they often comment on my genuine awe of the world around me. I'm always the one stopping and pointing with my jaw on the floor, still fascinated by the simplest aspects of life. I try to put my love of the world around me into the art.

What might people be surprised to know about you (or your work)?

Many of my most prominent pieces have been created with little to no budget. I have been fortunate to develop a creative community as passionate as me about the importance of collaborative artistic work. My family was not from an arts background, so at seventeen I moved out and started my path to photography while working a minimum-wage job. I built my career from scratch and was diligent about getting my work seen online and abroad. It was only about three years ago that my work started paying off—this was about ten years into the journey. Until that point, I faced many difficult crossroads where I thought I would need to give up on my dream of being a full-time photographer. It just wasn't proving sustainable. Something inside pushed me to keep going; the tranquility of the process and the profound connection I had established with the world through my art couldn't be discounted. It was January 2019 when my dance series first started going viral, and it has been a surprising and extraordinary journey since then. I hope my own experience serves as an example to others that persistence does pay off. It can be an uphill battle in this society to pave your own road, but with the right community and focus, it can become the most rewarding life lived.

What question do you wish I had asked you?

What is the number one challenge facing the world that you hope to contribute change to through your art?

What is your answer to that question?

Climate change is the most pressing issue we face today, and while I know the subject can be heavy, I do believe there is hope to turn things around. As a global society we already possess all the solutions we need to restore balance to our vast ecosystems. I believe that if we spent less time fearing the subject, and more time celebrating and supporting the people already at the frontlines of progress, we could achieve our goals to plateau temperature rises, eliminate production of harmful materials like plastic, minimize overconsumption of meat, eliminate use of fossil fuels, and protect forests and oceans that have already been infringed upon too far. There are nations around the world like Costa Rica that have set the example for us all; by the 1980s the country was down to about 30 percent wild forests from 75 percent originally. Since then, they have returned to 60 percent forested land, with 30 percent of the entire country marked as protected land. Similar efforts of protection are happening all over the world to protect forests and ocean habitats. Three of my favorite organizations at this time are Justdiggit, who are re-greening vast portions of Africa; Only One, who are rolling out massive bills and protections for ocean habitats worldwide; and Amazon Conservation, one of the leading organizations on the ground in the heart of our planet's lungs, fighting to protect and regrow this invaluable ecosystem.

It took me quite some time to realize the power of my own artistic expression; the reality is that art is a language which crosses borders when spoken language can't. While some people respond to a speech, others respond to a beautiful visual that says more than words ever could. I have had the joy of contributing to causes larger than myself through my art, and I will continue to do so for the entirety of my life. It's important to note that our environmental crisis encapsulates all human crisis. If we don't learn to treat one another with love and respect, how can we ever hope to do the same for Mother Nature? I hope that my work with both social and environmentally driven causes will contribute to a new wave of interconnectivity that elevates every form of life on this Earth, to the benefit of all.

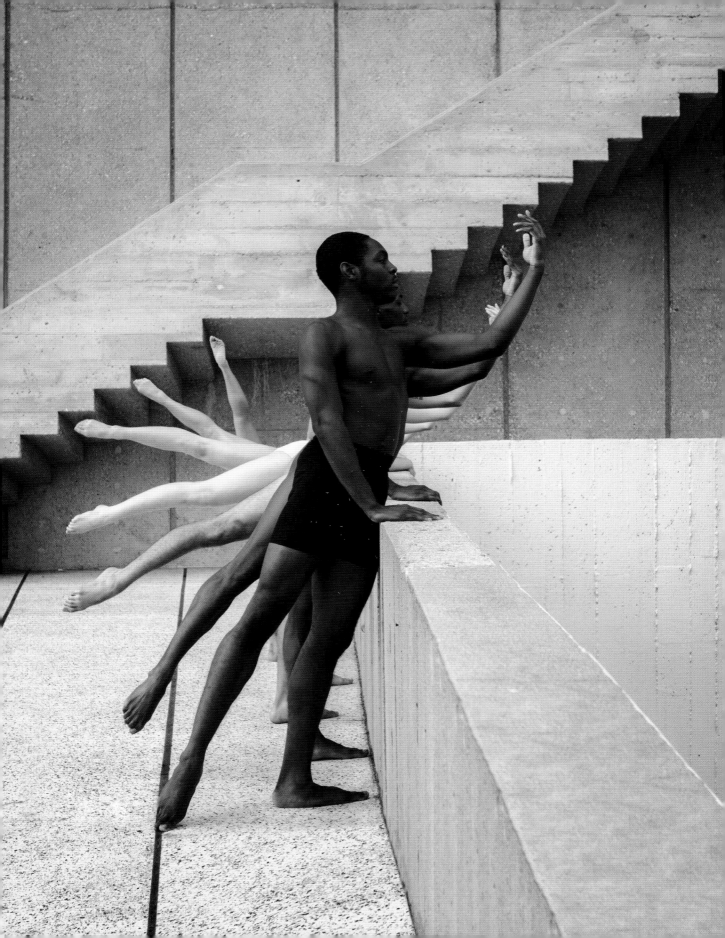

BRUSHSTROKES: PAINTING & ILLUSTRATION

LEFT
En équilibre
Gouache on paper, 2019

OPPOSITE PAGE
Sirène
Gouache on paper, 2020

What makes it possible for you to create the art you want to create in your life?
I was not an illustrator before, I became one five years ago. But the process of creation is deeply rooted in me and it made me overcome obstacles. I just allowed myself to become an artist.

What will you leave behind as your legacy?
Timeless poetry.

What attracts you to dancing bodies?
I am more interested in motion than in dancing itself. Illustration is a fixed image and I appreciate that every component of the image is in motion, that we feel that the body is moving, that the wind is blowing in her hair . . . it brings a form of lightness, of freedom, a sense of escape.

When and why did you start incorporating dance into your work, and what do you feel dance brings to it?
I incorporated dance very rapidly because motion is essential for me—that things are not unchangeable but in constant evolution.

Are there any works of art by other artists featuring dance that have inspired you?
I am a great admirer of Pina Bausch's work as a dancer and a choreographer. I've seen the movie Pina directed by Wim Wenders whilst visiting Berlin ten years ago. I did not know anything about her before and I felt in love with her work. Her choreographic splendors are breathtaking, with so many feelings that emerge.

What process do you go through to create your work? What inspires you?
I do not have a process that is clearly defined. Sometimes, a picture pops up naturally in my mind and I immediately know how to represent it. Sometimes, I just sketch it on my notebook, and I will leave it aside and come back to it a long time after because the idea has to evolve in my mind.

But what really makes me want to paint most of the time are colors: a mix of colors that I have seen on a picture, on clothes, in a bouquet of flowers . . . I have a real crush for this association of colors and I absolutely need to paint it. The pattern that I will paint afterwards is only an excuse for using this range of colors.

What might people be surprised to know about you (or your work)?
People often describe my work as soothing and soft, that [it] brings calm and serenity. But that does not reflect who I am, for I am rather an anxious and hyperactive person.

What question do you wish I had asked you?
What do I like the most about being an illustrator?

What is your answer to that question?
The extent of options, there is no limit to creation.

HAYV KAHRAMAN

Hayv Kahraman is an Iraqi artist based in Los Angeles whose figurative paintings examine the gendered and racialized body politics of migrant consciousness. Her work is a reflection on otherness as a form of dehumanization, focusing on the gap between the immigrant, non-white, genderly marked other and the way they are perceived by the white hetero-patriarchal normative same. Her work has been exhibited at Institute of Contemporary Art (ICA), Boston, MA (2020); Henry Art Gallery, Seattle, WA (2020); De La Warr Pavilion, United Kingdom (2019); Nottingham Contemporary, United Kingdom (2019); Benton Museum of Art at Pomona College, Claremont, CA (2018); Contemporary Art Museum (CAM), St. Louis, MO (2017); Joslyn Art Museum, Omaha, NE (2017); Rubell Museum, Miami, FL (2016); Cantor Arts Center, Stanford, CA (2013); and the Sharjah Biennial, United Arab Emirates (2009).

Website: hayvkahraman.com
Instagram: @hayvkahraman

OPPOSITE PAGE
Untitled (detail)
Oil on linen, 70 × 70",
178 × 178 cm, 2021

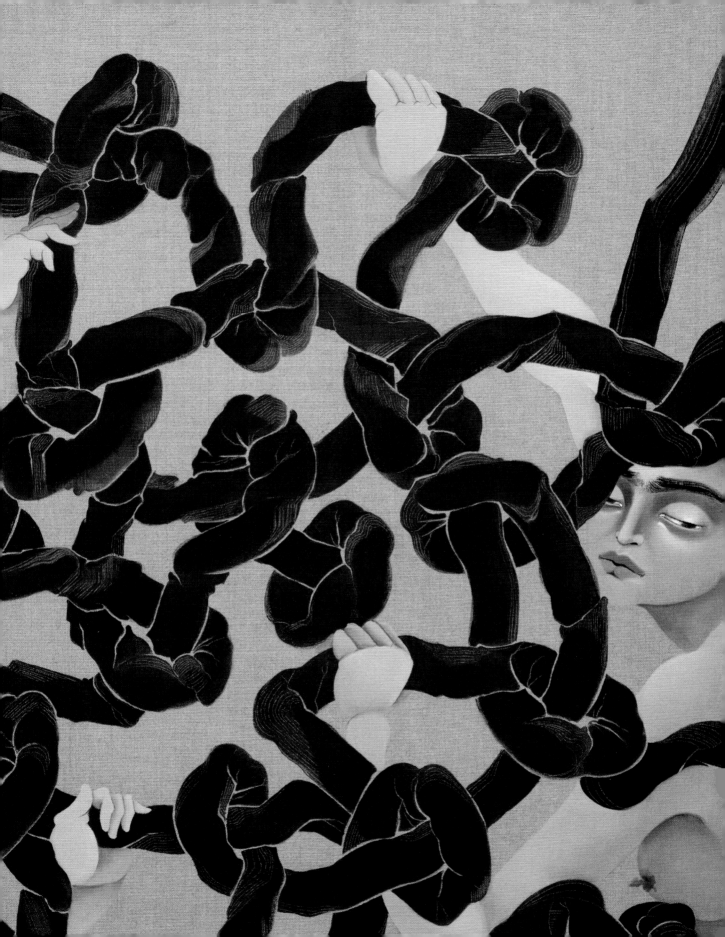

ABOVE
Untitled
Oil and torshi on linen,
70 × 70", 178 × 178 cm, 2021

OPPOSITE PAGE
Untitled (detail)
Oil and torshi on linen,
70 × 70", 178 × 178 cm, 2021

What makes it possible for you to create the art you want to create in your life?

I have an innate necessity to make art. It's the only way I know how to question and understand the world around me. It gives me a way to critically negotiate all the mess in this life, from imbalances to joy, and it anchors me in the here and now.

What will you leave behind as your legacy?

I'd like to think that my work might empower minorities, immigrants, women, BIPOC, LGBTQIA, and anybody who is considered non-normative to speak up and shine. It's time for us to take center stage and to thrive.

What attracts you to dancing bodies?

As somebody who has had their agency stripped away, my body becomes the only thing that I have access to. My body then can serve as a vehicle to resistance and re-existence. Bodies in paintings, or in physical space, are like notes on a sheet of music or paragraphs in a book.

When and why did you start incorporating dance into your work, and what do you feel dance brings to it?

To some degree dance came before painting for me. Or perhaps simultaneously. I attended the Music and Ballet school in Baghdad as a child, where I trained in classical ballet every day after school for three hours. It was rigorous practice, but this was the seed in understanding that movement can actually be a language. As I fled the war in the early nineties, I stopped my training and started a new life as a refugee in Sweden. I enrolled in classes there but was met with a teacher who continuously singled me out because I was brown. I stopped and started painting more and more. While the bodies that I choreographed in the paintings were static, they still had the ability to convey my thoughts.

Are there any works of art by other artists featuring dance that have inspired you?

When I saw the Mevlevi Sema performance in Turkey for the first time, I was floored. The whirling dervishes part of the Sufic tradition swirl, rotate, and move with such ease it made me think of a flock of birds in the sky. It was a meditative and transformative experience that made me imagine worlds beyond this realm.

What process do you go through to create your work? What inspires you?

I do a lot of research prior to the actual making and I usually work in series. There is almost always a subtle yet recognizable transition from one body of work to another that I like to call obsessions. It's not only concepts that attract me but sometimes its a sentence in a text or even just a word that can propel a substantive thought process. Once that's somewhat defined in my head, I start the sketching and painting. The entire endeavor in creating a painting is somewhat controlled albeit with smalls gaps allowing for failure and growth and I oftentimes use my own body as a formal reference.

What might people be surprised to know about you (or your work)?

As a child I always wanted to become a ballerina. It was actually a toss-up between dancer, tattoo artist, and just plain ol' visual artist.

"US and THEM" Part of *Silence is Gold*
Music by Jessika Kenney and choreography
by Ariel Osterweis, in collaboration with
dancers from The Sharon Disney Lund
School of Dance at CalArts. Los Angeles, CA,
October 2018.

DEAN LARSON

Dean Larson is a resident of San Francisco with roots on the East Coast, where he has long been associated with the resurgence of the American Realist Movement. He has written books, has been featured in numerous art periodicals, and has shown in museums and galleries across the US. He has also completed six solo exhibitions at the John Pence Gallery.

Larson is a restless, experimental artist who thrives on diversity. He is equally adept with landscapes, still-lifes, interiors and figurative painting as he is with the cityscapes of Europe, the East Coast, and San Francisco.

Larson's commissioned portraits and paintings can be found in corporate collections, universities, museums, churches, and courthouses. He has won the coveted Stacey National Award and Pollack-Krasner Foundation Grant. Larson has taught at the Academy of Art University since 2005 and maintains a studio near the Mission Dolores neighborhood.

Website: deanmlarson.com
Instagram: @deanlarson07

OPPOSITE PAGE
Ballet Bar
Oil on canvas, 30 × 24",
76 × 61 cm, 2022

ABOVE
Dance Reflections
Oil on canvas, 9 × 12",
23 × 30 cm, 2022

OPPOSITE PAGE
Dance Rehearsal
Oil on canvas, 22 × 28",
56 × 71 cm, 2007

FOLLOWING SPREAD, LEFT, TOP
Dance Rehearsal, Duet
Oil on canvas, 52 × 40",
132 × 102 cm, 2009

FOLLOWING SPREAD, LEFT,
BOTTOM
Dance Trio
Oil on canvas, 14 × 11",
36 × 28 cm, 2009

FOLLOWING SPREAD, RIGHT
Before the Rehearsal
Oil on canvas, 40 × 52",
102 × 132 cm, 2013

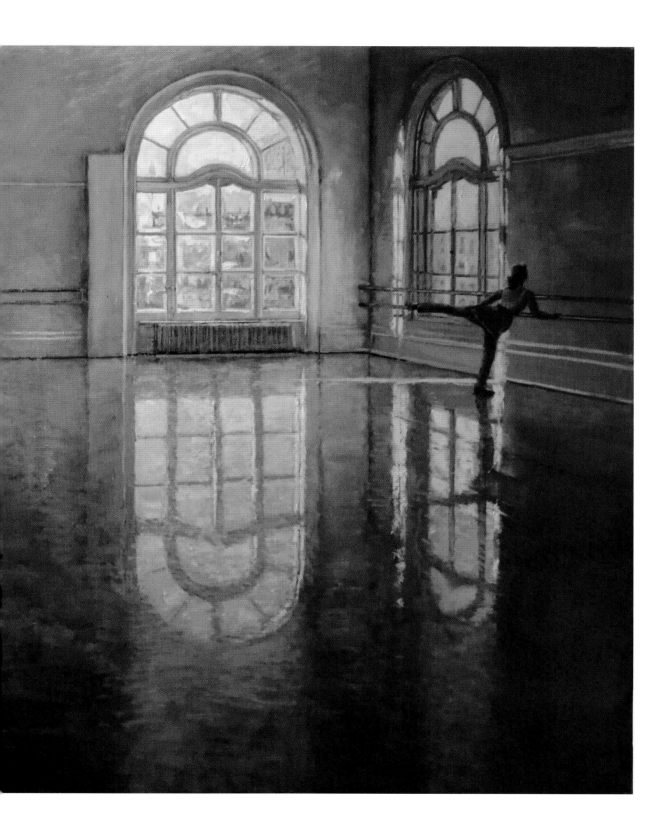

What makes it possible for you to create the art you want to create in your life?

Living your life as an artist is something you have to do, you can't imagine your life without it. Having grown up in a small town in Alaska, painting was the last thing on the minds of many people, but it just so happened that one of Alaska's greatest living artists lived in the same small town and he became my first mentor. My parents also supported me all along the way.

Later on I moved to Baltimore, Maryland, to attend an art school there, the Schuler School of Fine Arts. People thought I was crazy to move so far away, but it allowed me the chance to learn my skills and have access to the museums and galleries there and also in Washington DC, Philadelphia, and New York.

What will you leave behind as your legacy?

Sometimes paintings just happen and you're not sure how it happened, but it just did. My desire is to leave behind a handful of not just very good, but a few great paintings that somehow connect to viewers.

What attracts you to dancing bodies?

Dancers' bodies are lean and toned. Dancing demonstrates what the human machine is capable of doing. Dancers study for years to learn their skills, as all artists do, and once all the foundational skills are mastered, there are those that put themselves into the movements in such a way that the choreography comes alive.

When and why did you start incorporating dance into your work, and what do you feel dance brings to it?

After I left Baltimore and moved to San Francisco in 1997, friends recommended "try going to the ballet." While music had always been a big part of my life, experiencing ballet opened up a new world, visual and musical together. After I discovered ballet, attending modern dance also became a passion.

Are there any works of art by other artists featuring dance that have inspired you?

Besides the great Dance paintings by Edgar Degas, many of which blur the line between realism and abstraction, the huge painting *El Jaleo* of a flamenco dancer by John Singer Sargent possesses an energy where the movement, the music, and the euphoria are palpable. Standing before that monumental canvas is like being in the cave at the height of the performance.

What process do you go through to create your work? What inspires you?

Besides the movement and the music, the spaces where dancers rehearse are often dramatic in their own ways. Besides being large, open spaces, the often-preferred surface to dance on top of is Marley Dance Flooring which, when viewed from an angle, reflects a mirror image of the dancers as they move, giving the artist even more to work with.

What might people be surprised to know about you (or your work)?

In 2007 my late husband and his dance partner (José Iván Ibarra and Pete Litwinowicz) started their own dance company, DanceContinuum/SF, which they continued for six years. During that time rehearsals became a regular part of our routine providing me, as a visual artist, a window into another art form. From this experience a merging of the love of both painting along with dance grew and developed.

What question do you wish I had asked you?

Is it difficult painting a figure in motion as opposed to one standing stationary?

What is your answer to that question?

Capturing the idea and excitement of the figure in motion in oil paint is the challenge we come back to time after time. When a dancer is on stage they can be moving constantly. Unless we select the right moment to depict the work, we run the risk of appearing static or staged. While certain parts of the dancer's body can be moving slowly, other parts are moving quickly, so speed and energy become part of the subject.

OPPOSITE PAGE

The Dance Lesson,
Homage to Paul Cadmus
Oil on canvas, 14 × 11",
36 × 28 cm, 2015

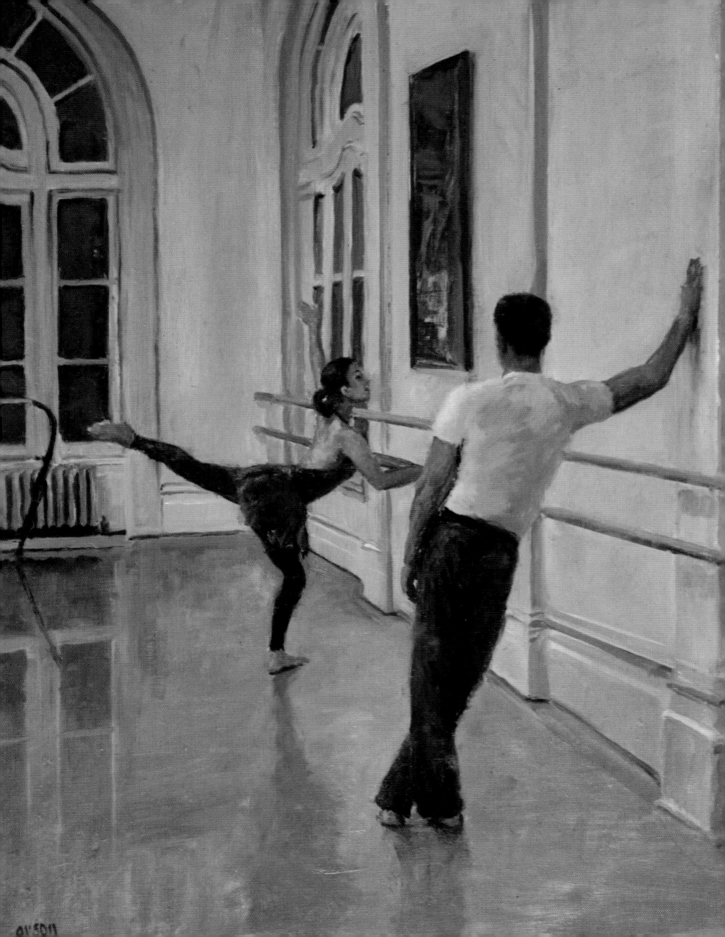

LUCIANO LOZANO

Luciano Lozano was born in Spain the same year man traveled to the moon. That may be the reason why he has traveled a lot since childhood. Self-taught, he has been working as an illustrator since 2007, after completing a postgraduate degree in creative illustration at EINA School in Barcelona.

In 2012, *Operation Alphabet*, illustrated by Lozano, won the Junceda Prize for the best book published abroad (by Thames and Hudson).

In 2015, *I Don't Like Snakes*, which Lozano illustrated (Walker Books), was chosen by BuzzFeed as one of the best children's books released that year. It was also shortlisted for the book award given by the School Library Association of the United Kingdom.

In 2017, *Diana Dances*, his first book as both author and illustrator, was published by Três Tigres Tristes in Spain. Since then, it's been published in ten different languages.

In 2019, his book *Brilliant Ideas by Wonderful Women* was published by Quarto in the UK and USA and by Les Éditions des Éléphants in France.

Also in 2019, *Stone Siren*, his second book as both author and illustrator, was published by Três Tigres Tristes in Spain. The same year his book *The Sun Shines Everywhere* was published in the United States by Little, Brown and Company.

His latest books as an illustrator are *Mayhem at the Museum* and *Boys Dance*, published by Penguin Random House in New York, both in 2020.

Luciano has collaborated worldwide with publishers and magazines.

His illustrations reflect his strong sense of color and texture, his frequent use of traditional techniques, and an undercurrent of subtle humor running throughout.

Luciano currently lives in Barcelona.

Website: lucianolozano.com
Instagram: @ilustrista

OPPOSITE PAGE
One of the endpapers of the book *Diana Dances*, published in English by Annick Press.

FOLLOWING SPREAD, LEFT, TOP
Am I a dancer? thought Diana. *I'm a dancer!*

FOLLOWING SPREAD, LEFT, BOTTOM

FOLLOWING SPREAD, RIGHT
I drew this illustration just for fun and suddenly Diana was born. This is where everything started.

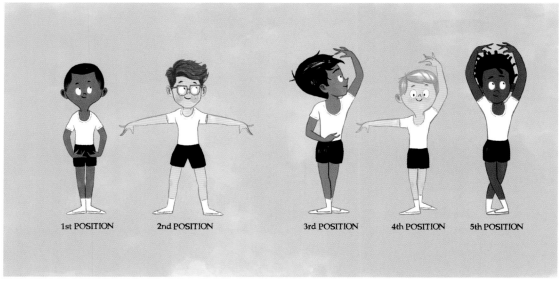

1st POSITION 2nd POSITION 3rd POSITION 4th POSITION 5th POSITION

TOP
Rehearsal at the
American Ballet
Theatre studio.

BOTTOM
If you wish to be a true
dancer, one of the
first things you need
to master is the Five
Basic Ballet Positions.

OPPOSITE PAGE, TOP
This is how you do a
plié. Practice is the key
to mastery.

OPPOSITE PAGE, BOTTOM
Whatever passions
you pursue, don't
forget that boys
dance, too.

Princes, pirates, villains, too. Slay the Mouse King in a coup! Some of the most famous male roles in ballet.

What makes it possible for you to create the art you want to create in your life?
A lot of work and passion. I think it's the only possible fuel for art, a mix of both.

What will you leave behind as your legacy?
I'm not sure, really. Perhaps the sense of humor and the empathy of the characters I create.

What attracts you to dancing bodies?
I've always loved how the human body moves. I've watched many ballets, especially contemporary dance, such as Sasha Waltz or Pina Bausch. I find it quite poetic and very inspirational.

When and why did you start incorporating dance into your work, and what do you feel dance brings to it?
It was for a book I illustrated some years ago, *Miles of Smiles* by Karen Kaufman Orloff, published by Sterling in the United States. There was a secondary character, and she wore a tutu. This was the beginning of a character I later developed: Diana, who was the main character of my first book as an author and illustrator, *Diana Dances*. This book has been published in ten different languages so far. Then I continued exploring the world of ballet as illustrator for the American Ballet Theatre's book *Boys Dance!* I had a lot of support from ABT in making sure all the ballet poses were accurate in the book. It was a great experience.

Are there any works of art by other artists featuring dance that have inspired you?
I love how Degas depicts dancers and captures movement.

What process do you go through to create your work? What inspires you?
Many things inspire me; inspiration may come from an idea, a sentence, or an illustration I create and then want to extend the story beyond [it]. There's a South American writer I love and I find very inspirational, Eduardo Galeano. And art by artists such as Gary Baseman, Yoshitomo Nara, Rose Wylie, Louise Bourgeois, and many more.

What might people be surprised to know about you (or your work)?
That I studied tourism and worked for many years at hotel desks, travel agencies, airports, and even the Channel Tunnel as a steward, until I decided to change my life when I was thirty-seven and became a professional illustrator.

What question do you wish I had asked you?
What I'd like to be when I grow up.

What is your answer to that question?
I think I'm getting closer to that goal. As I've had many different jobs and became a professional illustrator [when I was] not so young, I appreciate quite a lot where I am at the moment. I'd love to keep on illustrating, creating stories, and also exhibiting my art in galleries. Art is my passion.

KAROLINA SZYMKIEWICZ

Karolina Szymkiewicz is a freelance illustrator and a visual artist. Originally from Poland (Wrocław), Karolina moved to Scotland to study in 2006 and graduated with distinction from the master's in illustration course at Edinburgh College of Art in September 2011. Not long after, she moved to Leeds, England, where she is currently based and developing her practice, working on commercial commissions and personal projects.

In her fine artwork, the subjects which she is inspired by are linked to the experiences of the human body. This is reflected mainly in the theme of contemporary dance, which she has been exploring through traditional drawing.

In 2013, Karolina was shortlisted for the New Lights Prize Exhibition and was awarded the TIG Prize for most outstanding representational work. The following year, she completed a residency with TASTE Shop in Shanghai, which resulted in a sold-out exhibition titled *MA* in April to May 2014. Later on, in October of that year, her most-recent solo show took place, titled *Pandora's Box*. Since then, she's completed a collaboration with TurnAround Dance Theatre group, on the theme "mirrored minds," as well as participated in a group show entitled *Wheel of Fortune*.

Recently, she has been able to re-engage with the theme of dance in her work with a new piece called *Pivot*, planned to debut in *Northern Lights–New Light*, a ten-year retrospective in Saul Hay Gallery in Manchester, England.

Instagram: @karolinaszymkiewicz.art
Email: karolinaszymkiewicz.art@gmail.com

ABOVE
Pandora's Box 2
Digital and pencil drawing,
2014

OPPOSITE PAGE
Pandora's Box 1
Digital and pencil drawing,
2014

FOLLOWING SPREAD
Wheel of Fortune
Pencil drawing, 2015

ABOVE
Mirrored Minds 1
Digital and pencil drawing,
2015

OPPOSITE PAGE
Mirrored Minds 2 &
Mirrored Minds 3
Digital and pencil drawing,
2015

What makes it possible for you to create the art you want to create in your life?

I'd say, a pinch of curiosity and a whole load of grit is always useful. Also, I've been extremely lucky to have an ongoing support and encouragement from my husband. He believed in me long before I did.

What will you leave behind as your legacy?

I can't say I concern myself with legacy much. I purposefully aim to live in the here and now. I just follow my nose and it will be up to other people to decide on what my legacy might be. But I imagine I'm going to leave behind quite a lot of drawings!

What attracts you to dancing bodies?

The appeal of dance originated in my interest in the human body as an art form. Once rigorously mastered through training, dancers' bodies allow them to express themselves in the most unique and uninhibited forms. I'm fascinated by this type of experience.

When and why did you start incorporating dance into your work, and what do you feel dance brings to it?

My interest in dance crystallized during my master's degree when I chose it as a key theme. However, I've always been interested in the human figure and its depictions, especially in traditional sculpture. Additionally, I've always enjoyed life-drawing studies. Dance as a creative practice uses the human body as a tool to create art with. I feel a dialogue and collaboration between diverse art fields is extremely valuable. By creating a bridge between dance and illustration, I've gained a truly endless source of inspiration.

Are there any works of art by other artists featuring dance that have inspired you?

I've always been in awe of Lois Greenfield and her photographic masterpieces. She manages to capture a moment suspended in time with absolute perfection. This allows the viewer to marvel at what's imperceptible to human eyes. A fleeting split of a second blink immortalized forever in a single snapshot.

What process do you go through to create your work? What inspires you?

It would typically begin with me arranging a session in a dance studio with a contemporary dancer. I'd follow them with a camera allowing them freedom to improvise and explore. Afterwards, I'd go through a mountain of photographs and see what poses captured my attention. Then, a series of sketches, ideas, and planning would follow. Finally, I'd sit down, put an audiobook on, and get down to painstakingly creating the final piece, usually in pencil. These days I incorporate digital drawing techniques throughout my process as well, and I enjoy coming up with new methods to combine the two.

What might people be surprised to know about you (or your work)?

Day to day, I work as a commercial pattern designer and an illustrator. After working in kidswear for the past eight years, I'm currently setting up my own brand as "Caroline Hill." Right now, I'm particularly excited to be putting my expertise in traditional drawing to use, creating decorative, botanical surface prints.

What question do you wish I had asked you?

What is especially unique about the illustration of dance and dancers?

What is your answer to that question?

Personally, my drawings are a study of how the human body in motion can create highly evocative imagery. I am interested in poses that, like sculptures, express a psychological disposition. After all, the human body is a vehicle through which we experience the world around us. A dancer skillfully uses this means to speak of their inner landscape. My task is then to investigate their language, concentrate on a few letters, then translate and showcase these via the medium of my own practice. By doing this I want to provide a glimpse of an insight into their narrative. As a result, one is then able to contemplate a frame that usually gets lost in the flux of dance.

OPPOSITE PAGE
Pivot
Pencil drawing, 2021

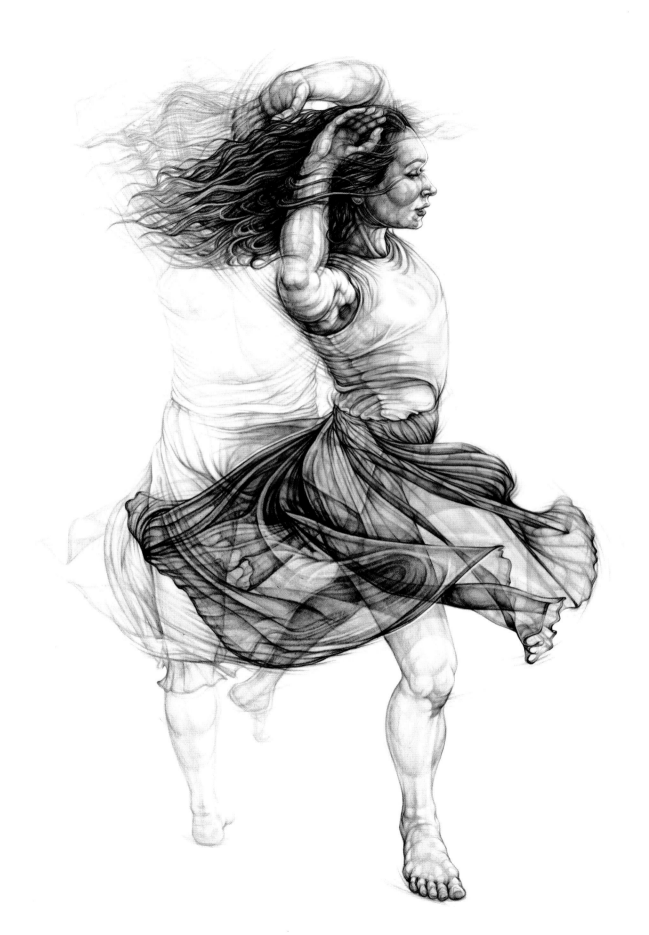

NICOLA VERLATO

Nicola Verlato is a painter, sculptor, architect, musician, and video maker born in Verona on February 10, 1965. He started very early in modeling sculptures and making drawings and paintings. At age nine, he was selling his first works. He studied painting in the studio of an elderly friar in a monastery from the age of nine to fourteen. He studied lute and composition at the conservatories of Verona and Padua. He studied architecture at the University of Venice. His first exhibition took place when he was fifteen, and after that, he worked for noble families making portraits and large compositions for palaces and villas besides decorations and sets for major events.

Nicola entered the contemporary art system only later by exhibiting in galleries and museums internationally. Among numerous exhibition occasions, his work appeared at the Fifty-Third Venice Biennale in 2009, the Prague and Tirana Biennials, the Rome Quadrennial in 1996 and 2008, and in exhibitions at the Royal Palace in Milan, the Contemporary Art Pavilion (PAC), and the Museum of Modern and Contemporary Art (MART), the National Museum of Stockholm, and of Helsinki, the Nuit Blanche of Toronto, the Akron Museum in Ohio, and the White Columns gallery in New York.

His work is represented by Postmasters New York–Rome; Morten Poulsen Gallery in Copenhagen; and Isabel Croxatto in Santiago, Chile.

His works are present in the collections of the MART in Rovereto, Italy; the George Lucas Museum in Los Angeles; Del Musac in Salamanca, Spain; and the Iloilo Museum of Contemporary Art in the Philippines. He has collaborated with FIAT and Gatorade, among other companies, in advertising campaigns based on his pictorial style.

He has directed music videos and advertising campaigns and has designed set designs.

After fourteen years in Venice, seven in Milan, seven in New York, and seven in Los Angeles, Nicola now resides in Rome. He is married to Yohko Shiraishi and has a daughter, Mei, who is half Japanese and half Italian.

His work is eminently figurative and hinges on the materialization of modern and ancient narratives and mythologies to demonstrate the absolute continuity of the central themes of mankind that continually adapt to the changes of time while maintaining their recognizability. His work has civil and community objectives precisely to recover the centrality of art and myth in the management of the territory. To make his works more and more effective from the social point of view, since 1992 he has started to implement his working process with new CGI technologies. In this field he is certainly a pioneer, if not the first ever to have married traditional painting and digital modeling. Some of his most important projects are based on the integration of traditional painting and digital modeling and on the aesthetic influence of video games in contemporary art.

He has held lectures and conferences in various institutions including Academies of Florence, Rome, and Verona; School of Visual Arts (SVA) in New York; Conference of Architecture and Urbanism in Toronto; Gnomon School Los Angeles; Villa D'este Tivoli; Macro Musem Rome; and IIC Los Angeles.

He taught painting for several semesters at the New York Academy–New York where he introduced students and faculty to the implementation of CGI and traditional painting.

OPPOSITE PAGE
"Another episode..."
Oil on wood panel, 36 × 48",
91.5 × 122 cm, 2011. Private
collection New York.

Website: nicolaverlato.com
Instagram: @nicolaverlato

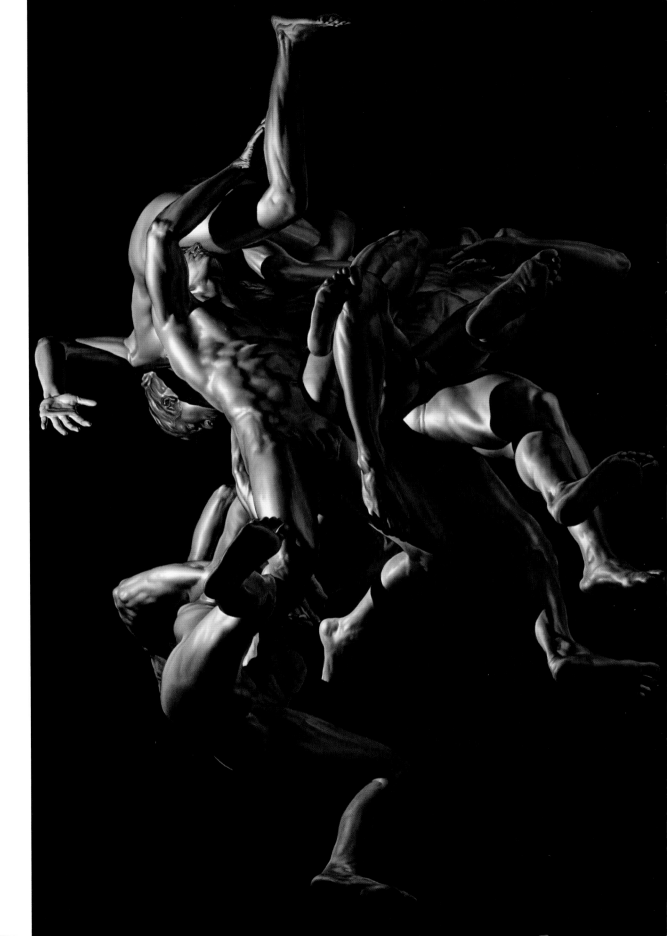

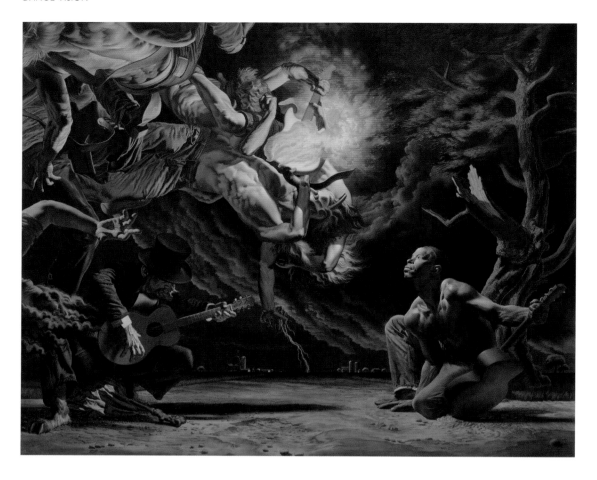

ABOVE
Sublime (Stockhausen's Aesthetics)
Oil on wood panel,
5 × 27", 90 × 70 cm,
2020. Private collection
Copenhagen.

OPPOSITE PAGE
"Breaking Point-3"
Oil on canvas, 48 × 36",
121 × 91 cm, 2013. Private
collection Milano.

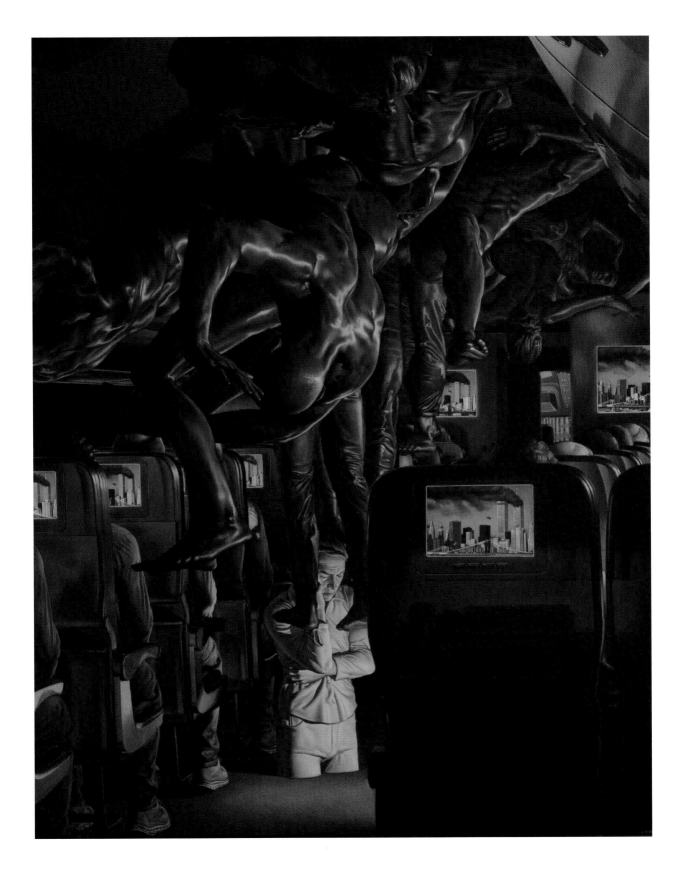

221

THIS SPREAD
**Obversion–Broken,
Broken Obelisk**
Oil on linen, 36 × 48",
91.5 × 122 cm, 2016. Private
collection Copenhagen.

THIS SPREAD

Hostia
Acrylic on linen, 112 × 66",
284 × 167 cm, 2014.
Private collection Creancey.

224

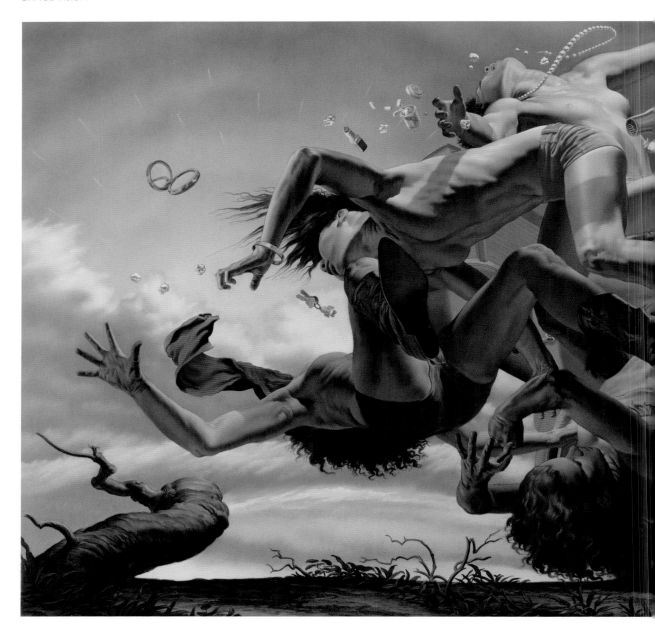

ABOVE

A wither shade of pale
Oil on linen, 96 × 60",
244 × 152 cm, 2012.
Private collection Milano.

OPPOSITE PAGE

There's no place like home
Oil on linen, 80 × 96",
203 × 244 cm, 2006.
Private collection Milano.

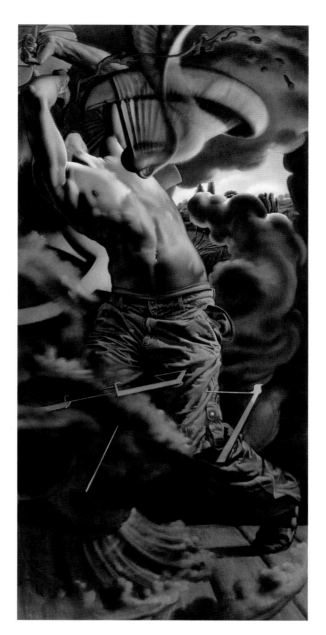

What makes it possible for you to create the art you want to create in your life?

From what I remember, I wanted to be a painter since the age of five. I started selling my paintings and participating in the first exhibitions at nine. I never stopped drawing or painting even for a day since then, so my whole life has always revolved around painting, and it's shaped, for good or bad, by that. Many often thought it was me [who should] be in the service of painting rather than the other way around. I could never think of stopping painting, but, in time, I continued to add other activities such as architecture, sculpture, and music to painting and drawing, as if starting from making images we could expand into other disciplines. I see painting as the center of an entire system of thought.

What will you leave behind as your legacy?

I would like my career to be seen as a contribution to the idea that history and the destiny of things are not sealed once and for all, and that the becoming of things is impossible to be channeled into pre-established tracks into any sort of teleological vision. When I started painting as a child, in the early seventies, I was told that it no longer made sense to paint figuratively after the avant-gardes. Today I don't think anyone would dare to say such a thing precisely because the work of some artists who refused to adapt to the deterministic dictates of art history have shown that history does not exist in Hegelian terms. The other thing, which is the consequence of this, is the bet to be able to create one or more works, on which I have been working for years, and include painting sculpture architecture which should be permanently established into a given territory.

What attracts you to dancing bodies?

In my work, either in paintings or sculptures, bodies are always in motion; I am attracted to bodies in motion because the emotional involvement they produce, once represented in painting and sculpture, is immense, probably the most intense that any possible media can produce. Today this phenomenon is studied in the field of neurology, but art has always been the indisputable testimony of this fascination that the representation of the body exercises on us.

The human body in movement, both in dance and in painting, manages to show the hidden engine of that movement which goes far beyond our self and it is something superior to our being mere individuals.

When and why did you start incorporating dance into your work, and what do you feel dance brings to it?

Actually I don't think I've almost ever worked directly on the idea of the dancing body, but there may be some works that come close to this concept, like the Michael Jackson painting, for example. What I think my work has in common with dance and those who practice it is the fact that we both work on a very ancient knowledge of human existence, the one that speaks to us of a sort of universal language preceding the verbal one, which is the one of the body that responds to extremely archaic impulses, which are those that still animate us deeply today.

I think that dance and the depiction in painting and sculpture of the body in movement are openings toward this ancestral archaic primal state of the human experience. No other fields of human knowledge can do it better.

Are there any works of art by other artists featuring dance that have inspired you?

Yes, there are some works that I have always loved very much, among which are those of Botticelli (the Graces in the *Primavera* at the Uffizi), the dancing maenads of several Greek, Roman, and Etrurian

bas-reliefs, vases, and paintings, the figures of Titian and then of Poussin, Rubens, and Tiepolo in their Bacchanalia up to Carpeaux; on the other side I have never liked Degas paintings about ballet dancers.

What process do you go through to create your work? What inspires you?

My work process is quite elaborate, and it's roughly articulated in three phases:

1. The sketch where a narrative is transformed into a form. This is the most important phase and it all happens in the drawing. I make dozens and dozens of more or less finished sketches until the linear narrative that I have decided to represent takes a shape in space (my work is all about this: the metamorphosis of time into space). It can happen that sometimes a new narrative is born from the drawing itself; it manifests itself in the tangle of lines that the hand traces on the paper.

2. The transformation of the two-dimensional sketch into a three-dimensional model. At this stage I add data to the form I elaborated in the previous phase: chiaroscuro, perspective, and anatomy. If I need it I can always step back to the sketch phase if I discover something new that can improve the "form."

3. The third step is the actual painting where all the information I got is assembled in the final image. The process is always open, so even in the final step I can go back to the initial or intermediate phase if I discover that something needs to be changed.

What inspires me the most is the constancy over time of the narratives that attract our attention and the urgency that I feel to give them a complete form in terms of painting and sculpture; this need is the real theme of my work that allows me to reconcile my individual time with the millennia of our animal species.

What might people be surprised to know about you (or your work)?

One thing, I think, may surprise many is that my work, which is very close to the classical corpus of Western art, is actually the result of the combination of very ancient processes with very innovative working methods.

The painting is always conceived through free-hand drawing, an irreplaceable tool for activating the figurative imagination necessary to formalize narratives in images, and also the pictorial phase is rigorously performed according to the classical practices of the grisaille sketch of the glazes, and it has continuous second thoughts precisely because it is not a transcription from other media, but, in the intermediate phase of image processing, I implemented the classic method with the use of 3D modeling programs.

I think I am a pioneer in this field because, after a long period of time working with clay and plasticine, I have been constantly using 3D CGI modeling programs to organize the scenes of my work since the early nineties. I have experimented with many different methodologies including 3D scanning of moving bodies and 3D modeling; I've also worked with VR and AR [virtual reality and augmented reality] apps and also produced NFTs [non-fungible tokens].

What question do you wish I had asked you?
Will art save the world?

What is your answer to that question?
Yes, in the long run it will, but it is a very harsh struggle to be able to bring it back to the conditions for this to happen.

MORGAN WEISTLING

A two-time winner of the Prix de West Purchase Award, Morgan Weistling is known for his paintings of American frontier spirit.

Weistling's intimate portrayals shed new light on the Old West as he captures the mood and atmosphere of the past. His oils are filled with lush brushwork of thick and thin paint that create a realistic impressionism.

His attention to the historical aspects of his subjects comes from his desire to portray the truth and beauty of America's pioneering spirit. His paintings have graced the covers of *Art of the West*, *Persimmon Hill*, *Southwest Art*, *Western Art Collector*, *American Artist*, and *U.S. Art* magazines and won numerous awards.

Weistling's book, *A Brush with History: The Paintings of Morgan Weistling*, spans his twenty years of award-winning paintings.

Website: morganweistling.com
Instagram: @weistling

OPPOSITE PAGE
The Waltz
Oil on canvas, 16 × 12",
41 × 30 cm

THIS SPREAD
The Barn Dance
Oil on canvas, 34 × 40",
86 × 102 cm

FOLLOWING SPREAD
The First Dance
Oil on canvas, 40 × 60",
102 × 152 cm

What makes it possible for you to create the art you want to create in your life?

Desire, ambition, inspiration, training, talent, support from family, and faith.

What will you leave behind as your legacy?

My legacy, or body of work, will hopefully speak for itself. I pray my collectors will always enjoy my paintings that they live with because it connects with them on a deeper level than just decoration. But every artist also wants to be admired by other artists. I think it's that motivation that pushes me to go as far as I can with each painting. I hope I will leave behind a legacy of paintings that inspires new artists and brings new inspirations for the future to come.

What attracts you to dancing bodies?

I love capturing movement in my paintings. I hate static figures. Even when I am painting a standing or sitting figure, I try to find a rhythm to their bodies to indicate movement. But when it comes to painting dancing figures, it's the best of all. The way the human body sets itself off-balance and compensates to move forward is a study in design. I love incorporating a narrative into such scenes that add another layer to all and bring it out of just decoration.

When and why did you start incorporating dance into your work, and what do you feel dance brings to it?

I paint relationships between people with stories that connect with the viewer. I feel it is a natural extension of the many other scenarios I paint. I also love working with people that know how to dance because they are so much more fluid with how to pose for artists. All my life, many of the best models are dancers.

Are there any works of art by other artists featuring dance that have inspired you?

I love Degas, of course, since the time I was a young artist. But I also love the series that David Grove did. There are many others but those come to my mind first.

What process do you go through to create your work? What inspires you?

I work with real people and pose them to fit an idea that is sketched out first. I then let real life inhabit the idea by allowing the models to act the part. With dancing paintings, it is very organic, and I allow the dancers to freely show me what is possible.

The way I paint, I sketch from imagination and then use reference photos taken and use those to make my original idea a reality. I merge the best of it all together on the canvas, which is where much trial and error takes place. I never finish a painting, I surrender them.

What might people be surprised to know about you (or your work)?

I am left-handed, which is very difficult. If you don't believe me, try painting a portrait with your left hand. You will find it very difficult.

What question do you wish I had asked you?

Who or what is your greatest influence in your art?

What is your answer to that question?

As I was growing up, my parents were the first to show me how to communicate through drawing. They both met in art school. At the age of fifteen, my mother found me a professional art school and I trained under a master teacher, Fred Fixler. He was a hard taskmaster, but it molded me into a professional artist and gave me the tools to succeed as an illustrator and finally a fine artist. And through that process, I found myself marveling at the world of beauty around me and it led me to recognizing the Creator of this beauty. And it's in that discovery that I find my daily inspiration to create and capture on canvas the marvelous designs all around us.

OPPOSITE PAGE, TOP
The Dance
Oil on canvas, 48 × 60",
122 × 152 cm

OPPOSITE PAGE, BOTTOM
Twilight Dancers
Oil on canvas, 20 × 40",
51 × 102 cm

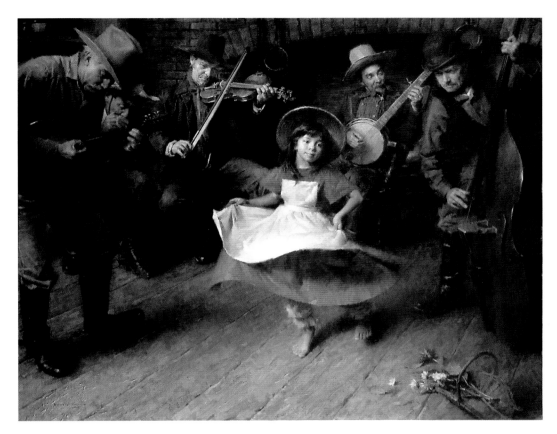

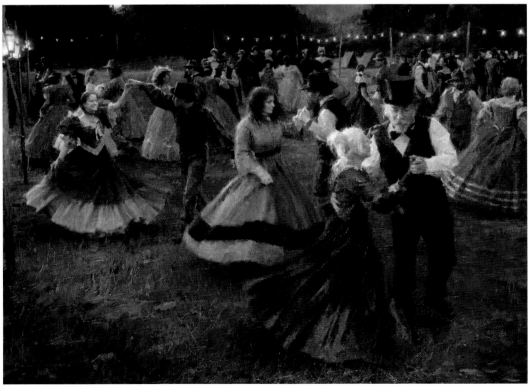

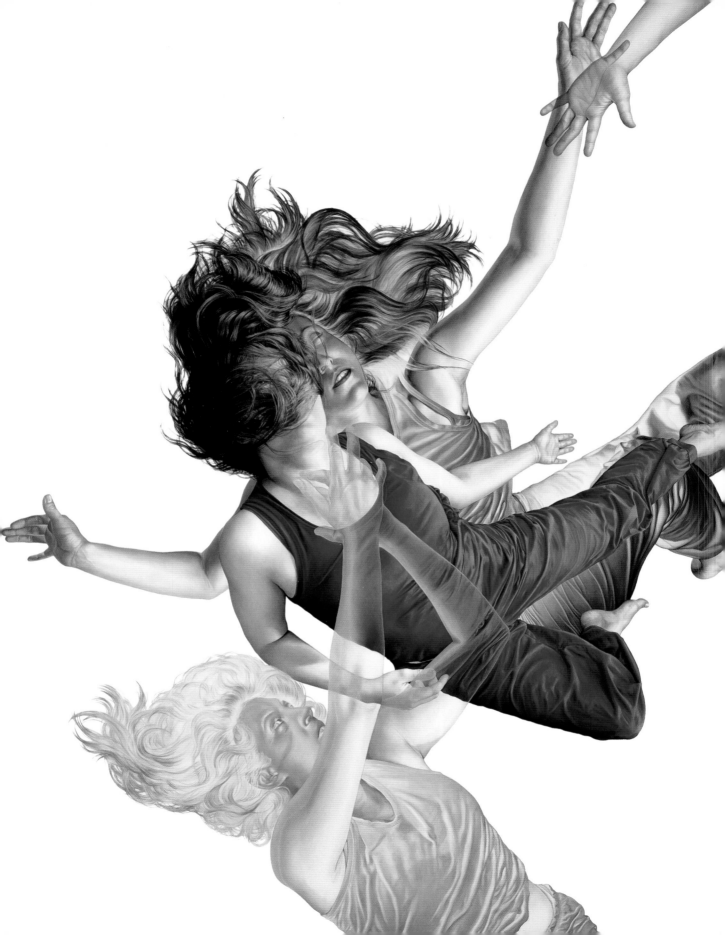

LEAH YERPE

Leah Yerpe (b. 1986) is a figurative artist who lives and works in Brooklyn, New York. Though she has no training in dance, it has been a key inspiration to her work for over a decade. She is fascinated by our bodies' ability to tell vivid stories without words. She frequently hires professional and amateur dancers to model for her drawings and paintings, considering the process one of collaboration. Through her repetition of figures within a void, she creates an otherworldly image that calls on the viewer to define on their own terms.

Leah received a BFA from SUNY Fredonia and her MFA from Pratt Institute. Her work has been exhibited extensively including presentations at the Watermill Center and Anna Zorina Gallery in New York. Her drawings have been reviewed in Huffington Post, Quiet Lunch Magazine, Nylon, among others, and featured on the cover of the *New York* magazine. Her work is included in renowned international collections including the permanent collections of the Dowd Gallery at SUNY Cortland and Purdue University.

Website: leahyerpe.com
Instagram: @leahyerpe

Birch
Oil on board, 36 × 36",
91 × 91 cm, 2021

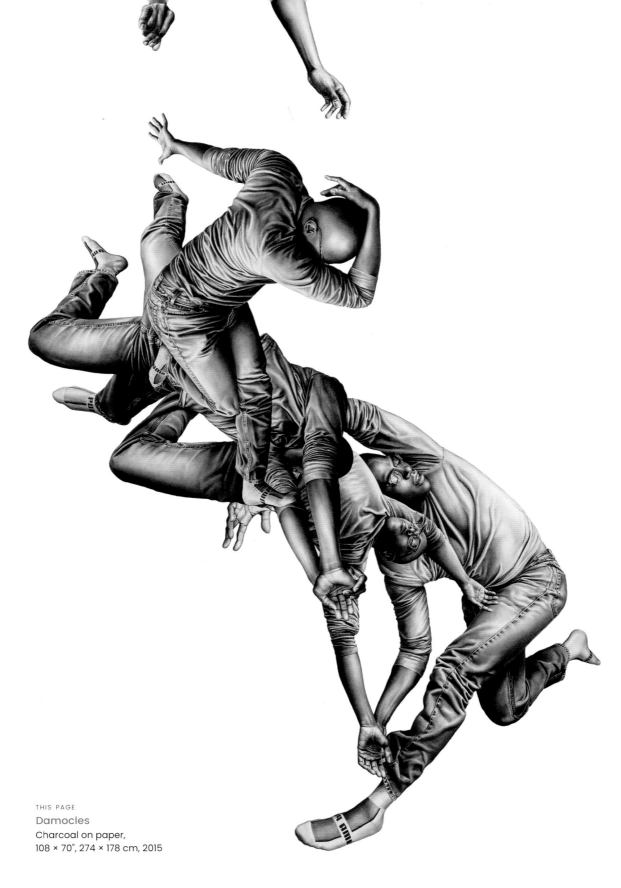

THIS PAGE
Damocles
Charcoal on paper,
108 × 70", 274 × 178 cm, 2015

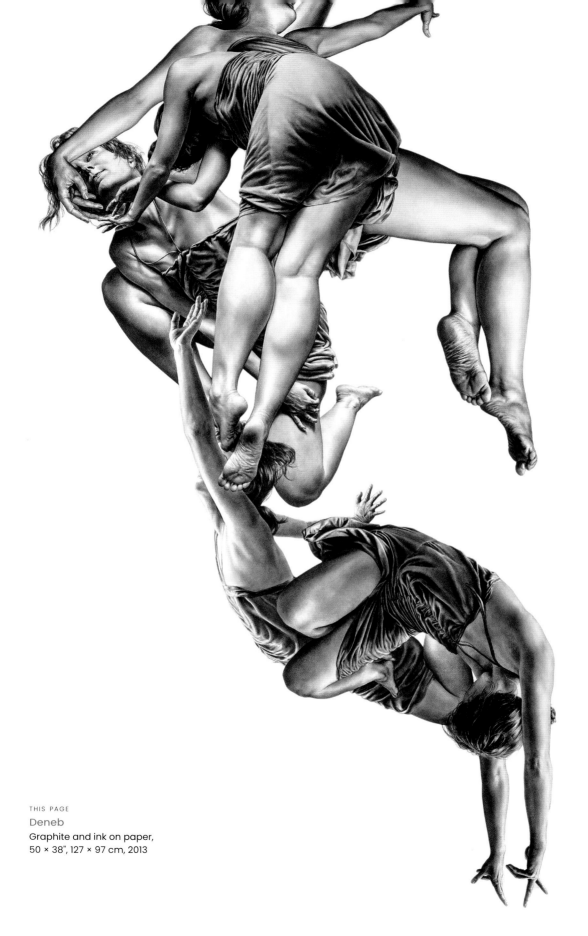

THIS PAGE
Deneb
Graphite and ink on paper,
50 × 38", 127 × 97 cm, 2013

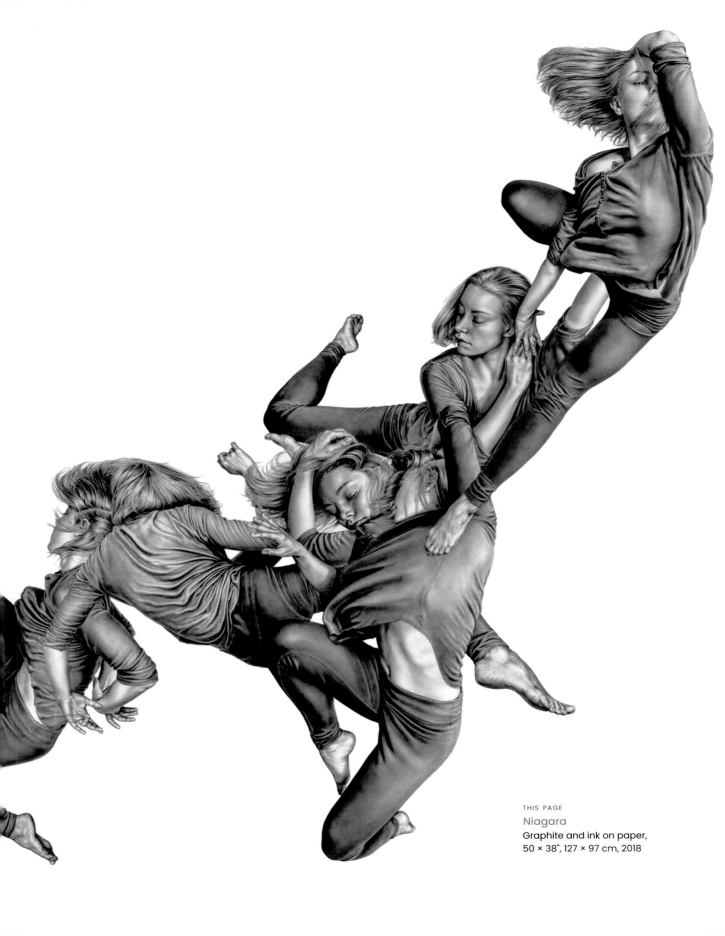

THIS PAGE
Niagara
Graphite and ink on paper,
50 × 38", 127 × 97 cm, 2018

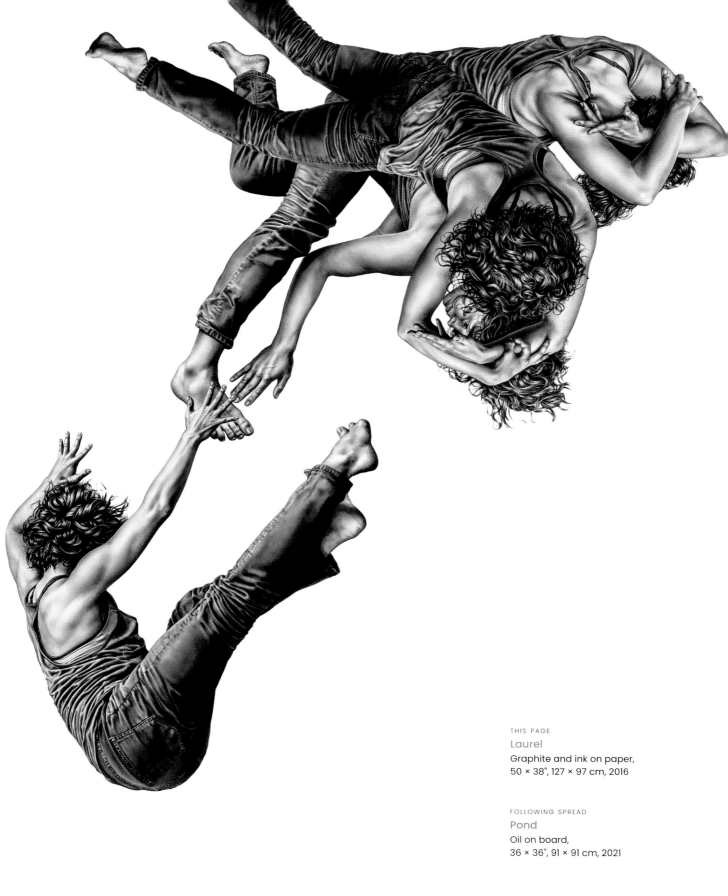

THIS PAGE
Laurel
Graphite and ink on paper,
50 × 38", 127 × 97 cm, 2016

FOLLOWING SPREAD
Pond
Oil on board,
36 × 36", 91 × 91 cm, 2021

What makes it possible for you to create the art you want to create in your life?

I am lucky to be able to support myself as an artist full-time. The work I want to make is highly detailed and extremely time-consuming. There is no way I'd have the time to create such elaborate work if I had to work another job to pay the bills. I am eternally grateful to those who saw the potential in me and chose to invest in my work early on. So many artists struggle to gain any sort of recognition, and funding for the arts is not nearly adequate to realize the vast sea of untapped potential out there.

What will you leave behind as your legacy?

All that matters to me are two things: #1, I want some people to look at my artwork and be moved to feel something deeply. And #2, I want to have helped students and young artists be empowered to express themselves and create something meaningful to themselves.

What attracts you to dancing bodies?

When I watch a really great dance performance, I feel completely absorbed. I get a sort of tingly sensation on my head, running down my spine. I imagine I feel the movement in my muscles and the air moving across my face. It's very exciting and relaxing at the same time. Hard to describe. The human body is capable of such vivid communication on a visceral level. In another lifetime perhaps I would have found myself a dancer instead of a studio artist. But I have too much performance anxiety. Instead, I let my artwork do the performing.

When and why did you start incorporating dance into your work, and what do you feel dance brings to it?

I believe dance began entering my work before I was consciously aware. Growing up in a rural area surrounded by forest and wildlife, I developed a deep connection to the organic, twining forms in nature. When I was an art student, I began to recognize these organic shapes in a lot of abstract art I was studying. I wanted to combine my love of representing the human figure with these abstract, organic shapes I found so compelling. Meanwhile, I moved to New York City and began taking advantage of the many performances happening all the time, and I fell in love with dance in particular. In retrospect, the movement of dance is an obvious connection in my work. But it took a couple years for me to fully appreciate this connection.

What process do you go through to create your work? What inspires you?

Each piece begins with a photoshoot. I often work with professional dancers, but not always. Every person carries themselves with a unique body language. This is why I allow my models to improvise all their poses without any direction from me. I don't want to impose or interfere. After the photoshoot, I spend a long time with the images we made, arranging them into collages that feel dynamic and interesting. I feel like a choreographer at this point. The strongest collages serve as reference for the finished artwork.

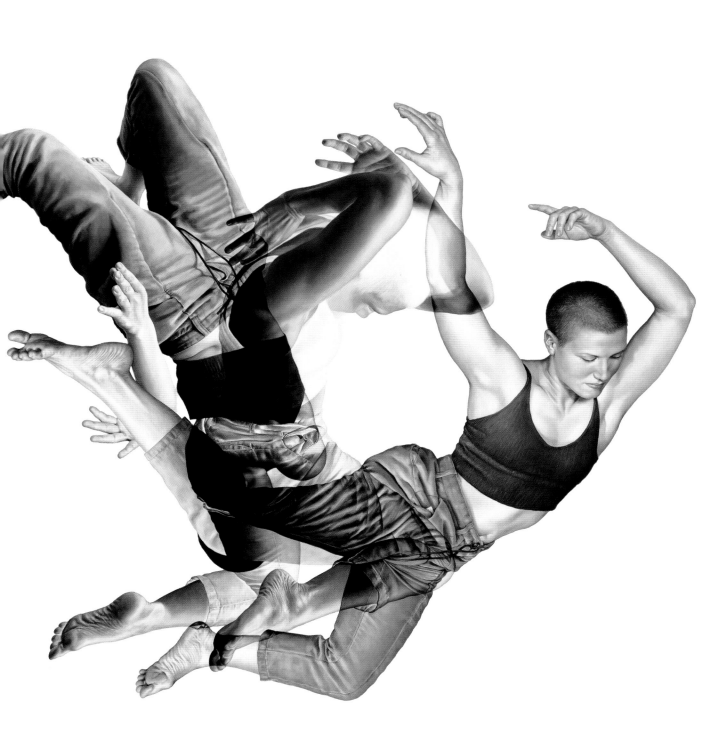

CRAFTING MOVEMENT: SCULPTURE

KEVIN CHAMBERS

Which came first—the artist or the inspiration? For Kevin Chambers, the artist was intrinsic, but inspiration came at age twelve. That is when he started formal art training in Blairsville, Georgia, with famed artist Colleen Sterling. "She was the first person I found that was making a living being an artist," he says. "It's the first time I realized it was a possibility for me."

Today, his works and collaborations are widely exhibited and displayed in public museums, including the Smithsonian Museum of Natural History, and national, international, corporate, and private collections around the world, from Switzerland to Japan, Dubai, and China.

Chambers received a BFA in media arts and animation from the Art Institute of Atlanta, a program that allowed him the latitude to develop his own personal style while he apprenticed for talented artists. He studied the human figure with contemporary masters such as Glenn Vilppu, Brian Booth Craig, and David Simon, and attended anatomical workshops led by Andrew Cawrse.

Some of Chambers's most significant commissions include two life-size bronze figures for Deep Time exhibit at the Smithsonian Museum of Natural History; the Alpharetta Veteran's Memorial depicting two 7-foot-tall bronze soldiers in a moment of pause on the battlefield; First Responders' Medallion in Roosevelt Park in Gainesville, Georgia; and *Kindred Revolution*, a family holding hands and dancing in a circle for Emory Brain Health Center in memory of Mary Taylor Rose.

Chambers has collaborated on numerous projects for corporate clients like the Four Seasons, the Hilton, the Hyatt, the Marriot Hotel Group, and the Ritz-Carlton. In 2015, Chambers was elected into the National Sculpture Society, the oldest and most prestigious group of professional sculptors in the nation. In 2017, he was voted one of the "Top Three Artists to Watch" in the United States by *Fine Art Connoisseur* magazine.

Chambers has a gift for expressing emotions, gestures, and personal stories in his art. He says, "I am constantly inspired by everything around me and try to bring that to my work." Chambers's signature pieces are nuanced with sensuality, rhythm, and motion.

Chambers's mastery of anatomy and of the three-dimensional form inspired him to teach, catering his instruction to each unique sculpture student. He teaches figurative sculpture classes year-round at his studio, KLC, in Atlanta. All of his classes have a strong base in anatomy, gesture, and proportion. Together with his wife, Lauren, Chambers established KLC Studios in 2015, offering classical fine art sculpture and painting instruction.

Website: kevinchambersart.com
Email: kevinsculpture@gmail.com

OPPOSITE PAGE
Stretching Michael
Limited Edition Bronze,
one-third life-size

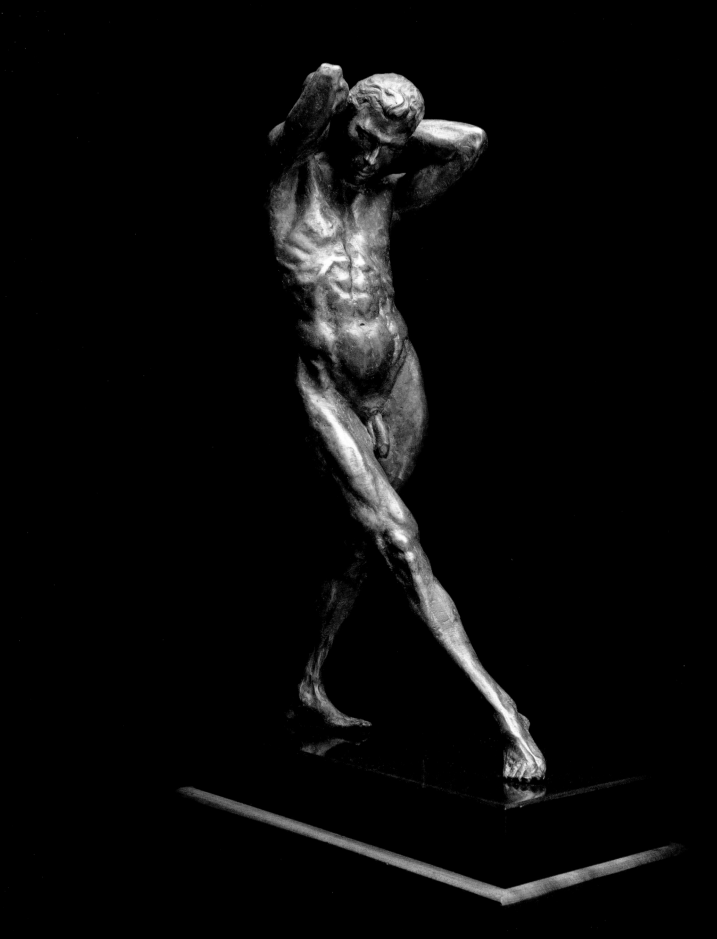

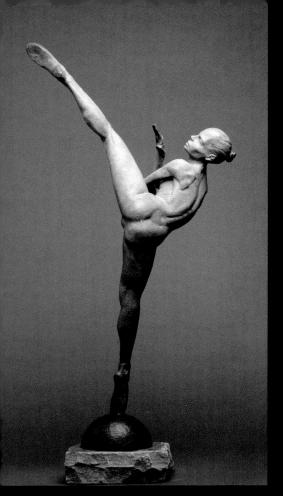

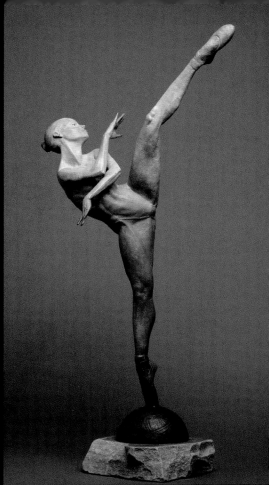

ABOVE

Continuum

Limited Edition Bronze,

one-third life-size

OPPOSITE PAGE

Apogee

Limited Edition Bronze,

one-third life-size

FOLLOWING SPREAD

Zenith

Limited Edition Bronze,

one-third life-size

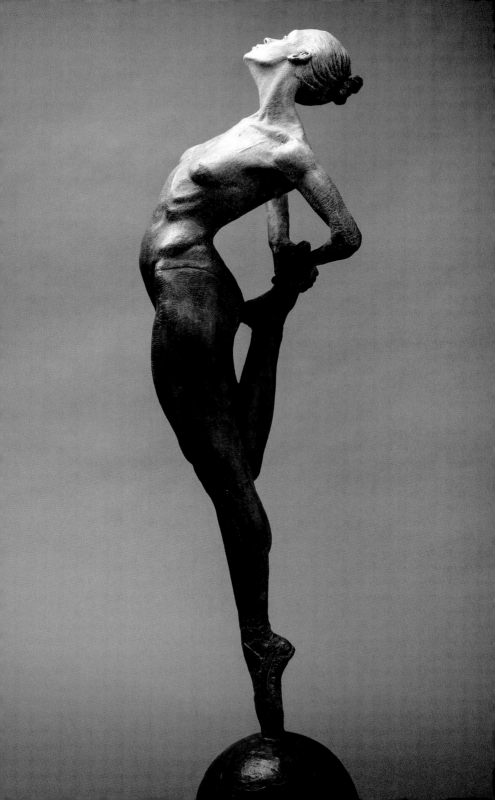

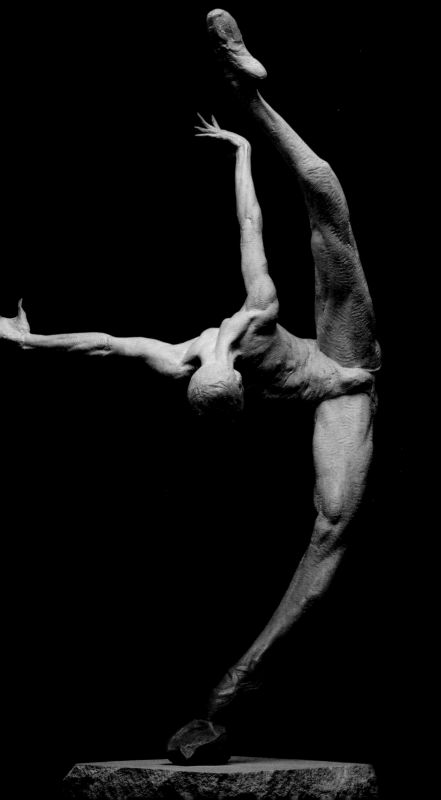

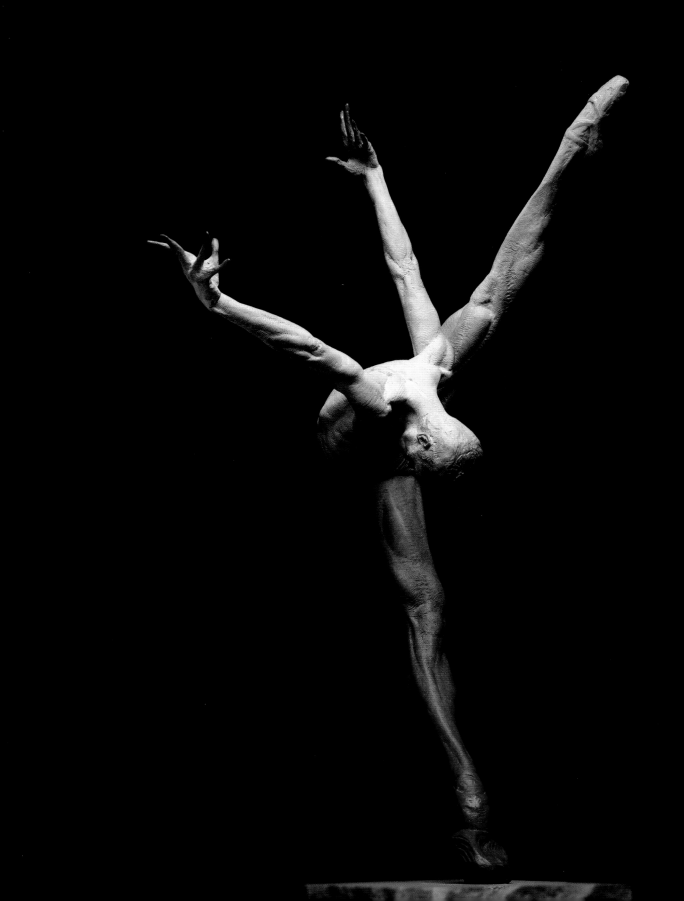

What makes it possible for you to create the art you want to create in your life?
I will always create. I don't think there is really anything that can stop that. I have been fortunate enough to be able to support myself with my work and build a studio that allows me to create the work I want to with minimal boundaries. Having good gallery representation and great collectors helps of course. The support of my wife is key. She has always been by my side pushing me to try new things and keep building my work. She is also quick to give an honest critique when she sees fit, which is probably the most important thing.

What will you leave behind as your legacy?
I hope to leave behind a continued appreciation for figurative arts. I hope my work inspires others to continue to build the world of figurative sculpture and arts.

What attracts you to dancing bodies?
I'm fascinated by how far a dancer can push the limits of the human body while maintaining a beautiful gracefulness. I love the study of human anatomy and dancers are generally amazing specimens to study. Their bodies are trained and developed to a point that almost every muscle is visible but in a balanced and beautiful way. Trying to capture that subtlety in a sculpture can be a life-long journey.

When and why did you start incorporating dance into your work? What do you feel dance brings to it?
I started working with dancers as a reference for much of the reasons listed above. Also, I have no ability to dance so I think that's probably part of what attracts me to it. By sculpting them, I in a way feel like I can be part of the beauty they create.

Are there any works of art by other artists featuring dance that have inspired you?
There are so many artists that have been fascinated with dancers over the years, the list could really be endless. I have always been inspired by the sculptures of Richard MacDonald. The dancer studies from Degas are mind-blowing. I remember

What process do you go through to create your work? What inspires you?
Sculpture is a very laborious medium to work with. It requires so much time and effort really at every level and can take years to actually get a finished bronze piece from when you start in clay. After the clay sculpture is created a rubber mold has to be made. After the mold is made, which is an art form of its own, the mold is cast in wax. The wax is then used by a fine art foundry to cast in bronze. In my studio I do most of the bronze work in house, so we take the bronze from the foundry and weld the sculpture back together, clean up all the welding and imperfections from casting, restoring the sculpture to the original beauty of the clay original. Then a chemical patina is applied to the bronze surface. Sculpture really takes a team to complete, and it is almost impossible to truly master each step of the process.

What might people be surprised to know about you (or your work)?
I think most people are surprised to learn that I'm actually very introverted and shy. Working with the live model and teaching requires me to confront and deal with those obstacles every day.

Sometimes I hide it well and sometimes it becomes very difficult and stressful to work one-on-one with a live model. I think it's probably why I am drawn to having other people sculpting with me in my studio. It allows me to withdraw more into my mind and quietly observe the model without distraction.

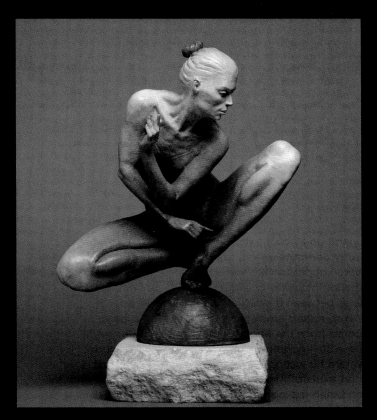

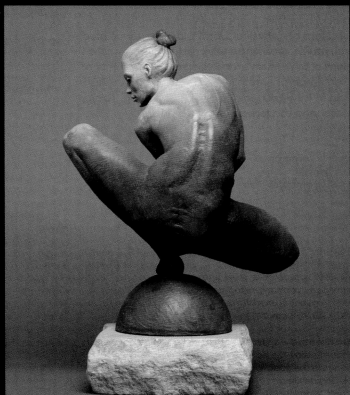

JONATHAN CHAPLINE

Jonathan Chapline draws from the aesthetics of early computer-generated imagery and computer-appropriated images, bringing these aesthetics into his painting practice as he blurs the lines between the virtual and physical world. The Texas-raised Brooklyn-based artist, who graduated from the Rhode Island School of Design, uses 3D-imaging software to re-create a world where his collaged compositions are extruded and transformed into hard-edge vector forms and then replicated onto canvas-covered panel with acrylic paint.

In addition to his paintings, Chapline pulls blocky figurative shapes out from the virtual space and into the physical world with brightly colored sculptures. Chapline's work resides in the collections of the X Museum in Beijing and the Institute of Contemporary Art in Miami. The artist has exhibited in New York, Los Angeles, Hong Kong, Tokyo, Basel, and London, among other cities.

Website: jonathanchapline.com
Instagram: @jchapline
Email: chaplinestudio@gmail.com

OPPOSITE PAGE
Figure (Standing)
Acrylic photopolymer, steel, epoxy, fiberglass, urethane, nylon, acrylic and vinyl paint, 64 × 48 × 30",
163 × 123 × 76 cm, 2020

Exhibited in the show *Plein-Air*. Presented by The Hole and ICA Miami in the open-air building by Herzog de Meuron at 1111 Lincoln Road, Miami Beach.

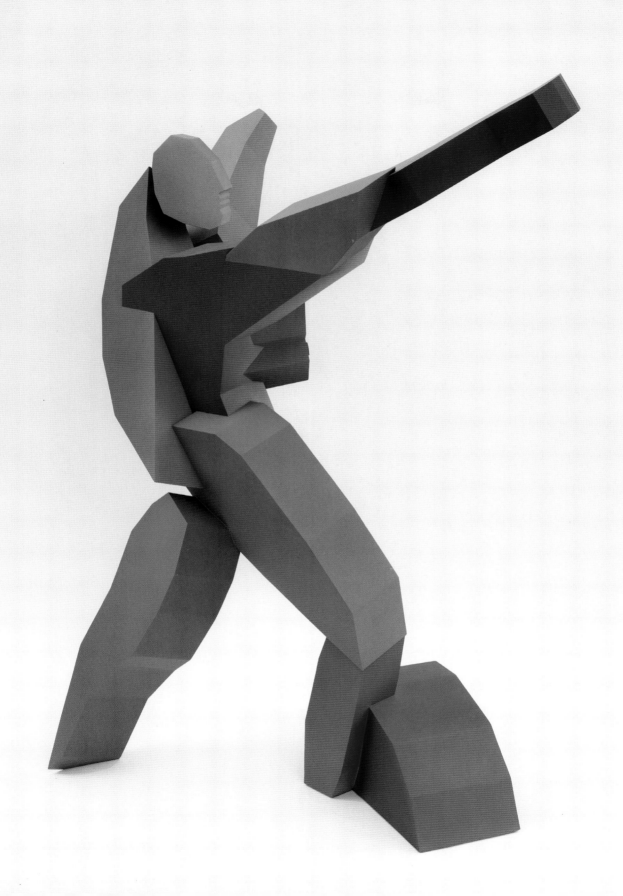

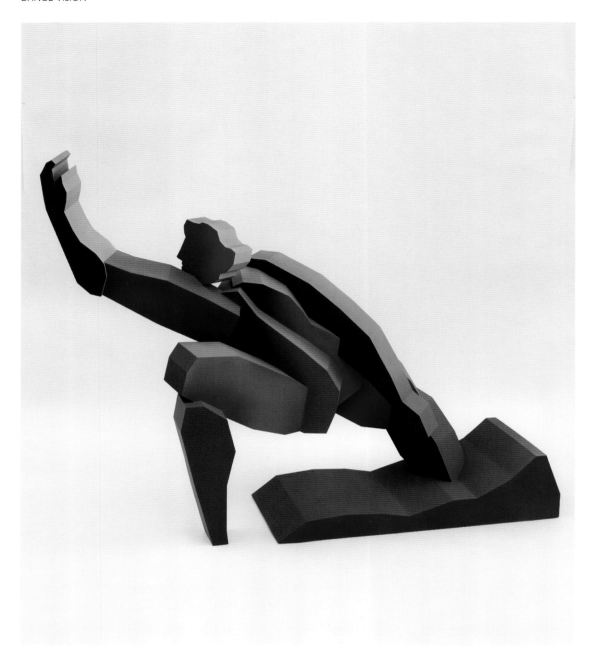

ABOVE
Figure (Sitting)
Acrylic photopolymer, steel, epoxy, fiberglass, urethane, nylon, acrylic and vinyl paint, 34 × 42½ × 32½", 86 × 108 × 83 cm, 2020

Exhibited in the show *Plein-Air*. Presented by The Hole and ICA Miami in the open-air building by Herzog de Meuron at 1111 Lincoln Road, Miami Beach.

OPPOSITE PAGE
Standing Figures II (Dawn)
ABS resin, urethane paint, oil-based gloss protection, 61 × 45¼ × 32½", 155 × 115 × 83 cm, 2021

Exhibited in the show *Statuesque* at Nanzuka Underground in Tokyo, Japan.

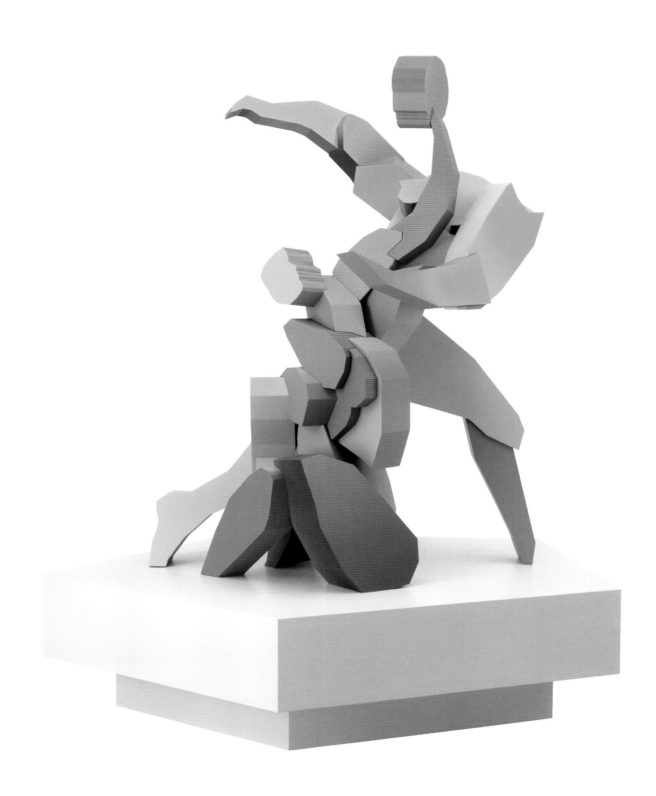

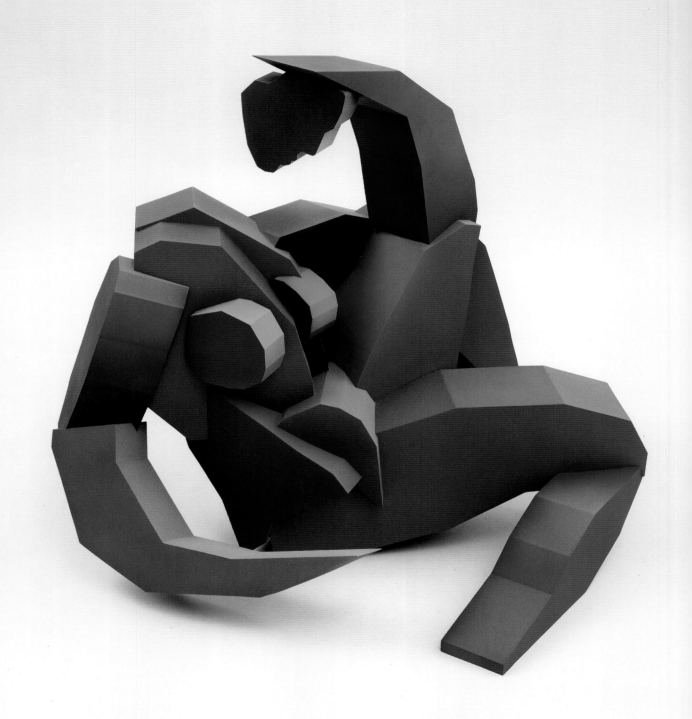

Figure (Sitting)
Acrylic photopolymer, steel, epoxy, fiberglass, urethane, nylon, acrylic and vinyl paint, 34 × 42½ × 32½", 86 × 108 × 83 cm, 2020

Exhibited in the show *Plein-Air*. Presented by The Hole and ICA Miami in the open-air building by Herzog de Meuron at 1111 Lincoln Road, Miami Beach.

What makes it possible for you to create the art you want to create in your life?

For me, I am constantly engaging my curiosity. I have to be engaged within the work, finding ways of asking questions, finding new ways of problem solving, and finding new ways of looking at things that I am trying to make. Looking at it differently, that would be the goal for me, constantly seeing and looking for things, at things from different perspectives.

What will you leave behind as your legacy?

Well, I think, I hope, that I find something unique, that all artists maybe find something unique that they can add to this collective artistic knowledge, that they have been able to [contribute to] a bubble of knowledge. I hope that I can increase that bubble of knowledge in some way, in all collective human knowledge, experience, and understanding; if I am able to increase that on some level somehow, that is what I am striving for every day.

What attracts you to dancing bodies?

I think it is a good way of attacking [my work], analyzing it. For me it is where I see the work and the scale of the work, if I can make a brush mark or make a shape that draws your eye from one space to another. Or, for me as a painter (I am a painter that also happens to make sculpture), if I make a brush mark on a panel, or even while sculpting large shapes, I always think about the largest arc that I can probably make, and that is dictated by my body and my scale, and I also think about a small mark the size of a wrist movement, I think of the economy of scale and movement in those ways and that arm to wrist movement. And then working on the computer, I also think about movement in terms of a mouse click or even moving a cursor or a scroll wheel; the infinite movement is very much how I create. If I am feeling that brush mark it's making, I am recording that movement within it, you know. So that's how I see the movement within the work, and then from that movement, I can lean into depictions. If I have a movement that is the size of an arm, then I can consciously be like, well, why don't I make it an arm and leg, and then what if that leg and arm imitate that same movement that I am making with my body?

When and why did you start incorporating dance into your work, and what do you feel dance brings to it?

I take it into a conscious understanding of it being more than just a visual representation. It is beyond just me having a visual understanding of what I am doing in my work.

Beyond pleasure, I get pleasure by producing, being active within the work, looking around it, painting . . .

Or even the sculptures, I feel the same way . . .

I think it is something that is natural; movement brings naturalness to my work.

Are there any works of art by other artists featuring dance that have inspired you?

Matisse, of course, the master, I'm sure everyone mentions him, and his paper cutouts. I think about him and, even in his later days when he made paper cutouts, he was bedridden and he was still able to get movement while he was in bed, dying, it confounds me to imagine that . . .

A couple people I truly admire, that talk about specifically bodies and movement. . . . Thomas Houseago depicts figures and form and movement through that; he uses materials that are super natural such as plaster, wood, charcoal, and bronze. The opposite of my work, which is about appropriating digital aesthetics that are trying to be natural, aesthetics that do not exist within nature, and he is doing the opposite, and I enjoy that honesty about his work: letting the material be, and also finding the figurative form within it, is also really beautiful.

For me with anything, if you see something that informs you it is going to inform your work, and then you start to realize things you never really thought of before . . . and excitement, I think excitement, these two artists get me excited, and even melancholy, even though they are active painting and sculptures. For me when I look at the art of sculpture, and see and that I am drawn to, I then try to disassemble it and understand where [the artists] are coming from, where they are getting their rhythm from within their work.

What process do you go through to create your work? What inspires you?

A main part of my practice is having a conversation, a call and response of ideas, and taking and giving, and learning, yeah, architecture fascinates me, always has been [that way]. I think also the lack of travel made me realize that travel has been an inspiration, living in New York, a constant new experience, living here, the places I inhabit . . .

Is there more to the process? Yeah, for me, a lot of it is sketching, going on walks, looking, a lot of looking, people watching, and also from that, it's a long process of working on the computer thing, then the sketches and photographs and dissembling of those ideas and translating those ideas, stripping them down and then assembling them in a 3D program. In that way, I am kind of in some ways disassociating it from movement and form, taking it to its basic element and what is left is, I think, the most simplistic version of the thing that I was interested in within the first place. And then from there, that is when I feel like I am able to start creating, and that's when the sculptures happen, and when I can riff off those ideas for the paintings too. I am a painter making sculpture.

What might people be surprised to know about you (or your work)?

Oh, that is a tricky one, I guess because I am so close to myself. . . .

It is hard to even start to anticipate what someone might be surprised to know . . .

I don't know.

What question do you wish I had asked you?

How can an artist making physical work, make work in this technological age, and are you fighting against it?

What is your answer to that question?

For me, that is the exciting thing, to try to live in both, in some way: How do you live a physical life and a digital one. And how do you focus on these vary tactile things, these tactile experiences and also have global experiences, too, which are not always easy to have at the same time; that is what I am excited about, from all these tools that are coming about and also all these different ways of experiencing things, online and in new technologies that are going out, I think there is going to be an infinite number of ways of creating new things, and that is exciting and I am excited about the future!

ABOVE

Sculpture (Stretching)
Acrylic photopolymer, steel, epoxy, fiberglass, urethane, nylon, acrylic and vinyl paint, 94 × 43.6 × 21.9", 239 × 111 × 56 cm, 2020

Exhbited in the show *Virtual Window* at Library Street Collective in Detroit, MI.

263

CODERCH & MALAVIA

Coderch & Malavia is a sculpture project in which the human body is at the core of the plastic discourse. A universe of meaningful forms centered on the idealized human figure. And a clear horizon: Beauty as an everyday tool. Joan Coderch and Javier Malavia came together in 2015 to carry out sculptural work featuring a refined technique, which is present from the modeling in the studio to the final piece cast in bronze.

Joan Coderch was born in 1959 in Castellar del Vallès, Barcelona, and he graduated from Barcelona's Faculty of Fine Arts in 1984. Javier Malavia was born in 1970 in Oñati, Guipúzcoa, and he graduated from Valencia's San Carlos Faculty of Fine Art in 1993. Once they met, they discovered their artistic similarities, which led to their undertaking this new project that follows in the footsteps of masters of figuration such as Maillol, Rodin, Marini, and Bourdelle.

Part of the originality of their art lies in the way they work, since they make their sculptures four-handed, thereby sharing in the creation of the pieces. Joan and Javier also have in common the values of their artistic creation, such as social commitment with regards to equality, the environment, and childhood.

Their project stands out due to its honesty and authenticity; they explore different human attitudes to life, in which mimicking nature, the search for emotion through the work, the revealing of the feelings that direct man, the encounter between the figure and posture, and the combining of beauty and discipline feature prominently. The human being is at the core of their art.

From the very beginning, Coderch & Malavia have managed to position themselves as outstanding figurative artists. They received the Reina Sofía Prize for Painting and Sculpture for their *Hamlet* artwork in 2017, and won first prize at the Fourteenth International ARC Salon Competition with the sculpture *The Swan Dance* in 2019. Their other awards include the Mariano Benlliure Sculpture Medal, and the TIAC Art Prize or the Arcadia Contemporary Award.

In addition to being nationally and internationally renowned, their work forms part of private collections in several countries in Europe, Asia, and America. They display their work in collective and individual exhibitions in both private entities and public spaces. Many venues in France, the United States (Miami), Mexico, Italy, and Greece have had the opportunity of enjoying their works where they regularly exhibit. They were present in Berlin's Urban Nation Biennial with their *Learning to Fly* piece in September 2019; in Sweden in an open-air sculpture park, Skulptur i Pilane, where they share space with Jaume Plensa and Tony Cragg, among others, through the exhibition of *Giant of Salt* and *Learning to Fly* in 2021.

In Spain, they have exhibited in the most important cities, such as Barcelona, Granada, Madrid, Valencia, and Málaga.

Joan Coderch and Javier Malavia currently live and work in Valencia.

OPPOSITE PAGE
Moonlight Shadow

Website: coderchmalavia.com
Instagram: @coderch.malavia.sculptors

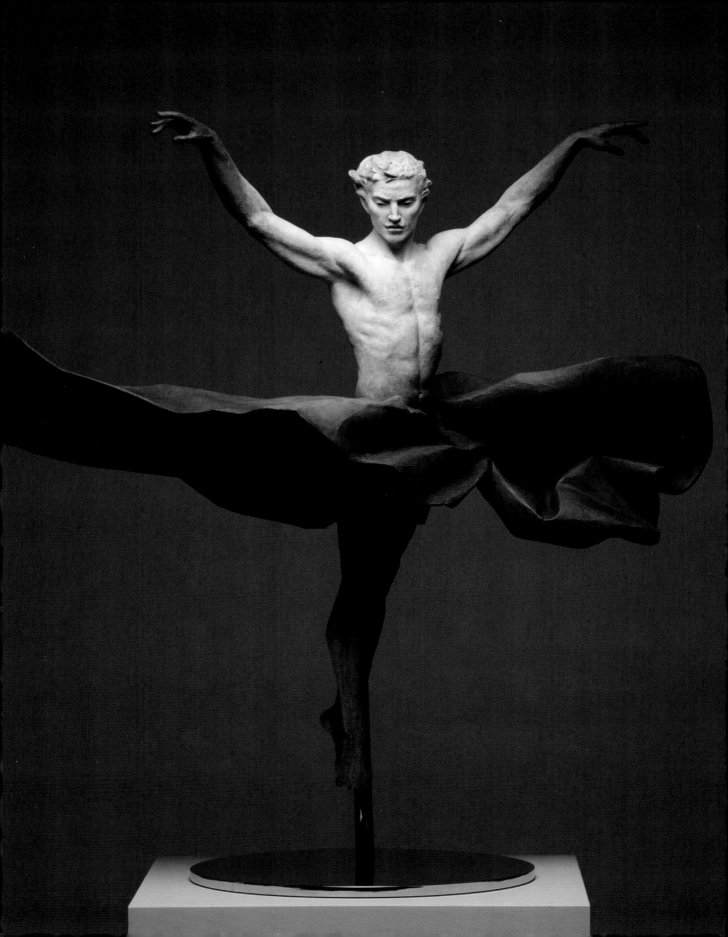

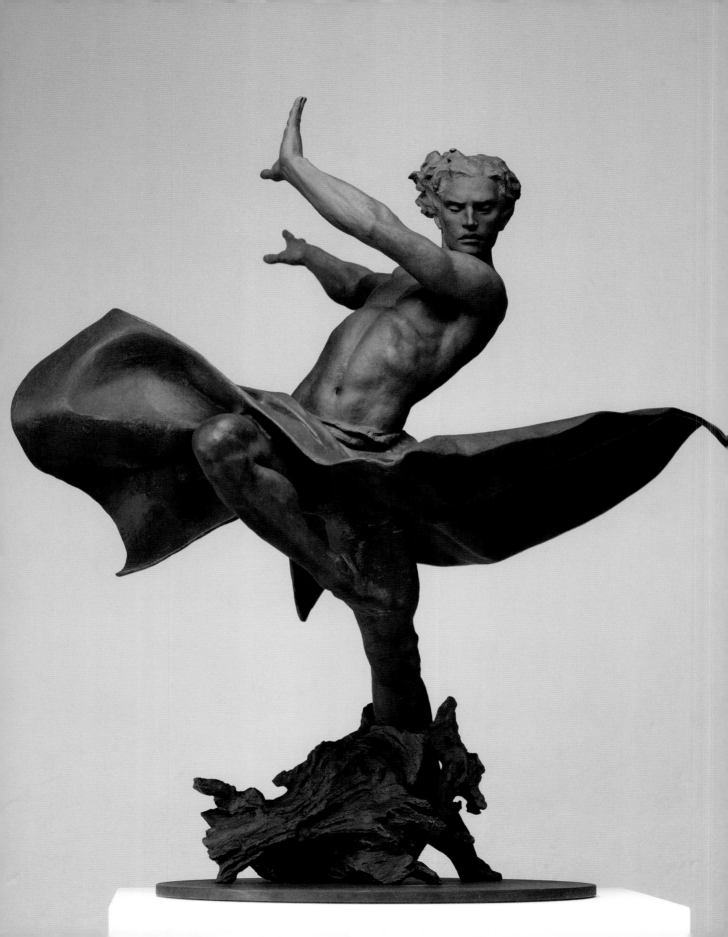

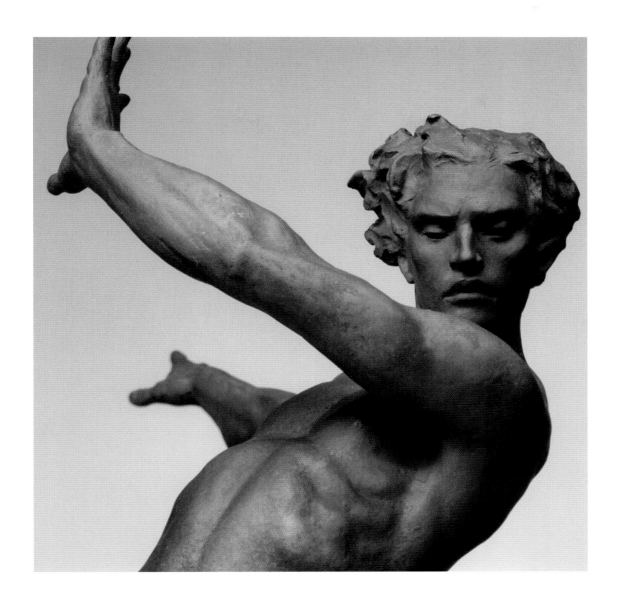

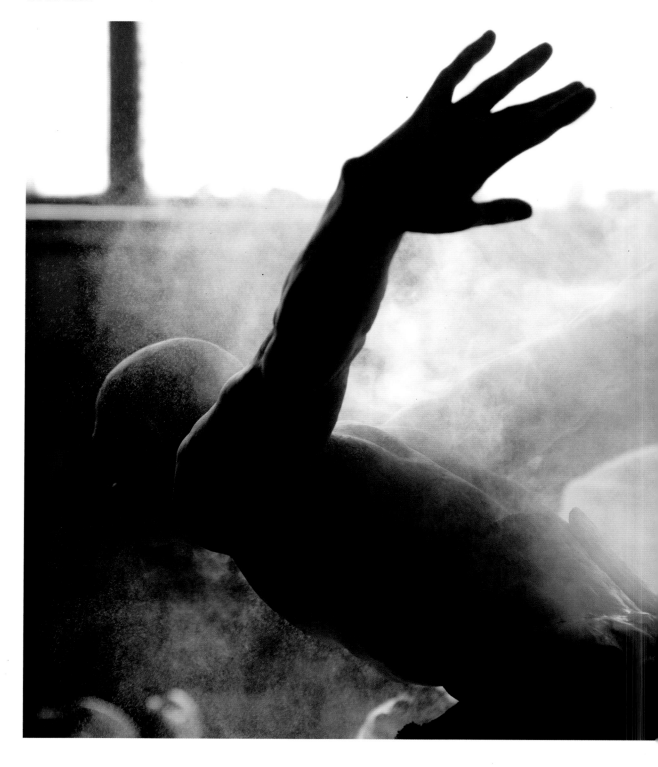

THIS SPREAD

The Flight of the Swan

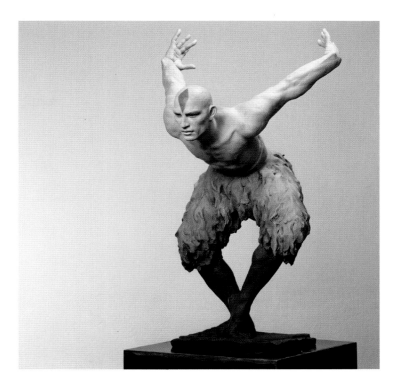

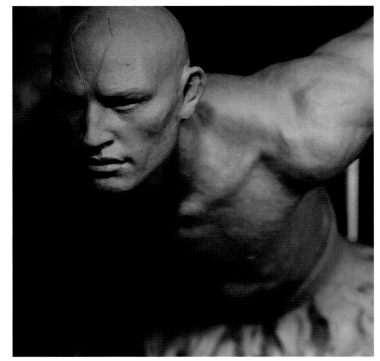

What makes it possible for you to create the art you want to create in your life?

We met when we became part of the sculptors' team of an international porcelain company, where we established a strong friendship and had the opportunity to work together. Without knowing it, we were putting down the foundations of what later would be Coderch & Malavia Sculptors.

The encounter between our artistic concerns and the desire to unleash our creativity led us to start Coderch & Malavia Sculptors in 2015.

Making the decision to start our project together has been one of the most difficult and exciting moments of our careers. Before that, we were doing things we liked, but that somehow did not fulfill us because they were commissions.

The vertigo produced by the unknown, the transition from a comfortable situation to a very different one . . . it felt like jumping down to emptiness! But we did it without hesitation and we can say today that we are living the best stage of our lives at a professional level.

What will you leave behind as your legacy?

The world is a work of art; we should not become mere spectators of what happens. We should get excited by and reflect on what surrounds us, just as we do with a piece of art. This process of reflection is, without a doubt, the basis for changing things, and this is what we want to leave as a legacy.

What attracts you to dancing bodies?

Art itself is a source of inspiration for art, and dance is art in motion. The control and mastery of the dancer's body has always been an object of fascination for us.

Although the dancers are constantly active, when we go to see a performance, we are always fascinated to see how there are movements that seem to freeze time. The great dancers seem to hang in the air during the jumps or to be perfectly immobile in the positions and turns.

That search for perfection in their art, their sacrifice, and their bodies' need to adapt to create beauty is undoubtedly one of our great sources of inspiration.

When and why did you start incorporating dance into your work, and what do you feel dance brings to it?

When I was very young, I was lucky enough to find a teacher of plastic arts who saw in me the love and sensitivity I had for volume. He supported me and helped me by teaching me the basics of modeling. He introduced me to the dancing world as a source of inspiration. This was for me a turning point. I discovered a whole new world, and I realized that sculpture, and art in general, is the perfect way to express my ideas and my feelings. –Joan Coderch

I've always liked to draw, and I've always loved nature, the human body, chemistry, and physiology. Before I started my university studies, I did not really know whether I wanted to follow one path or another. Suddenly, something clicked in my mind, just like when inspiration comes to you, and I realized that I wanted to study fine arts.

Once in class, the first contact I had with sculpture, especially the modeling, was like a crush . . . it was love at first sight!

When you have the naked body of a model in front of you, the beauty of the human body continues to fascinate you, and if that model is also a dancer, the fascination is even greater; you notice how each part of his body has adapted to be able to move, to be able to jump, to dance, and to create that art in movement.

Later I met my wife, who at that time was a classic ballet dancer. And you can understand that my interest for dancing grew a lot. –Javier Malavia

Are there any works of art by other artists featuring dance that have inspired you?

Edgar Degas and his dancers; he was able to portray the environment of schools and ballet theaters in Paris, reflecting the sacrifice of the dancers to achieve perfection in their art.

What process do you go through to create your work? What inspires you?

We start from several brainstorming sessions in which we put all the cards down on the table. During this process, we share our ideas, no matter if they are good or bad, to get to a point where we understand what is important to us and what it is that we want to develop.

We always work with live models; we look for our own way to develop the sculpture. It is not very easy, but after a long process, we find it.

After several model sessions, subtle gesture changes, and a thousand different expressions that have come and vanished, finally, although we had never seen the finished piece, she appears authentically.

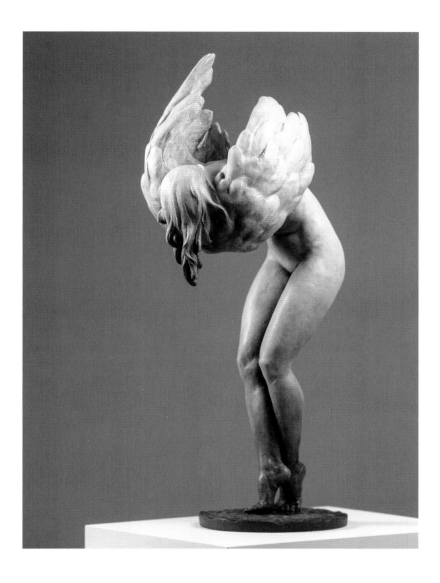

Odette

Literature, poetry, theater, photography, cinema, and ballet, they all serve as inspiration.

What might people be surprised to know about you (or your work)?
They will by surprised to know that we have dreamed of doing what we do now all our life. Art is part of us. Maybe we would be yearning for the life we currently live if we had dedicated ourselves to something else.

What question do you wish I had asked you?
How can two heads and four hands work together?

What is your answer to that question?
Sharing the creation of a work of art is complicated; there must be a predisposition to fit together artistically.

The fact that a work of art can emerge from the collaboration of two different sensibilities might catch people's attention because it might seem complicated, but in reality, we believe that this alliance empowers the final result.

Meeting and discussing is simple; the complicated part is organizing and sharing the physical creation of the work itself, because you need double discipline. You must learn to trust your partner and be able to share your ideas and your work with him, and, above all, you must put your ego aside in order to stay equal to commit to the final result.

CAROLE A. FEUERMAN

Carole A. Feuerman (b. 1945) is an American sculptor and author working in hyperrealism. She is one of the three artists credited with starting the movement in the late 1970s. She is best known for her iconic figurative works of dancers and swimmers. She is the only artist to make lifelike outdoor sculptures and the only woman to sculpt in this style. Her work has been included in exhibitions at the National Portrait Gallery–Smithsonian Institution; the State Hermitage Museum; the Venice Biennale; Galleria d'Arte Moderna; Palazzo Strozzi in Florence, and Palazzo Reale in Milan.

Growing up in New York City, Feuerman was deterred from being an artist. She attended Hofstra University and Temple University, and graduated from the School of Visual Arts in New York City to begin her career as an illustrator. During the early seventies she went by the artist's name Carole Jean, illustrating for the *New York Times* and creating album covers for Alice Cooper and the Rolling Stones, to name a few.

In 1981, Feuerman's work was chosen for exhibition at the Heckscher Museum in Huntington, New York. After this, she was invited to participate in the Learning through the Arts Program at the Guggenheim Museum.

Feuerman received the Charles D. Murphy Sculpture Award in 1981. In 1982 she received the Amelia Peabody Award for sculpture. In 2016, she received the Best in Show Award for her sculpture *Mona Lisa* by the Huantai Museum, and the sculpture was acquired for its permanent collection.

Feuerman has also been awarded the Medici Prize by the City of Florence, first prize at the Beijing Biennale, and the Austrian Biennale, and in 2008 she received first prize in the Olympic Fine Arts exhibition in Beijing. The piece was acquired by the Olympic Museum.

She has taught, lectured, and given workshops at the Metropolitan Museum of Art and the Solomon R. Guggenheim Museum. In 2011, she founded the Carole A. Feuerman Sculpture Foundation. Her artworks are owned by more than twenty museums, as well as in the collections of the City of Peekskill, New York; the City of Sunnyvale, California; former president Bill Clinton and former senator Hillary Rodham Clinton; the Frederick R. Weisman Art Foundation; Dr. Henry Kissinger; the Mikhail Gorbachev Art Foundation; Mr. Steven A. Cohen; Alexandre Grendene Bartelle; and the Malcolm Forbes Magazine Collection.

Feuerman's public works have been displayed across the globe, including but not limited to Central Park in New York; Saint-Tropez and Avenue George V in Paris; Beijing and Harbor City in Hong Kong, Palazzo Milan, Rome, and Giardino della Marinaressa in Italy; New Bond Street and Canary Wharf in London; and Knokke-Heist in Belgium. She lives in New York City and is the wife of Ronald Cohen, and the mother of Lauren Leahy, Sari Gibson, and Craig Feuerman, and the grandmother of Hannah Leahy, Sam Leahy, Isla Feuerman, and Kai Feuerman.

Website: carolefeuerman.com
carolefeuerman.info
carolefeuermanfoundation.org
Instagram: @carolefeuerman

OPPOSITE PAGE
Eyes Open

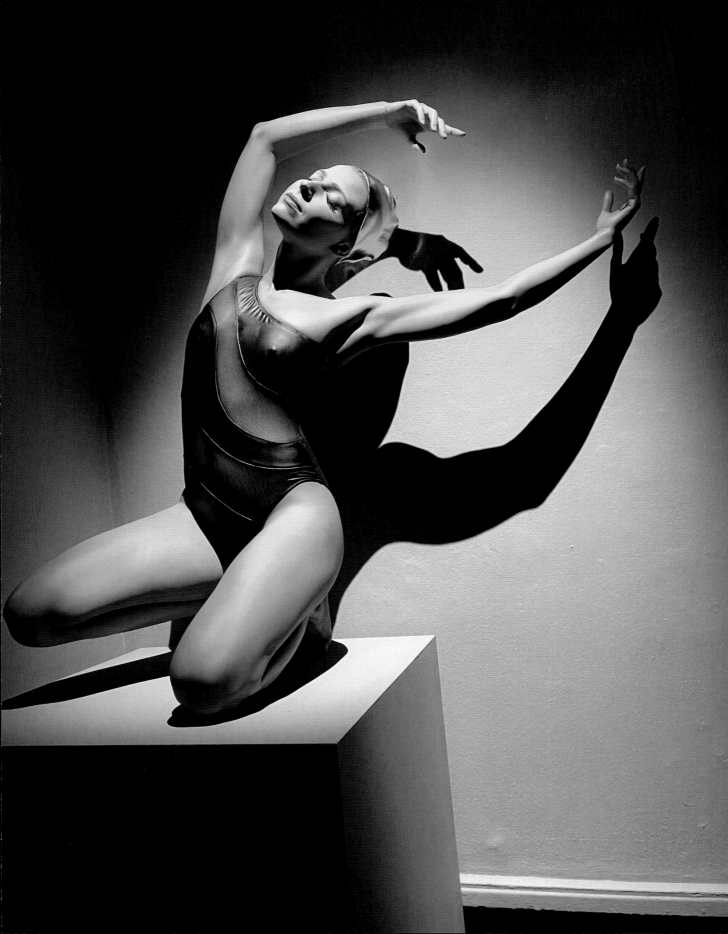

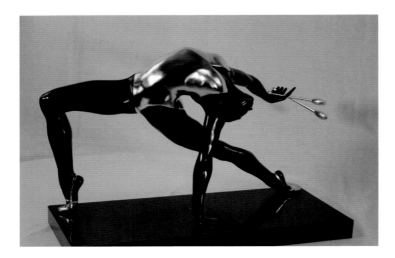

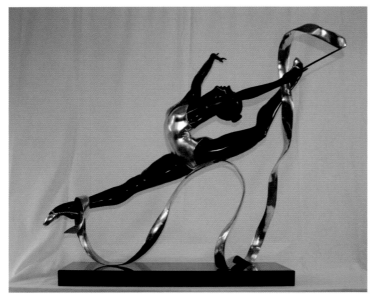

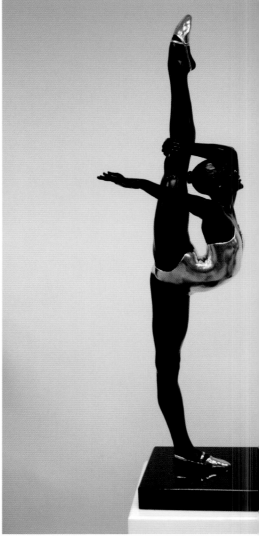

TOP LEFT
Extension

BOTTOM LEFT
Levitation

CENTER
Fire & Harmony

OPPOSITE PAGE
Infinite Dancer

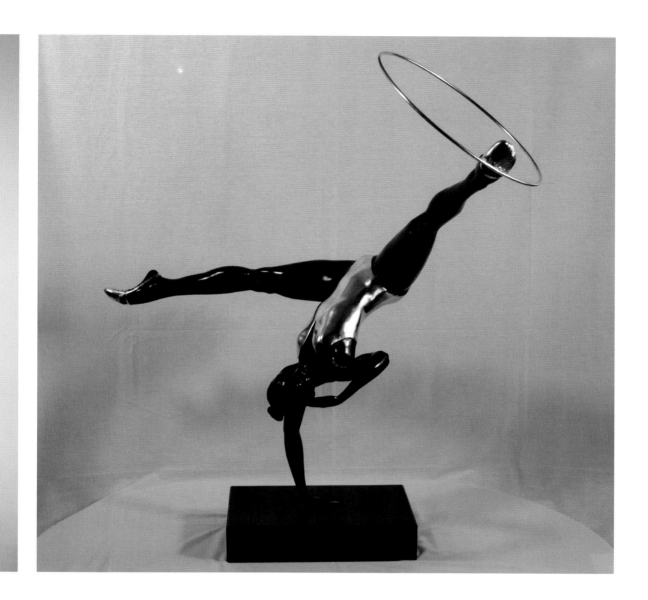

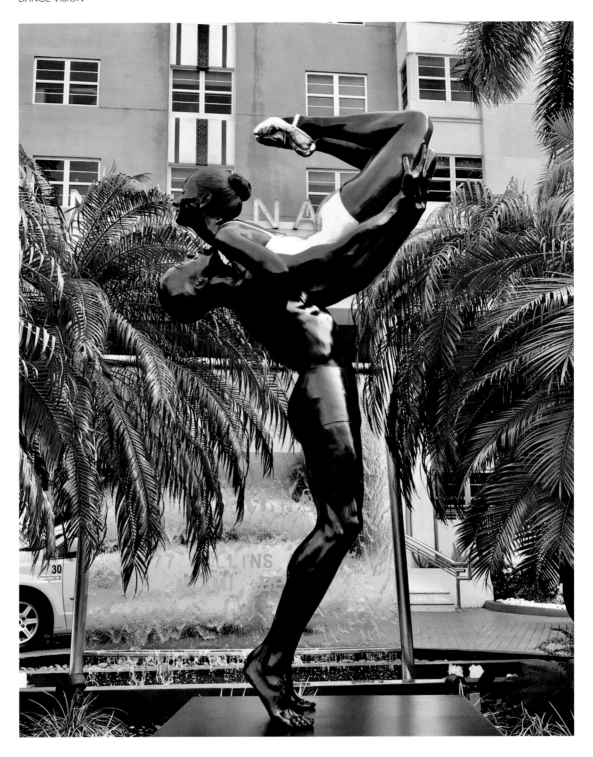

ABOVE
Strength

OPPOSITE PAGE
Strength (detail)

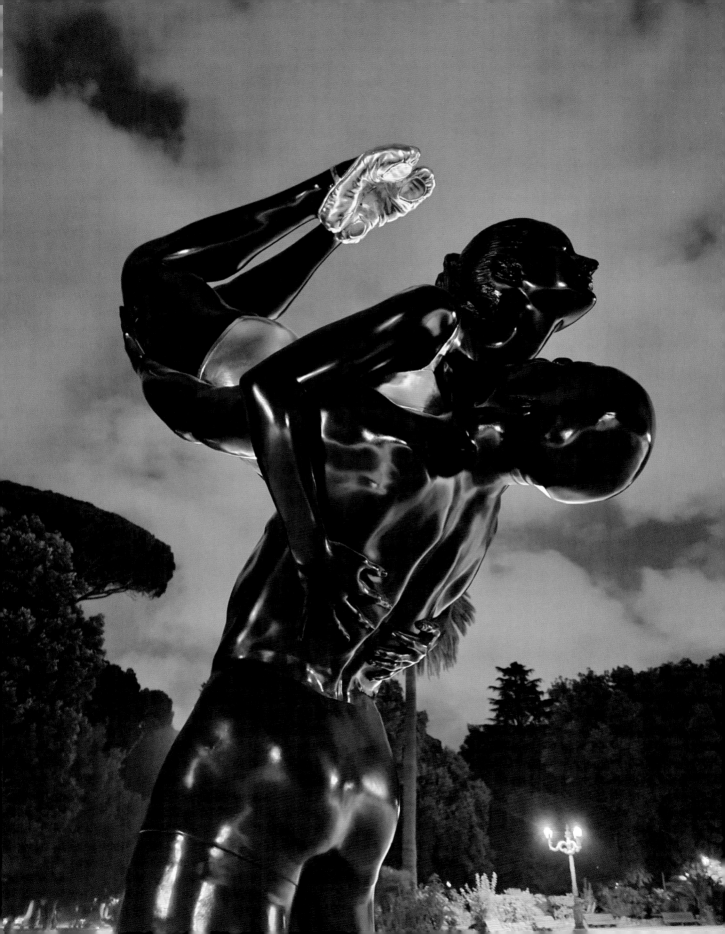

What makes it possible for you to create the art you want to create in your life?

Once upon a time, I had two unsuccessful gallery shows in New York: 52nd Street, which involves Malcolm Forbes, who walks in and says, "You have no sales." And I reply, "Yes." And then he goes on to say, "Well, I'm going to buy the whole show." Just when I thought all was a disaster, the unexpected happened. I tell people to stick with it, whatever that might be, and persevere. It only takes one thing to change your life, and then that greatness accumulates. I appreciate those that enjoy my work. People wait in line to kiss my sculptures at La Biennale di Venezia, and that touches me.

What will you leave behind as your legacy?

My sculptures. I hope these monumental sculptures will be my legacy. My dancers particularly. I've always wanted to do art that lasts, that won't disintegrate. Art that is permanent.

My children and grandchildren. My greatest creations are my kids, too.

My foundation, which will help underrepresented artists, because I once was one.

Are there any works of art by other artists featuring dance that inspire you?

Degas, *Little Dancer of Fourteen Years*. I have a little copy of *Little Dancer* in my house. I bought it in the Berkshires twenty years ago. For thirty dollars. It made me feel special. My initial interest in dance happened when I was a kid. And that love for dance grew. I welcome dance and the stories the body tells.

What attracts you to dancing bodies?

I think dance is the most beautiful thing in the world. Dance speaks to me. It fascinates me when dancers make these extreme shapes with their bodies. I admire that sheer desire to show the human body in such beauty. They do what they love, and I admire that. All types of dance, I love it, and I love to make sculptures about things I love.

What process do you go through to create your work?

First, I am inspired by an idea. Then I find someone to pose and portray the idea. I then decide what I want to make, and I choose the size: small, tabletop, fragment, huge, monumental. And then I decide the material: bronze, epoxy, and even painted black and gold. I do all the finishing of the sculptures. And then I have shows! My sculptures travel from Paris, Rome, Saint-Tropez and show in museums. They have passports, called a *carnet de passage*, and they go from place to place until someone gives them a home!

What inspires you?

All types of dance, especially rhythmic dance at the Olympics. Dance and sculpture have a relationship! Maybe they're even cousins!

What might people be surprised to know about you or your work?

I don't know, what surprised you?

I was surprised that I had not seen your work. It is so evocative. When I see your sculptures, I want to know more about these people. The sculptures leave stains in my memory because they are so approachable. It draws me in. Yes, that's it! Your sculptures are approachable. Yeah, I will kiss one of your sculptures!

When I think about hyperrealism, I think the contrast of realism versus your sculptures' closed eyes allows the realism to be approached and appreciated. Even with a kiss.

Why are the eyes closed?

I close them because they are hyperreal, and I think you can feel comfortable because their eyes are closed. There is a sense of respect. I also close my eyes. I create in my mind when I close my eyes and I am still. That's when I can see. I can see what I want to create within my work.

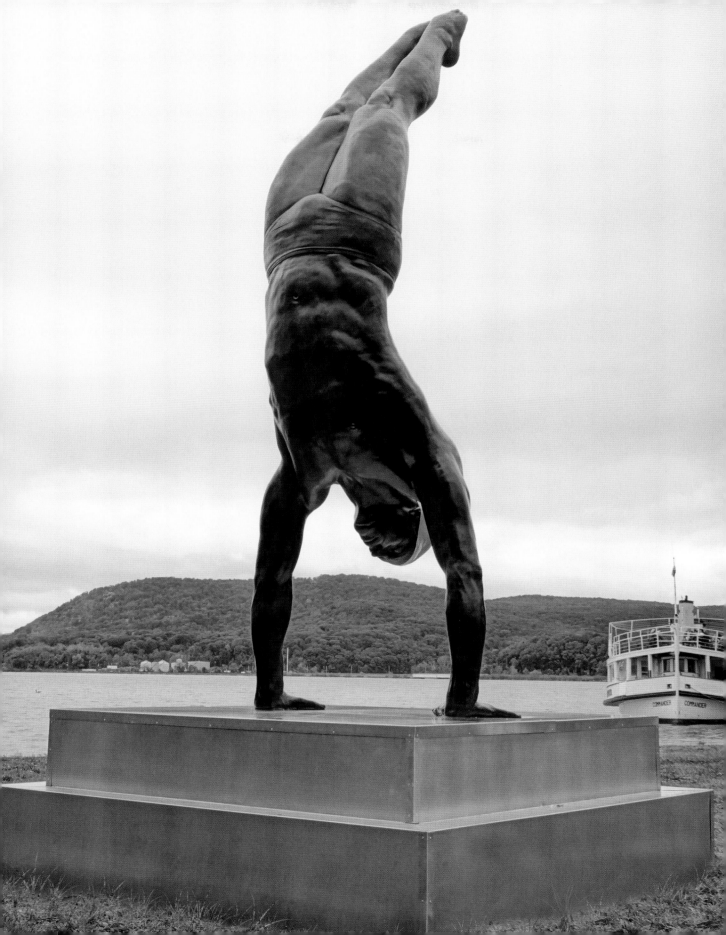

DORIT LEVINSTEIN

Dorit Levinstein is a contemporary painter and sculptor. As part of a career that seeks to join the two mediums, Levinstein's hand-painted sculptures are known for their signature vibrant color palette and elastic lines. Her creative process relies on the surrendering of ego to allow her sculptures to direct her in what she calls a "choreography of matter." Levinstein derives inspiration primarily from classical artists and the world of dance, as well as animals, flowers, and everyday objects. She has created commissioned works for indoor and outdoor settings, and her monumental sculptures grace the landscapes of municipalities around the world. Dorit Levinstein has been represented exclusively by Eden Gallery since 1999. Her art is available to view at Eden Gallery locations worldwide in New York City, Aspen, Miami, London, Mykonos, and Dubai.

Website: dorit-levinstein.com
Email: info@dorit-levinstein.com

OPPOSITE PAGE
Renoir Dancers XXL
Aluminum / Bronze Free
Standing Sculpture,
98 × 39 × 39",
249 × 99 × 99 cm

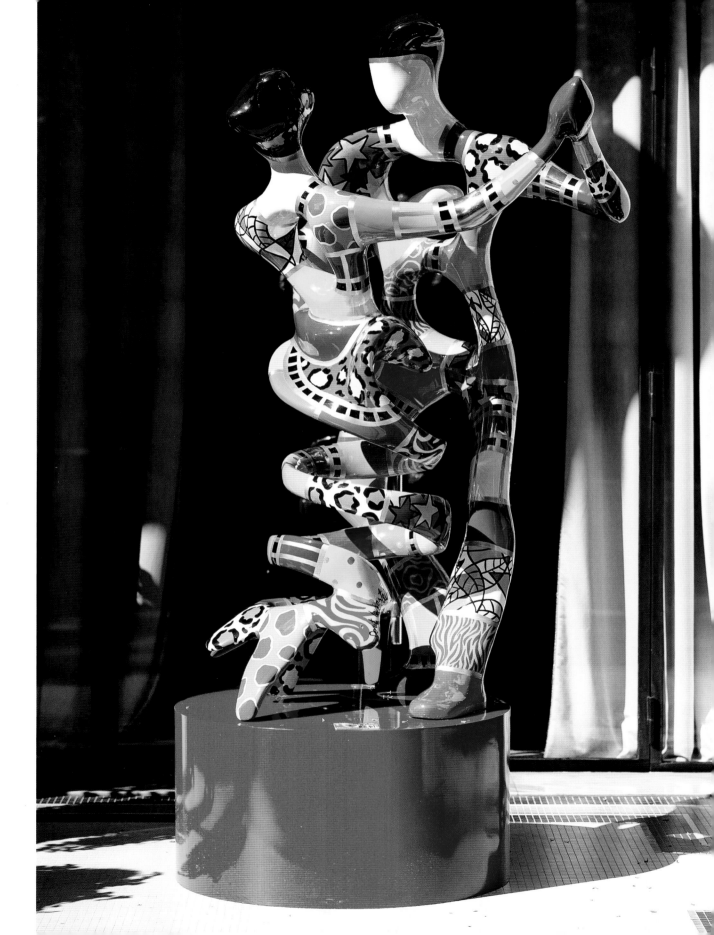

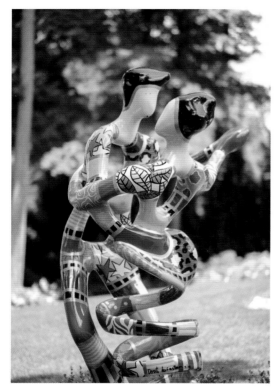

TOP, BOTTOM LEFT, TOP RIGHT

Renoir Dancers XXL
Aluminum / Bronze Free
Standing Sculpture,
98 × 39 × 39",
249 × 99 × 99 cm

BOTTOM RIGHT

Cumparsita XXL
Free Standing Bronze
Sculpture, 70 × 59 × 39",
178 × 150 × 99 cm

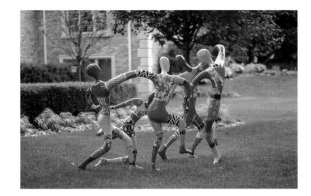

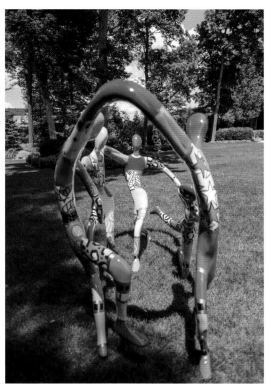

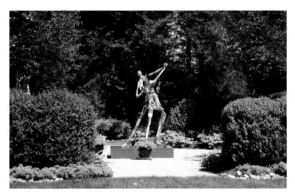

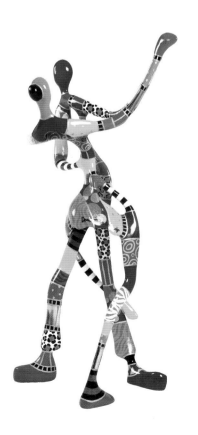

Matisse Dancers XXL
Aluminum Sculpture,
62 × 47 × 91",
157 × 119 × 231 cm

Cumparsita XXL
Free Standing Bronze
Sculpture, 70 × 59 × 39",
178 × 150 × 99 cm

What makes it possible for you to create the art you want to create in your life?

The passion within me to create something is the same as the need to breathe. I was born with this natural obsession. I believe that it's a kind of self-care. I do it all the time in everything I touch. Even if it's not sculpture, I'm busy changing my reality in some way, being creative by cooking or creating art.

What will you leave behind as your legacy?

I ask myself this question every day. I always try to be honest with myself, authentic, and curious. I want to do my best. Being myself, I don't search for a legacy per se. I don't think a lot about it because it's not something that can be counted on for sure. We shouldn't expect it.

What attracts you to dancing bodies?

Everything: changing positions, the process of moving. Exactly as in life, these bodies in motion are stories that I tell myself from my personal point of view.

When and why did you start incorporating dance into your work, and what do you feel dance brings to it?

I want to focus on relationships and dialogues between people that are communicated through body language. It is magical for me to try to understand interactions based solely on movements. One can tell a lot without saying even one word.

Are there any works of art by other artists featuring dance that have inspired you?

I am always impressed and jealous of a dancer's perfect body and beauty. I made some variations of the Matisse dancers and Renoir paintings. As I said before, what interests me is their relationships and communication. I love to watch people in every situation.

What process do you go through to create your work? What inspires you?

Every period in life that I go through I am very concerned about what is going on or what is bothering me at that moment. Subjects from a specific time are sometimes questions that I have asked myself. Other times, the subject is something that comes up and it is connected to my current situation. One can visit the same museum many times and each time look for other rooms that perhaps didn't interest them before. Everything is inside us; it just depends on what you are looking for at the moment.

What might people be surprised to know about you (or your work)?

That I am a very conflicted person and dealing with extreme situations. Many times, I criticize and argue with myself. However, I do always try to find joy and compromises within my pain. The truth comes out in my work. The work never lies.

What question do you wish I had asked you?

What is your favorite, happiest moment in your work?

What is your answer to that question?

The moment that I surrender to my creation. My creative process is like a tango dance. I dance with my work, my thoughts, and my decisions. In every single movement, there is always one leader, one "boss." When starting, usually I am the boss. When the creation starts to take form, it also takes on its own life and demands. I let it lead me. It is the greatest moment for me that makes me very happy and satisfied. It's a real joy.

OPPOSITE PAGE

Renoir Dancers XXL
Aluminum / Bronze Free
Standing Sculpture,
98 × 39 × 39",
249 × 99 × 99 cm

JAMES MOORE

Moore grew up in California's rural Central Valley. His path to becoming a sculptor was a circuitous one. Along the way he was a banker, a bodybuilder, and a father. But since his late teens he's followed the creative impulse to make art.

It all began on the Central California ranch his parents owned. There, without the benefit of formal training, he taught himself direct wood-carving. Even as he traveled traditional career paths, he continued to cultivate his artistic vision by working in makeshift home studios before and after his day jobs in banking and finance.

His earliest opportunities to share his work with the world came through nontraditional exhibition spaces like restaurants and coffee houses. The exposure gained through these exhibitions led to artist co-op group shows around the San Francisco Bay area. That exposure, in turn caught the attention of established commercial art galleries.

Over time as his work became more broadly known, he was awarded public art commissions to activate city parks and plazas. More than three decades after he created his first sculpture, his work is included in private collections around the world and in public collections across the country.

Over that same time Moore's reason for creating has evolved to reflect universal themes we can all identify with—no matter the viewer's age or background. His desire is to help cultivate a feeling of connection between individuals and a sense of inclusion within communities through the shared experience of public art.

Website: moorecontemporaryart.com
Instagram: @moorecontemporaryart
Facebook: James Moore CA
Email: jsteel408@gmail.com

OPPOSITE PAGE
Study for Sway
Welded stainless steel.
Leaning into the moment
with grace and power.

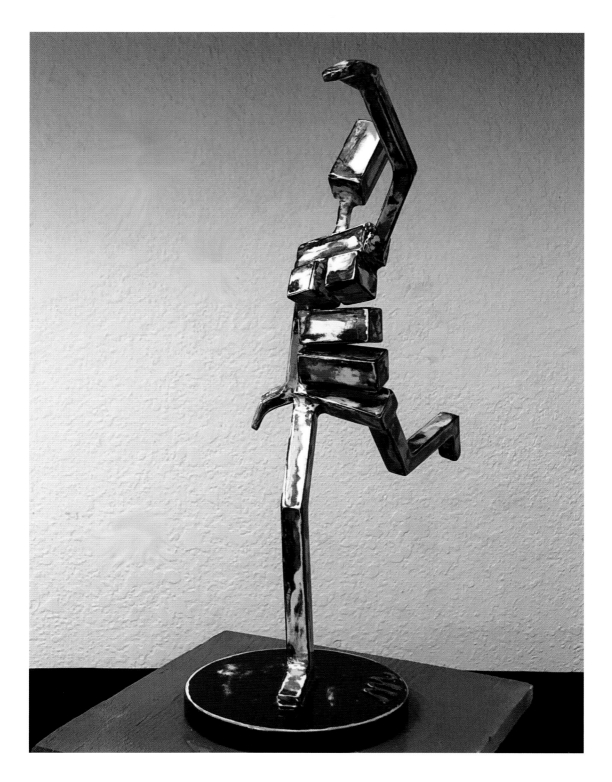

Study for Release

Welded stainless steel with automotive paint.
Life is a perpetual practice of letting go.

What makes it possible for you to create the art you want to create in your life?
Gifts . . . lots of gifts. First, there's the gift of being born in a time and place where one can act on one's creative impulse. Then there's the gift of being the child of a woman who taught me by example that I could actually follow my dreams. There's also the gift of having an innately optimistic view of life.

What will you leave behind as your legacy?
At this stage in my life, legacy is becoming more important to me. I trust that legacy will include my body of work, especially my public sculpture. I trust it will inspire a sense of possibility and optimism for people as they navigate their daily lives.

What attracts you to dancing bodies?
I see the body as a vessel that delivers to us and expresses to others the full range of our human experiences. Dance takes on the daunting task of making those experiences visible in a very focused way. Dancing bodies communicates those human experiences in a way that helps us know we are not alone.

When and why did you start incorporating dance into your work, and what do you feel dance brings to it?
I was exposed to images of dancers long before I could even imagine myself as an artist. The thing about artists is that influences can percolate for years, even decades before they show up in our work. That was true of the influence of dance on my work. The way most of us physically move through the world is pretty ordinary, albeit necessary. We sit, we stand, we walk, and occasionally we run or jump. But dance has the ability to take ordinary movements and stylize and contextualize them to reveal extraordinary things about the human experience. I like to use still images of dance movements as a sort of jumping-off point when I'm exploring new ideas.

Are there any works of art by other artists featuring dance that have inspired you?
Isamu Noguchi's *Endine* is not strictly a "dance" sculpture, but that figure conveys a feeling that it's in the process of a powerful, but subtle transition.

Another artist whose work I find quite compelling is Richard MacDonald. He's created some wonderful depictions of dancers that capture the power and grace of the dance.

What process do you go through to create your work? What inspires you?
I have more ideas for sculptures than I'll probably ever be able to complete in this lifetime. If the cloning thing ever gets to the human trial stage, sign me up. Until then, a lot of my process involves listening for what's trying to get my attention. I try to stay open and curious as I move through my day so when my muse whispers something, I'm in a place where I can hear it.

But I don't usually act until the whisper becomes more of a shout. It sounds something like, "Hey!! You really need to make me real, and you need to do it now!"

What question do you wish I had asked you?
Has the reason you make art changed over your career?

What is your answer to that question?
As a young artist, my reasons for making art were mostly about finding my voice. This stage is critical for a young artist, because there are so many influences in the world that seem to want to tell you what kind of art you should make and how you should make it.

As I've matured, as both an artist and a human being, my focus has shifted to creating sculptures for public spaces. My intention is to create sculpture that invites people to connect with essential parts of themselves as well as with others who might come from very different backgrounds.

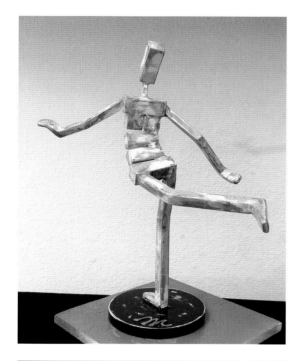

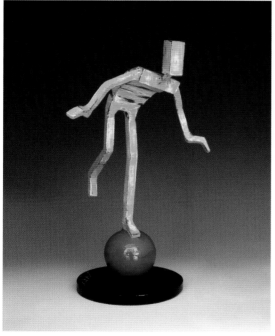

TOP

Study for Arabesque
Welded stainless steel with automotive paint Inspired by classical dance. This work conveys carefree lightness.

BOTTOM LEFT

Study for As The World Turns II
Welded stainless steel with automotive paint. Given that the world never stops, there's only one thing to do . . . go with the flow.

BOTTOM RIGHT

Study for As The World Turns IV
Welded stainless steel with automotive paint. The theme of this work is that movement is life.

ROS NEWMAN

My family has been dominated by artists. My father's great uncle was Henry Holiday, whose work includes *Beatrice and Dante*, considered his most important painting. My grandfather, Sir William Rothenstein, was a painter and the principal of the Royal College of Art [in London]. Over two hundred of his paintings are held in the National Portrait Gallery, and he inaugurated the War Artists Advisory Committee during World War II, following a request he made to the King. William's eldest son, John, was the longest running director of the Tate Gallery, almost thirty years; John's daughter Lucy is also a painter.

His daughter, my mother Betty, went to the Royal College of Art where she became great friends with Henry Moore and Barbara Hepworth. Unfortunately, Betty became unwell and couldn't work anymore.

William's youngest son, Michael Rothenstein, was a prolific printmaker, and Michael's daughter, Anne, is also a successful painter. Michael's son, Julian, is founder of Redstone Press.

My father, Dr. Ensor Holiday, was a scientist and worked with mustard gas during World War II; he invented Altair Designs, which are geometric patterns and designs for arts and crafts projects and still very popular today and enjoyed by children and adults alike.

I went to Chelsea Art School when I was sixteen, normal stuff but which didn't suit me, so I left and did various other things over the next few years. I attended Hammersmith College of Art in the early sixties, which was also a learning place for trades. It was here that I found oxy-acetylene welding. I was entranced, this is what I was looking for! I came to love working in metal and found that I could use steel as a modeling material. Since then I continued to use this technique to capture the movement of the human and animal form, which I love so much.

I had my first solo show in 1972 at the Alwin Gallery in London, and with the proceeds, was able to purchase an old barn near Fakenham, where I lived with my young daughter and husband, Barry, who spent some years converting it into a unique house.

I have lived in Norwich for over forty years and continue to enjoy the vibrant art scene. I'm a member of the 20 Group, and having exhibited my work at an array of different events over the years, with some permanent like the pond birds and the starling at N&N [Norfolk and Norwich] Hospital. Though I am no longer working, I can look back at an incredibly rich, exciting, and rewarding career. Steel found me and I embraced her with all my passion.

Website: sculptors.org.uk/artists/ros-newman

OPPOSITE PAGE
Delphi
2008

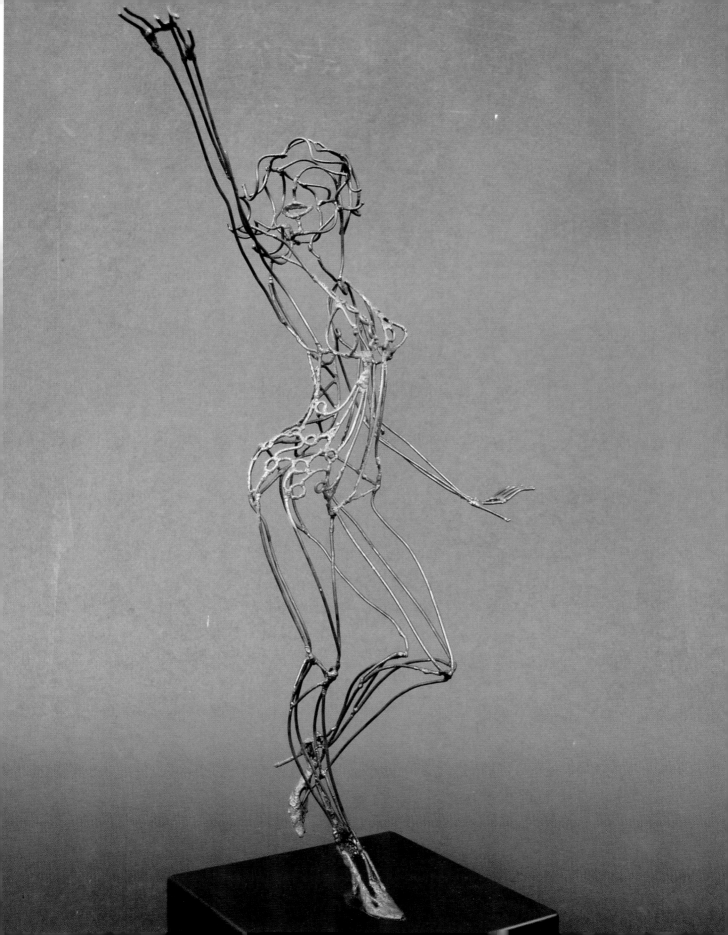

What makes it possible for you to create the art you want to create in your life?

The love of the subject. I started making a living out of it. I was always a prolific artist and making a living with my steel sculptures through exhibitions and commissions allowed me time to experiment and create other types of sculptures in different mediums and forms, which I always enjoyed.

What will you leave behind as your legacy?

All my figurative steel sculptures are one-offs and these are residing in people's homes all over the world. I also have installations of my birds in flight in public spaces throughout Norfolk, where I live. As a female sculptor welding steel with oxy-acetylene, I think I am one of the only ones in this field, so a certain amount of uniqueness is brought to the work, through its form and being the creator of it.

What attracts you to dancing bodies?

I have always been attracted to form and movement, in both animals and people. Suspension of movement can be seen as dance; do animals dance instinctively?

When and why did you start incorporating dance into your work, and what do you feel dance brings to it?

Dance is expressive and fluid. Sometimes it may be more interesting and challenging to present this in a static piece of sculpture. Especially, as I work in 3D, so one can look at a piece from any angle and completely understand the movement it is expressing. Movement is beautiful to the eye.

What process do you go through to create your work? What inspires you?

I usually start by making a small maquette of a piece I have in mind. From this I can understand the shape I am trying to create. As I am working on the actual piece, I incorporate other ideas into it or have flashes of inspiration that might change the direction of the piece. I would say the process is engineering and creativity meeting.

I am inspired by everything around me.

What might people be surprised to know about you (or your work)?

I remember meeting Haile Selassie when I was about four years old. He used to visit my grandfather, the painter William Rothenstein, in Gloucestershire during his exile from the Fascist invasion of Ethiopia by Mussolini in the late thirties.

I remember being in the garden and there was a door into it from the road. The door opened and in walked these two men dressed all in white who stood on either side of the door and Haile Selassie entered. I used to call him Mr. Nobody. He was a small man like my grandfather, maybe that added to their bond. Years later I visited Madame Tussauds in London, the wax museum, [and] all of a sudden I spotted a wax work, it was Mr. Nobody! My daughter loves when I retell this story.

What question do you wish I had asked you?

What would you have been if not an artist?

What is your answer to that question?

Probably a better mother, by spending more time with my daughter.

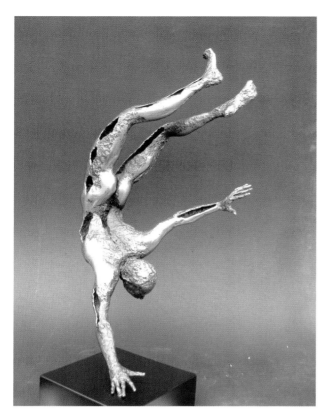
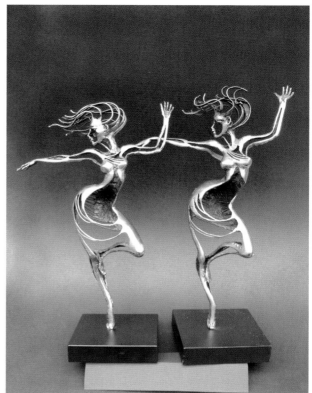
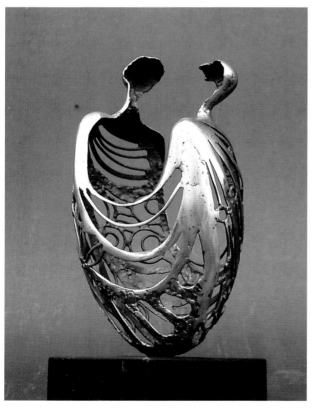
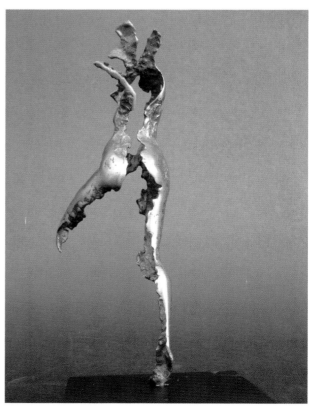

ART INVIGORATES: PERFORMANCE & DESIGN

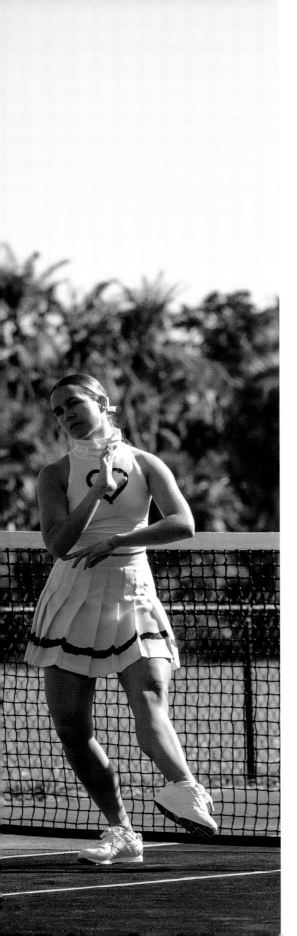

WILL COTTON

Will Cotton was born in Melrose, Massachusetts, and raised in New Paltz, New York. He has a BFA from Cooper Union, and lives in New York City. His work often explores themes of desire, insatiability, and most recently, the relationship between a cowboy and a pink unicorn.

His paintings are in the permanent collections of the National Portrait Gallery, Washington, DC; Smithsonian American Art Museum, Washington, DC; Seattle Art Museum, Washington; Columbus Museum of Art, Ohio; and Orlando Museum of Art, Florida, as well as many prominent private collections.

Cotton served as the artistic director of the *California Gurls* music video for pop singer Katy Perry. He is the subject of a monograph published by Rizzoli, USA.

Website: willcotton.com
Instagram: @willcottonnyc

OPPOSITE PAGE
Tennis Court Ballet
Co-created by Will Cotton and Kate Wallich. Pictured dancer Matt Drews and choreographer Kate Wallich, 2016.

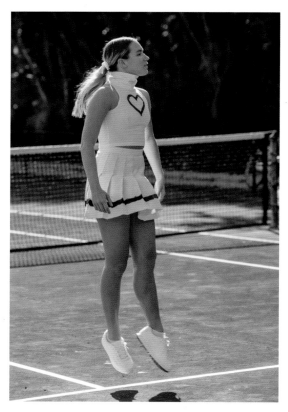

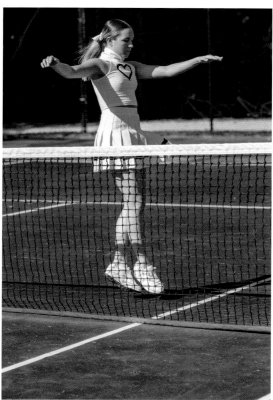

Kate Wallich and Lavinia Vago performing in Tennis Court Ballet, 2016

FOLLOWING SPREAD

Pictured dancers Savannah Lowery, Georgina Pazcoguin, and Ana Sophia Scheller performing in *Cockaigne*, 2011

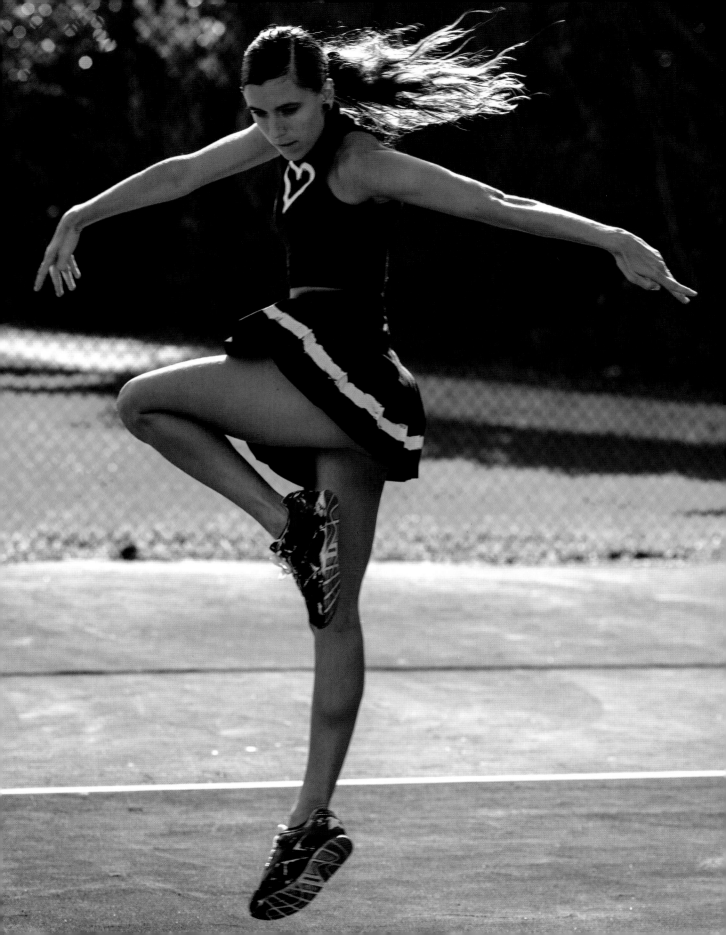

What makes it possible for you to create the art you want to create in your life?

I've always painted regardless of circumstance, but making the dance pieces was different. It's more expensive and requires rehearsal and performance spaces. For that I've had support from various public and private entities including the Performa Biennial and the Robert Rauschenberg Foundation. And the generosity of my friends and collaborators.

What will you leave behind as your legacy?

Most of the work I make is painting so those are real objects out there in the world that will continue to have a presence after I'm gone. The dance pieces feel to me more ephemeral; there's some photo and video documentation (and my inclusion in this book) as a record. I hope that in the future there could be a restaging; I've kept the sets and costumes.

What attracts you to dancing bodies?

In my paintings, there's a complete absence of the element of time—they are by nature pictures frozen in the moment. Watching the movement of a body through space and time is a completely different pleasure, something I can't capture in a painting.

When and why did you start incorporating dance into your work, and what do you feel dance brings to it?

In 2010, I was the artistic director on Katy Perry's *California Girls* music video; that was my first experience seeing choreography incorporated into the imagery coming out of my work. That whole process was very collaborative. I got to work with some terrific people including a costume designer, director, fabricators, a choreographer, etc. But I started asking myself what would happen if I had total control over all the various elements of the piece. After the video came out, I decided to compose two dance pieces in which I alone was responsible for the concept, costumes, and sets. I paired down the theme to just two material elements, whipped cream and cotton candy. I directed and chose the choreographers, composers, and musicians. The music was written by John Zorn and

Caleb Burhans, with choreography by Charles Askegard and Mona Malone. The music was played by Conrad Harris, Pauline Kim, Keith Cotton, John Zorn, and Heung Heung. What came out of it was something very abstract, very different from the Katy Perry music video.

Are there any works of art by other artists featuring dance that have inspired you?

When I was studying art at Cooper Union in the eighties, I became aware of some of the work that David Salle was doing with Karole Armitage. I loved the idea that there could be cross-pollination in contemporary art. He made the sets for her dances, and she became a subject in his paintings. I appreciated the whole meta narrative.

What process do you go through to create your work? What inspires you?

Sometimes it feels like a process of elimination. As I'm conceiving of a new piece, I'm really stripping away everything that's not exciting, that doesn't really capture my attention. Ever since I was in art school, I've found that there are certain prescriptions for what contemporary art should and shouldn't be. I've often found myself drawn to the margins of those constraints, to making work that doesn't fit that mold, to liking the "wrong" artists and subject matter considered unworthy in the contemporary art world. I've tended to find inspiration in things that seem outwardly frivolous such as candy and cakes and cartoons, pink unicorns, pin-up girls and handsome cowboys. I ultimately use those elements to put together a more interesting, often darker narrative.

What might people be surprised to know about you (or your work)?

That I cringe whenever someone refers to my work as whimsical.

What question do you wish I had asked you?

Would you be interested in designing sets and costumes for a ballet company in the future?

What is your answer to that question?

Yes.

OPPOSITE PAGE
Ruby Valentine and Hannah Cohen
performing in *Cockaigne*, 2011

NATALIE FRANK

Natalie Frank (b. 1980) is an interdisciplinary artist whose gouache and chalk pastel drawings, paper paintings, work in artistic design in performance, and ceramics focus on the intersection of sexuality and violence in feminist portraiture. Frank's portraits of women draw on overlooked stories and storytellers in literature that spans erotica to fairy tales. She engages with contemporary discourse around themes of S&M, female authorship, fantasy, and shifting societal power structures. Frank has produced a number of books, including *O* (Lucia Marquand, 2018), which visualizes tales from the sex positive feminist and revolutionary 1954 French erotic novel, *Story of O*; *The Sorcerer's Apprentice* (Princeton University Press, 2017); *Tales of the Brothers Grimm* (Damiani, 2015); and *The Island of Happiness: Tales of Madame d'Aulnoy* (Princeton University Press, 2021). Her drawing survey show, *Unbound*, co-organized by the Madison Museum of Contemporary Art, Wisconsin, and the Kemper Museum of Contemporary Art, Ohio, exhibited from June through October 2021.

Recent museum exhibitions include *Never Done: 100 Years of Women in Politics and Beyond*, Frances Young Tang Teaching Museum at Skidmore Collage, Saratoga Springs, New York; *In the Collection*, Yale Women Alumni, Yale University Art Gallery, New Haven, Connecticut; *Dread and Delight: Fairy Tales in an Anxious World*, curated by Emily Stamey, Weatherspoon Art Museum, University of North Carolina at Greensboro traveling to the Grinnell College Museum of Art, Iowa, and Akron Art Museum, Ohio; and *Natalie Frank: The Brothers Grimm* at the Drawing Center in New York City in 2015, which traveled to Blanton

Museum of Art, University of Texas at Austin, and University of Kentucky Art Museum, Lexington, in 2016.

Frank's work is represented in numerous collections, including Ackland Art Museum, the Art Institute of Chicago; the University of North Carolina at Chapel Hill; Blanton Museum of Art at the University of Texas at Austin; the Berger Collection, Hong Kong; Beth Rudin de Woody Collection; the Bowdoin Museum of Art, ME; the Brooklyn Museum of Art, NY; Everson Museum of Art, Syracuse, NY; the Hall Art Foundation; the Kemper Art Museum, St. Louis, MO; the Kentucky Art Museum; Mills College Art Museum, Oakland, CA; Montclair Art Museum, NJ; Pennsylvania Academy of the Fine Arts, Philadelphia, PA; the Rose Art Museum, Waltham, MA; the Weatherspoon Art Museum, Greensboro, NC; the Whitney Museum of Art, New York, NY; and Williams College Museum of Art, Williamstown, MA.

Natalie Frank's work has been covered in national and international publications and media outlets such as *Art and Auction*; *Art in America*; *Art Review*; *Artinfo.com*; *Artnet News*; *BOMB*; *Flash Art*; the *Huffington Post*; the *Los Angeles Times*; *Modern Painters*; *New York Magazine*; the *New York Observer*; the *New York Times*; *The New Yorker*; and the *Wall Street Journal*. She has been a visiting artist at Brooklyn College; Cranbrook Academy; Hunter College; Maryland Institute of Contemporary Art; the New York Academy of Art; the New York Studio School; New York University; Pratt; The School of Visual Arts; and Yale University.

OPPOSITE PAGE
The Ungrateful Son
Gouache and chalk pastel
on paper, 30 × 22",
76 × 56 cm, 2011–14.
Photo: Farzad Owrang.

Website: natalie-frank.com
Instagram: @nataliegwenfrank
Galleries: Rhona Hoffman Gallery, Chicago, IL

Frog King, Castle
Gouache and chalk pastel
on paper, 22 × 30",
56 × 76 cm, 2019.
Photo: Farzad Owrang.

Frog King I
Gouache and chalk pastel
on paper, 30 × 22",
76 × 56 cm, 2011–14.
Photo: Farzad Owrang.

Snow White,
Grimm Tales
Photo by Anne Marie
Bloodgood. Courtesy
Ballet Austin.

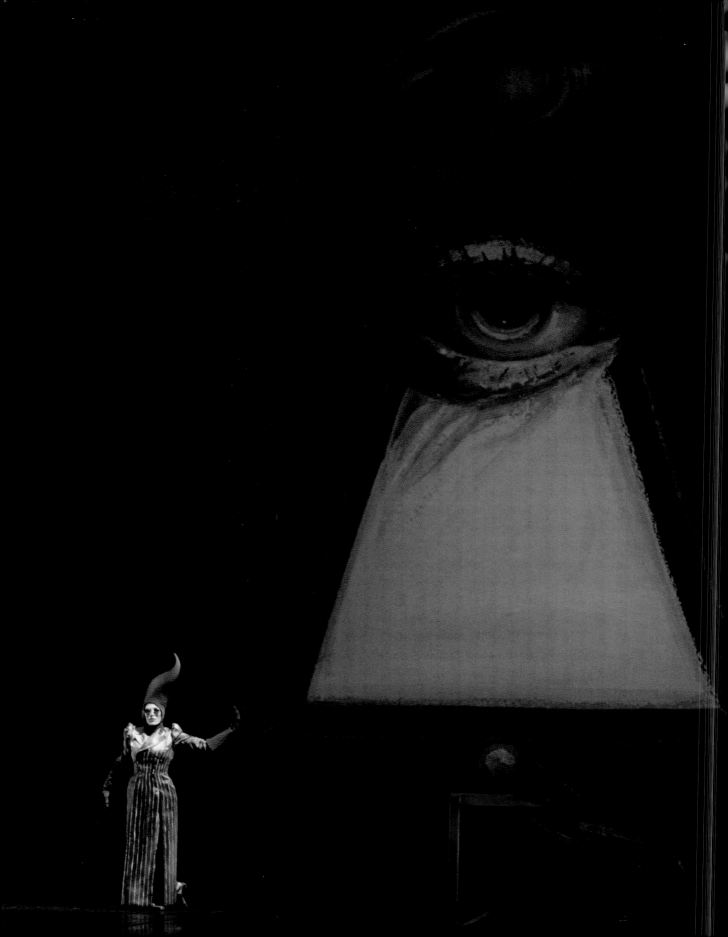

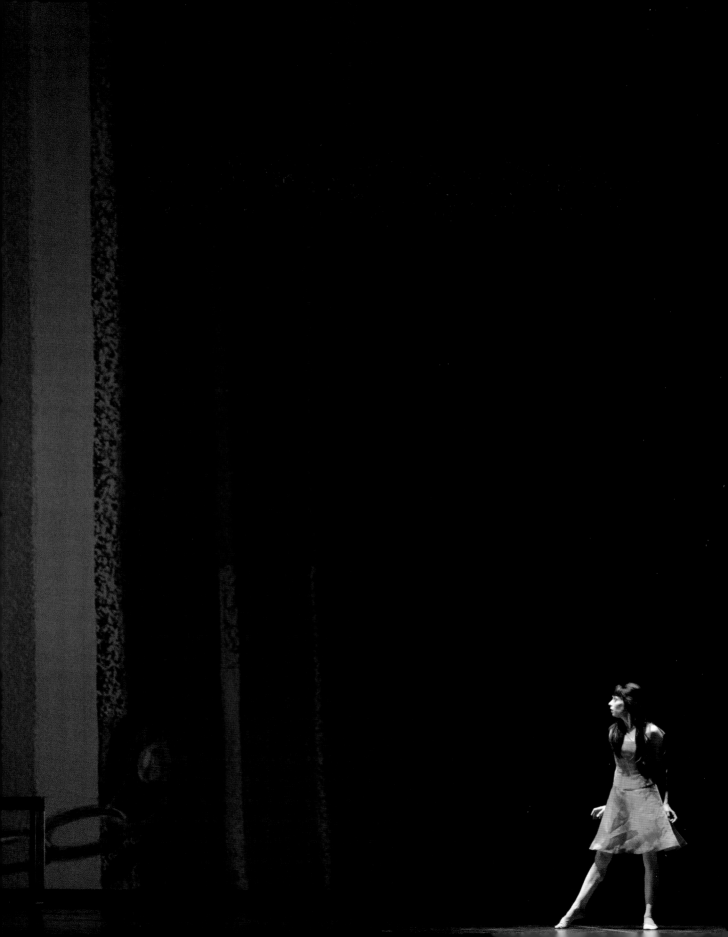

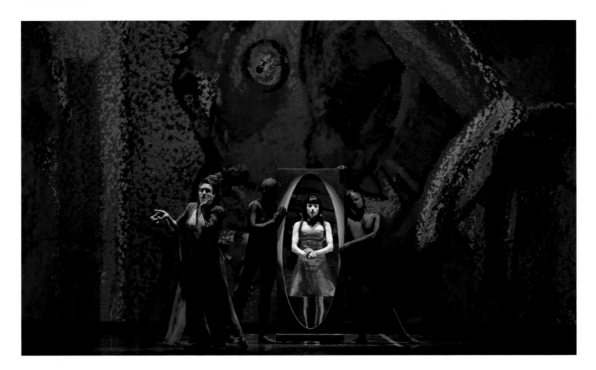

TOP
Snow White,
Grimm Tales
Photo by Anne Marie
Bloodgood. Courtesy
Ballet Austin.

BOTTOM
Snow White,
Grimm Tales
Photo by Anne Marie
Bloodgood. Courtesy
Ballet Austin.

OPPOSITE PAGE, TOP
The Juniper Tree,
Grimm Tales
Photo by Anne Marie
Bloodgood. Courtesy
Ballet Austin.

OPPOSITE PAGE, BOTTOM
Snow White,
Grimm Tales
Photo by Anne Marie
Bloodgood. Courtesy
Ballet Austin.

What makes it possible for you to create the art you want to create in your life?

I have been fortunate to have a supportive family, exposure to opportunity, and the generosity and time of mentors. When I was young my family embraced my desire to study drawing and painting, and I was able to study at the Slade, at University College London, from an early age, living in London for the summers, alone. It was here [where] I learned to paint. My mother attended figure drawing classes with me (because I was so young) in Texas, learning from the nude model, beginning when I was thirteen. I have always had a single-minded focus about my work and have carved out the time and space to spend time trying to figure it all out in the studio. It has been the obsession of my life. At Yale University, as an undergraduate, I had a phenomenal head of college who helped me travel to see art and to study in different countries. Exposure to places like the Dunhuang Caves in China, the Brancacci Chapel in Florence, and the Rodin Museum in Paris have guided me in my figurative, narrative work. The artist Dame Paula Rego has been a mentor of mine, encouraging me to draw work from literature and to trust my imagination in pastel. She encouraged me to draw the Grimm's fairy tales. Dr. Linda Nochlin, the feminist art historian, supported me in her writing and with friendship as I began to draw images of fairy tales and erotica. Ultimately, I let my work guide me. I want to continue working in different media: drawing, painting, opera, ballet, books, sculpture. New combinations of drawing and painting in three-dimensional forms feels like an area ripe with possibility.

What will you leave behind as your legacy?

I hope that I will be a part of a community of peers, loved ones, and friends. Artistically, I hope that my work can make some contribution to the enduring power and legacy of feminist portraiture.

What attracts you to dancing bodies?

Bodies in movement, and the contortions and silhouettes that arise from dance, are achingly beautiful. The body in motion feels like a reminder about a human being's possibility to change, grow, and shape the world around ourselves. Dance can represent a compressed temporal life span—so many emotions and life stages can be expressed and transmitted in a succinct period, with a type of abstraction that allows the viewer to feel and experience time.

When and why did you start incorporating dance into your work, and what do you feel dance brings to it?

In 2017, I was invited by Ballet Austin, in Austin, Texas to collaborate on a new, full-length production that brought my drawings of the unsanitized nineteenth-century Grimm tales from my book, *Tales of the Brothers Grimm: Drawings by Natalie Frank* (Damiani, 2015) to life. These seventy-five large-scale drawings and marginalia had comprised my first book and museum show, which opened at the Drawing Center, New York, NY, in 2015 and traveled to the Blanton Museum of Art, University of Texas, Austin, TX, as well as the Kentucky Art Museum, Lexington, KY, in 2016. These tales were not widely known in their original, dark forms whose genesis were centuries of women's

oral tales. I collaborated with Jack Zipes, the fairy tale scholar, who provided his translations of the tales, as well as the introduction. He and I have collaborated on three books since the Grimm's! In these drawings, in the book, and in the performance, I reinterpreted the unsanitized Grimm tales from a feminist perspective. I worked with Stephen Mills, the artistic director of Ballet Austin, to compile a talented team of artists to design sets, costumes, textiles, props, headpieces, and animations out of my drawings. It was stunning to see my work come alive in front of four thousand people—the images that I had drawn at a scale of 20 by 30 inches became 20 by 30 feet. In addition to my drawings from my book, I also made around one hundred new drawings for sets, costumes, and animations. Transforming drawing and layering of materials into hand-painted textiles, costumes, sets, and animations necessitated turning to different visual languages and collaboration with an incredible gifted group of professionals. *Grimm Tales* premiered in Austin in spring 2019. I am eager to do more!

Are there any works of art by other artists featuring dance that have inspired you?

Many of the greats were incredibly influential; Pablo Picasso, Marc Chagall, Robert Rauschenberg, Isamu Noguchi, Sonia Delaunay, Leonor Fini, and Maurice Sendak are a few of the artists that I immersed myself in the work of. I saw a brilliant show of Chagall's, *Fantasies for the Stage*, at LACMA in 2018 that inspired me. I was fortunate to work with an incredible team of artists: Constance Hoffmann, costume designer; Jeff Fender, textile artist; George Tsypin, set designer; Graham Reynolds, composer; Stephen Mills, choreographer; Howard Werner, animator.

What process do you go through to create your work? What inspires you?

In drawing and painting, I often photograph people that I know, light and dress them, and then pose them in scenarios that use literature as a springboard. Stories are powerful for me, especially those that are magic realist in nature and fuse narratives of the body with magic, power, sexuality, and violence. Everything begins with drawing and painting, and I hope to continue to push these media into opera, dance, and performance.

What might people be surprised to know about you (or your work)?

I feel pretty evenly balanced between my right and left brain. I enjoy organization, numbers, and logic. On the other hand, I revel in abandon, the ridiculous, and pure fun. It is always a balance. Despite some of the outlandish wish fulfillment that occurs in my work, I am actually introverted and a little shy.

What question do you wish I had asked you?

What piece of literature would you like to make into a dance?

What is your answer to that question?

I would love to see the *Story of O made* into dance. I want to be a part of performance that tackles feminist portraiture in bold ways. Bring on the sex and the complex interior lives of women!

ANTONY GORMLEY

Antony Gormley is widely acclaimed for his sculptures, installations, and public artworks that investigate the relationship of the human body to space. His work has developed the potential opened up by sculpture since the 1960s through a critical engagement with both his own body and those of others in a way that confronts fundamental questions of where human beings stand in relation to nature and the cosmos. Gormley continually tries to identify the space of art as a place of becoming in which new behaviors, thoughts, and feelings can arise.

While spending a great deal of time trying to make material equivalents to what it feels like to inhabit a body, Antony Gormley has always had great interest in watching other bodies in dance. He considers the dancer's life the most generous and demanding of any profession, using life itself as the primary medium of communication.

Having briefly studied contemporary dance at Cambridge as an extracurricular activity, Gormley has taken an active interest in the choreographic worlds of Merce Cunningham, Trisha Brown, Lucinda Childs, Pina Bausch, William Forsythe, Siobhan Davies, and Michael Clark. The inspiration of pure dance, with the body released as an expressive subject in its own right detached from concerns with narrative, has been an inspiration for over thirty years. He is less interested in the courtly disciplines of traditional ballet and more in the evolution begun by Martha Graham in which the body and its relationship to the floor and gravity opened up new expressive potentials for the language of the body in motion.

Antony Gormley's work has been widely exhibited throughout the UK and internationally through exhibitions at venues that include the National Gallery Singapore (2021–22); the Royal Academy of Arts, London (2019); in Delos, Greece (2019); Uffizi Gallery, Florence (2019); the Philadelphia Museum of Art (2019); Long Museum, Shanghai (2017); Forte di Belvedere, Florence (2015); Zentrum Paul Klee, Bern, Switzerland (2014); Centro Cultural Banco do Brasil, São Paulo, Rio de Janeiro, and Brasilia (2012); Deichtorhallen, Hamburg, Germany (2012); the State Hermitage Museum, St. Petersburg (2011); Kunsthaus Bregenz, Austria (2010); Hayward Gallery, London (2007); Malmö Konsthall, Sweden (1993); and Louisiana Museum of Modern Art, Humlebæk, Denmark (1989). Permanent public works include the *Angel of the North* (Gateshead, England), *Another Place* (Crosby Beach, England), *Inside Australia* (Lake Ballard, Western Australia), Exposure (Lelystad, The Netherlands), and *Chord* (Massachusetts Institute of Technology/MIT, Cambridge, MA).

Antony Gormley's work on *Survivor* follows critically acclaimed collaborations with Akram Khan, Sidi Larbi Cherkaoui, and Nitin Sawhney on *zero degrees* (2005, Sadler's Wells) and again with Sidi Larbi Cherkaoui on *Sutra* (2008, Sadler's Wells); *Babel* (2010, Sadler's Wells), for which he was given an Olivier Award for Outstanding Achievement in Dance for the design of the set (2011); *Noetic* (2014, Göteborg Opera); and *Icon* (2016, Göteborg Opera).

OPPOSITE PAGE
Min Tanaka, performing "Dance Buto," around Antony Gormley's sculpture *Sovereign State* (1989–90), at Tokushima Modern Art Museum. Photograph by Herve Bruhat, 1997.

Website: antonygormley.com

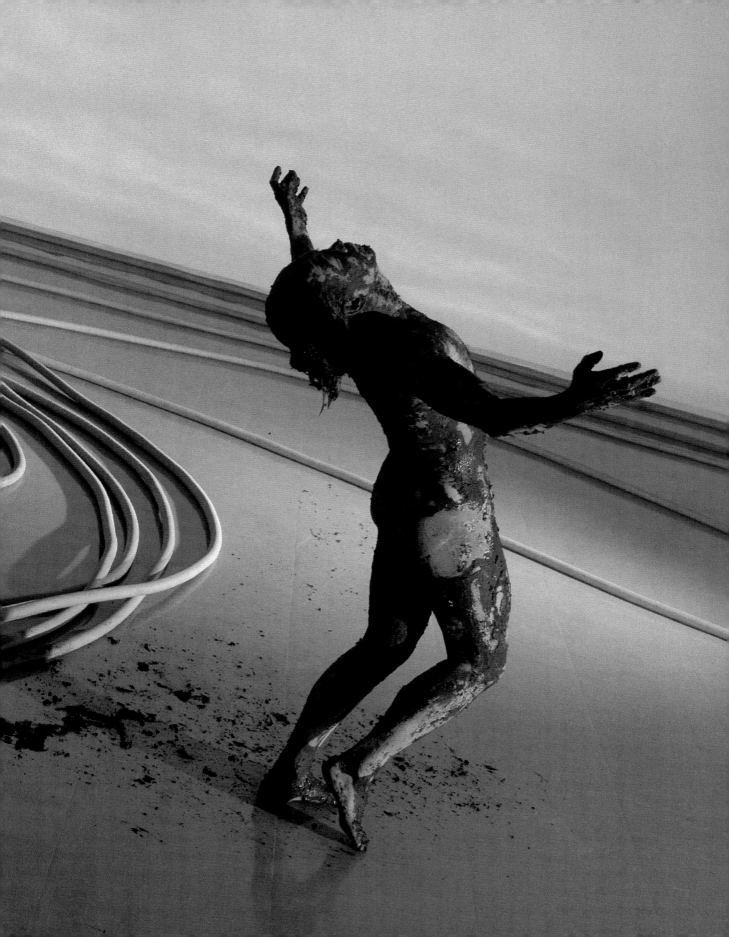

TOP
Zero Degrees
Choreographers and
dancers Akram Khan
and Sidi Larbi Cherkaoui.
Scenographer Antony
Gormley. Composer Nitin
Sawhney. Sadlers Wells,
London. Photograph by
Tristram Kenton, 2005.

OPPOSITE PAGE
Noetic
Creation by Sidi
Larbi Cherkaoui.
Scenography by Antony
Gormley. Composer
Szymon Brzóska.
GöteborgsOperans
Danskompani
Commission. Photographs
by Bengt Wanselius, 2014.

FOLLOWING SPREAD
Breathing Room III
Aluminium tube 25 ×
25 mm, Phosphor H15
and plastic spigots, 190 ×
667 × 352", 482.6 × 1693 ×
895.1 cm. Installation view
White Cube Masons' Yard,
London. Photograph by
Stephen White, London,
2010.

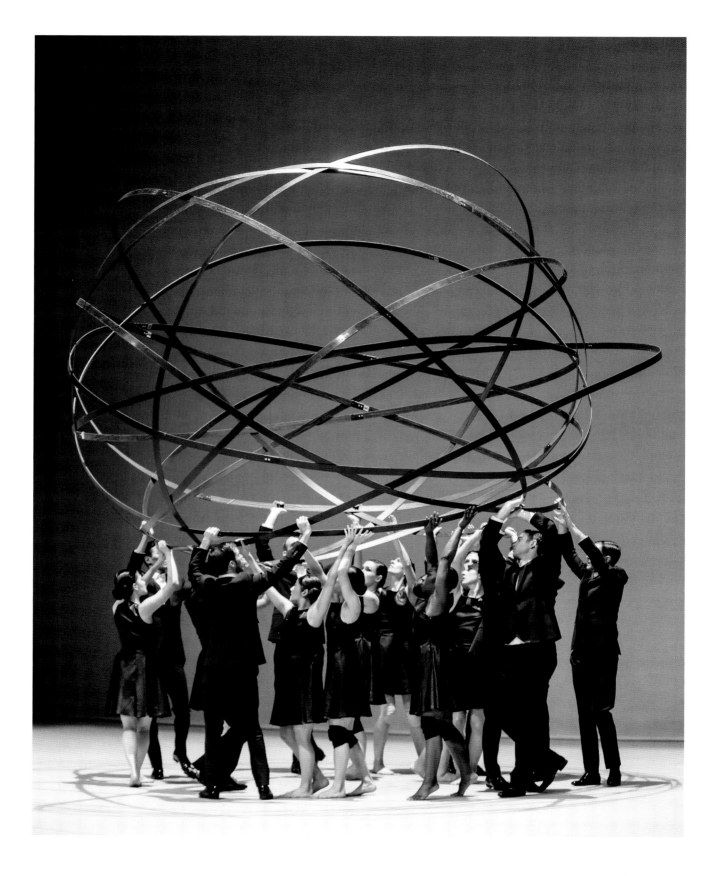

What makes it possible for you to create the art you want to create in your life?

Making art makes you want to make art, work comes from work, work can be very demanding. To support the demands of the work you need a place to work, a place to sleep, a place to eat, and good friends. My best friend is my wife, who is also an artist. I think artists should partner with each other because they understand the demands of the work.

What will you leave behind as your legacy?

The work will be my legacy and I hope to leave enough of it for it to be able to continue to be a marker in space and time and affect the life around it. As I get older, I think that arts ability to create place is more important than arts ability to demonstrate itself in exhibitions. With limited time available I want to spend more of my energy making places. Recently, we've also started the "Foundation Foundation" to look after my legacy and help emerging artists.

What attracts you to dancing bodies?

Sculpture proposes a fixed point in space and invites movement; circumnavigation and exploration invite participation in its field. Dance is architecture created in time by the contraction and extension of the body. Bodies in dance create a web of successive images on a foundation of stillness and silence.

LEFT
Model

Weathering steel. 198 × 1276 × 535", 502 × 3240 × 1360 cm. Installation White Cube Bermondsey, London. Photograph by Benjamin Westoby, 2012.

William Forsythe, Alain Platel, Anne Teresa De Keersmaeker, Sidi Larbi Cherkaoui, Akram Khan, and many others.

Are there any works of art by other artists featuring dance that have inspired you?

Robert Rauschenberg and John Cage's work with Merce Cunningham—especially *Pelican* (which I only know through film) inspires thoughts about how movement is modified or changed through not simply dancing with other bodies, but with *things*—Merce dancing with the chair, Rauschenberg on skates with the parachute—give you an insight into how adaptable the body is but also how dependent we are on our tools and our furniture.

What process do you go through to create your work? What inspires you?

And as I said above, work creates work—going to the studio every day is like going to a garden: You must do the work, prepare the soil, and make the structures that allow the flowers to flourish. Work is a form of fermentation and can be helped by all sorts of things: the right muscles, the right temperature, and being at the right place at the right time. The inspiration is life itself: the feeling of being alive, alert, awake, aware and trying to honor, respond, and materialize that.

What might people be surprised to know about you (or your work)?

I love snorkeling and diving. The feeling of being in the continuum immersed in a medium that is in touch with your skin but extends way beyond the visible. This is true of air, but diving makes it palpable. The way the sea accepts our intrusion into its realms I find very moving: the curiosity of reef fish, the light nibble on your face or limbs, the clicking and ticking of that acoustic ambience . . .

Life is very short and very precious. I admire dance and dancers because they use the medium of life itself to express its potential, and its potential to change. The degree to which dance can energize an audience is a miraculous alchemy. I so often I have arrived at the Sadler's Wells tired after a long day's work but leave lifted—filled with the collective energy transmitted.

When and why did you start incorporating dance into your work, and what do you feel dance brings to it?

As a child I loved Marcel Marceau, and the sense of pathos and timing in Buster Keaton. As I got older, I began to appreciate dance—whether the *Ballet Mécanique* of Oskar Schlemmer or the Jungian-inspired work of Martha Graham. When I was at university, I did contemporary dance classes. When in India I visited Mrinalini Sarabhai in Ahmedabad and the Kalakshetra School of Music and Dance in Chennai. In Japan I collaborated with Min Tanaka and was intrigued by Butoh's slowing of time. I love and have been influenced by the work of Lucinda Childs, Merce Cunningham, Jonathan Burroughs,

TIA HALLIDAY

Tia Halliday is an internationally recognized artist currently residing in Calgary, Alberta, Canada. In 2017, she was independently nominated for the Sobey Art Award (National Gallery of Canada), which is the highest award for a Canadian artist under forty. Tia has acquired numerous public grants and awards for her work in performance, drawing, painting, photography, and digital video. Tia has showcased her work in various solo and group exhibitions at museums and galleries across Canada and abroad. Halliday's work has been highlighted in numerous publications including the *Washington Post*, Frieze, *the Globe and Mail*, *Canadian Art*, the *Edmonton Journal*, and the *Calgary Herald*, among others. Halliday completed her BFA with distinction from the Alberta University of the Arts and attended the School of the Art Institute of Chicago. Tia obtained an MFA degree from Concordia University in Montreal, specializing in studio art and theory. She is also a tenured faculty member at the University of Calgary, where she teaches art and visual studies.

Website: tiahalliday.com
Instagram: @tiahallidayartist

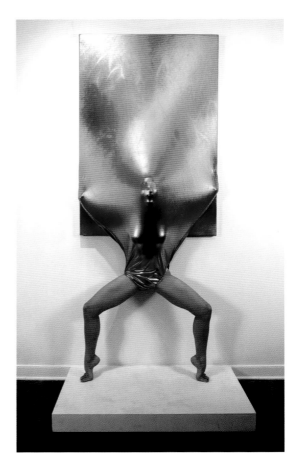

ABOVE
Chromo/Moto/Philia 1
Performance still, 2016

OPPOSITE PAGE
In the Skin of
a Painting 3
Performance Still, digital
inkjet print, 36 × 48",
91 × 122 cm, 2016

324

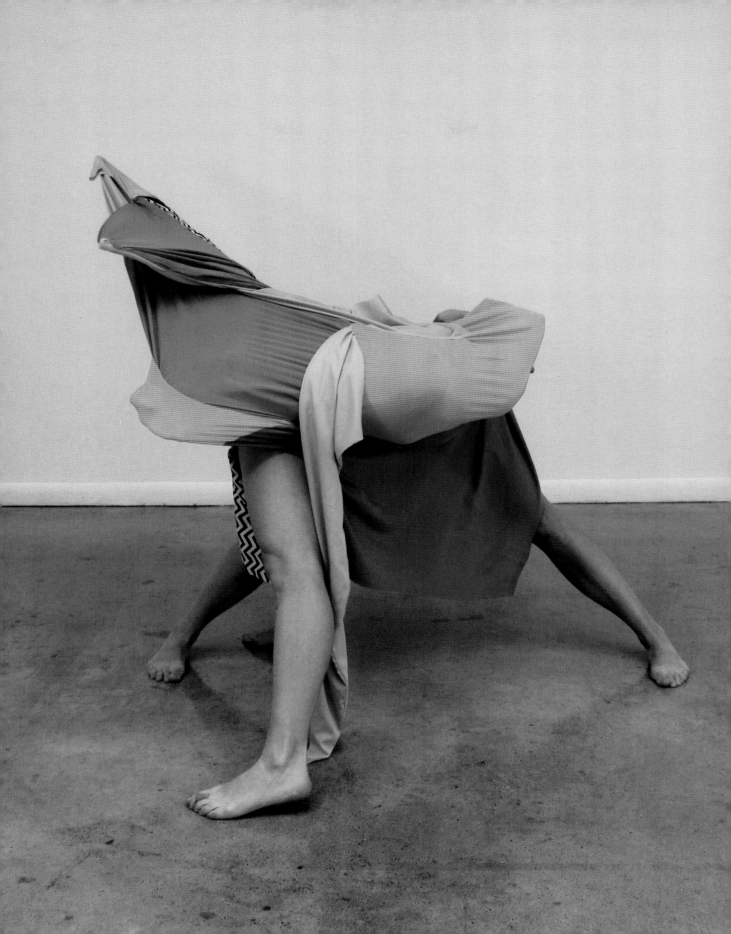

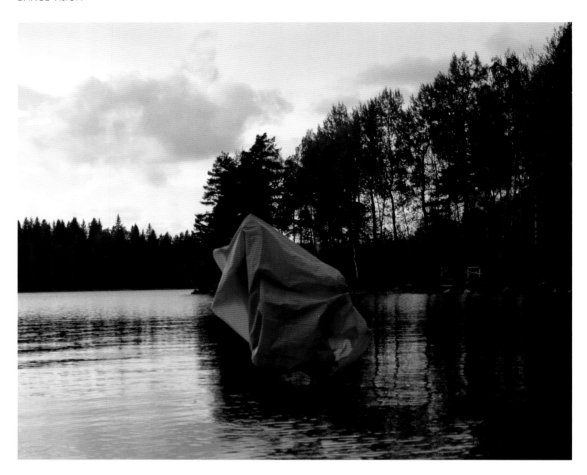

ABOVE
Latent Dream
Digital inkjet print,
36 × 48", 91 × 122 cm, 2015

OPPOSITE PAGE
Modern Narrative 1
Performance still, 2015

FOLLOWING SPREAD, LEFT
Sideshow 3
Aluminum dye
sublimation print on 1-inch
float mount, 41 × 53",
104 × 135 cm, 2017

FOLLOWING SPREAD, RIGHT
Circus II
Aluminum dye
sublimation print on 1-inch
float mount, 43 × 48",
110 × 122 cm, 2017

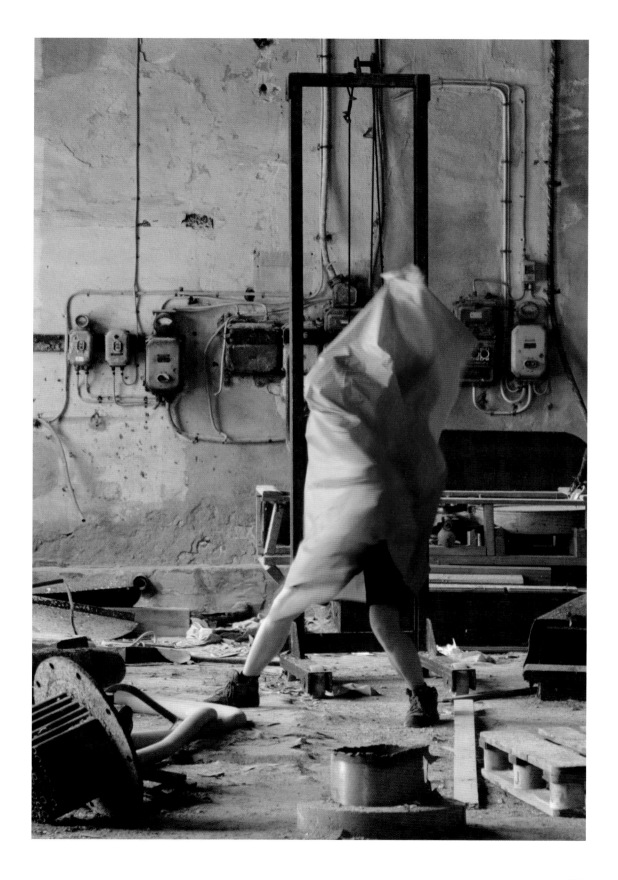

TOP
Illumination
Irregular shape, aluminum
dye sublimation print on
1-inch float mount,
36 × 51", 91 × 130 cm, 2016

BOTTOM
Spatial Negotiations
Performance still, digital
inkjet print, 40 × 34",
102 × 86 cm, 2014

OPPOSITE PAGE
Fetish 12
Aluminum dye
sublimation print on 1-inch
float mount, 56 × 53",
142 × 135 cm, 2017

FOLLOWING SPREAD
The Palpable Nature
of Praxis 3
Performance still,
performed by Melinda
Coetzee & Brynn Williams,
2017

FOLLOWING SPREAD
The Palpable Nature
of Praxis
Digital Collage from
performance still,
performed by Melinda
Coetzee & Brynn Williams,
2017

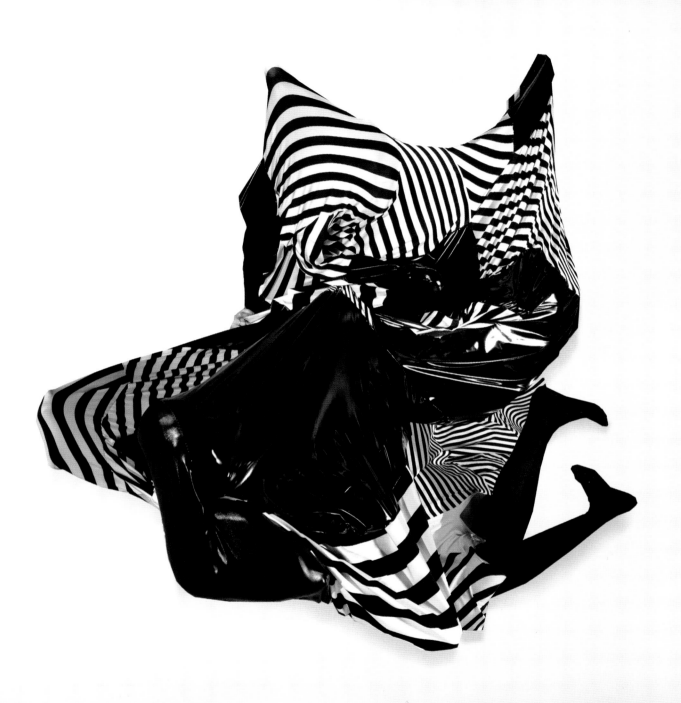

What makes it possible for you to create the art you want to create in your life?

I think there is a point in every artist's journey where you stop making the art you think you should make, or what others think you should make, and you settle on just listening to yourself and making the work you were always meant to create. It is all about listening to this very quiet inner voice. Listening to this authentic inner voice is absolutely necessary for a continuous creative practice. This voice can get muted or lost sometimes throughout one's career, but I believe it is always there. Listening to this voice is paramount; without it I think it's impossible to continue creating work year after year.

What will you leave behind as your legacy?

This is a very good question and one that I have not considered all that much. I don't worry too much about legacies. I simply hope that, at some point in time, my work or activity in the creative community may have motivated or inspired someone. That's all. I am not big into the idea of legacies.

What attracts you to dancing bodies?

I have always been totally interested in the body's movement. I could watch a dancer move and perform for hours and enjoy every minute of it. The human body is such an incredibly complex machine that must act with such amazing unison for the body to achieve locomotion (bones, muscles, ligaments). However, I think weight is something that interests me the most: how the body transfers weight, how the muscles propel weight forward and backward. I so enjoy how gravity effects the body and its movement. I find that fascinating.

When and why did you start incorporating dance into your work, and what do you feel dance brings to it?

Implicitly, I believe dance has always been a part of my artwork (my artwork being inclusive of two-dimensional artwork, performance, and more dance-based choreographic work). Explicitly, however, I would argue that my work has incorporated dance more obviously since 2014. I attended a residency in rural Sweden in 2014 and did some dance-based experiments in the woods there. These experiments were very exploratory and low stakes, allowing me to begin to carve out a sort of theoretical framework and visual language for myself. The camera was very important at this point too. Fabric became essential to my interest in exploring paradigms of drawing and painting through performance and dance.

Are there any works of art by other artists featuring dance that have inspired you?

Artists who have found a way of either representing or exploring two-dimensional art through dance have always interested me a lot. I really appreciate Trisha Brown's work. I am also continually inspired by many of the artists who participated in the On Line exhibition at MoMA. I find that

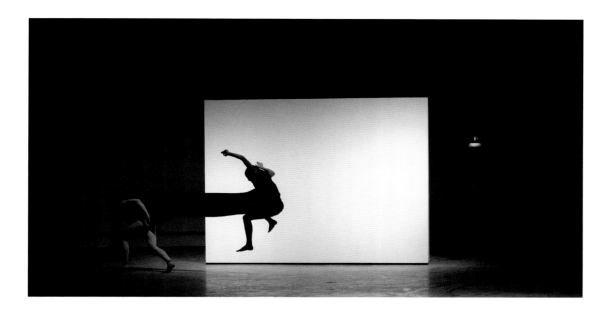

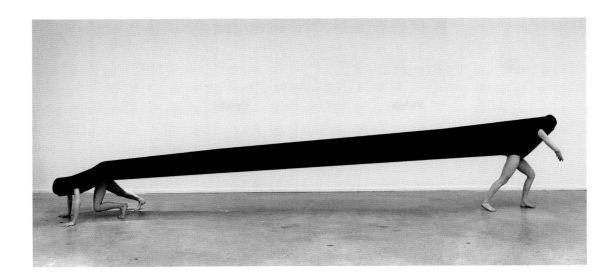

there is something so incredibly grounding about a dancer or physical performer's relationship to visual art and vice versa. Also, my more recent sculptural and collaborative work is significantly informed by folks like American artist Nick Cave.

What process do you go through to create your work? What inspires you?

I tend to navigate between two-dimensional and performance-based experiments to inform my professional work. Funny enough, it is often the two-dimensional that inspires the performance, while movement inspires the two-dimensional. For example, I always tend to start with collage. I will print many, many performance documentation photos that I have taken over the years and I will cut them all up and collage them together. This tends to spark a lot of ideas for performance-based work. Alternatively, spending time in the gym or moving my own body (feeling how my muscles work) seems to inform my work in drawing, painting, photography, and collage.

What might people be surprised to know about you (or your work)?

That is a very interesting question! One that I don't really know the answer to. However, I will say that, in my experience, significant ideas in my work can come from the strangest and most mundane places; I am always getting ideas from my domestic or quotidian experiences. These everyday experiences usually differ greatly from the art that is produced later but are no less important.

What question do you wish I had asked you?

What do you do when the ideas are not coming? What do you do when you feel creatively blocked? I mention this because I think there is so much that happens to artists emotionally and psychologically behind the scenes that we in the creative community do not discuss enough. Things like creative blocks can be incredibly difficult and stressful for artists, especially professional artists. Feeling creatively empty can be terrifying, and it can affect every facet of our lives as creatives. Therefore, I feel a greater dialogue is needed on this topic in both professional and popular spheres.

What is your answer to that question?

My short answer to this question is to go back to that extremely accessible stuff . . . for me it is probably the collage work. I think it is important currently to work on something smaller, that costs less and is more manageable. Something that is of very low consequence. In this space, I tend to try to focus on quantity rather than quality (i.e., how many little collage compositions can I make?). Because sometimes when you are blocked, the quality will not be there. But you can still get up in the morning and make something. Slowly, this can open new possibilities that will lead you out of that creative rut.

TRENTON DOYLE HANCOCK

For almost two decades, Trenton Doyle Hancock has been constructing his own fantastical narrative that continues to develop and inform his prolific artistic output. Part fictional, part auto-biographical, Hancock's work pulls from his own personal experience, art historical canon, comics and superheroes, pulp fiction, and myriad pop culture references, resulting in a complex amalgamation of characters and plots possessing universal concepts of light and dark, good and evil, and all the gray in between.

Hancock transforms traditionally formal decisions—such as his use of color, language, and pattern—into opportunities to create new characters, develop subplots, and convey symbolic meaning. Hancock's works are suffused with personal mythology presented at an operatic scale, often reinterpreting biblical stories that the artist learned as a child from his family and local church community. His exuberant and subversive narratives employ a variety of cultural tropes, ranging in tone from comic-strip superhero battles to medieval morality plays and influenced in style by Hieronymus Bosch, Max Ernst, Henry Darger, Philip Guston, and R. Crumb. Text embedded within the paintings and drawings both drives the narrative and acts as a central visual component. The resulting sprawling installations spill beyond the canvas edges and onto gallery walls.

As a whole, Hancock's highly developed cast of characters acts out a complex mythological battle, creating an elaborate cosmology that embodies his unique aesthetic ideals, musings on color, language, emotions and, ultimately, good versus evil. Hancock's mythology has also been translated through performance, even onto the stage in an original ballet, *Cult of Color: Call to Color*, commissioned by Ballet Austin, and through site-specific murals for the Dallas Cowboys Stadium in Dallas, Texas, and at the Seattle Art Museum's Olympic Sculpture Park in Seattle, Washington.

Trenton Doyle Hancock was born in 1974 in Oklahoma City, Oklahoma. Raised in Paris, Texas, Hancock earned his BFA from Texas A&M University, Commerce, and his MFA from the Tyler School of Art at Temple University, Philadelphia. He now lives and works in Houston, Texas.

Website: mindofthemound.com
Instagram: @trenton_doyle_hancock

ALL PICTURES

Cult of Color: Call to Color
2008. Story and visuals by Trenton Doyle Hancock. Choreography by Stephen Mills. Music by Graham Reynolds. Produced by Ballet Austin. Performance at Austin Ventures Studio Theater, Austin, Texas, 2013. Photo by Tony Spielberg. Image courtesy of the artist and James Cohan, New York.

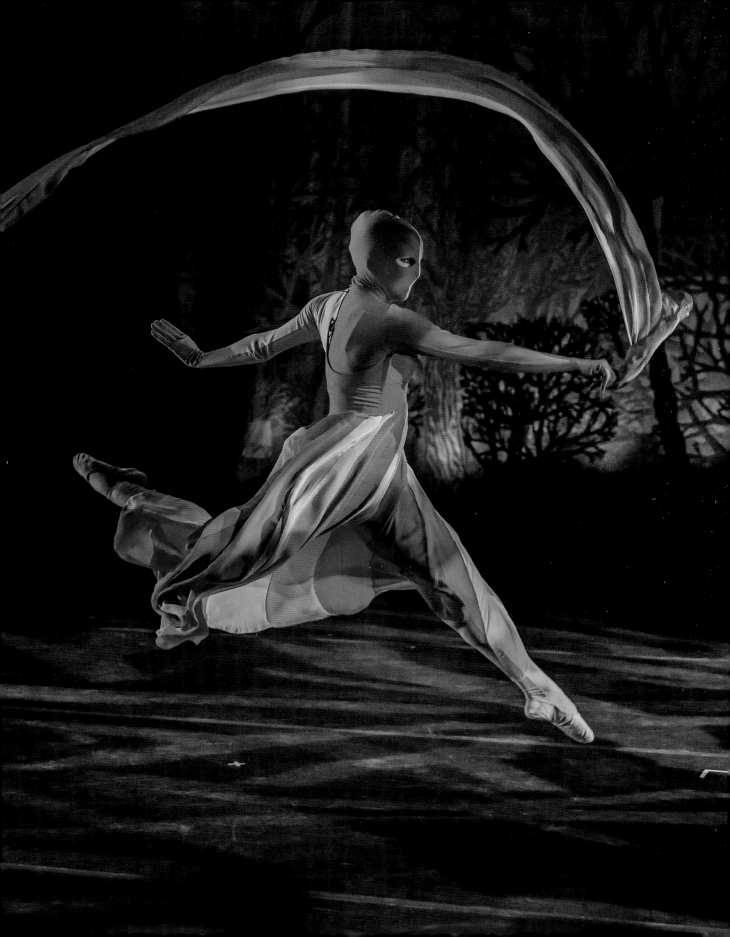

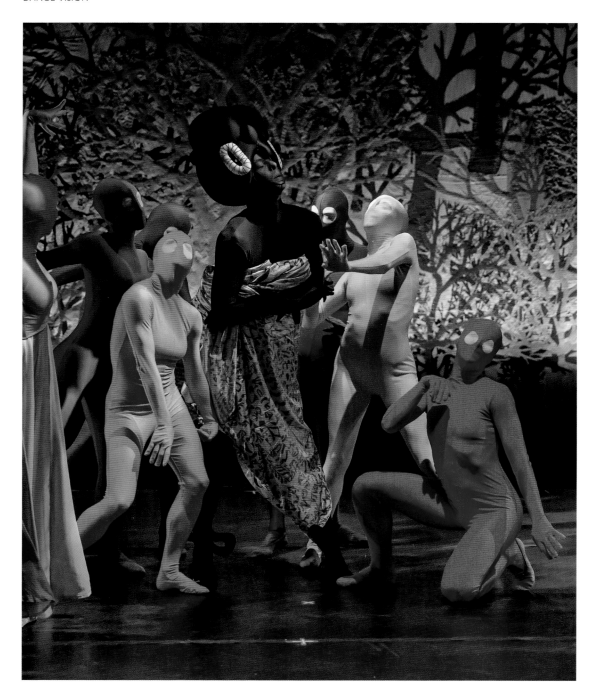

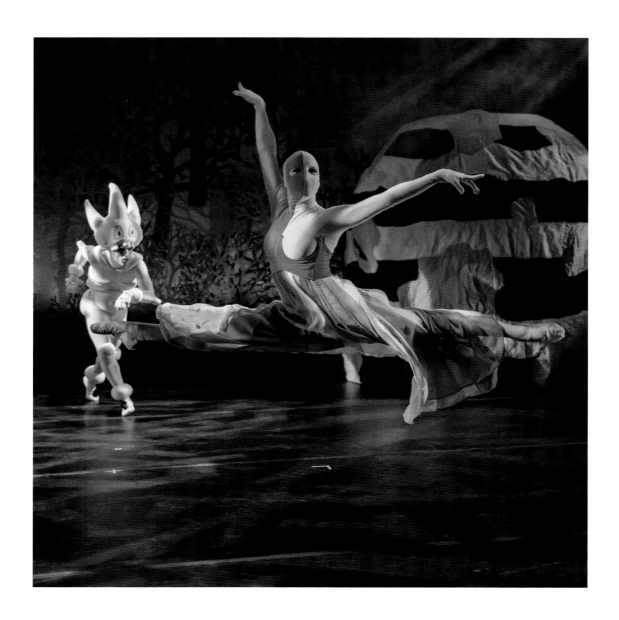

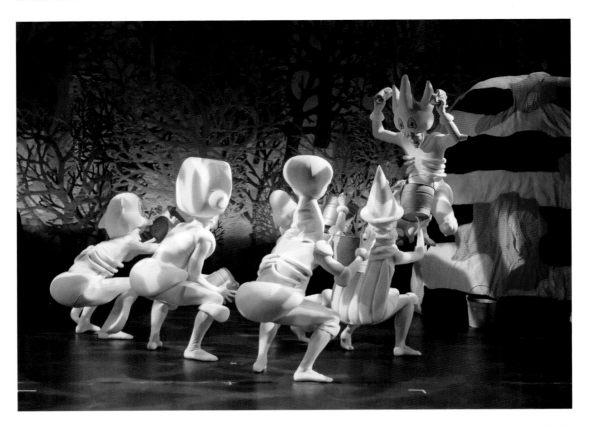

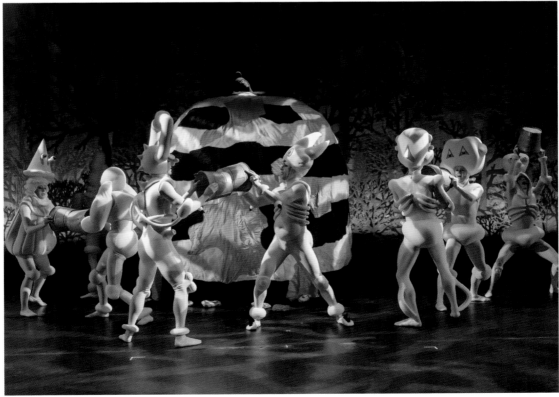

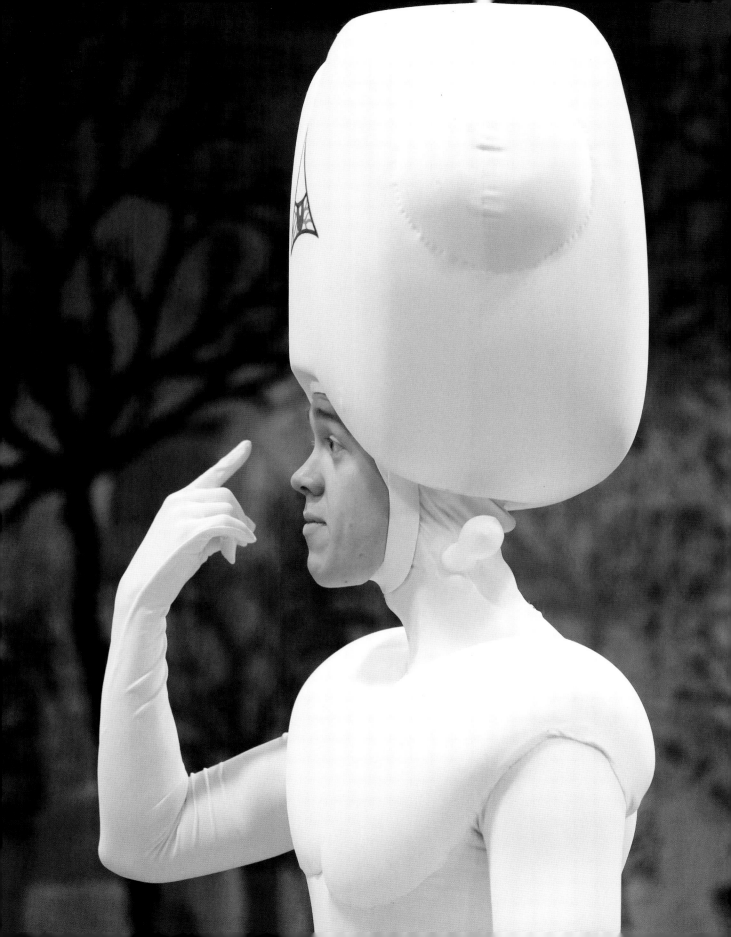

MARK RYDEN

Blending themes of pop culture with techniques reminiscent of the old masters, Mark Ryden has created a singular style that blurs the traditional boundaries between high and low art. His work first garnered attention in the 1990s when he ushered in a new genre of painting, Pop Surrealism, dragging a host of followers in his wake. Ryden has trumped the initial surrealist strategies by choosing subject matter loaded with cultural connotation.

Ryden's vocabulary ranges from cryptic to cute, treading a fine line between nostalgic cliché and disturbing archetype. Seduced by his infinitely detailed and meticulously glazed surfaces, the viewer is confronted with the juxtaposition of the childhood innocence and the mysterious recesses of the soul. A subtle disquiet inhabits his paintings; the work is achingly beautiful as it hints at darker psychic stuff beneath the surface of cultural kitsch. In Ryden's world cherubic girls rub elbows with strange and mysterious figures. Ornately carved frames lend the paintings a baroque exuberance that adds gravity to their enigmatic themes.

Mark Ryden received a BFA in 1987 from ArtCenter College of Design in Pasadena, California. His paintings have been exhibited in museums and galleries worldwide, including a career-spanning retrospective, *Cámara de las Maravillas* at the Centro de Arte Contemporáneo of Málaga, Spain, as well as an earlier retrospective, *Wondertoonel*, at the Frye Museum of Art in Seattle, Washington, and Pasadena Museum of California Art.

Ryden was recently commissioned to create the set and costume design for a new production of *Whipped Cream*, put on by the American Ballet Theatre with choreography by Alexei Ratmansky. *Whipped Cream* is based on *Schlagobers*, a two-act ballet with libretto and score by Richard Strauss that was first performed at the Vienna State Opera in 1924.

Mark Ryden currently lives and works in Portland, Oregon.

Website: markryden.com
Instagram: @markryden

Princess Tea Flower
Oil on board, 17 × 11",
43 × 28 cm, 2016

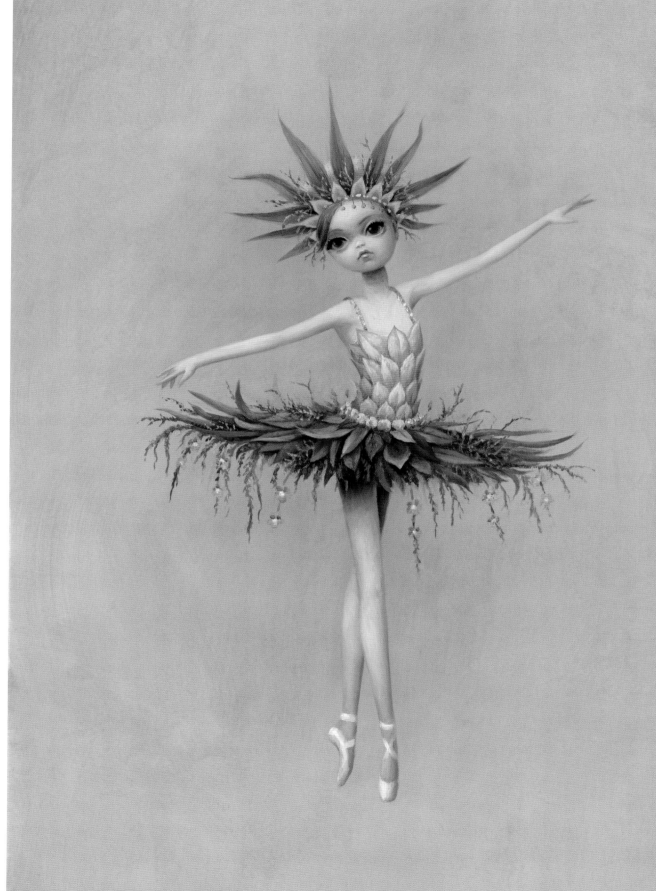

Tea Flower alternate

Oil on board,
17 × 11", 43 × 28 cm, 2016

Swirl Girl

Oil on panel,
23¼ × 11¼", 59 × 29 cm, 2017

Whipped Cream Girl

Oil on panel,
23¼ × 11¼", 59 × 29 cm, 2017

ABOVE

Princess Praline's
Procession
Oil on board, 17½ × 23½",
44 × 60 cm, 33 × 33 × 2¾",
framed, 2016

OPPOSITE PAGE

Whipped Cream Drop
Oil on board,
10½ × 16", 27 × 41 cm,
2016

ABOVE
Marzipan, Sugarplum,
Gingerbread
Oil on board,
14½ × 19½", 37 × 50 cm, 2016

OPPOSITE PAGE
Nurse Corps de Ballet
Oil on board,
17 × 11", 43 × 28 cm, 2016

ACKNOWLEDGMENTS

I want to thank my nana, Virginia Teal, for her belief in me. I want to thank my aunt, Brenda Teal, who brought her to see me perform. Thank you for the support.

I want to thank Frances Sparkman, the first person I ever went to visit in the hospital. Thank you for the present of you in my life. Thank you for your encouragement. And acceptance.

I want to thank my brothers, Trey and Isaac, for the laughs, the pillow fights, and shared bunkbeds: my travel buddies around the world.

I want to thank my family, my mother, Linda Teal, and my father, William Teal, for their great examples of being human. Thank you both for your spiritual wisdom. And for the belief in the unseen. Mother, thank you. You taught me how to listen. And for that I am grateful that I listened to my intuition, and I followed my dream. Father, thank you. You taught me how to move forward with discipline and zest. Thank you for the jogs, and those canons, those jog songs, "Up the Hill, Going Up, Never Stop, Never Stop, Never Stop."

My aunt, Tonya Jackson, you gave me space to be myself. Thank you. And thank you for the experience of being a dog owner.

My aunt, Pizza. A sense of mystery. Even to this day, I don't know your actual name.

I want to thank Rodolphe Lachat for everything.

I want to thank Regan Mies for your patience and remarkable ability to understand me.

Thank you so much, Abrams and Cernunnos, for your help and support through this process. Thank you, Denise LaCongo, the precise and wonderful production manager; Mary O'Mara, the keenest editorial manager; and Shawn Dahl and Benjamin Brard, the absolute best designers I could ever imagine. Did you see the cover?

I want to thank my friends: David Leyva, for saying hello to me, even when I was wearing a kissing booth.

Alessandro Scacchetti, thank you for being there to pick me up.

Holly Johnston, thank you for your constant and consistent friendship.

Jeanelle Jones, thank you for being there. I appreciate your ability to stay with me in a constant friendship.

Toni Denise, thank you for being the greatest cheerleader in the world! I appreciate your support.

I want to thank Ty Kaprelian and Becca Leon, two new friends that have given me the space to continue my evolution through this process.

I want to thank Juan Pablo for the challenge to be more of what I am.

I want to thank Bill Bowers for your great example of being comfortable in your own skin.

Thank you, Bob Burnside, for your help when I needed to find a place I can call home.

I want to thank Denise Thomas Saunders, for her belief in the unseen, and for the reminder to keep going.

I want to thank Kristen and Jeremy Hooper for their hospitality along my dance journey. And for the unforgettable summers in North Carolina.

I want to thank the Murphys, you showed me another definition of home. Thank you, Virginia and Joe Murphy. Harlan Murphy, thank you for the unconditional love, thank you for the unconditional love of the way I dance, the dances. Virginia Murphy, thank you for your ear. I spoke and you listened. I stood up and you saw me. I confused you and you understood me. Thank you. Joe Murphy, thank you for your support and encouragement. And your ear. And your advice. I appreciate our talks in the kitchen. Abel Murphy, thank you for the reminder to be myself. Or at least figure out what that means.

I want to thank Maman, Chantal Arnault, for her encouragement and acceptance. For being the first one to put my art on her wall.

I want to take a moment to remember the late Ros Newman and thank her for her commitment to create. And to create this special anthology with me.

I want to thank all of those who have been a part of my journey to this present moment: Jadin Wong, Richard Gibson, Elizabeth Gravelle, Charles Torres, Greg Amato, Nina Amato, Zory Karah, Tony Rizzi, Chidozie Nzerem, Mark Haim, Jesse Zarritt,

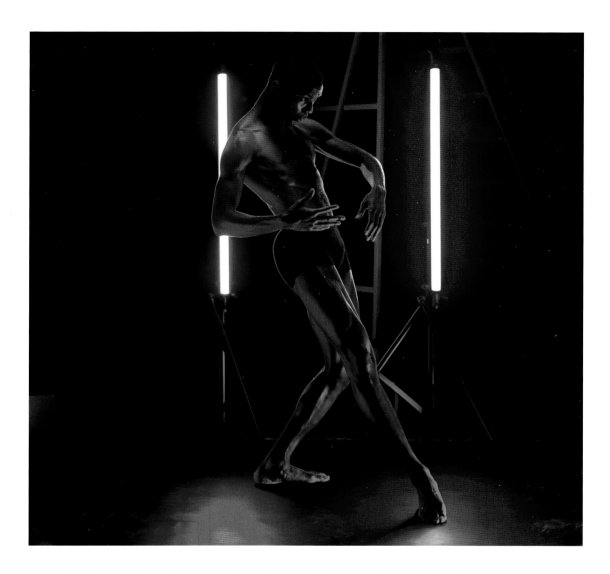

Gwen Welliver, Ishmael Houston Jones, Nicole Wasserman, Donna Faye Burchfield, Marcellus Harper, Kevin Thomas, Tiffany Glen, Brandye Lee, Alice Berry, Jerre Dye, Susan Chrietzberg, Jenny Odle Madden, Moira Logan, Elizabeth and Harold Robison, Isaac Hayes, Justin Lawhead, Justin Campbell, Lisa Rosenberg, Maggie Harrison, 1984BAKI, Erika Bradfield, Jeffrey Yohalem, Alexander Sloan, Gabrielle Pabonan, Debra Nelson, Annabella Sauveuse, Kelsey Wong, Mojdeh Mansoori, Airyka Rockefeller, Laura Pample, Pippa Samaya, Lois Greenfield, Julien Benhamou, Alice Tikston, Lee Gumbs, Jean Yves-Lemoigne, Axel Brand, Mati Gelman, Chris Herzfeld, Ravshaniya, Rob Woodcox, Nir Arieli, Ravshaniya Azoulay, Baki, Julien Benhamou, Axel Brand, Brendan Fernandes, Mati Gelman, Lois Greenfield, Camilla Greenwell, Lee Gumbs, Chris Herzfeld, Jean-Yves Lemoigne, Jordan Matter, Eva Nys, Yevgeniy Repiashenko, Pippa Samaya, Howard Schatz, Alice Tikston, Rob Woodcox, Virginie Cognet, Hayv Kahraman, Dean Larson, Luciano Lozano, Karolina Szymkiewicz, Nicola Verlato, Morgan Weistling, Leah Yerpe, Kevin Chambers, Jonathan Chapline, Coderch & Malavia, Carole A. Feuerman, Dorit Levinstein, James Moore, Ros Newman, Will Cotton, Natalie Frank, Antony Gormley, Tia Halliday, Trenton Doyle Hancock, and Mark Ryden.

TOP
Joshua Teal, the author,
by photographer Vin Eiamvuthikorn

DANCE VISION

ISBN 978-1-4197-6318-2
LCCN: 2022933032

Pages 116–123: Photographs by Jordan Matter, copyright © 2012, 2016, 2018, are reproduced by permission of the photographer. All rights reserved.

Unless otherwise noted, images are copyright the highlighted artist.

Cernunnos logo design: Mark Ryden
Book design: Benjamin Brard

Printed and bound in China
10 9 8 7 6 5 4 3 2 1

Abrams books are available at special discounts when purchased in quantity for premiums and promotions as well as fundraising or educational use. Special editions can also be created to specification. For details, contact specialsales@abramsbooks.com or the address below.

ABRAMS The Art of Books
195 Broadway, New York, NY 10007
abramsbooks.com